THE OIL PAINTING BOOK

THE OIL PAINTING BOOK

By Wendon Blake/Paintings by George Cherepov

WATSON-GUPTILL PUBLICATIONS/NEW YORK
PITMAN PUBLISHING/LONDON

Copyright © 1979 by Billboard Ltd.

Published in the United States and Canada by Watson-Guptill Publications,
1515 Broadway, New York, N.Y. 10036

Published in Great Britain by Pitman Publishing Ltd.,
39 Parker Street, London WC2B 5PB
ISBN 0-273-01254-8

Library of Congress Cataloging in Publication Data

Blake, Wendon.
 The oil painting book.

 1. Painting—Technique. I. Cherepov, George,
1909- II. Title.
ND1500.B55 1979 751.4′5 78-27048
ISBN 0-8230-3270-1

Manufactured in Japan

First Printing, 1978

CONTENTS

Foreword 6
Colors and Mediums 7
Painting Tools 8
Equipment 10
Painting Surfaces 12
Painting Medium 14
Getting Organized 16

Part One: Oil Painting 17

Introduction 19
Bristle Brushwork 20
Softhair Brushwork 21
Painting with Bristle Brushes 22
Painting with Softhair Brushes 24
Bristle and Softhair Brushwork 26
Knife Work 27
Painting with Bristles and Softhairs 28
Painting with Knife and Brush 30
Handling Paint 32
Demonstration 1. Basic Method 33
Demonstration 2. Fruit 36
Demonstration 3. Flowers 40
Demonstration 4. Metal and Glass 44
Demonstration 5. Rocks and Wildflowers 48
Working with Oil Paint 52
Demonstration 6. Summer Landscape 56
Demonstration 7. Autumn Landscape 60
Demonstration 8. Winter Landscape 64
Demonstration 9. Female Head 68
Demonstration 10. Male Head 72
Demonstration 11. Coastal Landscape 76
Correcting Oil Paintings 81
Scraping and Repainting 82
Wiping Out and Repainting 84
Repainting a Dry Canvas 85
Impasto Textures 86
Scraping Textures 87
Impasto Technique 88
Scraping Technique 90
Stretching a Canvas 92
Good Painting Habits 94
Care of Brushes 95
Preserving Oil Paintings 96

Part Two: Landscapes in Oil 97

Introduction 99
Bristle Brushwork 100
Bristle and Softhair Brushwork 101
Cliff Painted with Bristles 102
Trees Painted with Bristles and Softhairs 104
Impasto Painting 106
Painting Thin to Thick 107
Mountains in Impasto Technique 108
Snow Painted Thin to Thick 110
Color Mixing 112
Tree Colors 113
Sky and Land Colors 114
Colors of Water 115

Working with Color 116
Demonstration 1. Deciduous Trees 120
Demonstration 2. Evergreens 124
Demonstration 3. Meadow 128
Demonstration 4. Hills 132
Demonstration 5. Mountains 136
Demonstration 6. Clouds 140
Demonstration 7. Sunset 144
Demonstration 8. Stream 148
Demonstration 9. Snow and Ice 152
Demonstration 10. Pond 156
Selecting Landscape Subjects 161
Composing Landscapes 162
Lighting in Landscapes 164
Linear Perspective 166
Aerial Perspective 167
Brushstrokes Create Texture 168
Modeling with Brushstrokes 169
Textural Technique 170
Modeling Technique 172
Expressive Brushwork 174
Tree Forms 176

Part Three: Seascapes in Oil 177

Introduction 179
Bristle Brushwork 180
Bristle and Softhair Brushwork 181
Surf Painted with Bristles 182
Waves Painted with Bristles and Softhairs 184
Building Cloud Shapes 186
Building Rock Shapes 187
Modeling Clouds 188
Modeling Dunes 189
Rocks Painted Thin to Thick 190
Color Mixing 192
Sea Colors 193
Shore Colors 194
Sky Colors 195
Working wth Color 196
Demonstration 1. Waves 200
Demonstration 2. Surf 204
Demonstration 3. Tide Pools 208
Demonstration 4. Salt Marsh 212
Demonstration 5. Storm 216
Demonstration 6. Sunrise 220
Demonstration 7. Fog 224
Demonstration 8. Rocky Beach 228
Demonstration 9. Headland 232
Demonstration 10. Dunes 236
Selecting Seascape Subjects 241
Composing Seascapes 242
Lighting in Seascapes 244
Perspective 246
Expressive Brushwork: Water 248
Wave Forms 252
Expressive Brushwork: Shore 254
Cloud Forms 256

Painting in Oil. The simplest and most popular method of painting in oils is what professionals call the *direct technique*—and that's what this book is about. In the pages that follow, you'll learn how to paint still life, flowers, landscapes, seascapes, and portraits in a rapid, spontaneous way that reflects the unique character of oil paint. What makes oil paint so remarkable is that it stays wet and pliable for several days, while watercolor and acrylic dry in minutes. Thus, you can keep working on the entire surface of an oil painting as long as the color stays wet—in contrast to the watercolorist or the acrylic painter, who generally applies one layer of color, lets it dry, and then applies another. Working in the direct oil technique, you mix the exact color you want on the palette, then brush it onto the canvas, where it stays wet and patiently awaits your next move. You can then alter the hue by brushing a second color over the first and mixing them right on the canvas. You can pile thick color over thin without waiting for the first layer to dry. You can cover one color with another or scrape off a color to reveal what's underneath. You can start with broad strokes and paint right over them with small, precise strokes without waiting for the broad strokes to dry. You can work as quickly or as slowly as you want. It's all one continuous operation, and the whole painting is a single, juicy layer of wet paint—filled from edge to edge with vitality and the joy of painting.

How to Use this Book. The basic principle of this book is "learning by doing." You'll see every basic oil painting operation demonstrated step-by-step. Famed oil painter George Cherepov will execute a great variety of paintings as you watch "over his shoulder," beginning with simple subjects and then going on to much more complex ones. In these demonstrations, each illustration shows a stage in the progress of the painting, while the accompanying text describes the exact painting procedure. Having seen Cherepov do it, you should then try the process yourself. This doesn't mean that you should copy the painting in the book. Try to find a similar subject and attempt a similar painting, using the same methods you've seen in the demonstration.

How this Book Is Organized. You'll find that this book is divided into three parts: "Oil Painting," "Landscapes in Oil," and "Seascapes in Oil." Although the first few demonstrations are still life and flower subjects—simple subjects that you can set up indoors to try out the basic techniques—most of the demonstrations show you how to paint the moods and colors of the landscape, the shoreline, and the sea, which are the favorites of oil painters around the world.

Oil Painting. Part One introduces the fundamental tools and techniques, showing you how to paint with bristle brushes, softhair brushes, the painting knife, the combination of bristles and softhairs, and the combination of knife and brush. The first five demonstrations are indoor and outdoor still lifes—vegetables, fruit, flowers, metal and glass bottles, rocks and wildflowers—in which Cherepov shows all the different ways to handle the brush. Then he shows you how to put these techniques to work in painting the landscapes of summer, autumn, and winter; female and male portrait heads; and a coastal landscape.

Landscapes in Oil. Part Two starts by reviewing the basic techniques, showing how to use them to paint specific landscape components such as trees, rocks, mountains, and snow. Then there are step-by-step demonstrations in which Cherepov shows you how to paint ten popular landscape subjects: deciduous trees, evergreens, a meadow, hills, mountains, a cloudy sky, a sunset, a stream, snow and ice, and a pond.

Seascapes in Oil. Part Three begins by showing you how to use the basic tools and techniques to paint such common seascape elements as surf, waves, clouds, rocks, and dunes. Then Cherepov demonstrates how to paint ten popular seascape subjects, step-by-step: waves, surf, tide pools, a salt marsh, a storm, a sunrise, a foggy shoreline, a rocky beach, a headland, and sand dunes.

Background Material. In all three parts of *The Oil Painting Book*, you'll also find guidance about such problems as composition, lighting, perspective, and how to select suitable subjects. You'll learn not only how to handle the brush and knife, but how to create special effects by scratching, scraping, and the *impasto* technique, which means working with thick paint. When things go wrong, you'll learn how to correct them by scraping, wiping, and repainting. You'll learn how brushwork expresses the character of the subject. And since every component of landscape and seascape has its own special personality you'll find instructive close-ups of various tree, cloud, and wave forms. But the purpose of this book is not merely to teach you techniques. Above all, its purpose is to send you forth with the fundamental painting skills—and the powers of observation—to find your own favorite subjects and your own special way of painting.

Color Selection. When you walk into an art supply store, you'll probably be dazzled by the number of different colors you can buy. There are far more tube colors than any artist can use. In reality, all the paintings in this book were done with just a dozen colors, about the average number used by most professionals. The colors listed below are really enough for a lifetime of painting. You'll notice that most colors are in pairs: two blues, two reds, two yellows, two browns. One member of each pair is bright, the other is subdued, giving you the greatest possible range of color mixtures.

Blues. Ultramarine blue is a dark, subdued hue with a faint hint of violet. Phthalocyanine blue is much more brilliant and has surprising tinting strength—which means that just a little goes a long way when you mix it with another color. So add phthalocyanine blue very gradually. These two blues will do almost every job. But George Cherepov likes to keep a tube of cobalt blue handy for painting skies and flesh tones; this is a beautiful, very delicate blue, which you can consider an "optional" color.

Reds. Cadmium red light is a fiery red with a hint of orange. All cadmium colors have tremendous tinting strength, so remember to add them to mixtures just a bit at a time. Alizarin crimson is a darker red and has a slightly violet cast.

Yellows. Cadmium yellow light is a dazzling, sunny yellow with tremendous tinting strength, like all the cadmiums. Yellow ochre is a soft, tannish tone. If your art supply store carries two shades of yellow ochre, buy the lighter one.

Browns. Burnt umber is a dark, somber brown. Burnt sienna is a coppery brown with a suggestion of orange.

Greens. Although nature is full of greens—and so is your art supply store—you can mix an extraordinary variety of greens with the colors on your palette. But it *is* convenient to have just one green available in a tube. The most useful green is a bright, clear hue called viridian.

Black and White. The standard black, used by almost every oil painter, is ivory black. Buy either zinc white or titanium white; there's very little difference between them except for their chemical content. Be sure to buy the biggest tube of white sold in the store; you'll use lots of it.

Linseed Oil. Although the color in the tubes already contains linseed oil, the manufacturer adds only enough oil to produce a thick paste that you squeeze out in little mounds around the edge of your palette. When you start to paint, you'll probably prefer more fluid color. So buy a bottle of linseed oil and pour some into that little metal cup (or "dipper") clipped to the edge of your palette. You can then dip your brush into the oil, pick up some paint on the tip of the brush, and blend oil and paint together on your palette to produce the consistency you want.

Turpentine. Buy a big bottle of turpentine for two purposes. You'll want to fill that second metal cup, clipped to the edge of your palette, so that you can add a few drops of turpentine to the mixture of paint and linseed oil. This will make the paint even more fluid. The more turpentine you add, the more liquid the paint will become. Some oil painters like to premix linseed oil and turpentine, 50-50, in a bottle to make a thinner *painting medium*, as it's called. They keep the medium in one palette cup and pure turpentine in the other. For cleaning your brushes as you paint, pour some more turpentine into a jar about the size of your hand and keep this jar near the palette. Then, when you want to rinse out the color on your brush and pick up a fresh color, you simply swirl the brush around in the turpentine and wipe the bristles on a newspaper.

Painting Mediums. The simplest painting medium is the traditional 50-50 blend of linseed oil and turpentine. Many painters are satisfied to thin their paint with that medium for the rest of their lives. On the other hand, art supply stores do sell other mediums that you might like to try. Three of the most popular are damar, copal, and mastic painting mediums. These are usually a blend of a natural resin—called damar, copal, or mastic, as you might expect—plus some linseed oil and some turpentine. The resin is really a kind of varnish that adds luminosity to the paint and makes it dry more quickly. Once you've tried the traditional linseed oil-turpentine combination, you might like to experiment with one of the resinous mediums.

Other Solvents. If you can't get turpentine, you'll find that mineral spirits (the British call it white spirit) is a good alternative. You can use it to thin your colors and also to rinse your brushes as you work. Some painters use kerosene (called paraffin in Britain) for cleaning their brushes, but it's flammable and has a foul odor. Avoid it.

Bristle Brushes. The brushes most commonly used for oil painting are made of stiff, white hog bristles. The filbert (top) is long and springy, comes to a slightly rounded tip, and makes a soft stroke. The flat (center) is also long and springy, but it has a squarish tip and makes a more precise, rectangular stroke. The bright (bottom) also has a squarish tip and makes a rectangular stroke, but it's short and stiff, digging deeper into the paint and leaving a strongly textured stroke.

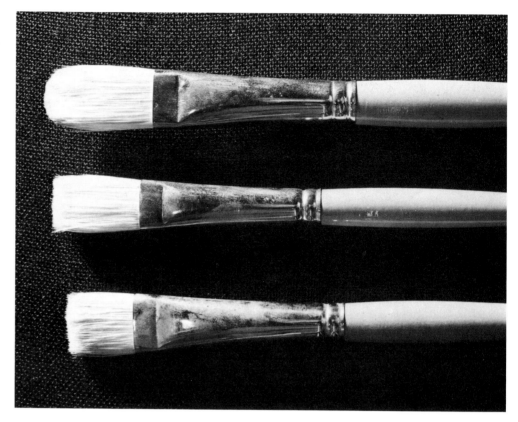

Softhair Brushes. Although bristle brushes do most of the work in oil painting, it's helpful to have some softhair brushes for smoother, more precise brushwork. The top two brushes here are sables: a small, flat brush that makes smooth, rectangular strokes; and a round, pointed brush that makes fluent lines for sketching in the picture and adding linear details such as leaves, branches, or eyebrows. At the bottom is an oxhair brush, and just above it is a soft, white nylon brush; both make broad, smooth, squarish strokes.

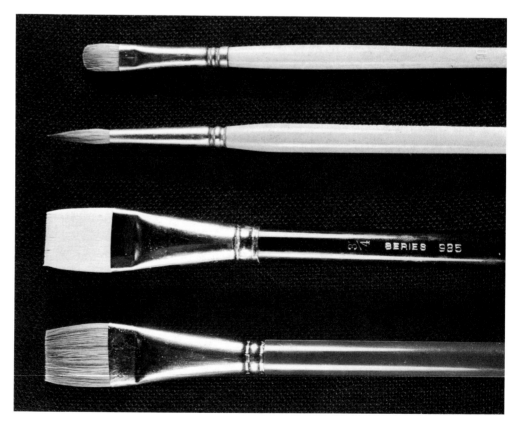

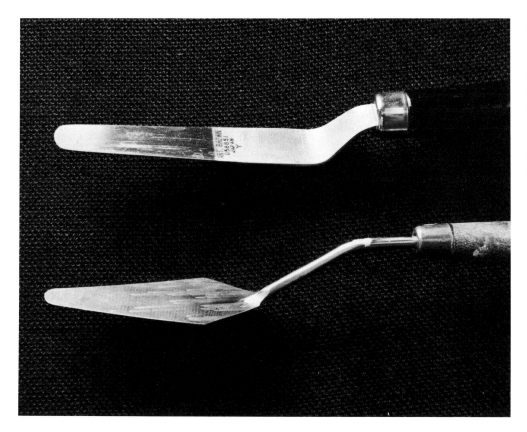

Knives. A palette knife (top) is useful for mixing color on the palette, for scraping color off the palette at the end of a painting session, and for scraping color off the canvas when you're dissatisfied with what you've done and want to make a fresh start. A painting knife (bottom) has a very thin, flexible blade that's specially designed for spreading color on the canvas.

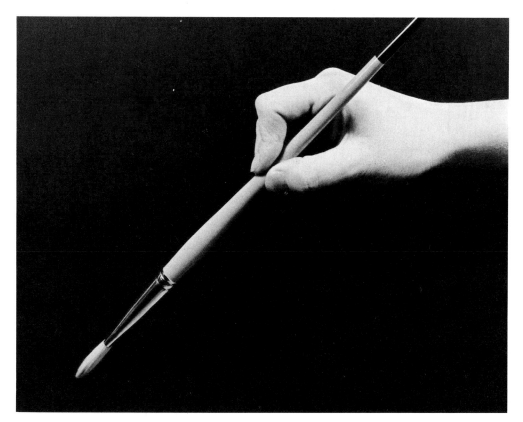

Holding the Brush. Your brushwork will be bold, free, and relaxed if you hold the brush at least halfway up the handle. As you become more confident, your strokes may become bolder still, and you'll want to hold the brush still farther back. There *may* be times when you'll want to hold the brush closer to the bristles in order to paint precise details; but don't get into the habit, or your strokes will become small and constrained.

Easel. For working indoors, a wooden studio easel is convenient. Your canvas board, stretched canvas, or gesso panel is held upright by wooden "grippers" that slide up and down to fit the size of the painting. They also adjust to match your own height. A studio easel should be the heaviest and sturdiest you can afford so that it won't wobble when you attack the painting with vigorous strokes.

Paintbox. A paintbox usually contains a wooden palette that you can lift out and hold as you paint. Beneath the palette, the lower half of the box contains compartments for tubes, brushes, knives, bottles of oil and turpentine, and other accessories. The lid of the palette often has grooves into which you can slide two or three canvas boards. The open lid will stand upright—with the help of a supporting metal strip which you see at the right—and can serve as an easel when you paint outdoors. You can also buy a lightweight, folding outdoor easel if you prefer.

Palette. The wooden palette that comes inside your paintbox is the traditional mixing surface that artists have used for centuries. A convenient alternative is the paper tear-off palette: sheets of oilproof paper that are bound together like a sketchpad. You mix your colors on the top sheet, which you then tear off and discard at the end of the painting day, leaving a fresh sheet for the next painting session. This takes a lot less time than cleaning a wooden palette at the end of the painting day. Many artists also find it easier to mix colors on the white surface of the paper palette than on the brown surface of the wooden palette, since the paper is the same color as the white canvas.

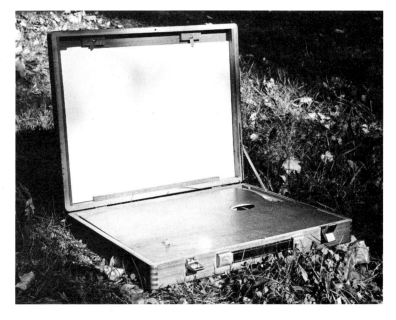

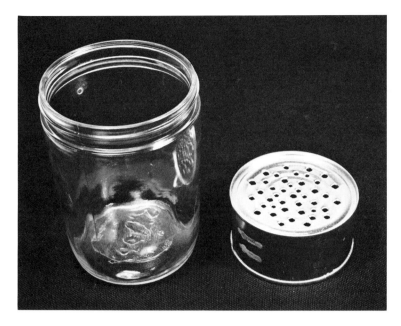

Brush Washer. To clean your brush as you paint, rinse it in a jar of turpentine or mineral spirits (called white spirit in Britain). To create a convenient brush washer, save an empty food tin after you've removed the top; turn the tin over so that the bottom faces up; then punch holes in the bottom with a pointed metal tool. Drop the tin into a wide-mouthed jar—with the perforated bottom of the tin facing up. Then fill the jar with solvent. When you rinse your brush, the discarded paint will sink through the holes to the bottom of the jar, and the solvent above the tin will remain fairly clean.

Paint Tube. When you squeeze color out of a tube, squeeze the tube at the far end and roll up the empty portion. In this way you'll get the maximum amount of color out of the tube—and the maximum amount of paint for your money.

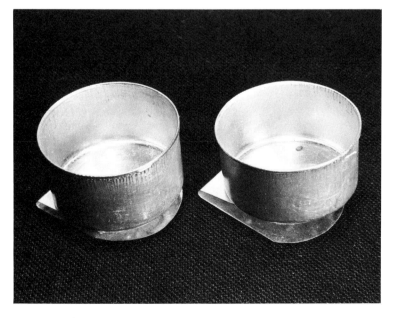

Palette Cups (Dippers). These two metal cups have gripping devices along the bottom so that you can clamp the cups over the edges of your palette. One cup is for turpentine or mineral spirits to thin your paint as you work. (Don't use this cup for rinsing your brush; that's what the brush washer is for.) The other cup is for your painting medium. This can be pure linseed oil; a 50-50 blend of linseed oil and turpentine that you mix yourself; or a painting medium that you buy in the art supply store—usually a blend of linseed oil, turpentine, and a natural resin such as damar, copal, or mastic. Be sure to clean your palette cups at the end of the painting day, or they'll get gummy.

Canvas. The most popular surface for oil painting is cotton or linen canvas. Canvas boards—inexpensive fabric that's covered with white paint and glued to stiff cardboard—are sold in every art supply store. Beginners usually start by painting on canvas boards and then switch to stretched canvas later on. You'll find instructions for stretching your own canvas—which means nailing the fabric to a rectangular wooden framework—later in this book. The weave of the canvas softens your brushstrokes and makes it easy to blend the paint, as you can see in the soft forms of these clouds. The texture of the canvas generally shows through unless you apply the paint very thickly.

Panel. Some painters prefer to work on the smoother surface of a panel. Today, this is usually a sheet of hardboard that's the modern replacement for the wood panels used by the old masters. Like canvas boards and stretched canvas, the panel is coated by the manufacturer with a layer of white oil paint or white gesso. It's easy and inexpensive to prepare your own panels. Most art supply stores stock acrylic gesso, a thick, white paint which you brush onto the hardboard with a nylon housepainter's brush. As it comes out of the jar or the can, the gesso is thick. For a smooth painting surface, thin the gesso with water to a milky consistency and then apply several coats. If you like a rougher painting surface, apply the gesso undiluted or add just a little water; your nylon brush will leave delicate grooves in the gesso, as you see here. Even when the gesso has a slight texture, the brush glides more smoothly over a panel than over canvas. Thus, brushwork on a panel has a smoother, more fluent look, as you can see in these clouds.

Thick Color. As it comes from the tube, oil paint is a thick paste. The manufacturer adds just enough linseed oil to the powdered pigment to produce a rich, buttery consistency that comes easily out of the tube—but the paint is far from fluid. If you like to paint with thick color, you can dip your bristle brushes into the mounds of color on your palette and go right to work. But most painters like to work with color that's more fluid than the pasty compound that comes from the tube. Even if you like to work with thick, rough strokes, it usually helps to add just a bit of painting medium to make the paint more brushable. How much medium you add will depend on the subject and the kind of brushwork you have in mind. The rough surfaces of these rocks are painted with heavy strokes of color that's only a bit more fluid than the paint that comes from the tube. For this kind of rugged brushwork, add just a touch of painting medium, whether it's pure linseed oil, a 50-50 blend of linseed oil and turpentine, or one of the resin mediums you buy in the art supply store. Don't add any extra turpentine, since it will make your paint much more fluid. For thick, heavily textured strokes that show the marks of the brush, it also helps to work with your shortest, stiffest bristle brushes.

Thin Color. The soft, blurry forms of this willow tree are painted with thin color that's diluted with a lot of painting medium. Here's where it really helps to add some extra turpentine to make the paint more fluid. However, just turpentine isn't enough. You'll find that pure turpentine not only makes the paint thinner but also reduces the rich, oily consistency of the paint. For soft, subtle brushwork, you want paint that's both thin *and* oily. So you've got to add some more linseed oil or resin medium, along with the turpentine. This blend of turpentine and oil produces just the right consistency for these big blurry strokes, as well as the more precise linear strokes of the branches and leaves. You also have to choose the right brush to match the consistency of the paint. Here, the broad, soft strokes are made by a large filbert. The slender, precise strokes are made by a round sable.

Buying Brushes. There are three rules for buying brushes. First, buy the best you can afford—even if you can afford only a few. Second, buy big brushes, not little ones; big brushes encourage you to work in bold strokes. Third, buy brushes in pairs, roughly the same size. For example, if you're painting a sky, you can probably use one big brush for the patches of blue and the gray shadows on the clouds, but you'll want another brush, unsullied by blue or gray, to paint the white areas of the clouds.

Recommended Brushes. Begin with a couple of really big bristle brushes, around 1″ (25 mm) wide for painting your largest color areas. You might want to try two different shapes: one can be a flat, while the other might be a filbert. And one might be just a bit smaller than the other. The numbering systems of manufacturers vary, but you'll probably come reasonably close if you buy a number 11 and a number 12. Then you'll need two or three bristle brushes about half this size, numbers 7 and 8 in the catalogs of most brush manufacturers. Again, try a flat, a filbert, and perhaps a bright. For painting smoother passages, details, and lines, three softhair brushes are useful: one that's about 1/2″ (25 mm) wide; one that's about half this wide; and a pointed, round brush that's about 1/8″ or 3/16″ (3-5 mm) thick at the widest point.

Knives. For mixing colors on the palette and for scraping a wet canvas when you want to make a correction, a palette knife is essential. Many oil painters prefer to mix colors with a knife. If you'd like to *paint* with a knife, don't use the palette knife. Instead, buy a painting knife, with a short, flexible, diamond-shaped blade.

Painting Surfaces. When you're starting to paint in oil, you can buy inexpensive canvas boards at any art supply store. These are made of canvas coated with white paint and glued to sturdy cardboard in standard sizes that will fit into your paintbox. Later, you can buy stretched canvas—sheets of canvas precoated with white paint and nailed to a rectangular frame made of wooden stretcher bars. You can save money by stretching your own canvas. You buy the stretcher bars and canvas and then assemble them yourself. If you like to paint on a smooth surface, buy sheets of hardboard and coat them with acrylic gesso, a thick, white paint that you buy in cans or jars and then thin with water.

Easel. An easel is helpful, but not essential. It's just a wooden framework with two "grippers" that hold the canvas upright while you paint. The "grippers" slide up and down to fit larger or smaller paintings—and to match your height. If you'd rather not invest in an easel, there's nothing wrong with hammering a few nails partway into the wall and resting your painting on them; if the heads of the nails overlap the edges of the painting, they'll hold it securely. Most paintboxes have lids with grooves to hold canvas boards. When you flip the lid upright, the lid becomes your easel.

Paintbox. To store your painting equipment and to carry your gear outdoors, a wooden paintbox is a great convenience. The box has compartments for brushes, knives, tubes, small bottles of oil and turpentine, and other accessories. It usually holds a palette—plus some canvas boards inside the lid.

Palette. A wooden paintbox often comes with a wooden palette. Rub the palette with several coats of linseed oil to make the surface smooth, shiny, and nonabsorbent. When the oil is dry, the palette won't soak up your tube colors, and the surface will be easy to clean at the end of the painting day. Even more convenient is a paper palette. This looks like a sketchpad, but the pages are nonabsorbent paper. At the beginning of the painting day, you squeeze out your colors on the top sheet. When you're finished, you just tear off and discard the top sheet. Paper palettes come in standard sizes that fit into paintboxes.

Odds and Ends. To hold your turpentine and your painting medium—which might be plain linseed oil or one of the mixtures you read about earlier—buy two metal palette cups (or "dippers"). To sketch the composition on your canvas before you start to paint, buy a few sticks of natural charcoal—not charcoal pencils or compressed charcoal. Keep a clean rag handy to dust off the charcoal and make the lines paler before you start to paint. Some smooth, absorbent, lint-free rags are good for wiping mistakes off your painting surface. Paper towels or a stack of old newspapers (a lot cheaper than paper towels) are essential for wiping your brush when you've rinsed it in turpentine. For stretching your own canvas, buy a hammer (preferably with a magnetic head), some nails or carpet tacks about 3/8″ (9-10 mm) long, scissors, and a ruler.

Work Layout. Before you start to paint, lay out your equipment in a consistent way so that everything is always in its place when you reach for it. If you're right-handed, place the palette on a tabletop to your right, along with a jar of turpentine, your rags and newspapers or paper towels, and a clean jar in which you store your brushes, hair end up. Establish a fixed location for each color on your palette. One good way is to place your *cool* colors (black, blue, green) along one edge and the *warm* colors (yellow, orange, red, brown) along another edge. Put a big dab of white in one corner, where it won't be fouled by other colors.

PART ONE

OIL PAINTING

Painting in Oil. For centuries oil paint has been the most popular painting medium—because it's the easiest. As it comes from the tube, the paint has a delightful, buttery consistency. When you dip your brush into that little mound of gleaming color on the palette and then make a stroke on the canvas, the color obeys your command immediately. The stroke stays exactly where you put it. It stays wet and waits for you to decide what to do next. You can spread the paint further, smooth it out, heap it up, blend another color into it, or scrape it off and start again. If you apply a thick stroke, it stands up from the canvas, and that bold stroke continues to stand up until it dries hard as leather. The buttery consistency of the tube color makes it easy (and fun) to mix on the palette with a brush or a knife. And you can make the paint as fluid as you like, simply by blending in a few drops of turpentine or oil with a knife or a brush.

What is Oil Paint? Like every other kind of artists' colors, oil paint starts out as dry, colored powder, called pigment. The pigment is then blended with a vegetable oil called linseed oil—squeezed from the flax plant, whose fibers are also used to make linen. Together, the pigment and oil make a thick, luminous paste that the manufacturer packages in metal tubes. It's the oil that produces the buttery consistency that makes oil paint so easy to push around on the canvas. And the oil takes a long time to dry on the painting surface, giving you lots of time to work on the picture, to experiment, and to change your mind as often as you like. The linseed oil is called the *vehicle*. But there's another liquid which is equally important in oil painting: a *solvent* that will make the paint thinner and more fluid and then evaporate as the paint dries. This solvent is usually turpentine, though some painters use mineral spirits (or white spirit, as it's called in Britain), which works the same way and is worth trying if you're allergic to turpentine. Oil painters usually add a bit of linseed oil *and* a bit of turpentine to the tube color to make it more brushable.

Handling Oil Paint. The greatest pleasure of oil paint is the way it responds to the brush or the knife. If you paint with pure tube color—no extra oil or turpentine—you can pick up thick globs of paint on the brush or knife and lay on bold, richly textured strokes. If you add just a bit of linseed oil and turpentine, the paint takes on a creamy consistency which is ideal for more fluent brushwork. It's like spreading warm butter. The paint becomes so soft and pliable that you can blend one stroke or one color smoothly into another, producing beautiful gradations. And if you add still more linseed oil and turpentine, the paint becomes fluid enough to paint crisp lines and precise details.

Drying Time. The gradual drying time of oil paint is one of its greatest advantages. The turpentine evaporates in minutes, but the oil remains and takes days to dry solid. Actually, the oil never really evaporates, but simply solidifies to a tough, leathery film. Although some colors tend to dry faster than others, your painting does remain moist long enough for you to produce effects that aren't possible in any other medium. You can keep blending fresh color into the wet surface until you get the exact hue you want. You can go over a passage with a brush, stroke after stroke, until you produce exactly the rough or smooth texture you want. If you want a very soft transition between two areas of color—such as the light and shadow sides of a cheek or a cloud—you can smudge one color into another to produce a lovely, blurred edge. And if anything goes wrong, you can scrape away the wet color.

Basic Techniques. In the pages that follow, the first thing you'll find will be a brief survey of the basic equipment you'll need for oil painting—tube colors, mediums, brushes, knives, easel, paintbox, palette, and other accessories. Then you'll see how oil paint looks on the two most common painting surfaces: canvas and a hardboard panel. You'll learn how to paint with bristle brushes, made of stiff, white hoghairs; with softhair brushes, made of sable, oxhair, squirrelhair, or nylon; with combinations of bristles and softhairs; and with the painting knife.

Painting Demonstrations. Then famed painter George Cherepov will demonstrate, step-by-step, how to paint eleven subjects—the sort of subjects you'll want to master. Cherepov will demonstrate the basic painting method with a very simple still life of vegetables from the kitchen. And since still life is the easiest subject to paint while you're learning, he'll then show you how to paint a bowl of fruit, a vase of flowers, and a group of glass or metal bottles. He'll then proceed to an outdoor "still life" of rocks and wildflowers and move on to landscapes of the seasons: summer, autumn, and winter. He'll show you how to paint a male and female portrait head, and he'll demonstrate how to paint a coastal landscape.

Special Effects. Following the painting demonstrations, you'll learn three different ways to correct an oil painting—scraping and repainting, wiping out and repainting, and repainting a dry canvas. You'll learn special techniques such as impasto—which means working with thick paint—and scraping. You'll learn the tricky process of stretching a canvas. Finally, you'll learn how to take care of your painting equipment and how to varnish, frame, and preserve a finished oil painting so that you can enjoy it for many years.

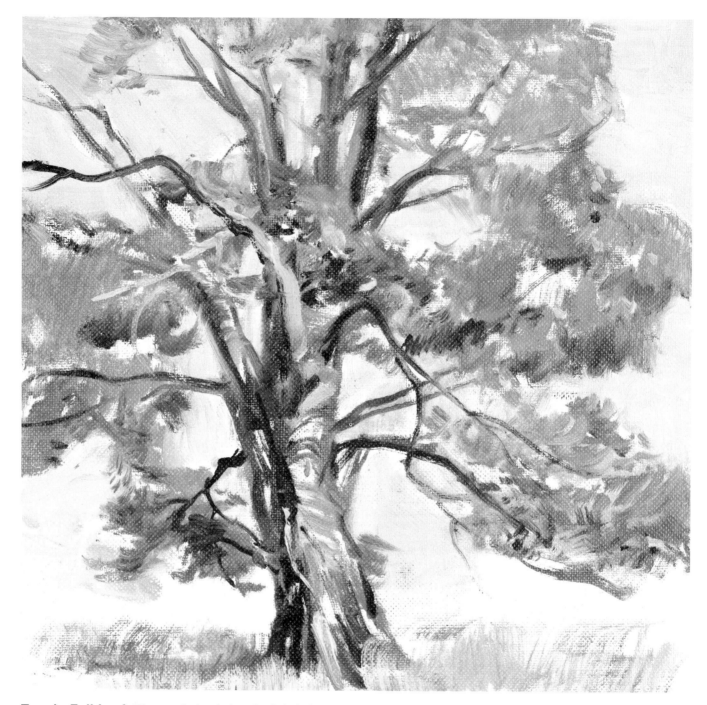

Tree in Full Leaf. The sturdy hoghairs of a bristle brush normally leave a distinct mark in the paint. Strokes made by a bristle brush usually have a slightly rough, irregular quality, which is part of their beauty. These big, stiff brushes are actually capable of far more precision than you might think. If you work with the whole body of the brush, you can produce broad strokes like those in the masses of leaves. If you work with the very tip of the brush, moving it sideways so that only the edge touches the canvas, you can produce slender strokes, like these branches and twigs. A quick touch of the tip or the corner of the brush can suggest such details as the individual leaves among the lower foliage.

Clump of Bare Trees. A sable, oxhair, or white nylon brush is made of much softer hairs that apply the paint more smoothly and leave very little impression on the painting surface. If you work with thin paint and move the brush back and forth to blend the strokes, you can practically eliminate the mark of the brush—as you see in the sky behind these birches. When you apply the paint more thickly, you can see the strokes, but they're not nearly as rough as strokes made by a bristle brush. Compare the smooth trunks of these birches with the rougher trunk of the tree on the facing page. The rough strokes in the grass do look something like bristle brushstrokes, even though they're made with a softhair brush; the brush carries very little paint and is applied with quick, scrubby strokes, with spaces left between them. The thicker trunks and the smooth sky tone are painted with a flat softhair brush. The thinner trunks and branches are painted with a round softhair brush. Bristle brushes can carry lots of thick color, containing very little medium. But to work effectively with softhair brushes, add enough medium to make the paint more fluid.

Step 1. To try out your bristle brushes, find some roughly textured subject like this tree. For the first sketchy lines on the canvas, thin your tube color with lots of turpentine and work with the tip of the brush. Keep the paint as thin as watercolor so that the brush sweeps quickly over the canvas—you can wipe off the strokes with a rag if you want to make any changes. Don't be too careful with these first strokes; most of them will be obliterated by the heavier strokes that come next.

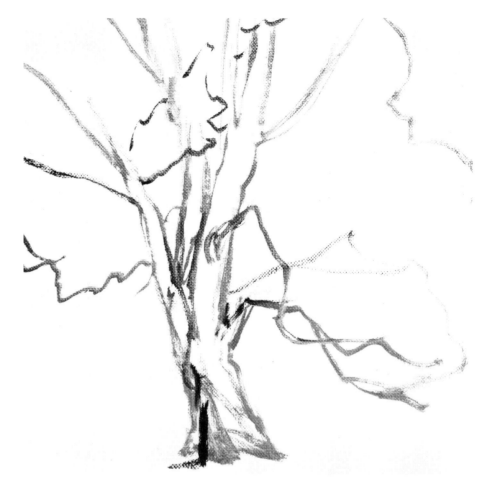

Step 2. Now, working with slightly thicker color—add some linseed oil along with the turpentine—start to brush in the clusters of leaves with broad, free strokes. Notice that many of the strokes in Step 1 have already disappeared under the leaves. Working with the tip of the brush, you can add some darks for the shadows on the trunks. Don't worry about details at this early stage. The idea is to cover the canvas with broad masses of color.

Step 3. By the time you're finished with Step 2, all the clusters of leaves should be covered with rough strokes of color. These are what painters call the middletones—tones that are darker than the lightest parts of the picture, but lighter than the darkest parts. When you have enough middletones on the canvas, you can start to add some darks: the shadows under the clusters of leaves; some more shadows on the trunk and branches; and the shadow cast by the trunk on the grass to your left. Now you're working with the tip of the brush and the strokes are smaller. But don't make your strokes too precise. Work with free movements.

Step 4. Save the brightest touches of light and the details for the very end. Use the tip of the brush to indicate the sunstruck branches and leaves. You can also use the tip of the brush to add darks to the branches—and to add some more branches. Just use the tip to suggest a few leaves. Now you have some idea of the different kinds of strokes you can make with bristle brushes: broad, scrubby strokes for the clusters of foliage; linear, rhythmic strokes for the branches; and mere touches for a few leaves.

Step 1. To learn what your softhair brushes can do, find some subject—like these birches—that lends itself to smooth, linear brushwork. Once again, start out by thinning your tube color with plenty of turpentine so that you can draw the main lines of the composition with the tip of the brush. These trunks are drawn with the tip of a round sable. In fact, this whole demonstration is done with sables, but it's worth noting that exactly the same job could be done with white nylon brushes, which are a lot less expensive!

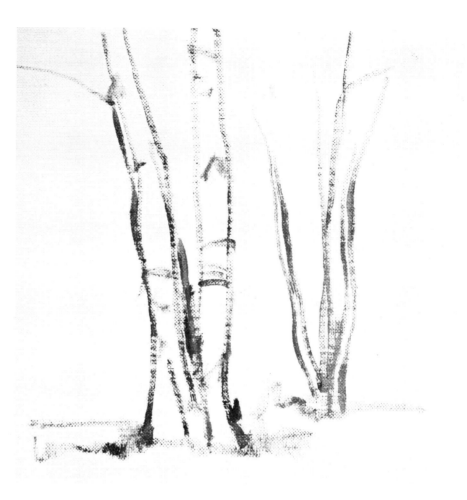

Step 2. In the early stages of a painting, the most important thing is to cover the canvas with broad strokes of wet color. The sky is painted with horizontal and vertical strokes made by a flat softhair brush, leaving bare canvas for the trunks. The darks at the bottoms of the trunks and along the ground are painted with a round softhair brush. Note that the sky is painted right over the smaller tree, which is almost obliterated. This is no problem; the tree will be repainted right over the sky. You can see the marks of the brush in the sky, but they're much smoother and less distinct than the strokes made by the bristle brush in the preceding demonstration.

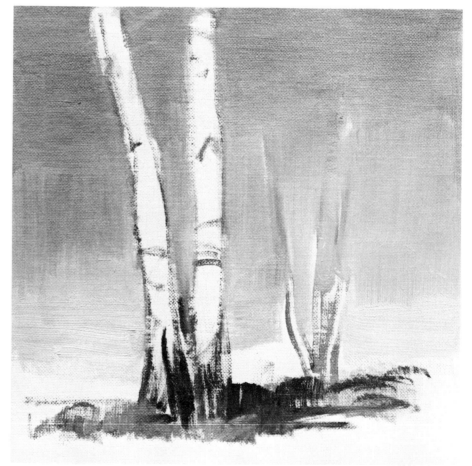

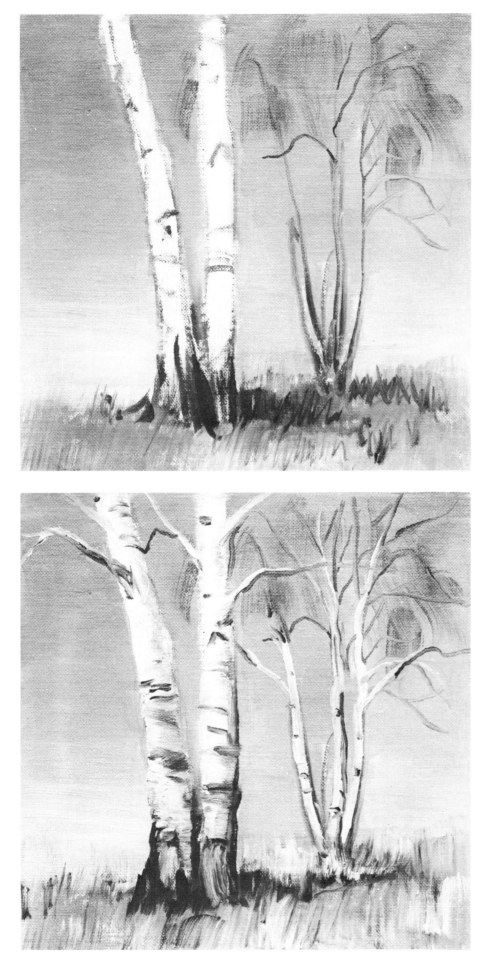

Step 3. Here's where you can see the unique character of softhair brushwork. The sky is blended with the overlapping, horizontal strokes of a flat softhair brush, producing a lovely gradation from dark to light and almost eliminating the marks of the brush. Then the tip of a round softhair brush reestablishes the slender trunks of the smaller tree and indicates the texture of the grass. For such smooth brushwork, you need fluid paint that contains a lot of medium.

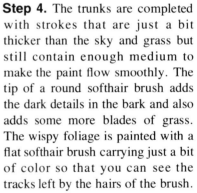

Step 4. The trunks are completed with strokes that are just a bit thicker than the sky and grass but still contain enough medium to make the paint flow smoothly. The tip of a round softhair brush adds the dark details in the bark and also adds some more blades of grass. The wispy foliage is painted with a flat softhair brush carrying just a bit of color so that you can see the tracks left by the hairs of the brush.

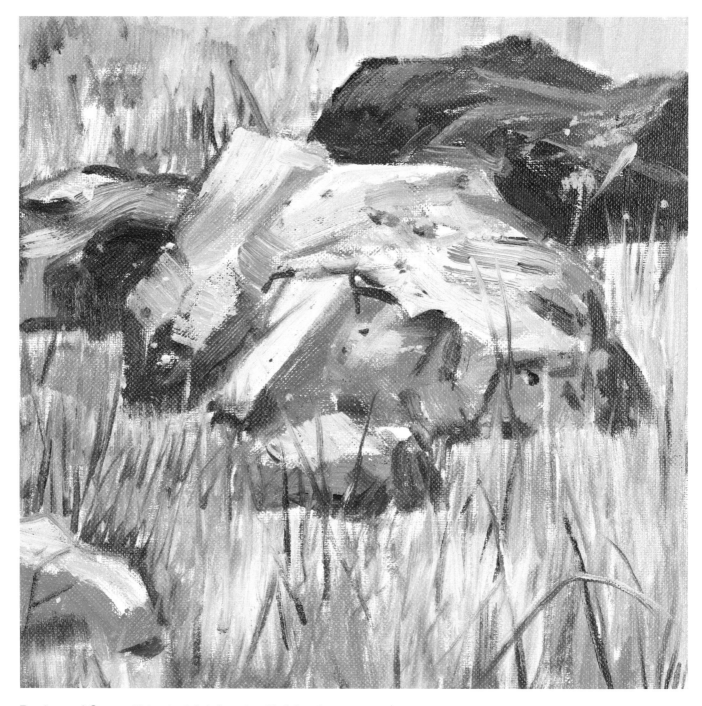

Rocks and Grass. Using both bristle and softhair brushes will give you a rich vocabulary of brushstrokes. In the sunlit tops and shadowy sides of these rocks, you can see the thickly textured strokes made by bristle brushes carrying a heavy load of color, diluted with only a touch of medium. The thinner, smoother color of the grass is made by softhair brushes carrying fluid paint that contains much more medium. The rocks are painted with broad strokes made by a flat bristle brush, while the grasses and weeds are painted with the tip of a round softhair brush.

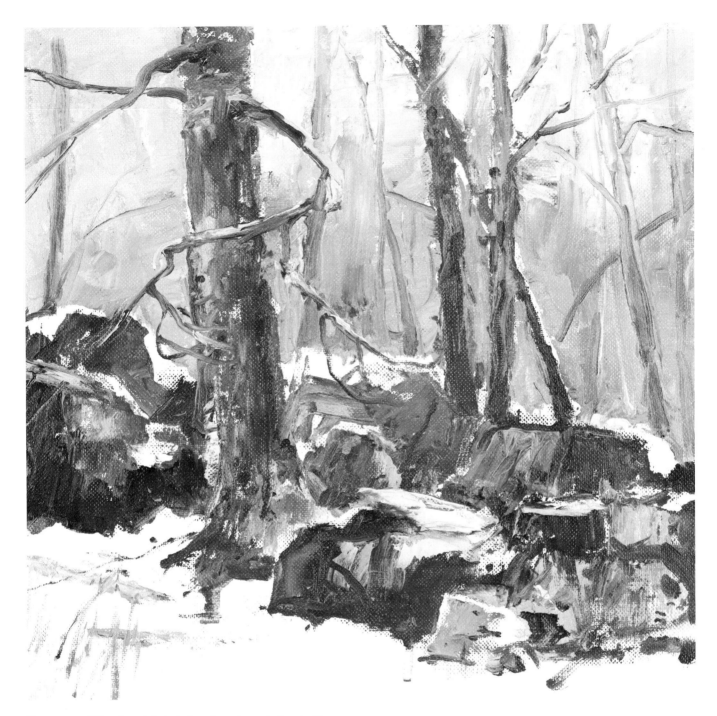

Trees and Rocks. A bristle brush and a painting knife can both carry thick color and make bold, heavy strokes. These two painting tools work well together. The knife applies the broad, irregular planes of color that don't require much precision, such as the tones between the trunk and the distant trees, the broader strokes on the trunks, and the light and shadow planes on the rocks. The bristle brush is used to paint the more precise forms of the trunks, the branches, and the details of the rocks. Look closely and you can see the imprint of the bristles in contrast with the smoother paint left by the knife blade.

Step 1. Now try combining bristle and softhair brushes to see how many different kinds of strokes you can produce. Try to find some subject that combines big, rough forms and soft, delicate forms, like these rocks and weeds. Once again, begin by brushing in the main forms with fluid color thinned with lots of turpentine. A round softhair brush is usually best for this job.

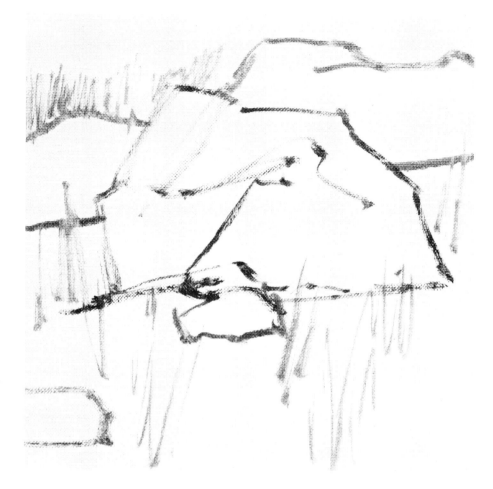

Step 2. It's always best to begin by covering the broadest areas of the picture with big strokes. The rocks are quickly covered with flat strokes made by a big bristle brush. The stiff bristles leave distinct grooves in the paint, accentuating the rough character of the rocks. Such thick strokes contain only a little medium—or no medium at all—so that the paint remains a heavy paste.

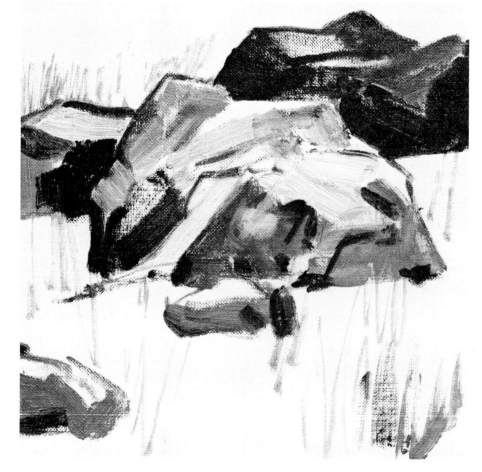

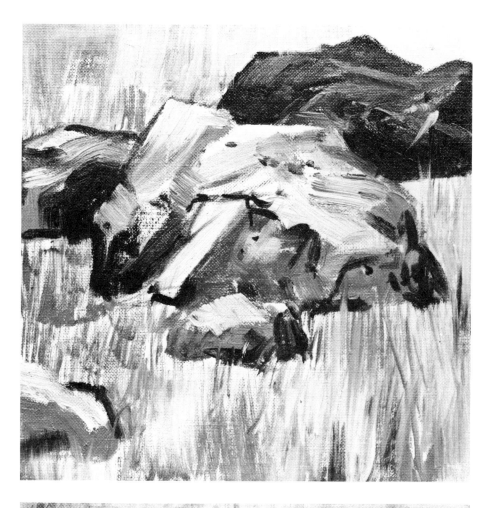

Step 3. Now the round softhair brush comes into play. Because the softhair brush can't handle thick, pasty color, the paint is thinned with medium to a more fluid consistency. Then the rocks are surrounded with thin, fluid strokes for the grass. Some strokes are dark, while others are light, and the softhair brush easily blends them together. The bristle brush returns to complete the rocks with thick strokes.

Step 4. By the end of Step 3, the entire canvas is covered with broad masses of color, with very little attention to detail. The details are saved for the final step, when the tip of the round softhair brush adds more blades of grass and weeds, a few lighter flecks for wildflowers, and a crack to the rock in the lower left area.

Step 1. A bristle brush and a painting knife are an ideal combination for painting big, rugged forms with rough textures such as a landscape with treetrunks and rocks. When you try out this combination of painting tools, work with thick color. You may be surprised to discover that you can draw the composition on the canvas with the edge of the knife, as you see here. Pick up some color on the underside of the knife. To make the slender lines of the trunks, just touch the side of the knife to the canvas and pull the blade downward, as if you're slicing bread. For thicker lines, such as those on the rocks or at the bases of the trees, press the edge of the blade against the canvas and pull slightly sideways to spread the paint.

Step 2. Now working with the underside of the blade covered with thick color, you can spread broad strokes on the canvas very much as you'd spread butter on a slice of bread. The rocks are painted with broad, squarish strokes made by the flat underside of the blade. For the slender trunks at the right, you pick up color under the tip of the blade and use it like a brush, pulling the knife downward over the canvas. The broader trunk is painted partly with the tip and partly with the entire underside of the blade, not carrying too much paint, so some patches of bare canvas show through.

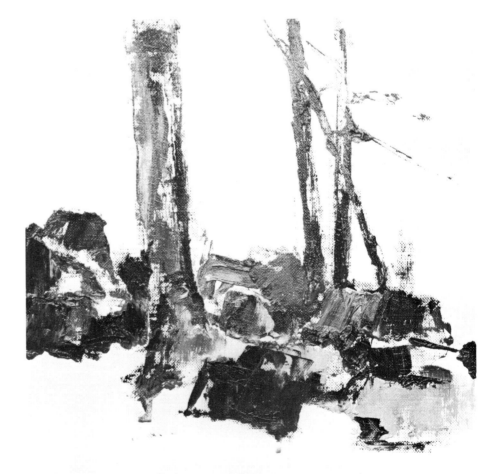

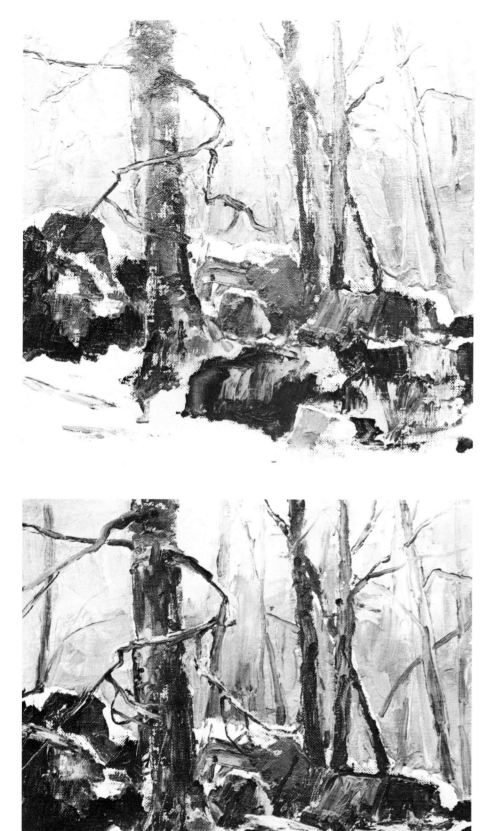

Step 3. The pale tones of the misty woods behind the trees are painted with broad strokes of the underside of the blade. More trunks are added with the tip of the blade. The curving branches on the thicker trunk are painted with curving strokes of the tip. More squarish strokes are added to the rocks in the lower right.

Step 4. Now the bristle brush comes into play to strengthen certain forms and add final details. Brushstrokes are carried right over the knifestrokes to strengthen the trunks and the branches. More branches are added by the brush—a job which is too precise for the knife. On the rocks and on the big trunk, the knife blends the lights and darks just a bit and roughens the smooth knifestrokes to create a more ragged texture. When you've painted most of the picture with a knife, don't overdo the brushwork. Use the brush selectively and then stop.

Setting the Palette. Obviously, you start the painting day by squeezing out your dozen colors on the palette. Squeeze the collapsible tube from the end, replace the cap, and then roll up the empty portion of the tube. You'll get more paint out of the tube this way—which means that you'll save money on expensive artists' colors. It's usually best to place these colors along the top edge of the palette and along the left side if you're right handed, or along the right side if you're left handed. Keep the center and the lower edge of the palette clear for mixing color. Keep the paint in the mixing area away from the edges of the palette where the fresh color is stored. Don't let the mixtures foul the mounds of pure color.

Mixing Colors. Above all, think before you mix. Decide on the hue you're hoping to mix and then decide exactly which colors you're going to move from the edges of the palette to that central mixing surface. Don't wander around the palette, poking your brush into various colors at random, then scrubbing them together "to see what happens." Plan your color mixtures in advance: pick up a generous amount of each color with the tip of your brush or your palette knife; then blend them in the center of the palette with decisive movements. If you prefer to mix with the brush, scrub the colors together with a circular or back-and-forth movement, but don't spread the color too far—try to keep it in one place. Many professionals prefer to mix with the palette knife, claiming that they get brighter, cleaner mixtures because they can wipe the knife blade absolutely clean before they dip the blade into fresh color. Use a circular movement when you mix with the knife, spreading the paint out, then heaping it together and spreading it out again until the color blends smoothly.

Avoiding Mud. Two or three colors, plus white, should give you just about any color mixture you need. One of the unwritten "laws" of color mixing seems to be that more than three colors—not including white—will produce mud. If you know what each color on your palette can do, you should never really *need* more than three colors in a mixture. And just two colors will often do the job. It's also important to keep your knives and brushes as clean as you possibly can. Before you pick up a fresh color, rinse your brush in turpentine and make sure to wipe away most of the turpentine on a sheet of newspaper or a paper towel. You can keep your knife blade clean and shiny by wiping it frequently with a paper towel.

Diluting Color. Pure tube color is generally too thick for lively, fluent brushwork. That's why you've got those palette cups (or "dippers") full of linseed oil and turpentine—or perhaps one of those resin painting mediums you read about awhile back. In the earliest stages of painting, when you're making your preliminary brush drawing, you can thin your color to a very fluid consistency with pure turpentine. But once you begin to cover the canvas with color, then it's important to dilute your color with a 50-50 mixture of linseed oil and turpentine, or with a resin medium. This preserves the creamy consistency of the paint, which pure turpentine tends to break down. It's important to keep those cups of medium and solvent as clean as possible. Before you dip a brush into the cup, wipe the hairs with a paper towel or rag, or rinse the brush in turpentine and dry it on a piece of newspaper.

Testing Color Mixtures. One of the most productive ways to spend an afternoon is to run a simple series of tests that reveal how all the colors on your palette behave when they're mixed with one another. Be methodical about it. Take a dozen sheets of canvas-textured paper and mark each sheet with the name of just one color on your palette. Then mix that color with every single hue on your palette and paint a patch of that mixture on the paper, about 1″ (25 mm) square. At the lower edge of each color patch, scrub in a little white to record how the mixture changes when you lighten it. If you have the time and the patience, it's particularly interesting to try each mixture two or three times, varying the proportions of the colors. For instance, if you're mixing cadmium red and cadmium yellow, first try a mixture in which the red and yellow are added in equal quantities; then try more red and less yellow; finally, try more yellow and less red.

Color Charts. Be sure to label each color patch with the names (or perhaps just the initials) of the colors in the mixture. Now you've got a series of color charts which you can tack on your wall and study when you're planning the color mixtures in a painting. The whole job of making these charts won't take more than a few hours and will save you countless days of frustration when you're actually mixing the colors for a picture. After awhile, all these color mixtures will be stored in your memory, and you'll no longer need the charts. But while you're learning, they're a great convenience. Making these charts is the fastest way to learn how to mix colors—and they're fun to do.

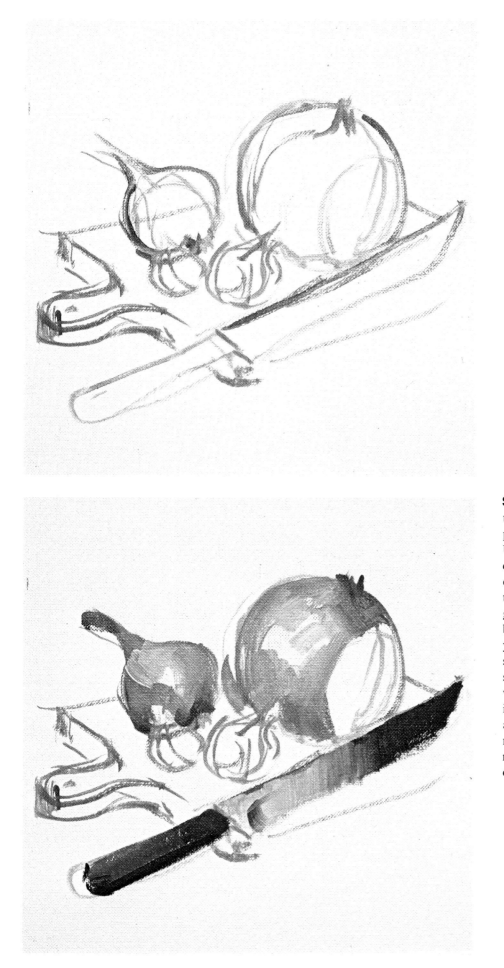

Step 1. When you're learning how to handle oil paint, it's best to begin by painting a few simple, familiar household objects such as these vegetables and kitchen utensils. Just group them casually on a table-top and go to work. Sketch the forms on the canvas with a few charcoal lines. Use a clean rag to dust off most of the charcoal, leaving the lines very faint. Then reinforce the lines with the tip of a round softhair brush dipped in some quiet color such as burnt umber and diluted with plenty of turpentine.

Step 2. The next step is to cover the most important shapes in the picture with broad strokes of color. Use your biggest bristle brushes and don't worry about details. In the early stages, the paint shouldn't be too thick, so add enough medium to give you a creamy consistency. The big onion is painted with cadmium yellow, ultramarine blue, and burnt sienna. The smaller onion is burnt sienna, yellow ochre, and white with some ultramarine blue added in the darks. The darks of the knife are also burnt sienna and ultra-marine blue, with the yellow onion mixtures reflected in the lighter part of the blade.

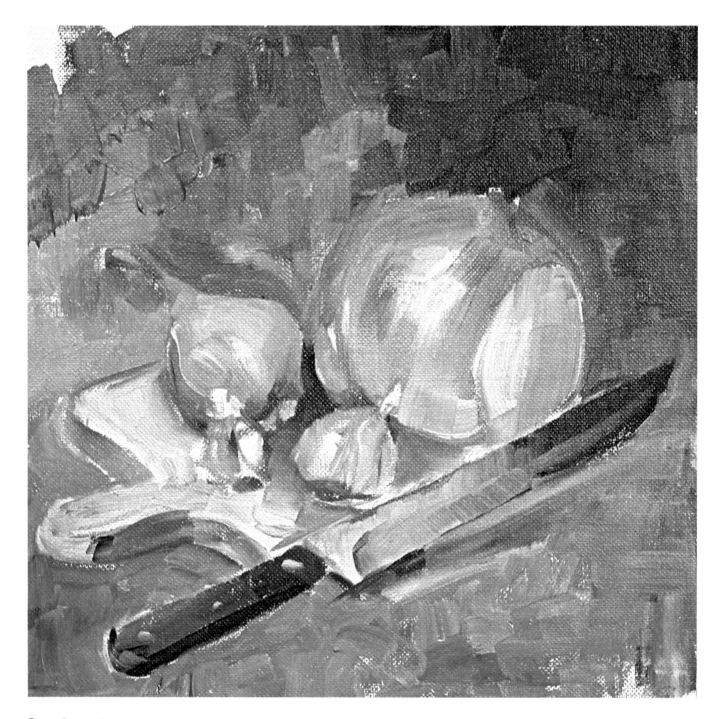

Step 3. Having covered the main shapes with color, your next goal is to cover the entire painting surface. Once again, work with your biggest bristle brushes and use bold, free strokes, paying no attention to details. Don't worry if the painting looks rough and perhaps a bit sloppy; you'll fix that in the final stage. Right now just think about broad areas of color. The dark tone above and behind the onions is a mixture of burnt umber, ultramarine blue, yellow ochre, and white. You can see the broad, squarish strokes of the big bristle brush—there's no attempt to blend them or smooth them out. This same mixture is carried down over the tabletop, switching from burnt umber to burnt sienna, then adding more yellow ochre and white. The rounded forms of the two onions are shaped with strokes of the shadowy

background mixture plus more white; notice how the strokes curve around the forms. The cut side of the big onion is painted with vertical strokes of this mixture plus a lot of white. The smaller shapes of the garlic are painted with free, curving strokes of ultramarine blue, burnt umber, and white. The top of the wooden breadboard is painted with this mixture, with less white in the shadow between the onions and the garlic. This same shadow tone appears on the side of the handle of the breadboard, along with some strokes of the yellowish tone used on the big onion. More of this yellowish tone is blended into the knife blade to suggest a reflection in the shiny metal. Part of the knife handle is lightened with a mixture of burnt sienna, yellow ochre, ultramarine blue, and white.

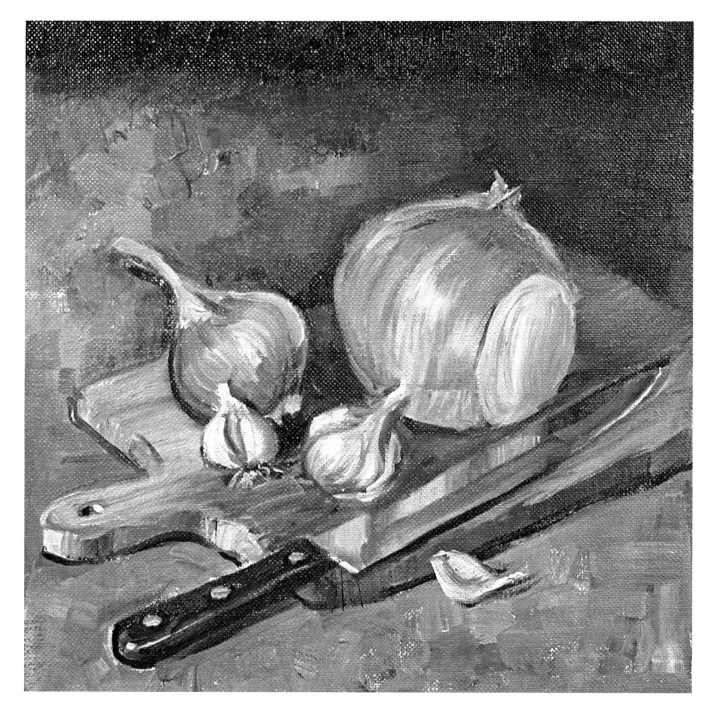

Step 4. By the end of Step 3, the entire picture is covered with wet, juicy color. So far, all the work is done with big bristle brushes. Only in the final stage do smaller bristle brushes and a softhair brush come into play. The tip of a small bristle brush is used to draw curving strokes over the rounded forms of the onions and garlic: mixtures of ultramarine blue, yellow ochre, burnt umber or burnt sienna, and white for the darker strokes; burnt umber, yellow ochre, and lots of white for the paler strokes. The same brush carries the same mixtures across the top of the breadboard to suggest the grain of the wood. The edge of the breadboard is darkened with ultramarine blue, burnt sienna, and a little white. Then the tip of a round softhair brush draws lines of this same mixture over the garlic and into the knife blade. The softhair brush then draws darker lines of the same mixture (containing less white) along the undersides of the vegetables, breadboard, and knife, to suggest shadows. This same brush adds touches of detail such as the rivets in the knife handle and the hole in the breadboard handle, plus a stroke of pure white toward the tip of the knife blade. A flat softhair brush blends and smoothes the background tone in the upper right area, adding some strokes of ultramarine blue, burnt sienna, and white to suggest the edge of the tabletop disappearing into the darkness. But the blending isn't carried too far—most of the original brushwork remains, still rough and spontaneous.

Step 1. Fruit is another common subject which is easy and delightful to paint. Rather than sketching your preliminary lines in charcoal, you might like to try working directly with a round softhair brush, burnt umber, and plenty of turpentine so that the lines won't be too dark. Then you can reinforce and correct these first lines with a darker mixture containing less turpentine. Here, you can see where the dark lines are drawn right over and around the lighter ones.

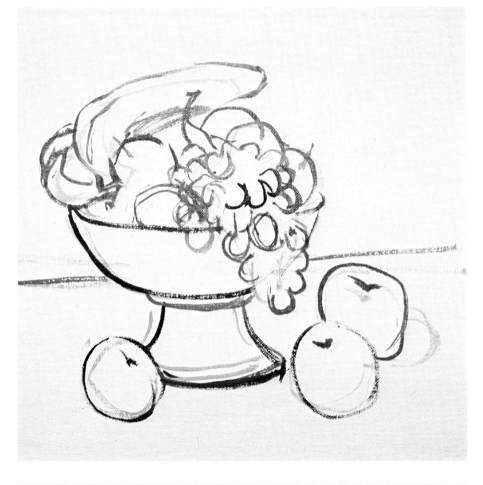

Step 2. Following the same basic method, start out once again by covering some of the important shapes with broad strokes of creamy color diluted with just enough medium to make the paint flow easily. The apples are painted with curving strokes of alizarin crimson, cadmium red, cadmium yellow, and a little white. The oranges in the bowl are quickly covered with cadmium red, cadmium yellow, and white. The bananas and the lemon on the tabletop are painted with cadmium yellow and white, softened with a touch of burnt umber and ultramarine blue.

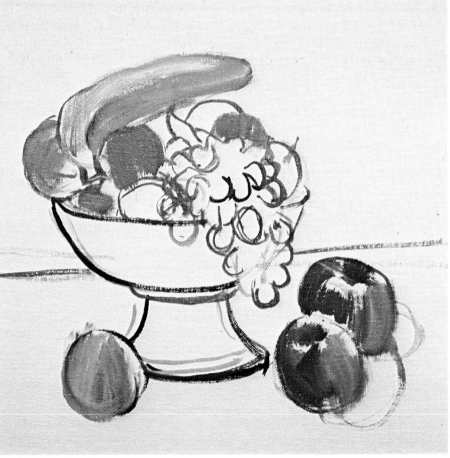

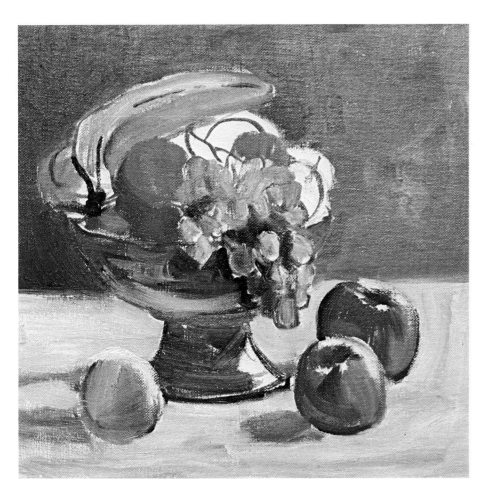

Step 3. At this stage, the goal is still to cover the entire canvas with wet color, working with big bristle brushes and not worrying about detail. The background is covered with a mixture of alizarin crimson, cadmium red, a little ultramarine blue, and white. The tabletop is brushed with horizontal strokes of burnt umber, ultramarine blue, and white—with a darker version of this mixture in the shadows. More of the apple mixture is brushed over the fruit in the bowl. The grapes are covered with dark and light strokes of ultramarine blue, cadmium yellow, burnt sienna, and white. The bowl is painted with curving strokes of ultramarine blue, alizarin crimson, and white.

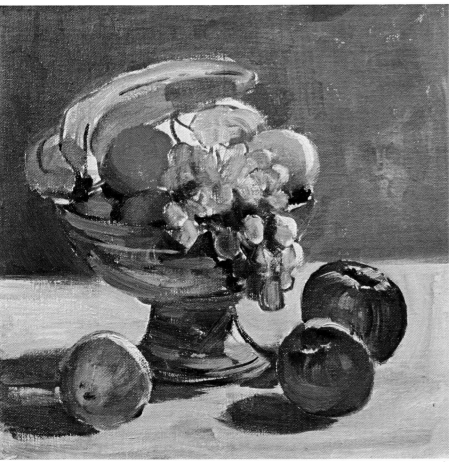

Step 4. Now smaller bristle brushes add some darks and lights to make the forms look more three-dimensional. Some burnt sienna and ultramarine blue are added to the apple mixture for the shadow sides of the apples. Some burnt umber and ultramarine blue darken the lemon on the table top. The shadows on the table are extended with this same mixture. Touches of dark are added among the fruit in the bowl with burnt sienna and ultramarine blue. The bowl is brightened with strokes of cobalt blue and white. And some strokes of almost pure white—with just a hint of cobalt blue—are drawn over the tops of the fruit to make them look shiny.

Step 5. When the canvas is completely covered with wet color, you're ready to start refining the forms. Shadows are added to the bananas with curving strokes of cadmium yellow, burnt umber, ultramarine blue, and white. A bit more white is added to the apple and lemon mixtures to soften the tones of the fruit in the bowl. Light and dark strokes of ultramarine blue, cadmium yellow, and white are drawn around the grapes with the tip of a round brush. The same brush is used to strengthen the shape of the bowl with dark lines of burnt sienna and ultramarine blue.

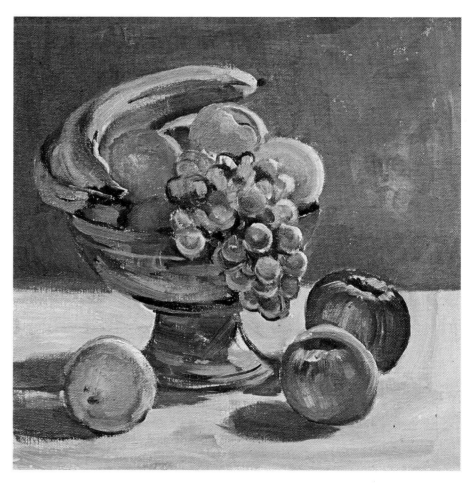

Step 6. The painting is now approaching its final stages, and it's time to begin thinking about details. So far, nearly all the work has been done with flat bristle brushes. Now a small round brush draws dark lines of burnt umber and ultramarine blue to indicate the stems of the grapes and apples, the dark patches on the banana skins, and the shadows among the grapes. This same brush is rinsed in turpentine, wiped on newspaper, and picks up a bit of pure white to suggest flashes of light on the edges of the banana, grapes, apples, and vase.

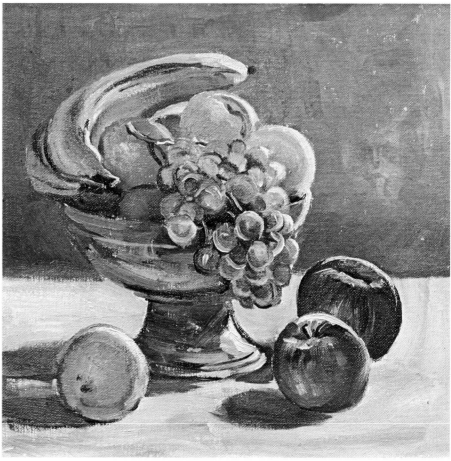

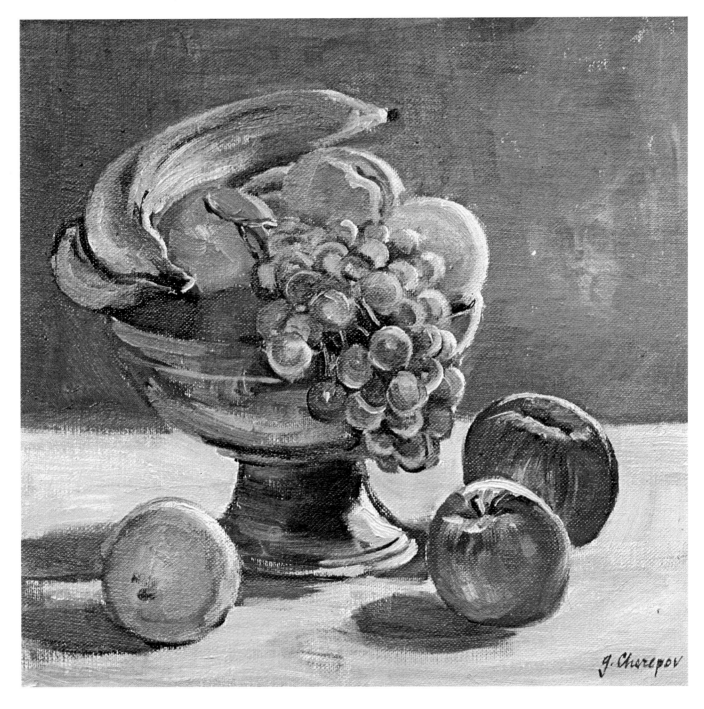

Step 7. You might think that the picture is finished at the end of Step 6—but not quite. There's still room for a few refinements. A small bristle brush adds some cadmium yellow and white to the inside of the banana and blends this bright tone into the shadow. The shadow on the base of the bowl is darkened with burnt umber and ultramarine blue. A small, flat softhair brush blends the lights and shadows on the grapes to make them more luminous—and then the round brush adds some shiny strokes of white slightly tinted

with the original greenish mixture. Some of the warm background tones are blended into the light areas of the tablecloth and also into the shadows cast by the fruit and the bowl. Notice that the only touches of really thick paint are saved for these final stages: the bright tone inside the curve of the banana, the flash of light on the base of the bowl, and the lighted top of the nearest apple are painted with thick strokes that literally stand up from the canvas.

Step 1. Flowers are certainly the most popular of all still life subjects. Don't waste too much time arranging them neatly in the vase. Just arrange them casually and go to work on the preliminary drawing on the canvas. Here you can see the first pale lines of the composition, followed by darker lines drawn right over them. Notice that most of the flowers are drawn as simple, round forms, with only a few strokes to indicate petals. After all, these strokes will soon be covered with opaque color—which already begins to appear in rough strokes at the top of the bouquet.

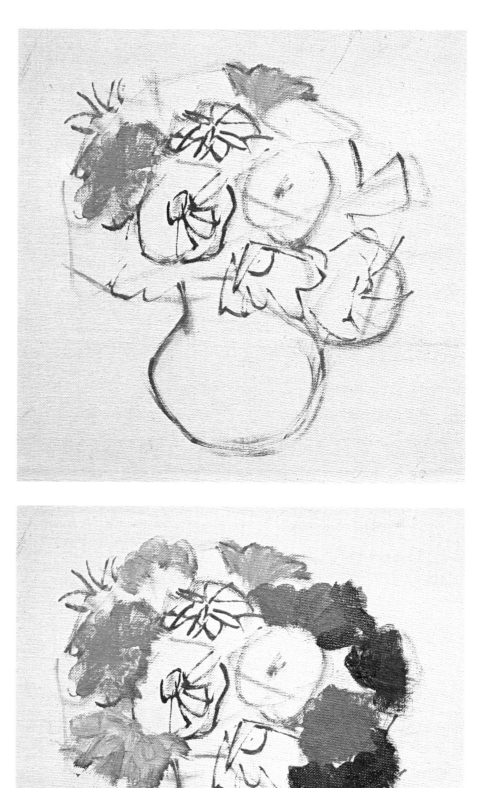

Step 2. Now begin to scrub in the colors of the flowers with your biggest bristle brushes. Just paint them as patches of bright color and don't worry about their precise forms. The red flowers are cadmium red, alizarin crimson, and a bit of ultramarine blue in the darks. The pink flowers are the same mixture, plus a lot of white. The orange flower is cadmium red and cadmium yellow, plus some white. The yellow flower at the top is cadmium yellow, white, and a touch of ultramarine blue. The darkest flower at the right is ultramarine blue, alizarin crimson, and white.

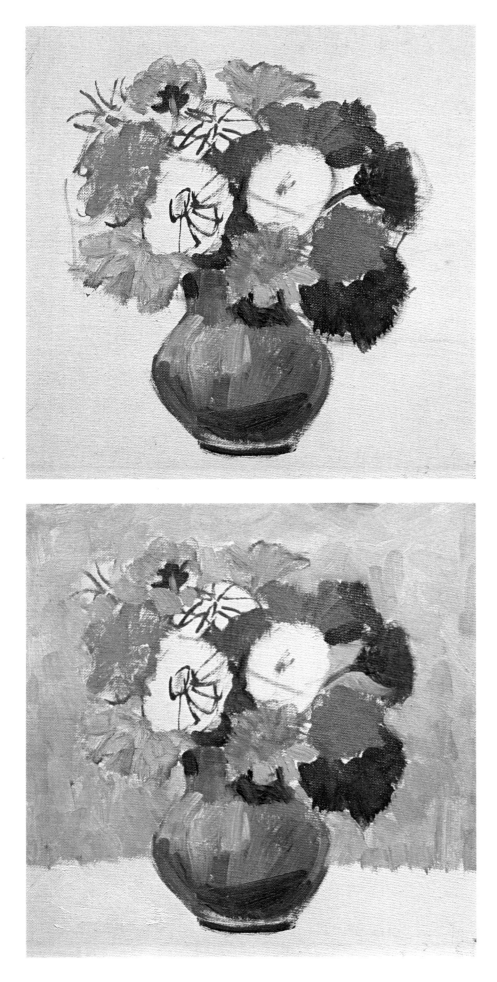

Step 3. The bristle brush now blocks in the shape of the vase with phthalocyanine blue, burnt sienna, and white. The tip of a small bristle brush adds a few stems and some other notes of green among the flowers with viridian and burnt sienna. Another yellow flower is painted with cadmium yellow and white, with a little burnt umber in the shadow area. You still can't see any petals, but the brushstrokes seem to follow the direction of the petals, and those rough dabs of color begin to look like flowers.

Step 4. The wall behind the flowers is painted with short, quick strokes of ultramarine blue, cadmium red, yellow ochre, and white, with a bit more yellow ochre in the upper left area. Don't worry if the background tone works its way over the edge of the flowers, which will be sharpened up in later stages.

Step 5. The tablecloth is painted with cadmium yellow, white, and a bit of burnt umber in the shadow, The flat shape of an orange flower is added to the bouquet with cadmium red, cadmium yellow, and some white. At this point, the entire canvas is covered with rough strokes of color, leaving bare canvas for just two white flowers. Not a single flower is painted in precise detail, and the entire job is done with bristle brushes.

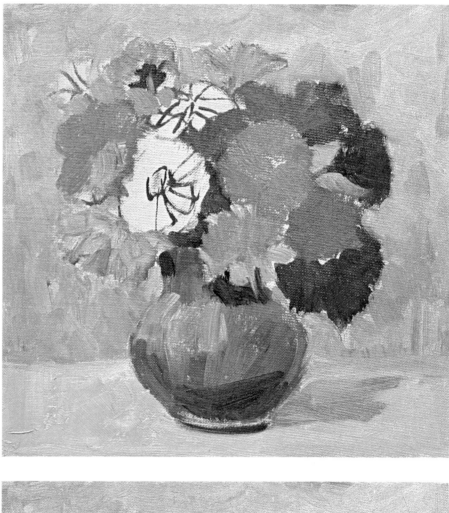

Step 6. Now the smaller bristle brushes and the round softhair brush go into action. The larger white flower is painted with white and yellow ochre in the lights, ultramarine blue, burnt sienna, yellow ochre and white in the shadows. Some burnt sienna and ultramarine blue are stroked across the tabletop to suggest folds in the cloth. The round brush picks up a fluid mixture of burnt sienna and ultramarine blue, then dashes in a few quick, casual lines to suggest the center of the flowers and some petals. The side of the vase is darkened with the original mixture used in Step 3, but which now contains less white.

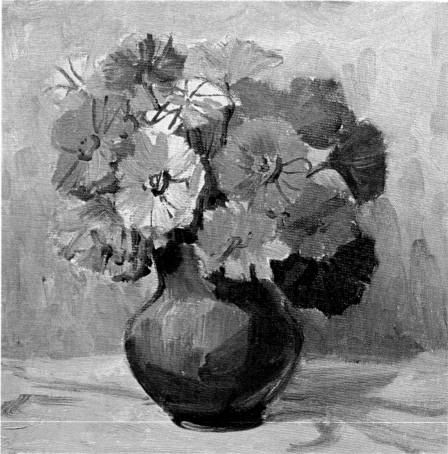

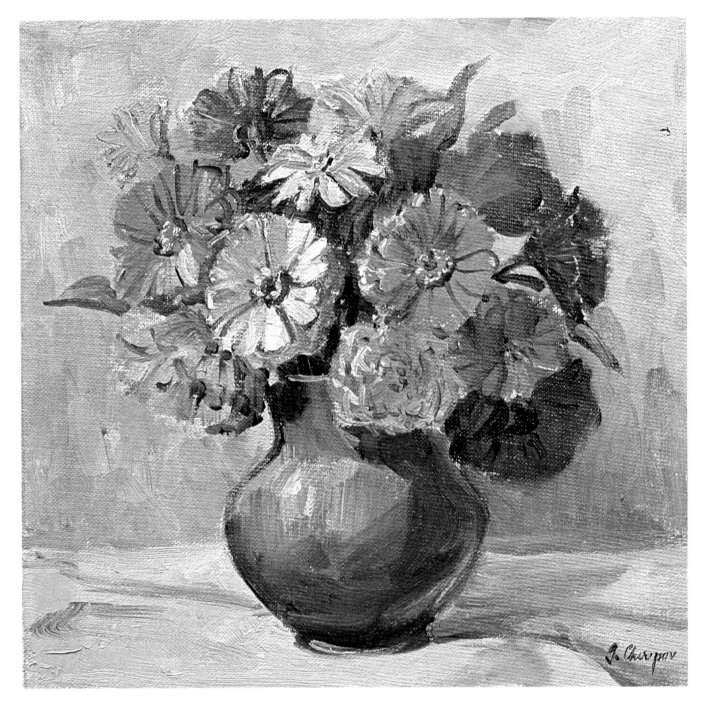

Step 7. The last precise touches are saved for the final stage. The smaller white flower is completed with the round brush, using the same mixtures used for the bigger white flower. The tip of the round brush adds more dark lines to the flowers—but doesn't paint every petal! Only a few petals are picked out in each flower. Then the round brush picks up a bright mixture of white tinted with just a little yellow ochre and adds some quick strokes to the flowers in the center of the bouquet to suggest light flashing on the petals. More leaves and other notes of green are added with viridian, cadmium yellow, and ultramarine blue. The shadow on the table to the right of the vase is darkened with this same mixture. The brushwork is worth studying carefully: the flowers look surprisingly complete, although they're nothing more than scrubby patches of color with a few light and dark lines drawn over them.

Step 1. The hardest still life objects are metal and glass, so don't try these until you've done some easier still lifes of vegetables, fruit, and flowers. Then arrange a few bottles and other kitchen containers on a tabletop and draw them carefully with charcoal or with a round brush. Start out with very pale lines. Draw the shapes as simply as you can, using just straight and curved lines.

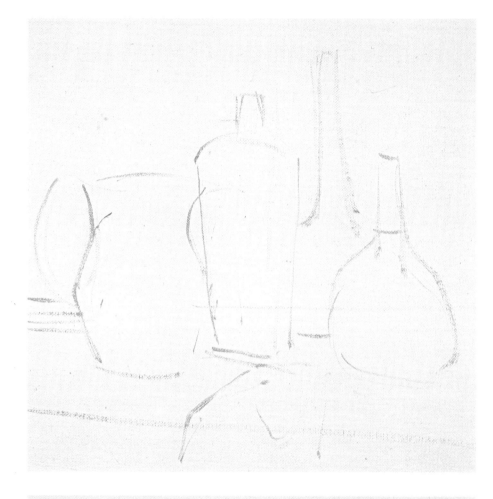

Step 2. When the shapes seem right, go over the lines with darker color, still using plenty of turpentine so that the brush moves freely over the canvas. Don't make the lines *too* precise, since they'll be covered with paint very soon.

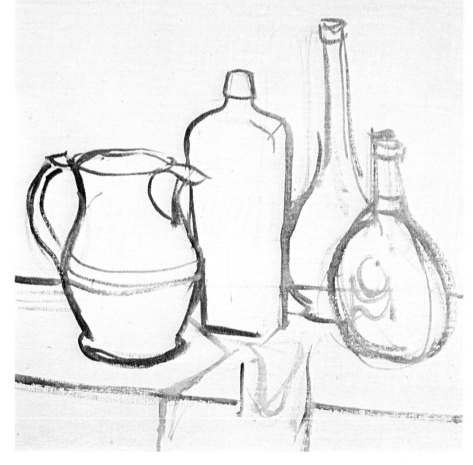

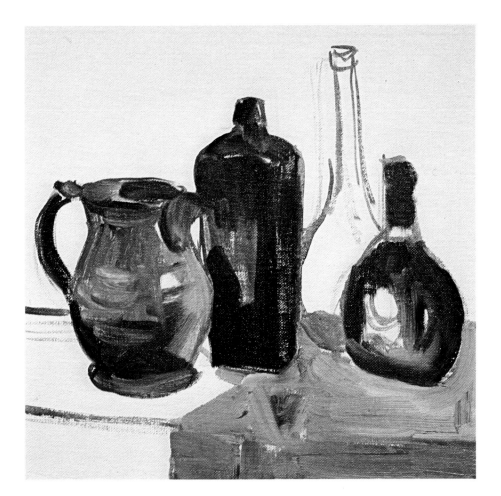

Step 3. Cover the main forms with broad strokes of creamy color. Make your brush follow the directions of the forms: straight strokes for rectangular forms and curving strokes for rounded forms. The pitcher is painted with strokes of burnt umber, ultramarine blue, and white. The bottles are burnt umber, cadmium yellow, ultramarine blue, and white. The cloth on the table is the same mixture with more yellow and white.

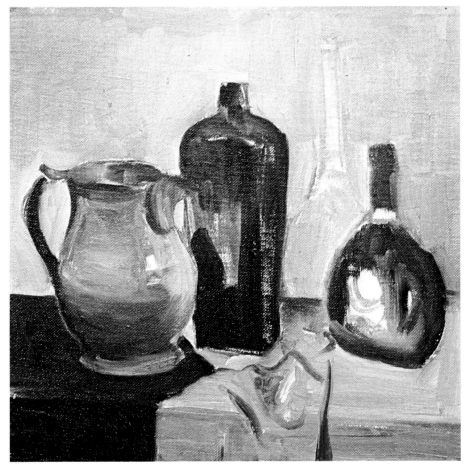

Step 4. The wall is painted with vertical strokes of cadmium yellow, burnt umber, a little ultramarine blue, and lots of white. The bare tabletop is painted with burnt sienna, ultramarine blue, yellow ochre, and white; the folds in the cloth are painted with the same mixture. Notice that the background tone is painted around the pale, ghostly shape of the glass bottle, which will be completed later. More strokes of the original mixture are added to the shadowy underside of the pitcher.

Step 5. With the canvas virtually covered, it's time to sharpen up the edges of the forms. Working with the original mixtures, a small bristle brush carefully retraces the edges of the pitcher to the left and the bottle to the right. A label is added to the face of the bottle, and some dark lines are drawn around the neck. A yellow ribbon is added to the bottle with cadmium yellow, burnt umber, and white.

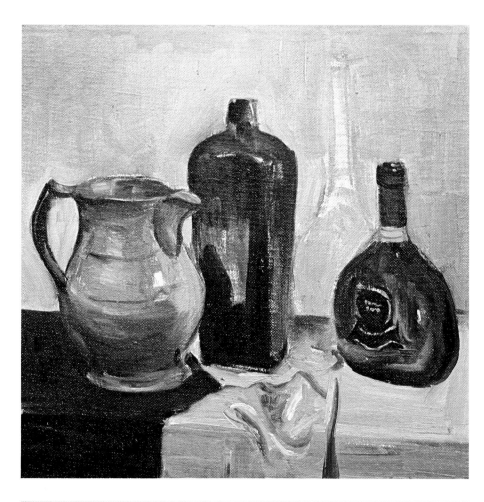

Step 6. The pale, transparent form of the slender bottle is painted with ultramarine blue, alizarin crimson, yellow ochre, and white—with almost pure white in the highlights. This same pale mixture is brushed into the sides of the darker bottles to the right and left of the pale bottle. And this mixture is used to add some lighter notes to the metal pitcher.

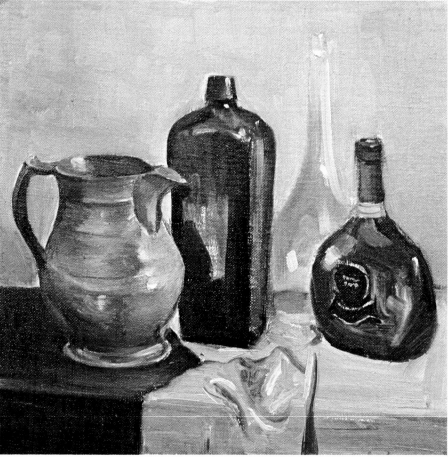

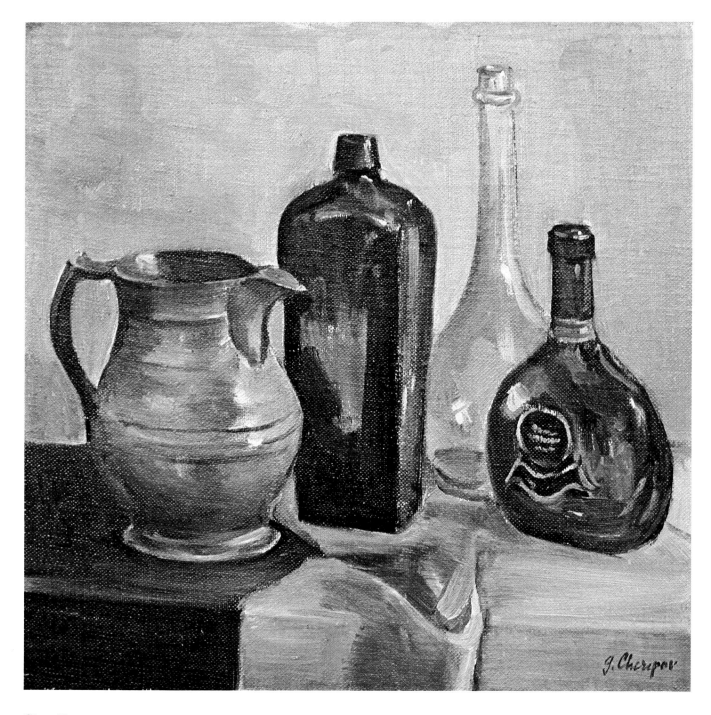

Step 7. As usual, the finishing touches are saved for the final stage. The tip of a round brush draws crisp, dark lines of ultramarine blue and burnt sienna around the edge of the bottle to the right and uses the same mixture to sharpen up the edges of the other dark bottle. This same mixture is drawn around the base of the pitcher and inside the dark opening. Then the brush is rinsed, and the edges of the pale glass bottle are sharpened with thin strokes of the original mixture. Highlights of ultramarine blue and white are added to the dark bottle at the right, while highlights of pure white are added to the other bottles and the pitcher. A final adjustment needs to be made to the central bottle and the cloth. The drapery is darkened with some burnt umber and yellow ochre; the folds are simplified; and a reflection of the drapery color is added to the face of the dark bottle.

Step 1. Having painted several still lifes indoors, the logical next step is to find what might be called an outdoor still life. Try painting some big, solid objects such as a rock formation, perhaps surrounded by wildflowers. In this preliminary drawing, you can see that the pale lines of the rocks are drawn first, then corrected and reinforced by darker lines. These strokes are all burnt umber diluted with plenty of turpentine.

Step 2. The rocks are begun with broad, squarish strokes of a bristle brush to suggest their blocky shapes. The lighter tones are mixtures of ultramarine blue, burnt sienna, yellow ochre, and white. The darker strokes are ultramarine blue and burnt sienna. Each stroke is a slightly different combination of these colors so that some strokes are dominated by blue, others by reddish brown, and still others by yellow.

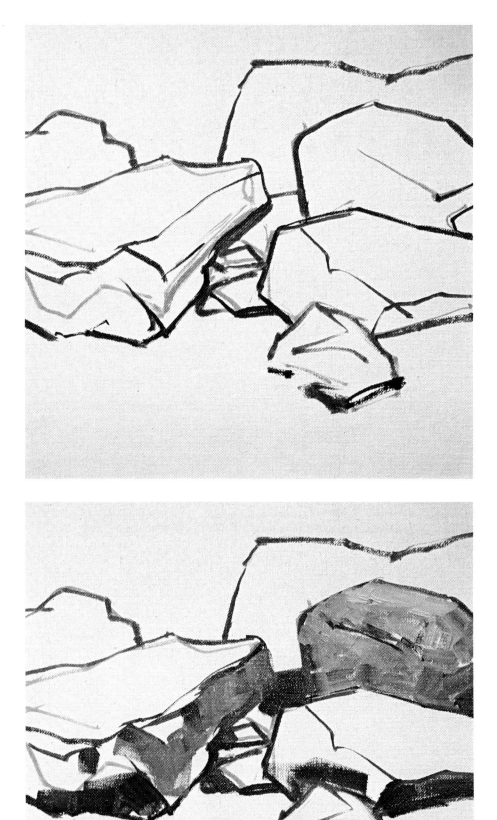

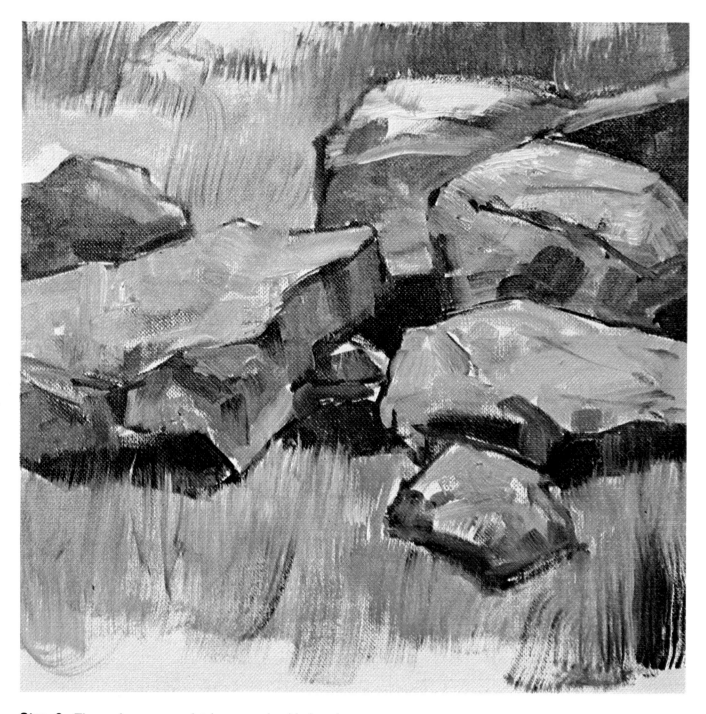

Step 3. The rocks are completely covered with broad
strokes of the mixtures introduced in Step 2. The strokes
aren't blended, but each stroke stands out with its own tex-
ture and color. Notice the stroke of almost pure white that
suggests a flash of sunlight on the topmost rock. The
meadow above and below the rocks starts out as a broad,
very scrubby tone of cadmium yellow, viridian, a little
burnt sienna, and a lot of turpentine, simply to cover the
canvas. Then the tip of a round brush works over this mix-
ture with rapid strokes of viridian and burnt sienna blended
partly into the wet undertone and suggesting weeds and
grasses. Notice how these slender strokes move up over the
shadowy undersides of the rocks.

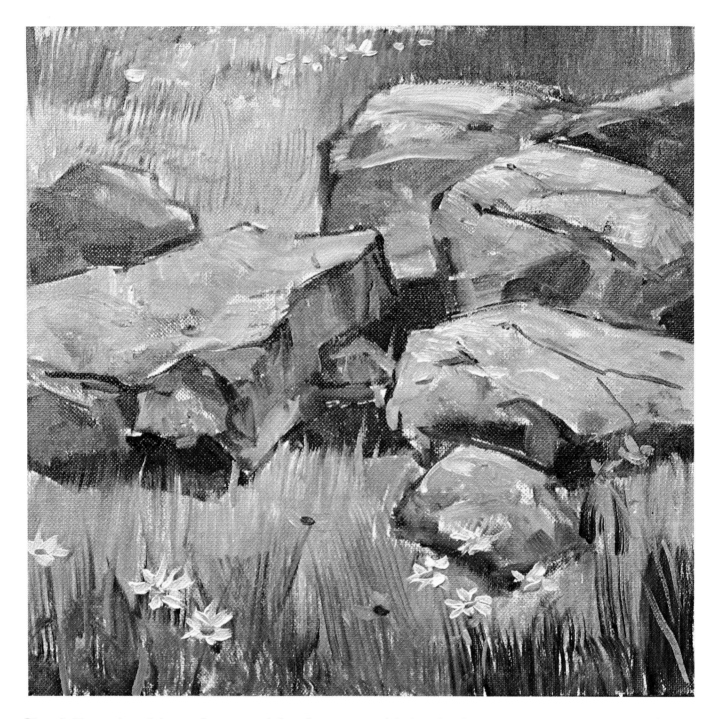

Step 4. The strokes of the meadow are carried to the top and bottom of the canvas with the same round softhair brush. Dark blades of grass are suggested in the left foreground with a mixture of cadmium yellow, viridian, and burnt sienna. Paler strokes of this mixture are carried upward to the base of the rock where the mixture is now mainly cadmium yellow. Light and dark strokes of this mixture are continued above the rock and over the distant meadow. Then a much darker blend—mainly burnt sienna and viridian—suggests the grasses and weeds in the lower right area. Now a bristle brush picks up a pale version of the original rock mixture of ultramarine blue, burnt sienna, yellow ochre, and lots of white. This blend is carried over the tops of the rocks with rough, thick strokes that emphasize the rocky texture. The tip of the round softhair brush draws some cracks in the rocks with burnt sienna and ultramarine blue diluted to a fluid consistency. This same brush adds some wildflowers with strokes of pure white for the petals and a dab of cadmium yellow and burnt sienna at the center. The orange flowers are cadmium red and cadmium yellow, with burnt umber in the center.

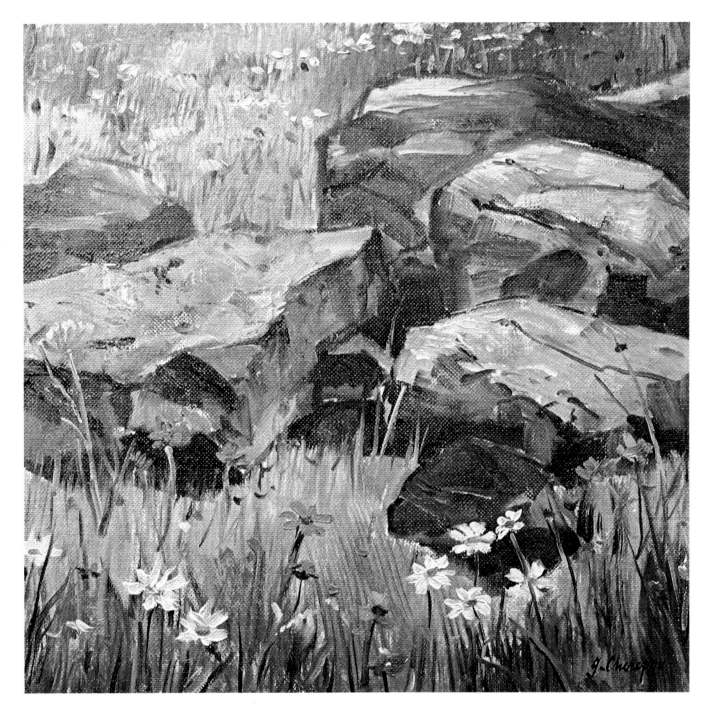

Step 5. The rocks need more contrast between their sunlit tops and shadowy sides. So the sides are darkened with bristle brushstrokes of burnt sienna, ultramarine blue, yellow ochre, and just a little white. Notice that the dark strokes are thin—containing a lot of medium—while the lighter strokes at the tops of the rocks are thicker paint, containing much less medium. The white flower strokes, begun in Step 4, are now carried over the distant meadow at the top of the picture, interspersed with a few touches of the orange mixture. Although the strokes are pure white, they blend slightly with the underlying color; thus, the white becomes cooler or warmer, depending upon the tone underneath. More orange flowers are added in the foreground. Their dark and light stems are the same dark and light mixtures used to paint the grass and weeds. Some scattered purple flowers are a blend of ultramarine blue, alizarin crimson, and white. The picture is completed with crisp dark and light strokes of viridian, burnt sienna, and cadmium yellow—applied with the round brush—to indicate more detail in the foreground.

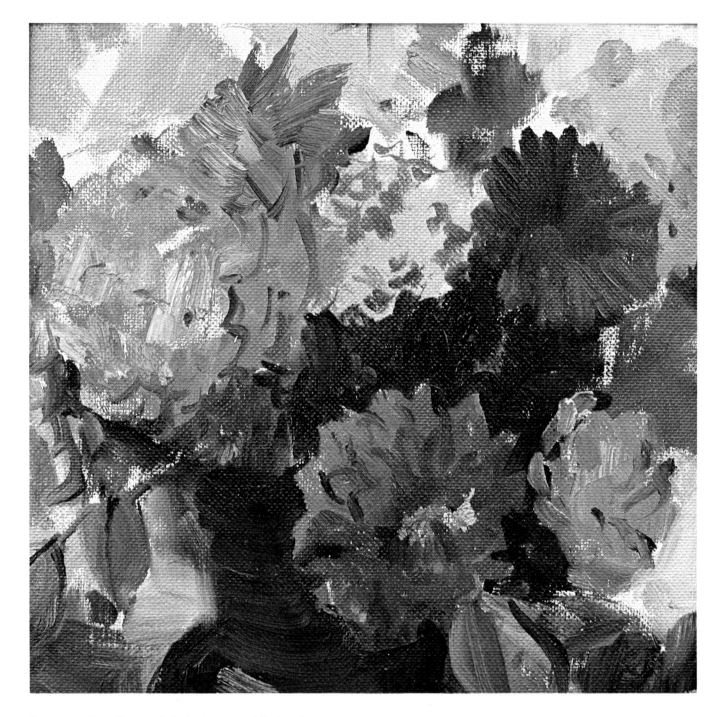

Selective Detail. Now let's look at some lifesize close-ups of several oil paintings to see how the paint is handled. This cluster of flowers—part of a much larger painting—shows you how little detail you need to make a subject look convincing. All the strokes are quick, free, and casual. Each flower is essentially a roughly painted patch of color in which you can see the strokes quite clearly. To make these patches of color look more like flowers, just a few details are added. You can see how a few dark lines suggest petals in the yellow and red flowers at the center of the picture. The strokes follow the direction of the forms: notice how the flower at upper right is painted with radiating strokes that move outward from the center. But you can't see a single petal! This principle of selective detail works just as well when you're painting rocks, trees, or any other subject.

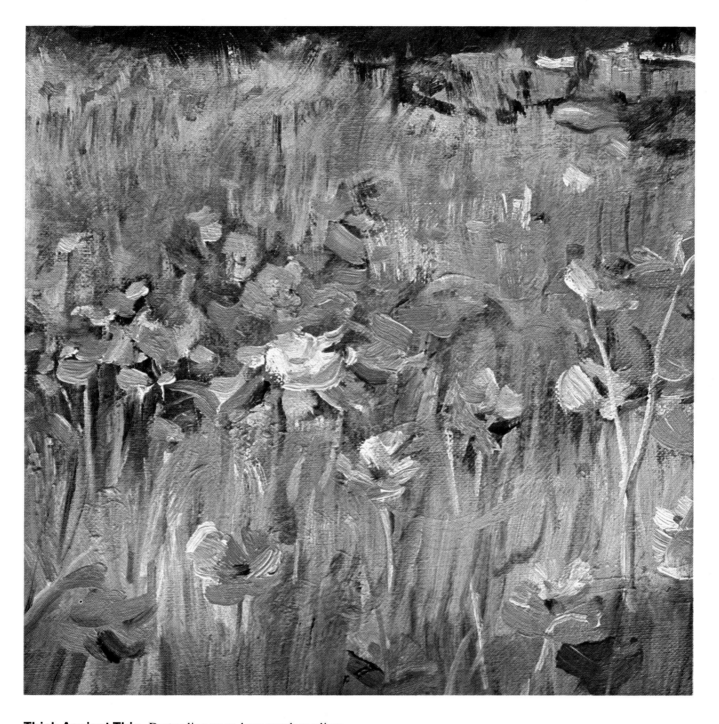

Thick Against Thin. Depending upon how much medium you add to your tube color, oil paint can be as thick or as thin as you like. Some subjects lend themselves to thin color, while others seen to need thick color. And it's often a good idea to play thick color against thin. For example, the grasses in this meadow are first painted in slender strokes of thin color that contains a lot of medium. Then the wildflowers are painted right over the wet strokes of the grasses—but in short strokes of thick color that contains very little medium. The thickness of the wildflowers accentuates the contrast between the flowers and the grass. The flowers seem to jump up above the grass. Notice how the nearest flowers are more thickly painted than the flowers in the distance.

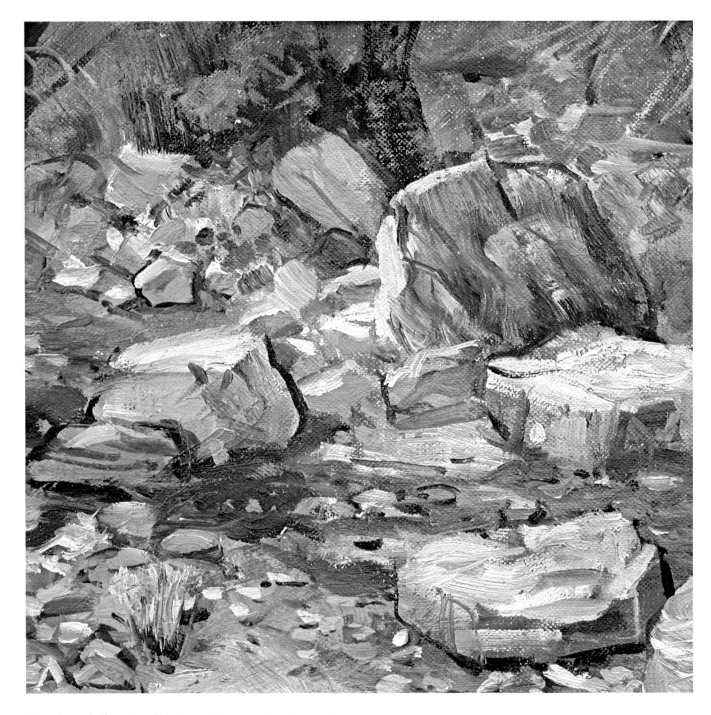

Brushwork Creates Texture. Because oil paint can be thick or thin and brushwork can be rough or smooth—depending upon whether you use bristle or softhair brushes—you can make the texture of the paint match the texture of the subject. For example, if you're painting rocks like these, you can work with thick, pasty paint containing little or no medium. And you can work with stiff bristle brushes—brights are the stiffest—to make your strokes look ragged and irregular. This combination of thick paint and ragged brushwork is ideal for expressing the rough, craggy texture of the rocks. Even the pebbles can be painted with small touches of thick paint, which makes them seem to stick up from the ground.

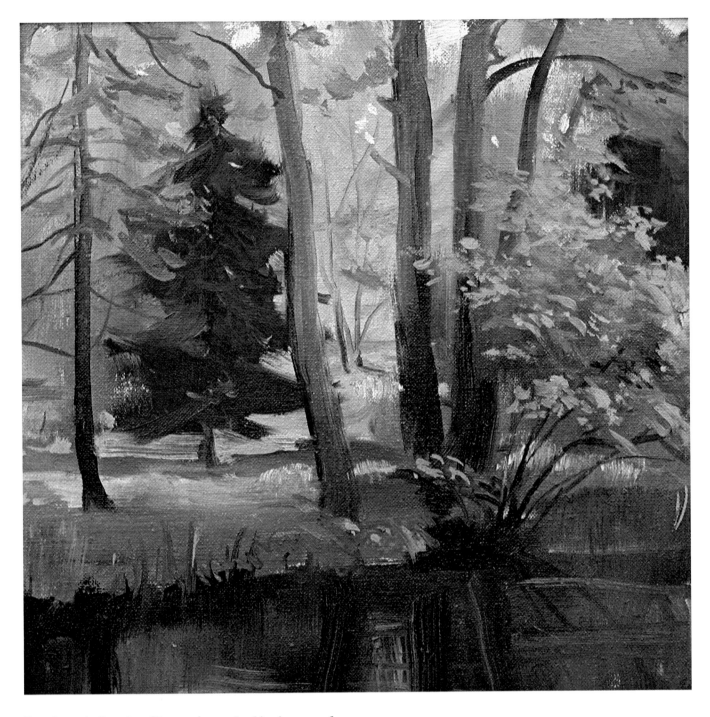

Brushwork Creates Atmosphere. In this close-up of a section of a painting of deep, shadowy woods, you can see how thin, fluid paint creates a totally different effect from the rocks on the preceding page. The paint is diluted with a lot of medium to produce a soft, fluid consistency. And softhair brushes are used to make fluent strokes that melt together and have very little texture. This combination of soft brushwork and fluid color creates a magical, shadowy atmosphere. Notice how the reflections of the trees seem to melt away into the dark water. In the same way, the left side of the evergreen blurs softly into the paler tone of the woods beyond.

Step 1. Summer is a fine time to go outdoors and paint your first landscape. It's usually best to make your first brush lines in some color that will harmonize with the colors of the finished picture. The preliminary brush drawing is cobalt blue plus plenty of turpentine. Then the distant hills are painted with mixtures of cobalt blue, alizarin crimson, yellow ochre, and white. You can see that some strokes contain more blue, others contain more crimson, and still others contain a lot of white.

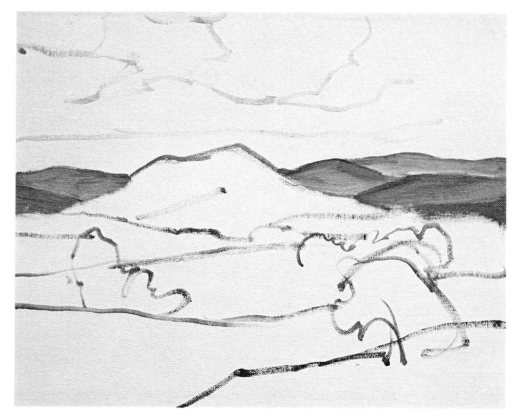

Step 2. The big, dark hill is painted with the same blend of colors—although you can see that the proportions of blue, red, yellow, and white vary from stroke to stroke. The darker strokes contain more blue or red. The light patch is mostly yellow ochre and white. The dark mass at the base of the hill is mostly blue and red, with almost no white. Everything is done with bristle brushes. The strokes are all broad and rough.

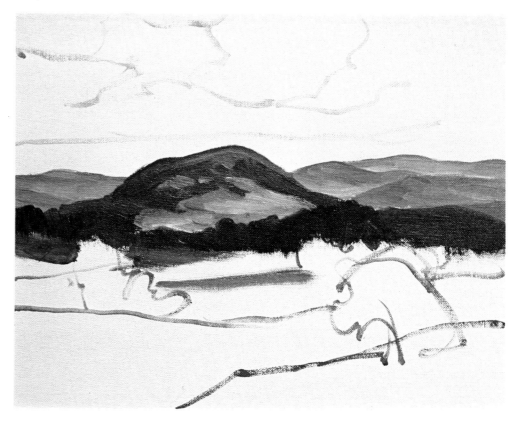

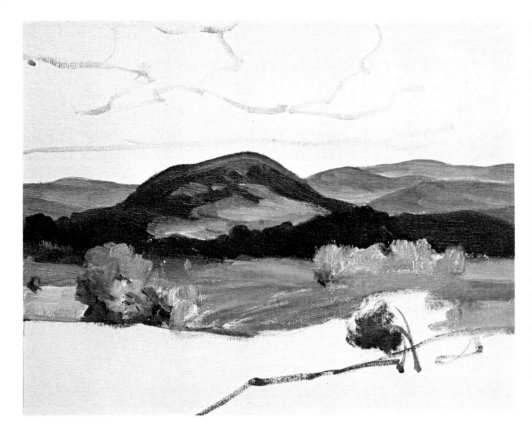

Step 3. The sunny colors of the meadow are painted with essentially the same combination of blue, red, yellow, and white—but cadmium yellow is substituted for the more muted yellow ochre, while the delicate cobalt blue is replaced by the deeper ultramarine. The combination of cadmium yellow and ultramarine blue produces these lovely yellow-greens, warmed here and there by a stroke of crimson or cooled by a stroke of blue. Notice that the meadow is painted with smooth, horizontal strokes, while the trees are executed with short, scrubby, vertical and diagonal strokes that suggest clusters of foliage.

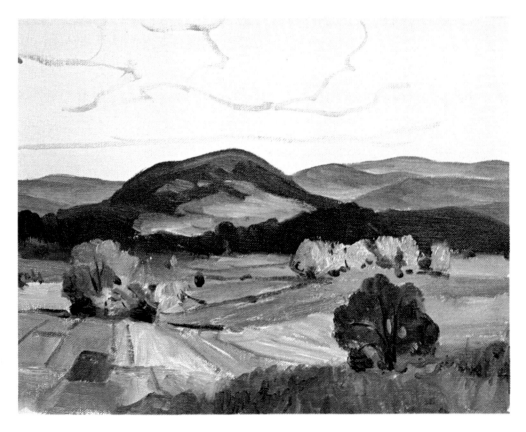

Step 4. More strokes of the meadow mixtures are carried into the foreground, which is even sunnier and contains more cadmium yellow and white in the brightest patches. The meadow is divided into the geometric forms of cultivated fields, each with its own color—containing more blue, red, or yellow. The dark tree and the patch of shadow in the right foreground are a blend of cadmium yellow, ultramarine blue, and burnt sienna instead of alizarin crimson. This same mixture is used for the shadows on the more distant trees. The tip of a round brush picks up this mixture and draws the lines of the fields as well as the trunks and branches of the trees.

Step 5. Until now, no work has been done on the sky. Here you can see that the sky tones are brushed around the shapes of the clouds, which remain bare canvas. The mixtures are the same ones used for the hills: cobalt blue, alizarin crimson, yellow ochre, and white. The lower sky is mostly yellow ochre and white, with just a hint of blue and red. The upper sky is dominated by blue with a good deal of white but just a hint of red and yellow in the mixture. At the midpoint of the sky, these two tones are softly blended together by a flat softhair brush.

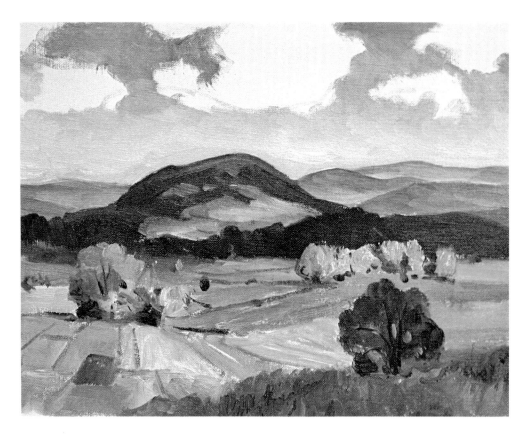

Step 6. The shadowy undersides of the clouds are also painted with a flat softhair brush. The colors are the same as the sky, but with more alizarin crimson and a lot of white. For the sunlit edges of the clouds, the bristle brush comes into play again, carrying a thick blend of white with just a speck of sky tone. You can see that the sunny edges are thicker and more ragged than the soft, smooth shadow strokes. A small, flat softhair brush picks up the dark sky tone and adds some dark notes to the undersides of the clouds—then adds some wisps of dark clouds in the lower sky at the left.

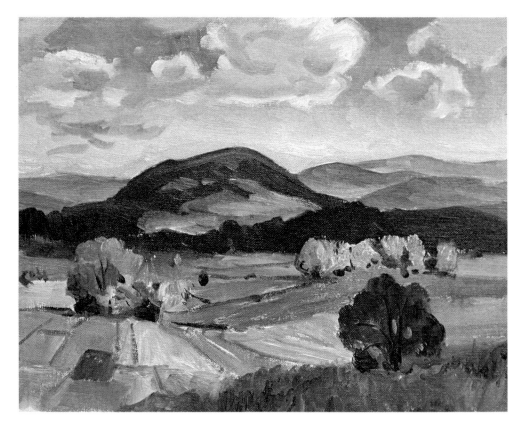

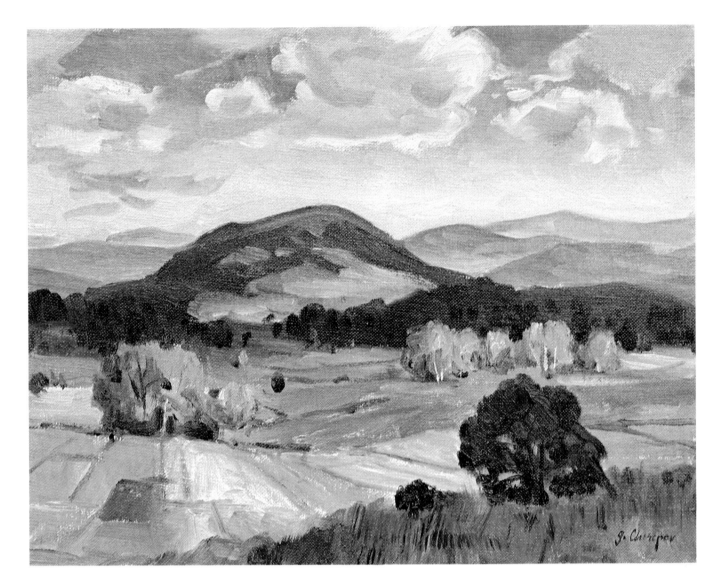

Step 7. The round softhair brush adds the last touches of detail—often so subtle that you must look closely to find them. The dark tree in the foreground is adjusted with strokes of ultramarine blue, burnt sienna, and yellow ochre, making the tree darker still and pitching it slightly to the side. Notice how several gaps are left in the foliage for the sun to shine through. A dark bush is added to the foreground with the same mixture, and dark blades of grass are added. Touches of the same mixture are added within the darkness of the woods at the base of the big hill, suggesting individual trees. Then a bristle brush repaints the sunlit trees—just above the dark tree in the lower right—with rougher, heavier strokes of the original mixture, but with a little more red. The center of the meadow is darkened and warmed in exactly the same way to accentuate the sunny fields in the foreground. These fields are made even sunnier with strokes of cadmium yellow, white and just a little ultramarine blue. The round brush finally comes back to add a few white wisps of clouds in the upper right area, some white trunks among the distant trees, a few touches of darkness among the trees, and more lines between the fields.

Step 1. When you paint a group of trees, start out by drawing the trunks with some care, but don't try to draw the precise shapes of the clusters of leaves. Try to visualize each cluster as a big, simple shape, then draw a quick line around the shape—bearing in mind that this line will soon disappear. This autumn landscape begins with a brush drawing in burnt umber that defines the main treetrunks and the edge of the shore but merely suggests a few other trunks, branches, and leafy masses. The leaves are begun as a flat, scrubby tone of cadmium yellow and a little burnt umber.

Step 2. The yellow shapes of the leaves of the main tree are extended outward with more of the same mixture. Then some shadows are suggested with cadmium yellow, yellow ochre, and burnt umber. These mixtures are carried downward into the water, which will reflect the colors of the surrounding foliage.

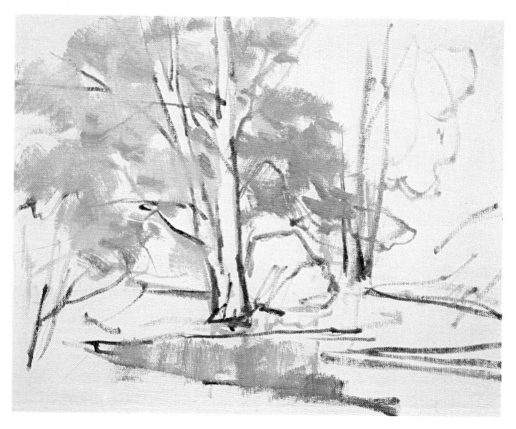

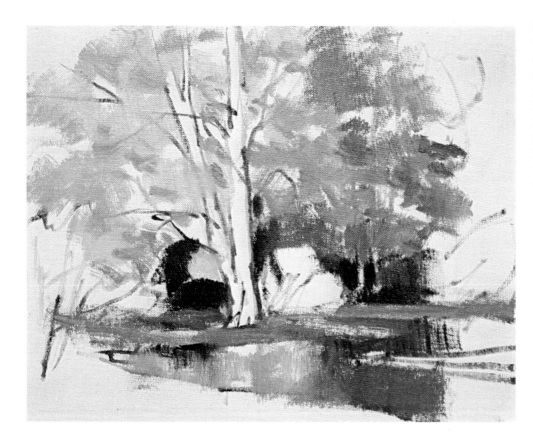

Step 3. To paint the coppery tone of the distant trees, some cadmium red and burnt sienna are added to the cadmium yellow. This same mixture is brushed along the shoreline. Some darks are added with burnt sienna and ultramarine blue, and some dark reflections are added to the water with these mixtures.

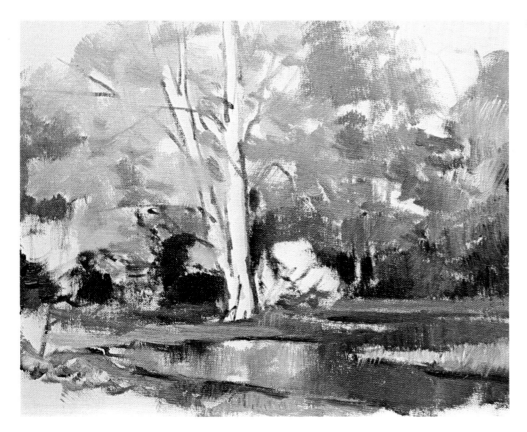

Step 4. Green foliage is added at the right with viridian, burnt sienna, and a slight touch of phthalocyanine blue—which must be added in tiny quantities, or it will dominate the mixture. This same mixture is carried down into the water to reflect the trees above. Some viridian, burnt sienna, and white are added to the near shore and along the left side of the picture.

Step 5. The bright color of the bush at the bottom of the central tree is painted with alizarin crimson, white, and a hint of ultramarine blue. The copper tone of the foliage at the left is burnt sienna, cadmium yellow, and ultramarine blue. The near shoreline is covered with the same mixture that first appeared in Step 4. And the sky is covered with free strokes of cobalt blue, alizarin crimson, yellow ochre, and white. Notice how spots of sky tone appear through the foliage.

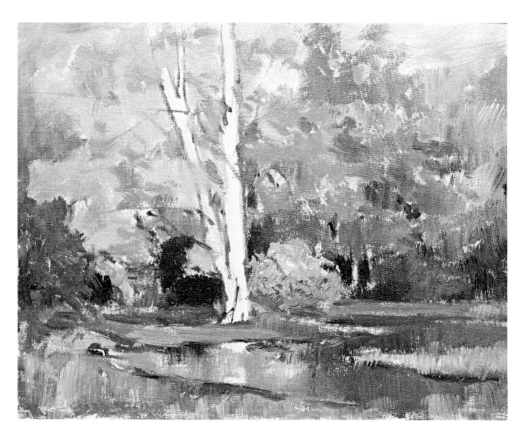

Step 6. So far, the entire canvas is covered with color—expect for the two trunks of the central tree— and it's time to start adding details. The central trunks are painted with short, thick strokes of the same mixture as appears in the sky, but with more white. Then the round brush picks up a fluid mixture of burnt umber and ultramarine blue to add dark trunks and branches. As soon as these dark lines are added, the scrubby strokes in Step 5 are transformed into clusters of leaves. Notice how the colors of the trunks are reflected in the water—a little softer and less distinct.

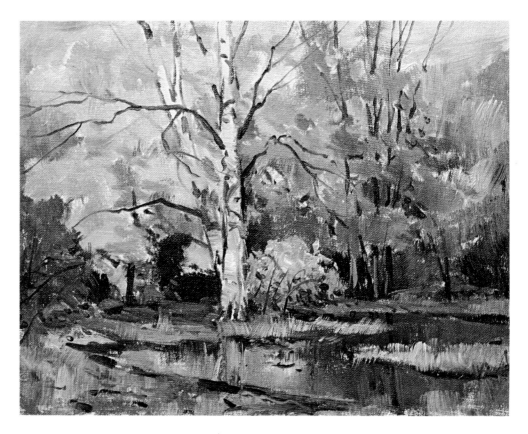

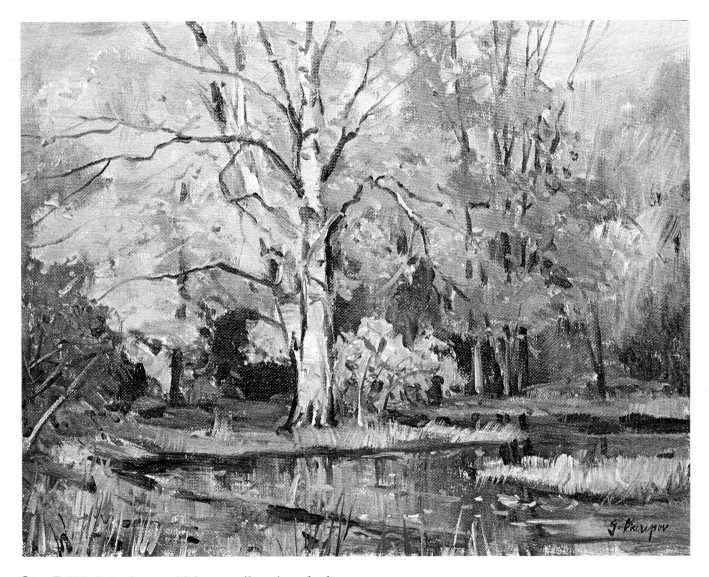

Step 7. This is the time to add those small touches of color that *suggest* so much more detail than you actually see if you look closely at the picture. The tip of a small bristle brush adds thick dabs of cadmium yellow and white here and there among the foliage of the central tree, making you think that you see individual leaves—although you really don't. In the same way, flecks of cadmium red and cadmium yellow are added to the orange trees at the right and among the coppery foliage at the extreme left. Flecks of white and yellow are added to the pond to suggest floating leaves. Dried grasses and weeds are suggested with the tip of a round brush carrying a pale mixture of white, yellow ochre, and burnt umber. More foliage tones are added to the pond. Notice how the brushstrokes express the forms: those last bits of foliage are painted with short, choppy strokes; the branches are painted with wandering, rhythmic strokes; while the reflections in the pond are painted with vertical strokes.

Step 1. Because a winter landscape has a generally cool tone, it's best to use a cool color for your preliminary brush drawing. You can use cobalt or ultramarine blue diluted with a lot of turpentine, or you can use a mixture of blue and burnt umber, as you see here. This brush drawing indicates the shapes of the trunks, the edges of the stream, the tops of the snowdrifts, and the horizon line. When you paint a landscape, it's often a good idea to work from the top down. The sky is begun with cobalt blue and white.

Step 2. To suggest a glow of warm light in the lower sky, a mixture of yellow ochre, alizarin crimson, and white is brushed upward from the horizon. When you're painting a snow scene, it's particularly important to get the sky tone right. After all, snow is just crystallized water; like water, the snow will reflect the colors of the sky.

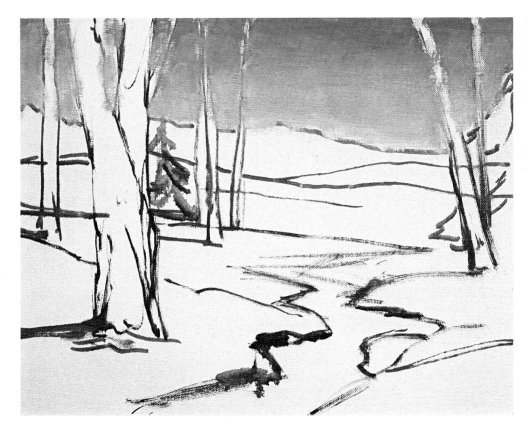

Step 3. The strokes of the sky are blended with a flat softhair brush. Now the warm tone at the horizon merges softly with the cooler tone at the top of the picture. Look carefully at skies and you'll see that the color is often darkest and coolest at the top, gradually growing warmer and paler toward the horizon.

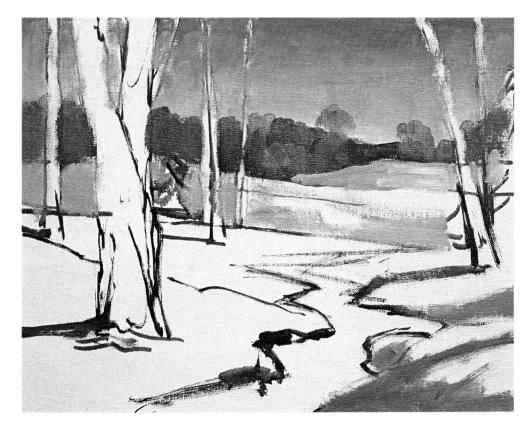

Step 4. The shadows of the snow reflect the color of the sky, so they're painted with the same mixture of cobalt blue, alizarin crimson, and yellow ochre, plus white. The lighted areas of the snow are still left bare canvas. The same three colors are used to paint the distant woods along the horizon, but with more alizarin crimson and yellow ochre added to produce a warmer tone.

Step 5. The sunlit tops of the snowbanks are painted with white that's tinted with just a touch of yellow ochre and cadmium red to add a hint of warmth. The lights and shadows of the snowbanks are blended together to produce a soft transition. The distant treetrunks are painted with the mixture that was used for the trees along the horizon. The big tree to the left is begun with a rough stroke of this mixture to indicate a shadow.

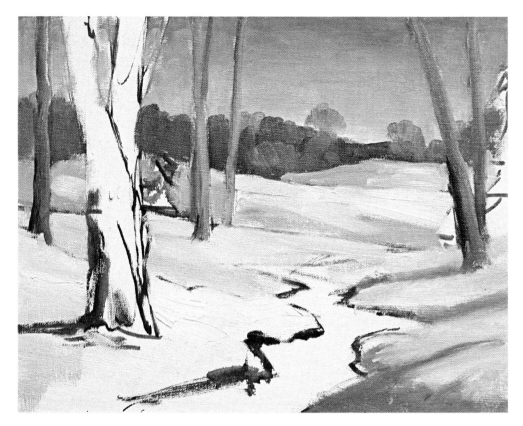

Step 6. The big tree is now covered with rough, thick strokes of burnt sienna, yellow ochre, viridian, and white—with more white in the sunlit patches. The roughness of the brushwork matches the roughness of the bark. The dark tone of the brook is painted with fluid strokes of viridian, ultramarine blue, and yellow ochre; a few white lines are added with the tip of a round brush. The same greenish mixture is used to suggest an evergreen in the upper left area. Two more distant trees are added with the same mixture used for those at the horizon.

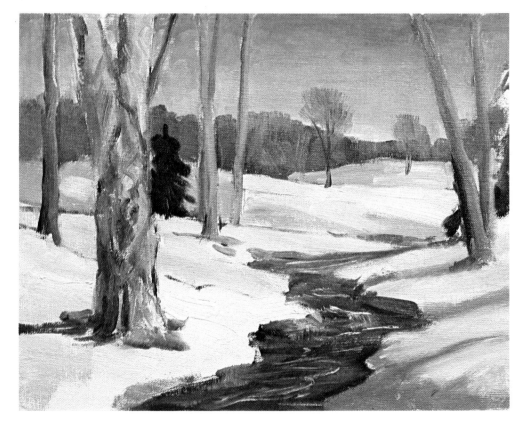

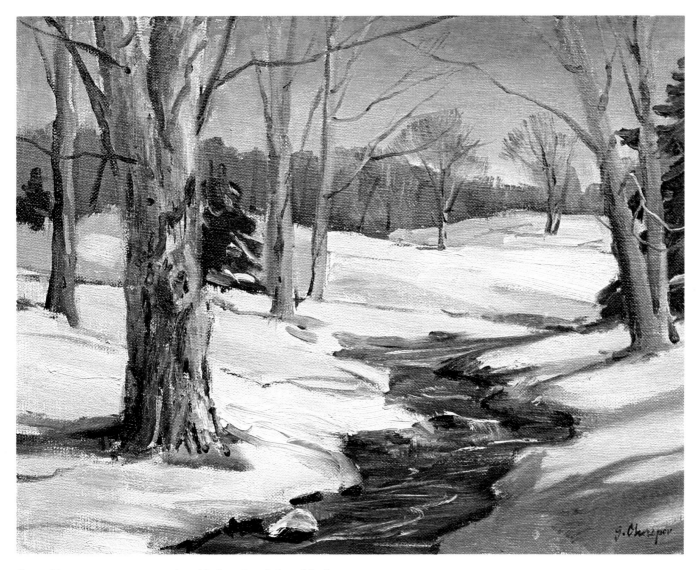

Step 7. Another evergreen is added at the right with the mixture used in Step 6. A bristle brush strengthens the shadows on the snow with the mixture introduced in Step 4. Then another bristle brush builds up the lighted areas of the snow with the mixture used in Step 5. Around the big tree, you can see that much thicker paint is used for the lights than for the shadows—a good rule to follow. Then a small round brush uses the original tree mixtures to draw branches, twigs, and shadows along the trunks. The curve of the snow is accentuated by slender lines that suggest shadows cast by the branches. The dark lines along the edges of the stream and on the big trunk are drawn by the tip of the round brush carrying a mixture of viridian and burnt umber. A few strokes of pure white are added to suggest snow on the branches, on the distant evergreen, and on the rock in the stream.

Step 1. When you sketch in the first lines of a portrait head, start with the biggest shapes. Draw the curving sides of the face, the mass of the hair, the neck, and the shoulders. Then draw a pale, horizontal line about halfway down the face to indicate the location of the eyes. To harmonize with the warm flesh tone, this preliminary brush drawing is done with burnt sienna diluted and lightened with turpentine.

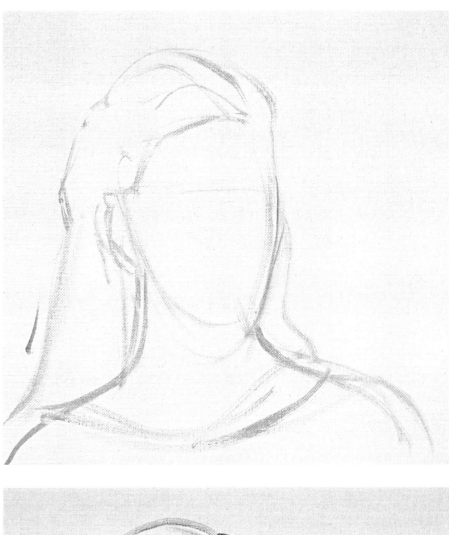

Step 2. When you've drawn the biggest forms simply but accurately, then you can add the features. Notice how these features are placed within the egg-shape of the face. The eyes are roughly halfway down from the top of the head. The tip of the nose is about halfway between the eyes and chin. And the mouth is about halfway between the tip of the nose and the tip of the chin. The top of the ear aligns with the eyes, while the lobe falls somewhere between the nose and the upper lip.

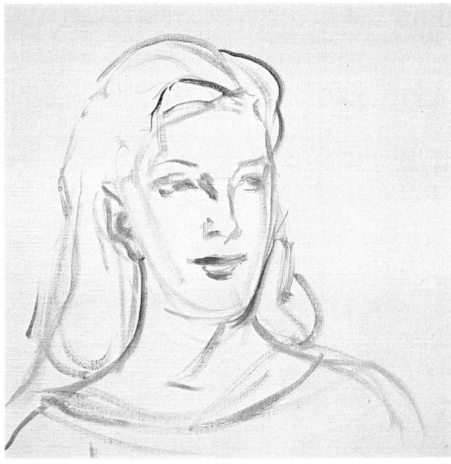

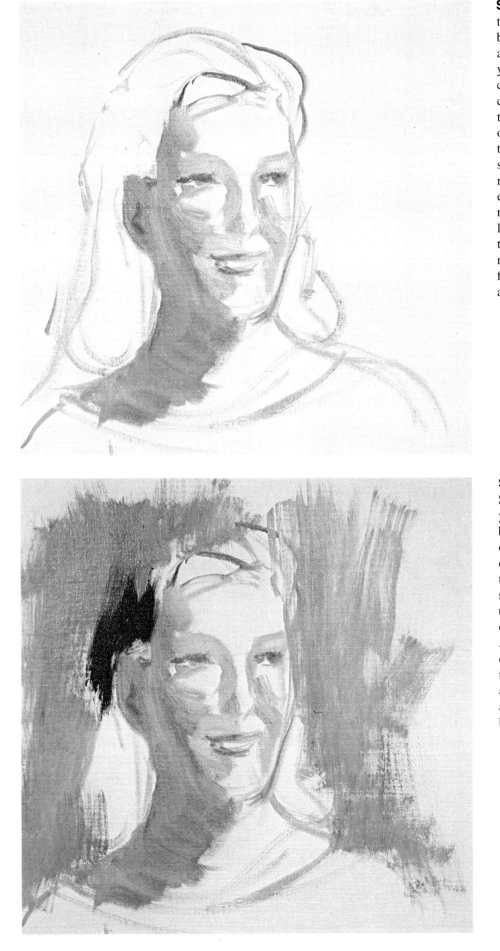

Step 3. A large bristle brush paints the shadow tone that runs from the brow over the cheek, jaw, neck, and shoulder. This is a mixture of yellow ochre, cadmium red, and cobalt blue. This same mixture is carried into the eye sockets, along the side of the nose, beside the other cheek, and along the side of the mouth. You can see that some strokes contain more red and others more blue. The bright tone of the ears is this mixture, but with much more red. Don't worry if the underlying brushlines begin to disappear; they're not meant to be anything more than guidelines to be followed freely when you brush in the big areas of color.

Step 4. The same mixture used in Step 3, but with more blue and yellow, is brushed freely over the background and carried to the edges of the face and hair. The guidelines of the hair almost disappear under this background tone. But then dark strokes of ultramarine blue, burnt umber, and yellow ochre start to re-establish the dark shape of the hair. At this point, several important color areas are clearly established: the lighted areas of the face, which are still bare canvas; the shadow areas of the face; and the tone of the background.

Step 5. The entire shape of the hair is covered with the dark mixture of burnt umber, ultramarine blue, yellow ochre, and a bit of white, painted with broad strokes that follow the curve of the hair. This dark shape is important because it clearly defines the lighter contours of the forehead, cheek, jaw, ear, neck, and shoulders. Now, even though the head is very roughly painted, it looks strongly three-dimensional.

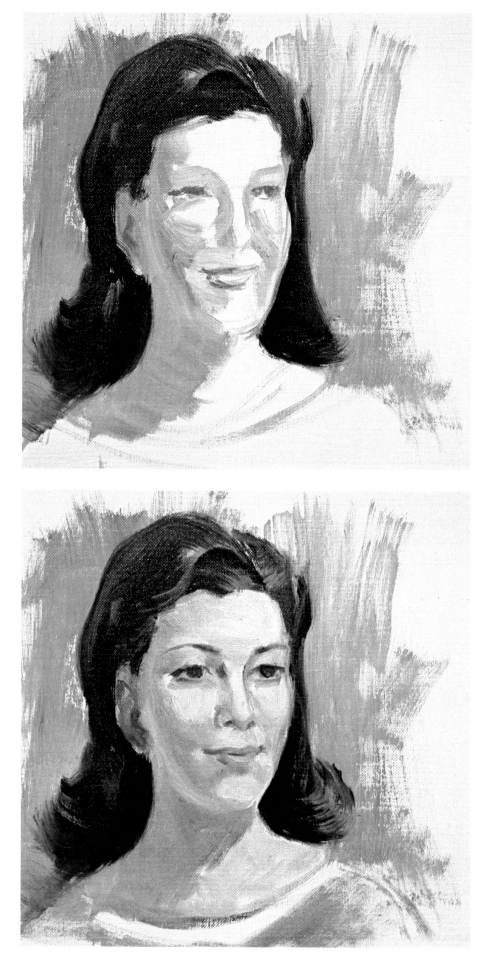

Step 6. The lighted areas of the face are brushed in with the same mixture as was used for the shadows, but with much more white. These areas are painted with a flat softhair brush that carefully blends the light and shadow areas where they meet. The shadow areas are painted more precisely with the original mixture, adding a bit more red around the cheeks and adding a touch of burnt umber to the dark shadow that runs over the throat. A round brush adds small touches of the hair mixture to the eyes, eyelashes, eyebrows, nostrils, and the hollow of the ear. This same brush suggests some individual strands of hair with the original hair mixture, which now contains more white and yellow ochre. The lips are painted with the same mixture as the flesh, but with more red.

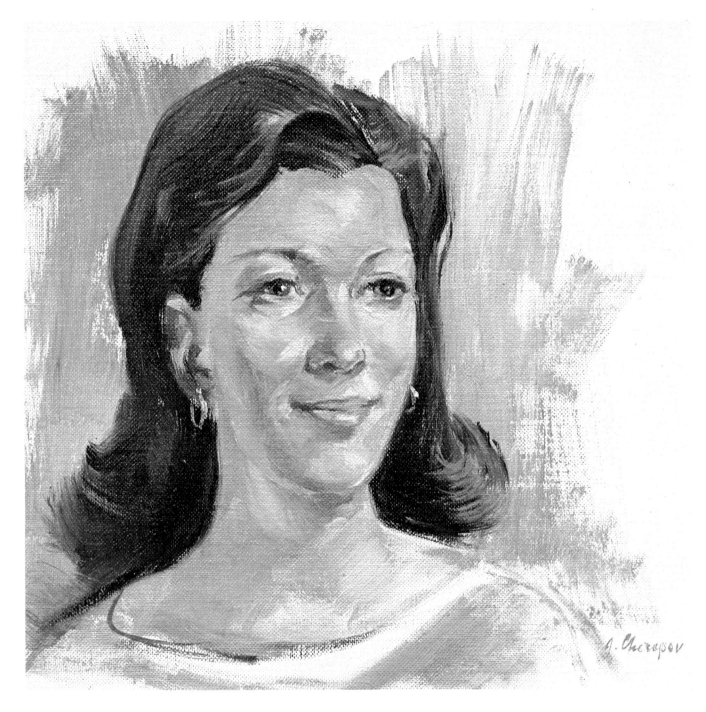

Step 7. By the end of Step 6, the entire head is covered with broad tones and a few touches of detail. In the final stage, these tones are made richer amd more lifelike with small strokes of flat and round softhair brushes. Notice how small touches of warm color are softly blended into the forehead and between the eyes; around the eye sockets and the curves of the cheeks; to the sides and tip of the nose; and down over the jaw and chin. The shadows around the eye sockets, under the nose, under the lower lip, and under the chin are strengthened. Touches of pale color are added to the center of the forehead, the cheeks, the tip of the nose and ear, the lower lip, and the chin, which become more luminous. All these touches are done with the original mixture used for the shadow in Step 3, with more red and yellow added for the warm tones and more white added for the highlights. The eyes are darkened with small, precise strokes of the hair mixture, and then tiny touches of white are added for the highlights. The loose brushwork of the background is left untouched, and the dress is merely suggested with rough strokes of cadmium red and cadmium yellow. The hair is almost as loosely painted as the background. The gold earrings are nothing more than quick strokes of yellow ochre and white. The careful brushwork is limited to the face—but even here, the strokes are never *too* precise.

Step 1. This male head, like the female head in Demonstration 9, begins with a brush drawing that simply defines the outer shape of the head, the contour of the hair, and a bit of the neck and shoulders. A horizontal line is drawn to locate the brow, and a shorter horizontal line locates the tip of the nose. This preliminary brush drawing is a fluid mixture of burnt umber and cobalt blue.

Step 2. Now the smaller forms are drawn with darker lines over the big, simple form in Step 1. The brush defines the distinctive shapes of the brows, eyes, cheeks, nose, mouth, jaw, chin, and ear, as well as the inner line of the hair. Once again, notice that the eyes are about halfway down, the nose is midway between the eyes and chin, and the mouth is roughly midway between the nose and chin. The top of the ear lines up with the corner of the eye, while the lobe lines up with the nostril.

Step 3. At this stage in the portrait, the most important thing is to establish the broad areas of light and shadow. Now they're painted at the same time, with one brush carrying the light mixture over the forehead, nose, and cheek, while the other brush carries the shadow mixture over the eye sockets, then down over the cheeks, upper lip, and chin. Both these tones are a mixture of yellow ochre, cadmium red, and cobalt blue, with more white in the light areas.

Step 4. The entire face is covered with rough patches of these light and shadow mixtures. A bit of burnt sienna is added in the darker areas. The original brush lines, drawn in Steps 1 and 2, have almost completely disappeared under broad strokes of color. But the head already begins to look round and life-like, even though the details of the drawing have been obliterated.

Step 5. A background tone of cobalt blue, yellow ochre, and white is brushed freely around the head. So far, all the work has been done with bristle brushes. Now smaller flat and round sables reconstruct the contours of the head with dark strokes of burnt sienna, ultramarine blue, yellow ochre, and white. You can see where crisp strokes and lines have been drawn into the eyes and ear; around the outer edge of the brow, cheek, jaw, and chin; and in the shadow areas beneath the cheeks, nose, lower lip, and jaw. The hair is painted with free strokes of cobalt blue, burnt umber, and white, with a few lines of the dark mixture used on the face.

Step 6. The background tone is carried out toward the edges of the canvas. Then the same softhair brushes are used to strengthen the contrasts within the face. Lighter strokes of the original flesh tone—with more white—are blended into the center of the forehead, into the nose, around the eye sockets and mouth, over the edges of the ear, and down into the neck. The shadows of the eye sockets, nose, lips, cheeks, and chin are repainted with a darker version of the flesh mixture. Then the lights and shadows are blended softly into one another. The hair is developed with more precise strokes of cobalt blue, burnt umber, and white. The same mixture is repeated in the collar.

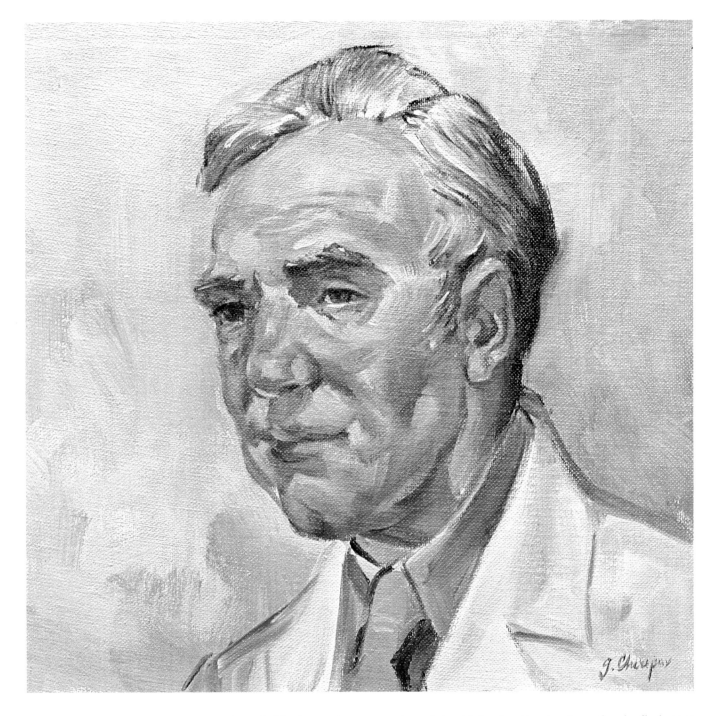

Step 7. Step 6 comes very close to being a finished portrait, but there are still a few refinements to be added in Step 7. The background tone is carried to the outer edges of the canvas and lightened with more yellow ochre and white along the front of the face in order to strengthen the contrast between the pale background and the darker flesh tones. As the background tone is painted along the brow, cheek, jaw, and chin, the contours of the face are made rounder and softer. Paler flesh tones are brushed in along the edge of the face to make them softer and more luminous. As you run your eye over the entire face, you can see other light touches that add luminosity: touches of pale flesh tone above the brows and around the eye sockets; touches of warmth in the cheeks; pale strokes within the shadows to make them look more transparent. Observe how the strokes on the cheeks and forehead curve around these bony forms. It's these last, almost invisible, touches that add vitality to the portrait. The jacket, by the way, is the same mixture as the hair, while the necktie is cadmium yellow subdued with a touch of cobalt blue and burnt umber, then lighted with white.

Step 1. A coastal scene, dominated by sky and water, is an interesting challenge. This painting is done on a gesso panel—a sheet of hardboard coated with white acrylic gesso, thinly applied so that the dark tone of the hardboard comes through slightly. The preliminary brush drawing defines the horizon, the rocks along the shore, the distant headland, and the cliff in the lower right area. This is a picture with strong contrasts, so the lines are drawn with a dark mixture of ultramarine blue and burnt umber.

Step 2. The strip of land along the distant shore, the headland just below the horizon, and the first tones of the beach are painted with a mixture of ultramarine blue, yellow ochre, alizarin crimson, and white. More blue is used in the distant form, while more red and yellow appear in the strokes along the beach.

Step 3. The dark forms of the rock are painted in flat tones of ultramarine blue and burnt umber. The cliff to the right is begun with the same mixture. What makes this painting interesting is the pattern of dark, rocky shapes against the lighter sky and water. So the first goal is to place these shapes in their proper positions on the panel.

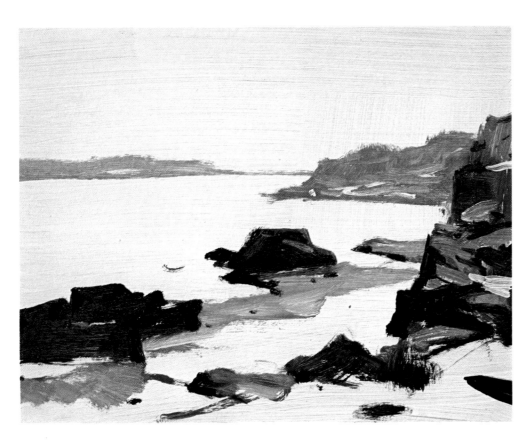

Step 4. The cliff is covered with the dark mixture of ultramarine blue and burnt umber. Then the distant shore and headland are repainted with thicker strokes of the original mixture used in Step 2, but with more blue and white. Strokes of this same mixture indicate lighted tops on the rocky forms within the cliffs to the right. A single stroke of this mixture appears on the top of the central rock.

Step 5. The sky is painted with overlapping, short, irregular strokes of cobalt blue, yellow ochre, alizarin crimson, and white—with more red and yellow toward the horizon. You probably remember that this is similar to the mixture used to paint the distant shore and headland. The sky is bluest and darkest at the top, paler and warmer at the horizon.

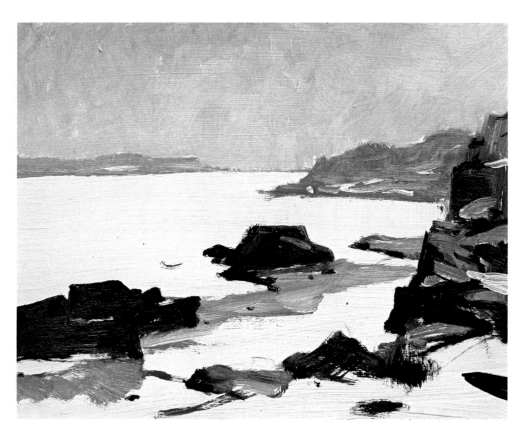

Step 6. Since water normally reflects the color of the sky, the sky mixture now reappears in the rough strokes of the crashing waves just beyond the rocks. To the beach between the rocks and the nearby cliff, a painting knife adds thick strokes of white, slightly tinted with the sky mixture; later, these white strokes will be transformed into wet, shining sand.

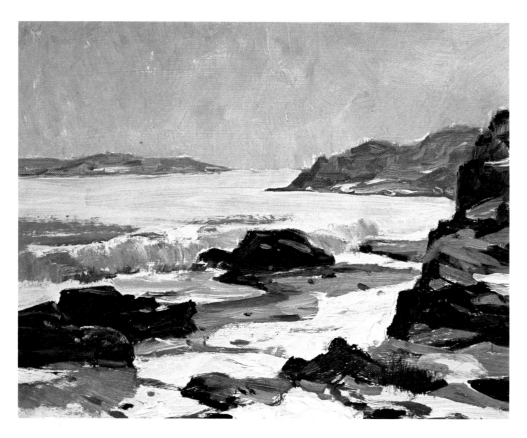

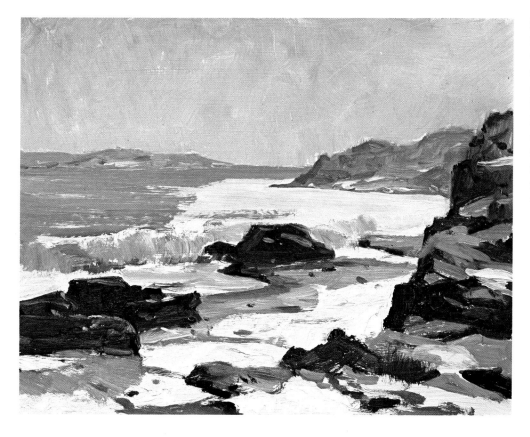

Step 7. Now the sea beyond the crashing waves is begun with horizontal strokes of the sky mixture. It's darker because it contains less white, but it's still a blend of cobalt blue, alizarin crimson, yellow ochre, and white. The sunlit edge of the crashing wave is the same white that appears on the beach, faintly tinted with the sky tone.

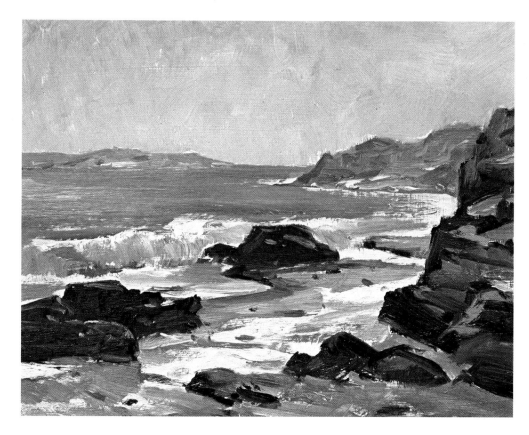

Step 8. The tone of the water is carried across to the beach at the right, where a bit of the tinted white is blended in to suggest sunlight shining on the wet sand. The sand in the immediate foreground is painted with the sky mixture too, but dominated by alizarin crimson and yellow ochre. This tone is brushed over the heavy strokes of white on the shining beach. The rocks along the lower edge of the picture are defined with dark strokes of burnt umber and ultramarine blue.

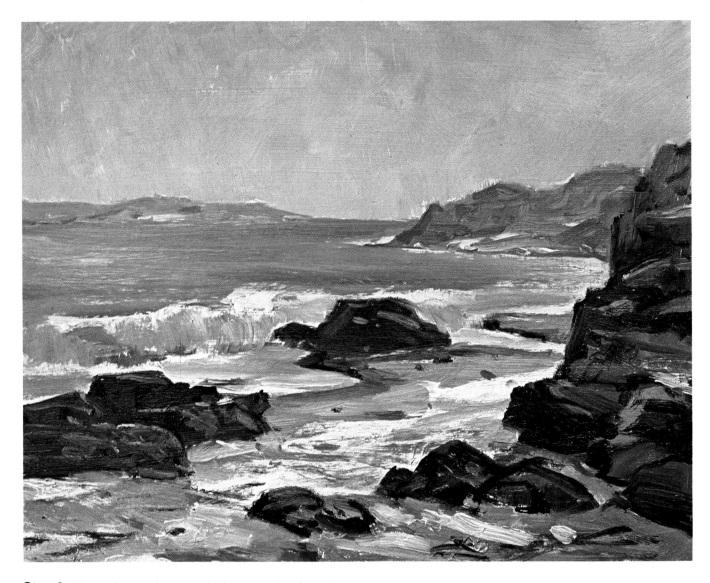

Step 9. The entire panel, covered with wet color, is ready for the final touches. Strokes of white tinted with the sky tone are carried across the beach in the foreground to suggest the reflections in the wet sand. A few strokes of burnt sienna and yellow ochre add a touch of warmth to the rocks at the extreme left. Beneath these rocks, strokes of cadmium yellow, slightly dimmed with cobalt blue, suggest scraps of seaweed. More strokes of sandy shore color are dragged lightly over the shining white just beyond the foreground rocks. The tip of a round brush is dipped into a dark mixture of ivory black, burnt umber, and ultramarine blue to draw dark lines that define the rocks and cliff more precisely. These dark lines deepen the shadows and add more cracks between the rocks. Notice the small, dark flecks scattered here and there along the beach to suggest pebbles.

Correcting as You Work. While you're working on a painting, there will certainly be times when you want to change your mind. You may want to move a couple of trees closer together, simplify the shape of a cloud, paint the grass a brighter color, or simply eliminate a distracting rock. If you want to make these changes while the painting is still wet, don't try to cover up your "mistake" by just painting over it. The underlying paint is apt to work its way up into the new strokes and make the repainting job a lot harder. Furthermore, when you pile wet paint on top of wet paint, the surface of the picture starts to get wet and gummy, making the fresh paint hard to push around. Before you repaint any part of a picture, it's always best to remove as much wet color as you can. Scrape that first layer of paint with the side of your palette knife and wipe the blade of the knife on a rag, a paper towel, or a sheet of newspaper. Don't try to reuse the paint you've taken off.

Scraping and Repainting. When you scrape off some unsatisfactory section of the painting, you won't get down to bare, white canvas. The knife doesn't take off every trace of wet paint, but leaves a "ghost" of that tree you wanted to move or that rock you wanted to delete. This is no problem. A fresh layer of color will easily cover what's left of the underlying paint. In fact, that "ghost" has two advantages. Just a faint trace of wet color on the canvas will actually make your brush move more easily over the painting—it can be a very pleasant surface to work on. And that pale image can serve as a helpful guide for your brush to follow.

Wiping out and Repainting. Of course, many artists find that "ghost" image distracting. When they want to make a change, they prefer to eliminate as much of the underlying image as they can. Then the solution is to take a tough, lint-free rag, dip it in turpentine or mineral spirits (white spirit in Britain), and scrub away the wet color. If the paint is fairly thick, it's a good idea to scrape it first with a palette knife. This takes off all the paint that sticks up from the surface. After the scraping, you can use the rag and solvent to dig further into the fibers of the canvas and get rid of the "ghost" that's left by the scraping.

Repainting a Dry Canvas. What if the picture has sat around the studio for a week or more—which probably means that it's now dry to the touch? You can't remove the image easily, but it *is* easy to paint over the dry surface. Start by working over the surface gently with fine sandpaper or steel wool; this will take off some of the paint and roughen the surface slightly so that it becomes more receptive to new brushwork. Then it's a good idea to moisten the surface with just a bit of medium. Dip a clean, lint-free rag in your mixture of linseed oil and turpentine—or one of the more exotic mediums you read about earlier—and wipe the rag over the area you expect to repaint. The canvas should be slightly moist, giving you the pleasant sensation that you're working on a wet painting after all. But the canvas shouldn't be so wet and shiny that the brush slithers over the surface and the bristles don't dig in; if the canvas seems too wet, wipe it gently with a dry rag, leaving the surface just faintly moist.

Maintaining Spontaneity. When you repaint some part of a picture, one of the hardest jobs is to make the repainted portion look as spontaneous as the rest of the picture. The most important advice is: don't be too careful! When you scrape out or wipe out some section of a wet painting, don't be too neat. Scrape or scrub vigorously. Don't remove the offending section so carefully that you leave a neat, sharp edge looking as if you've done the job with a scissors. Leave the edge a bit rough and blurry. Don't worry if you scrape or scrub a bit beyond the area you expect to repaint. For example, if you're scraping out the cheek of a portrait head, don't try to preserve every stroke of the background tone that appears next to the cheek. It's better to take out the cheek and a little of the background tone as well. Then, when you repaint the cheek, you'll have to repaint some of the background too. And you'll feel free to paint both cheek and background with bold strokes.

Be Ruthless. Nothing is more painful than trying to remove and repaint some section of a picture that does contain some good parts. What do you do when the foliage of the tree seems wrong, but you've done a particularly good job with the branches buried among the foliage? Can you scrape away the foliage and manage, somehow, to preserve the brushwork of the branches? Probably not. If you try to scrape or wipe too neatly around those branches, they'll never look like they're part of the same tree when you repaint fresh foliage around them. It's better to be ruthless and scrape off the leaves and branches together. Repaint them both with bold strokes. After all, if you got the branches right the first time, you can do it again!

Step 1. This bouquet of flowers looks too neat and lacks variety because all the blooms are roughly the same size. The blooms need to be distributed in a more casual way and painted with more gusto. The vase is also dull because it lacks strong light-and-dark contrast. The floral decoration on the side of the vase lends nothing to the picture.

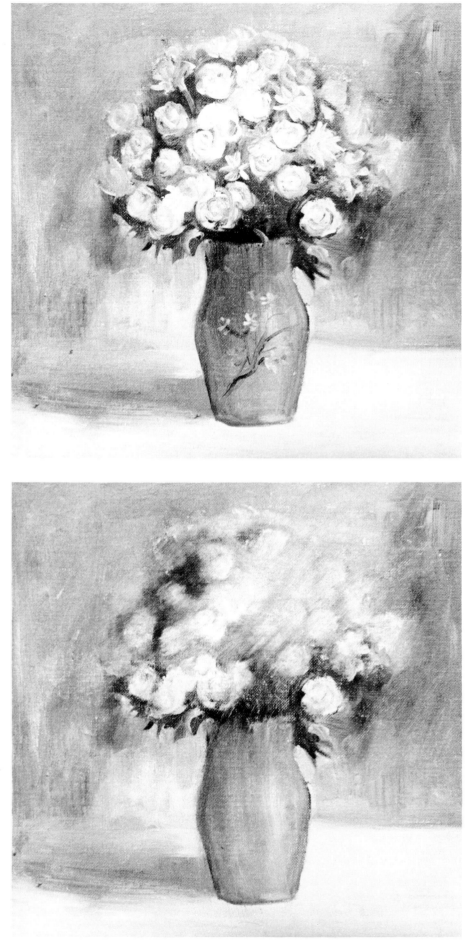

Step 2. The flowers and vase are scraped with the side of the palette knife. This scraping operation doesn't remove all the color. Most of the paint is removed, but you can still see a "ghost" image of the flowers. The general shape of the vase remains intact, making it easier to repaint. However, enough paint has been removed to reveal the texture of the canvas—which will *feel* like bare canvas when the brush goes back to work.

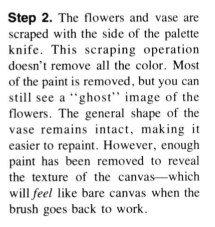

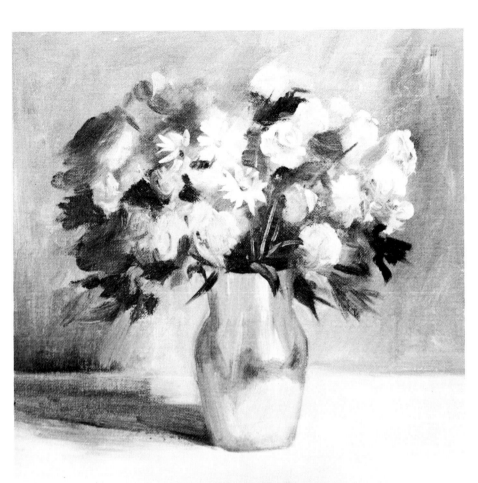

Step 3. The flowers are rearranged in a looser, more "accidental" design. The lighting is changed so that there are stronger contrasts of light and shade within the bouquet and on the vase, plus shadows on the tabletop and wall. The new bouquet is begun with rough, free strokes that quickly cover the "ghost" image in Step 2. The bold strokes of light and shadow on the vase rapidly cover the pale tone that remained in Step 2.

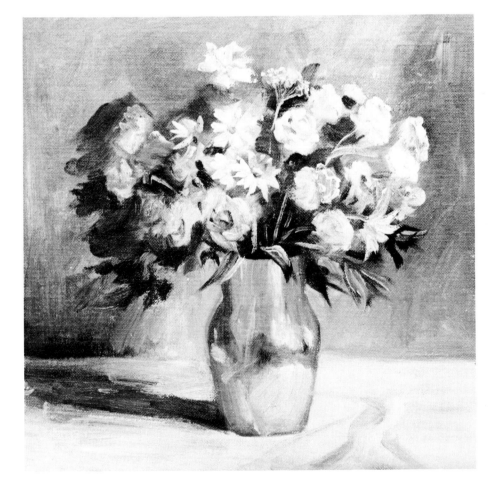

Step 4. Smaller strokes are added to the flowers to suggest petals and stems. But most of the brushwork remains loose and suggestive, unlike the tighter brushwork in the original painting shown in Step 1. Highlights are added to the vase, and the contours are sharpened. The shadows on the tabletop and wall are strengthened. The "ghost" image in Step 2 has served as a guide, particularly in the repainting of the vase, but now the original painting has disappeared totally under the new, more vigorous brushwork.

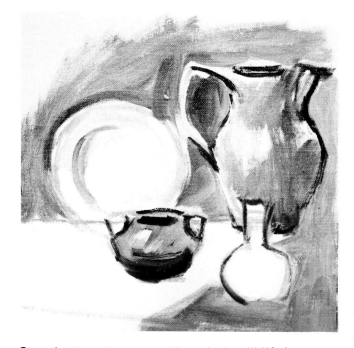

Step 1. The entire composition of this still life is wrong. The pitcher faces outward and leads the eye away from the center of the painting. The two smaller vessels need to be relocated. Only the dish seems to be in the right place.

Step 2. Scraping the painting won't work—the knife won't take off enough paint to remove the pitcher and the two smaller vessels that need to be relocated. A clean, lint-free rag is dipped in turpentine or mineral spirits. The canvas is scrubbed until the three forms disappear entirely. A faint tone remains, but this will be covered easily when the picture is repainted.

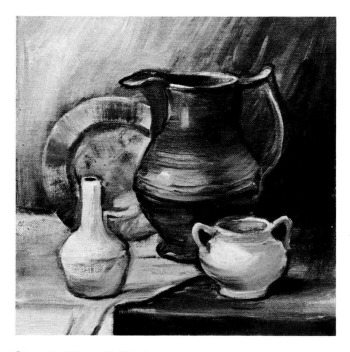

Step 3. With fluid color diluted with plenty of solvent, the pitcher is turned around and relocated so that it occupies the focal point of the painting. The small vase and pot are transposed. The four objects are now regrouped so that they overlap and join forces to make a more unified pictorial design.

Step 4. The still life is now completed with strokes of heavier color. The pale tone that remains in Step 2 is now completely covered with fresh color. There's no trace of the original location of the still life objects that appeared in Step 1.

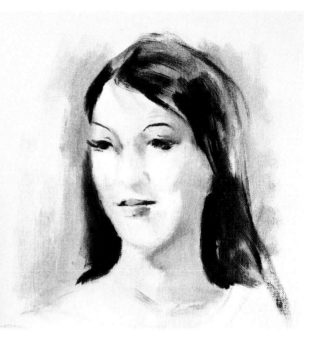

Step 1. This portrait head is much too pale and the shapes are too vague. The painting is dry, however, which means that it's too late to scrape off the original color with a knife or scrub it off with a rag.

Step 2. The solution is to remove the more prominent brushstrokes with fine sandpaper or steel wool, which also roughens the surface of the canvas and makes it more receptive to fresh brushwork. Then the surface is moistened with a clean rag dipped into just a bit of medium. When fresh paint is applied to this moist surface, the brush feels as if it's moving over a wet painting.

Step 3. The hair, the shadows on the face and neck, and the dark tones of the features are repainted with bold strokes and darker color. As the brush moves over the damp surface, the strokes seem to melt softly into the canvas.

Step 4. In the completed painting, the two layers of color—dry below and wet above—look like one continuous layer of wet paint. Working on a moist surface makes all the difference. The new strokes would look harsh if they were painted on dry canvas.

Fallen Tree and Grass. The traditional term for thick paint is the Italian word *impasto*. Strokes of thick, pasty color are a simple way to render rough, irregular textures such as this fallen tree with its rough bark, broken branches, and twisted network of roots. The thick strokes of the bark literally stick up from the canvas. Some of the foreground weeds are also painted with thick color that makes them seem closer than the weeds in the distance. For *impasto* brushwork, use color straight from the tube or add just a touch of painting medium—but not enough to make the paint too fluid.

Treetrunk and Rocks. But thick paint isn't the *only* way to create rough textures. You can do just the opposite. Instead of building the paint up from the surface of the canvas with *impasto* brushwork, you can scrape down into the wet paint, making grooves and deep scratches with the tip of the palette knife or the point of the brush handle. You can see such scratches running along this fallen treetrunk, giving the impression of dried, cracked bark. On the facing page, some of the sunlit weeds are painted with strokes of thick color that stand up from the canvas. But in the example on this page, the light-struck weeds are scratched out of the dark paint, revealing the paler tone of the canvas beneath.

Step 1. Like any other subject, the fallen tree begins as a brush drawing in thin color diluted with plenty of turpentine. There's no hint of the thick paint and rough brushwork that will come later. It's always best to begin with thin paint so that you can wipe away the lines with a cloth if you change your mind about the composition or the accuracy of the drawing.

Step 2. The darkest tones are painted first: the shadowy areas of the trunk and branches, the patch of shadow beneath the roots, and the jagged shadow cast by the trunk on the grass. At this stage, the paint is still quite thin and fluid, diluted with a good deal of medium.

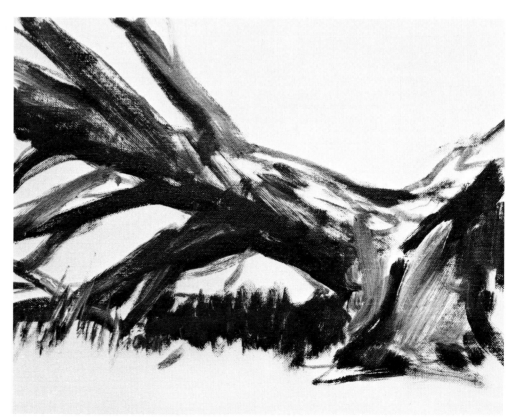

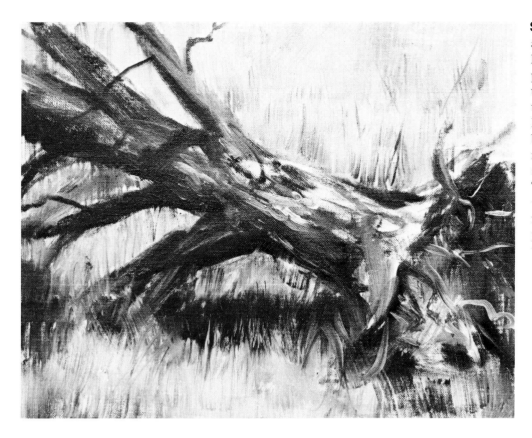

Step 3. Lighter tones are added to the trunk. The lighted areas of the grass are painted beneath the tree, between the branches, and in the meadow beyond. A few light patches appear on the bark, and some lightstruck roots are brushed over the shadow at the base of the tree. The entire canvas is covered with wet color, which is still fluid and creamy. The impasto strokes are saved for the very end.

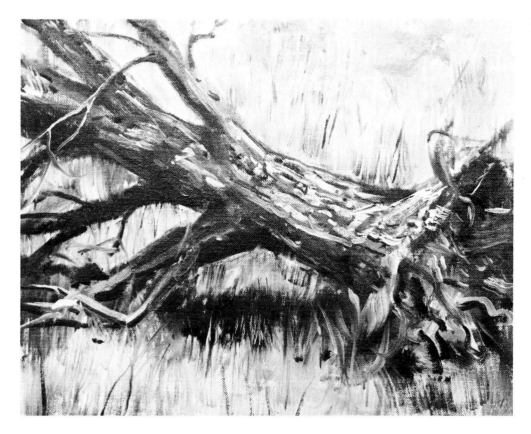

Step 4. Now the lightest tones of the bark, branches, weeds, and roots are painted with rough, quick strokes of thick color. Each impasto stroke is made with a firm, decisive movement of the brush—and the stroke is left unchanged. The rough texture of the stroke would be ironed out if the brush moved back and forth. In the finished painting, the darks remain thin and fluid; only the lights are thickly painted. In fact, most of the canvas is thinly painted, and the impasto appears only in certain areas. It's best to use impasto brushwork selectively—thick strokes will look more important if they're surrounded by thinner color.

SCRAPING TECHNIQUE

Step 1. This outdoor "still-life"—a heavy log, rock, and weeds—begins with a simple brush drawing that defines the major shapes. There's no attempt to draw details such as the crack in the log or the weeds that will be scratched into the wet paint in the final stage.

Step 2. The trunk and rock are begun with broad strokes of a bristle brush, roughly painted so that the marks of the bristles show and express the texture of the subject. The paint on the log is thick and pasty, and many of the strokes are made with a painting knife.

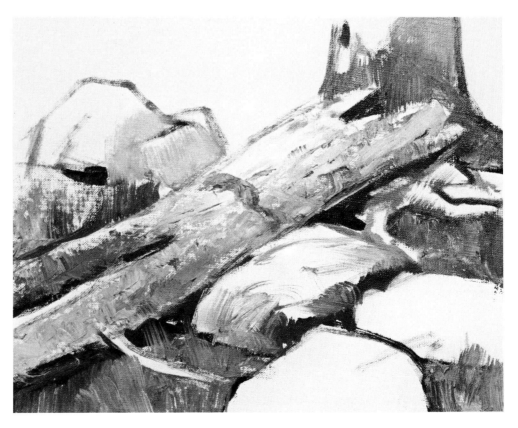

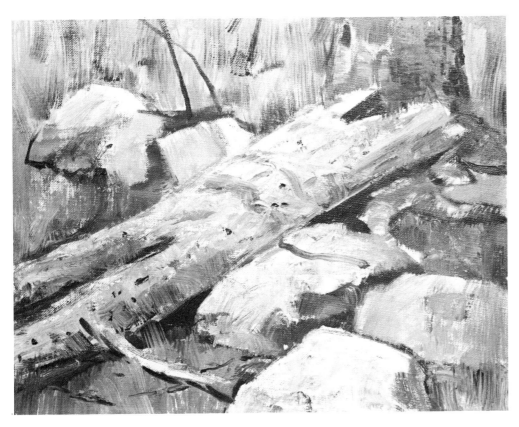

Step 3. Now the entire canvas is covered with wet color. The paint on the fallen trunk is particularly thick. When scratches are made into this thick color, they'll stand out more clearly than they would if the color were thinly applied.

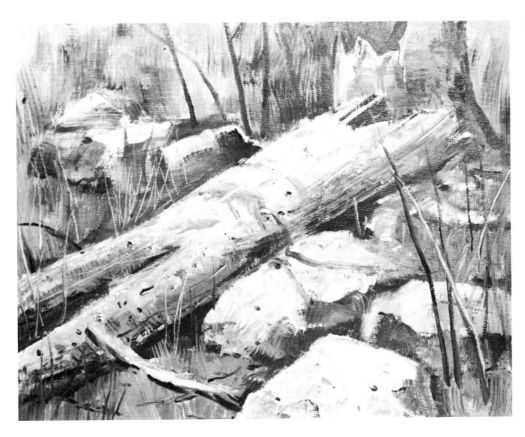

Step 4. The tip of the palette knife and the pointed end of the brush handle travel up the side of the trunk, leaving grooves and scratches that suggest the texture of the bark. More scratches become the slender strands of weeds that spring up around the sides of the trunk and among the rocks. The lighted tops of the rocks are scraped here and there with the side of the knife blade. The tip of a round brush adds some dark weeds and twigs that contrast nicely with the light scratches.

Step 1. If you want to stretch your own canvas, buy wooden stretcher bars at your art supply store. These are wooden strips with slotted ends that fit together to make a rectangular frame. You'll need four bars, one for each side of the frame. The best nails for stretching canvas are 3/8″ or 1/2″ (9-12 mm) carpet tacks.

Step 2. When you assemble the slotted stretcher bars, they should fit together tightly without the aid of nails or glue. Check them with a carpenter's square to make sure that each corner is a right angle. If the corners aren't exactly right, it's easy to adjust the bars by pushing them around a bit.

Step 3. Cut a rectangle of canvas that's roughly 2″ (50mm) larger than the stretcher frame on all four sides. As it comes from the store, one side of the canvas will be coated with white paint, and the other side will be raw fabric. Place the sheet of canvas with the white side down on a clean surface. Then center the stretcher frame on the fabric.

Step 4. Fold one side of the canvas over the stretcher bar and hammer a single nail through the canvas into the edge of the bar—at the very center. Do exactly the same thing on the opposite stretcher bar, pulling the canvas tight as a drum and hammering a nail through the canvas into the edge of the bar. Then repeat this process on the other two bars so you've got a single nail holding the canvas to the centers of all four bars.

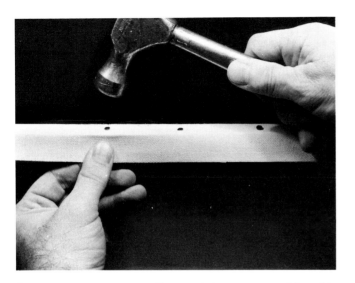

Step 5. Add two more nails to each bar—one on either side of the original nail, about 2″ (50 mm) apart. Working with the back of the canvas facing you, pull the canvas tight with one hand while you hammer with the other. Repeat this process on all four sides. Keep adding pairs of nails to each side, gradually working toward the corners. Pull the canvas as tight as you can while you hammer. At first you may have trouble getting the canvas tight and smooth. Don't hammer the nails all the way in; let the heads stick up so you can yank the nails out and try again.

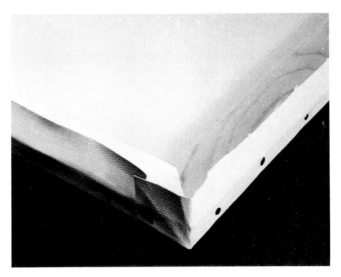

Step 6. When you get to the corners, you'll find that a flap of canvas sticks out at each corner. Fold it over and tack it to the stretcher as you see here.

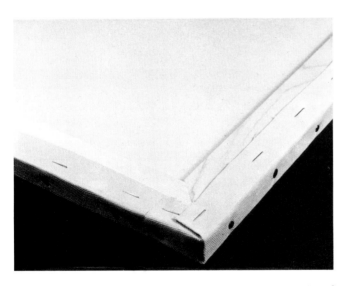

Step 7. Then fold the remaining canvas over the backs of the stretcher bars and staple it down to make a neat job. Speaking of staples, you might like to try using a staple gun for the whole job—instead of tacks or nails.

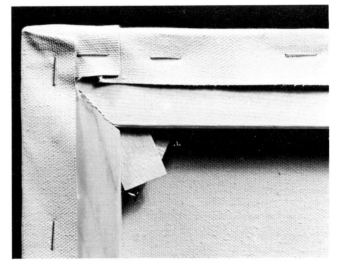

Step 8. Here's a close-up of the corner, seen from the back, showing the canvas all neatly folded and stapled down. Inside the corners of the stretcher bars you can see the ends of triangular wooden keys, which you hammer into slots to stretch the canvas tighter if it's not absolutely smooth. Your art supply store will give you the keys when you buy the stretcher bars. Hold the keys in place by hammering small tacks behind them. If the canvas starts to loosen and get wavy later on, just hammer in the keys a little further.

Cleaning Your Palette. When you're finished painting, the center of your palette will be covered with smears and dabs of wet color. Along the edges of your palette, there will probably be little mounds of half-used tube color. If you're working on a wooden palette, it's easy enough to wipe off the central mixing area with a rag or a paper towel and a little turpentine or mineral spirits (called white spirit in Britain). Wipe the surface until it's clean and shiny. If you leave a muddy film of color on the mixing area, those traces of old mixtures may work their way into fresh mixtures the next time you paint. And that film of color will develop gradually into a crust that impedes the action of your brush or knife.

Saving Color. As long as you clean the central mixing area, there's nothing wrong with leaving the little mounds of wet color around the edges. Just wipe away any mixtures that may have accumulated around the mounds—leaving bright, fresh color for your next session. If you're planning to paint the next day—or within the next few days—the little piles of color on your palette will stay wet for your next painting session. If they start to dry out, they tend to form a leathery skin on the surface but contain moist color within. You can just puncture the leathery skin, peel it away, and work with the fresh color inside. If you're using a tear-off paper palette, you can simply peel away the top sheet; scoop off the mounds of moist color with your knife; transfer them to the next fresh sheet; then toss away the soiled sheet. If you're not planning to paint again for a week or more, discard the unused color and begin with a clean surface next time.

Care of Tube Colors. By the time you're finished painting, many of your tubes will be smeared with wet color. Wipe them clean with a rag or a paper towel so that you can read the labels and identify the colors the next time you paint. It's terribly frustrating to scramble around among paint-encrusted tubes trying to figure out which is which. Be particularly careful to clean the necks of the tubes and the insides of the caps so that they'll screw on and off easily. You'll also get more paint out of the tube if you roll the tubes up from the end instead of squashing them flat.

Care of Brushes. Don't just rinse the brushes in turpentine or mineral spirits, then wipe them on a newspaper, and assume that they're clean. No matter how clean the brushes may look, these solvents always leave a slight residue on the bristles. Eventually the residue builds up and stiffens the bristles so that they're no longer lively and responsive to your touch. After rinsing the brushes in a solvent and wiping them on newspaper, you *must* take the time to lather each brush in the palm of your hand. Use a very mild soap with lukewarm water. Keep lathering and rinsing in water until there's no trace of color in the suds. Be sure to work the lather up the bristles to the ferrule—the metal tube that holds the bristles. Then rinse away every bit of soap. Don't be discouraged if the bristles still look a bit discolored after repeated latherings. A very slight hint of color usually remains. But if you've lathered the brushes until the *suds* are snow white, you've removed all the color that will come out.

Care of Knives. The top and bottom surfaces of your palette knife and painting knife blades should be wiped clean and shiny. Use a rag or a paper towel. Don't overlook the edges and tips of the blades—wipe them too. With repeated use, these edges tend to become sharper, so wipe them with care. If they get too sharp, you can blunt them with the same kind of abrasive stone that's normally used for sharpening knives.

Care of Fluids. In the same way that you wipe your tubes clean after a painting session, wipe your bottles of oil, turpentine, and painting medium so that you can read the labels. Before you screw on the caps, wipe the necks of the bottles and the insides of the caps so that they won't stick. Screw on all caps very tightly so that your turpentine or mineral spirit won't evaporate, and your oil won't dry out.

Rags, Newspapers, and Paper Towels. By the end of the painting session, you'll probably have quite a collection of paint-stained rags, paper towels, and newspapers. Don't let this debris accumulate. Get it immediately into a tightly sealed metal container. Then get it out of the house! Remember that if oily rags and papers are left long enough, they gradually absorb oxygen and ignite by spontaneous combustion.

Safety Precautions. None of the painting materials recommended in this book are serious health hazards, but several can be mildly toxic. Oil paints in general—and the cadmium colors in particular—ought to be kept out of your digestive system. While you're painting, some color will always end up on your hands. For this reason, it's important to avoid eating or smoking while you paint. And be sure to wash your hands thoroughly with mild soap and water at the end of the painting session. Unlike many solvents, turpentine and mineral spirits don't produce deadly fumes. But it's still a good idea to work in a ventilated room: an open window or skylight will send those fumes out into the open air, rather than through the house. Although other solvents such as gasoline (petrol in Britain), kerosene (paraffin in Britain), and other industrial compounds are sometimes recommended for use in the studio, they're usually flammable or toxic or both. So stick to turpentine or mineral spirits.

Washing. Rinse your brush in turpentine or mineral spirits, dry it on newspaper, then lather it with mild soap and lukewarm water in your palm.

Shaping. Keep lathering and rinsing until the suds are snow white. Wash out the bristles with clear water. Press the damp bristles into a neat shape.

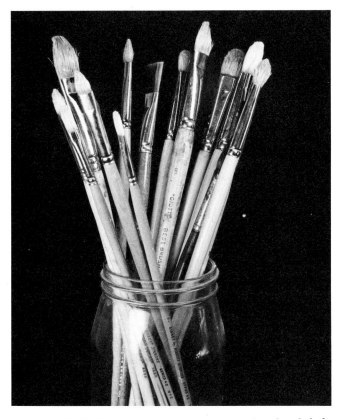

Drying. While they're drying, store brushes in a jar, bristle end up. If you use your brushes often, store them in the jar between painting sessions.

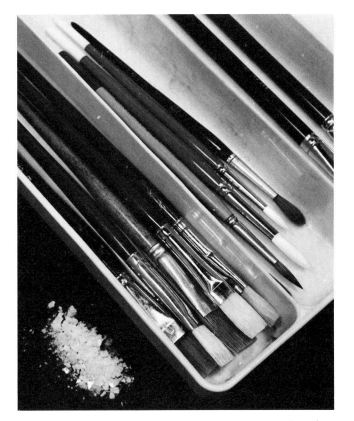

Storing. If you don't use brushes regularly, store them in a shallow box (or a silverware tray like this one) and put them in a drawer with moth-killing crystals.

Permanent Colors. Looking at the dates on the oil paintings in the world's great art museums, you know that an oil painting can last for centuries. But a picture is only as durable as the materials used to paint it. To begin with, not all colors are equally permanent—some will crack or change color over the years. There are also some colors that form unstable chemical combinations: that is, they deteriorate when they're mixed with certain other colors. So the lesson is: stick to permanent colors. All the colors recommended in this book are extremely durable when used by themselves or in combination with other colors. There's just one exception. Ivory black has a tendency to crack when it's used straight from the tube, although it's fine when you use it in mixtures with other colors. So make a point of blending ivory black with at least one other tube color. If you'd like to experiment with other colors, always check the manufacturer's literature to find out how permanent that color will be.

Permanent Painting Surfaces. A painting is only as durable as the surface it's painted on. Professional oil painters normally work on stretched canvas: high-quality linen or cotton nailed to a rectangular framework of well-seasoned wood. Or they work on the hardboard panels that have replaced the wood panels used by the old masters. In either case, the canvas or hardboard is coated with white oil paint or gesso, applied either by the manufacturer or by the artist himself. Yes, canvas boards are the most popular surface among Sunday painters and students. They're durable enough for you and your family to enjoy for many years. But the canvas is inexpensive, and the cardboard backing will eventually start to crumble. So when you start thinking about posterity, switch to stretched canvas or hardboard panels.

Varnish. Oil paintings—unlike watercolors—aren't exhibited under glass. The leathery surface of a dried oil painting is a lot tougher than a sheet of paper. However, an oil painting is normally protected by a coat of varnish that serves the same purpose as a sheet of glass. When you go shopping for varnish, you'll probably see some bottles labeled *retouching varnish* and others labeled *picture varnish*. They have different functions.

Retouching Varnish. Most oil paintings are dry to the touch in a week or so, but it takes at last six months for the paint to dry all the way through. As soon as the surface feels dry, you can protect it with *retouching varnish*. This is a thin mixture of solvent and a little resin such as damar or mastic. The solvent evaporates, leaving behind just enough resin to preserve the freshness of the colors—and perhaps brighten the colors a bit—while the paint film continues to dry. Apply retouching varnish with a soft nylon housepainter's brush. Work with parallel strokes. Don't scrub back and forth or you'll disturb the paint, which isn't as dry as it looks.

Final Varnish. The bottle that's labeled *picture varnish* is a thicker version of the same formula used to make the retouching varnish. The main difference is that the picture varnish contains a lot more resin. This is the final varnish that protects the surface of the picture like a sheet of glass that protects a watercolor. Most oil paintings are ready for a coat of picture varnish after about six months. But if you paint with very thick strokes, they'll take longer to dry all the way through, and it's best to wait as long as a year. Again, use a soft nylon housepainter's brush and work with parallel strokes. Move the brush in one direction only—from top to bottom or from one side to the other. Work on a clean, dust-free, horizontal surface and leave the painting there until the varnish dries to a smooth, glassy film. Don't scrub the brush back and forth, or you'll disturb the smooth surface of the varnish.

Framing. The design of a frame is a matter of taste. It's up to you to decide whether you like a frame that's ornate or simple, colorful or subdued. But remember that the frame also preserves the picture. If you choose a wooden frame, make sure that it's thick and sturdy enough to protect the edges of the canvas from damage. The frame should also be rigid enough to keep the canvas from warping. If you prefer to frame the picture in slender strips—rather than the thicker, more traditional kind of frame—rigid metal strips will provide better protection than wood. If the painting is on stretched canvas, it's a good idea to protect the back by tacking or stapling a sheet of cardboard to the wooden stretcher bars.

Storing Oil Paintings. If you're not going to hang paintings, store them vertically, not horizontally. Don't stack one on top of the other like a pile of magazines. Find some closet where the canvases or panels can be stored upright, standing on their edges. The front of one painting should face the back of another; that way, they don't stick together if the paint is still slightly soft. Remember that stretched canvases are particularly fragile; handle them so that the corner of one canvas won't poke a hole in the face of another.

PART TWO

LANDSCAPES IN OIL

Landscapes in Oil. Whether you paint outdoors or indoors—or both—painting landscapes in oil is a great delight. Oil paint is amazingly versatile. If you enjoy working on location, you can pack all your tubes and brushes, your palette, plus a few canvas boards into a compact paintbox that's no bigger than a small valise. This box becomes a kind of traveling studio. Flip open the lid—which stands up to function as your easel— and you're ready to paint anywhere. If you're a quick and impulsive painter, you can work with decisive strokes and finish a landscape in a few hours, right on the spot. If you prefer to work more slowly and deliberately, you can start a painting on the spot and finish the picture at home; because oil paint takes several days to dry, the colors on the canvas remain soft and pliable, giving you plenty of time to complete the landscape at your leisure. Or if you'd rather start *and* finish a painting in the comfort of home, you can always make some quick oil sketches on location and then take these indoors to use as reference material for a larger, more ambitious painting. Oil paint will always adapt itself to your personality and your working habits.

Indoors or Outdoors. Although some people are outdoor painters and others are indoor painters, it's important to remember that the best landscape paintings always *start* outdoors, even if they're finished in the studio. The only way to learn how to paint a tree or a rock is to set up your paintbox right there in the meadow. There's no substitute for firsthand knowledge of your subject. Working on location will strengthen your powers of observation and train your visual memory. So it's important to spend as much time as you can painting on location, even if those paintings are nothing more than small, quick studies for larger paintings which you hope to develop indoors. Those outdoor paintings—no matter how rough and crude they may turn out to be—will have a freshness and authenticity that you can get only by looking straight at the subject. Then, if you want to use these outdoor paintings as the basis for more work indoors, your indoor paintings will have a feeling of reality that you can never get by painting from memory—or from a photograph.

Basic Techniques. *Landscapes in Oil* begins with a rapid review of some fundamental techniques. First, you'll see how to use bristle brushes for a roughly textured subject such as the rugged forms of a cliff and rocks. Then you'll see how to combine stiff bristle brushes with more pliable softhair brushes to paint a subject—such as trees and grass—that combines rough brushwork with softer strokes. The Italian word *impasto* means thick paint, and you'll see how the im-

pasto technique is used to paint a mountainous landscape. When you paint in oils, it's usually a good idea to start out with thin color and gradually work your way toward thicker color: you'll see how this is done in a snowy landscape.

Color Sketches. Several pages of color sketches will give you some guidelines for painting the various colors of trees, skies, land, and water. You'll compare the very different greens of deciduous trees and evergreens, the hot colors of autumn, and the more delicate colors of trees on an overcast day. You'll see how the color of the sky changes from a sunny day to a gray day. You may be surprised to discover how many different greens you can find in a landscape of meadows and hills, or how many different tones you can see in a sandy shore. And you'll see how the colors of water change as they reflect the surrounding landscape and the sky.

Painting Demonstrations. After looking at some close-ups of sections of various landscapes—which will show you various ways of handling color—you'll watch noted painted George Cherepov demonstrate, step-by-step, how to paint ten of the most popular landscape subjects. He begins with trees and other growing things: deciduous trees, a forest of evergreens, and a meadow with trees and wildflowers. Then he goes on to the big shapes of the landscape: hills and mountains. He shows you how to paint two different kinds of skies: a sunny sky filled with puffy clouds, and the dramatic shapes and colors of a sunset. He concludes with three different forms of water: a stream with a rocky shore, a winter landscape with snow and ice, and a pond filled with the reflections of trees. Each step of these demonstrations is shown in color.

Special Problems. Following these painting demonstrations, you'll find guidance on selecting landscape subjects, and you'll find some rules of thumb for composing effective landscapes. You'll learn how the direction of the light can radically change the look of trees or mountains—or any other subject. You'll see how linear and aerial perspective can enhance the sense of space in your landscape paintings. Demonstration paintings of a gnarled tree and a hilly landscape will show how your brushstrokes can create a feeling of texture or three-dimensional form. You'll observe how expressive brushwork can emphasize the unique character of the subject, whether it's a cloud formation or a forest. And the book concludes with suggestions about painting the diverse forms of trees, certainly one of the most common landscape elements throughout the world.

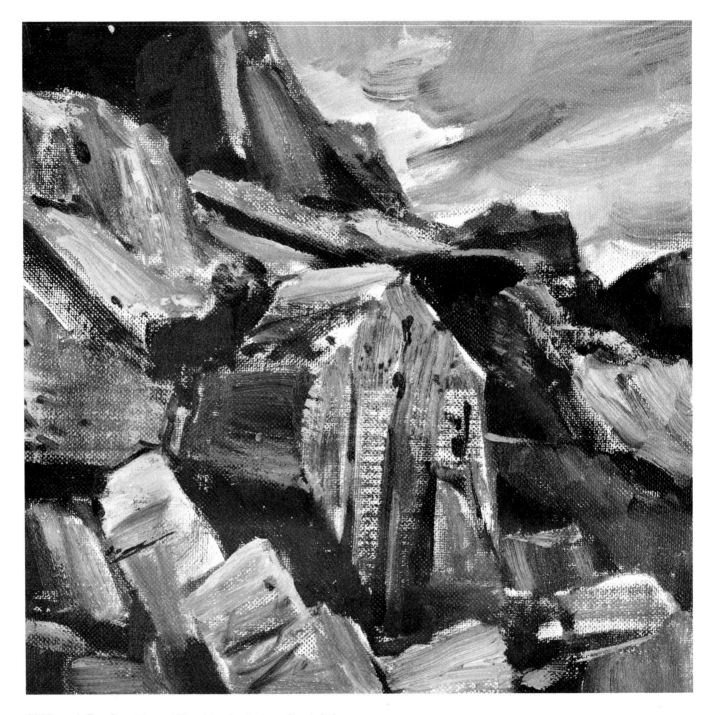

Cliff and Rocks. The stiff, white hoghairs of a bristle brush are best for broad, rough strokes, which usually show the marks of the bristle. If you use the paint straight from the tube—adding little or no painting medium—the color has a thick, pasty consistency. A stiff bristle brush, loaded with stiff color, is particularly effective for painting roughly textured subjects such as a rock formation. If you add a little painting medium to make the tube color more fluid, the paint becomes creamier, and you can make softer strokes like those in the sky at the upper right. Oil painters generally do most of their work with bristle brushes, covering the canvas with big, broad strokes.

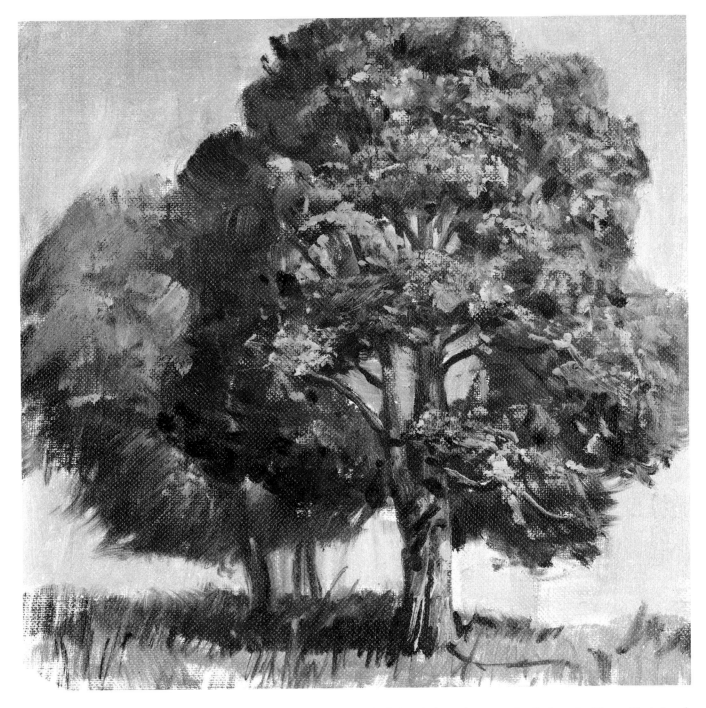

Trees, Near and Far. Like the rocks on the preceding page, these trees are begun with broad strokes of a bristle brush. However, the paint is diluted with medium to a more fluid consistency so that the brush makes a softer, smoother stroke, which you can see most clearly in the shadow side of the foreground tree. The hoghairs still leave a distinct mark in the paint, but the stroke isn't nearly as rough. On top of the big strokes of the bristle brush, the tip of a round, soft-hair brush does the more detailed work. The softhair brush adds the paler touches of the leaves in sunlight, the linear strokes of the branches, the vertical shadow strokes on the sunlit treetrunk, and the scribbly strokes of the grass beneath the trees. The slender, delicate hairs of the softhair brush won't carry as much thick paint as the bristle brush. Softhair brushes work best with fluid paint, so add plenty of medium.

Step 1. The shapes of the cliffs and the rocks are drawn with straight strokes of a small filbert carrying paint that's diluted with turpentine to a very fluid consistency. Undiluted tube color is too thick for drawing lines, so you've got to add turpentine or medium.

Step 2. A larger bristle brush picks up some slightly thicker color diluted with just enough medium to make the paint flow smoothly. Then the dark shadow sides of the cliff and rocks are painted with broad strokes. Notice how the texture of the canvas board breaks up the strokes, which begin to suggest the roughness of the rocks.

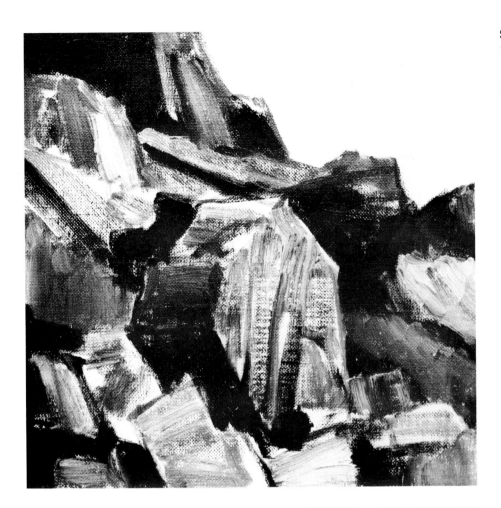

Step 3. Now the sunlit faces of the boulders and the cliff are painted with undiluted tube color. This stiff paint is applied with the short, stiff bristles of a bright, which makes a stroke that has a particularly rough texture. The paint is so thick that it doesn't cover the canvas in smooth, even strokes. You can see that the strokes are ragged and irregular. On the face of the big rock at the center, the weave of the canvas breaks up the stroke to accentuate the rocky texture.

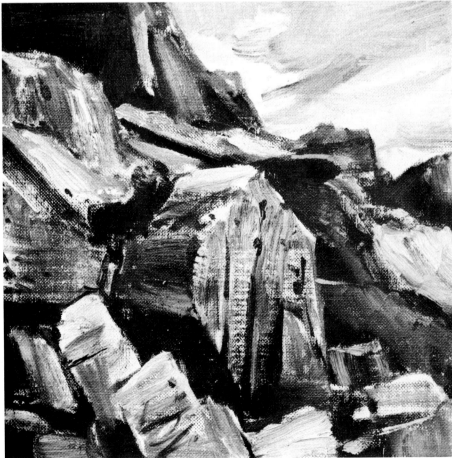

Step 4. For the softer, more fluid strokes of the sky, a large filbert picks up much creamier paint diluted with medium to a more fluid consistency than the rocks. You can still see the brushstrokes, but they're softer and less distinct. For details such as the dark cracks, the point of a round, softhair brush adds a few dark strokes of very fluid color containing plenty of medium. Finally a bright adds some thick strokes of undiluted color to strengthen the sunlit tops of the rocks.

Step 1. For drawing the complex curves of the foliage and the delicate shapes of the trunks and branches of these trees, a round softhair brush will do a more precise job than a bristle brush. The color is thinned with turpentine to the consistency of watercolor. Then the tip of the brush moves smoothly over the surface of the canvas, making crisp, graceful lines.

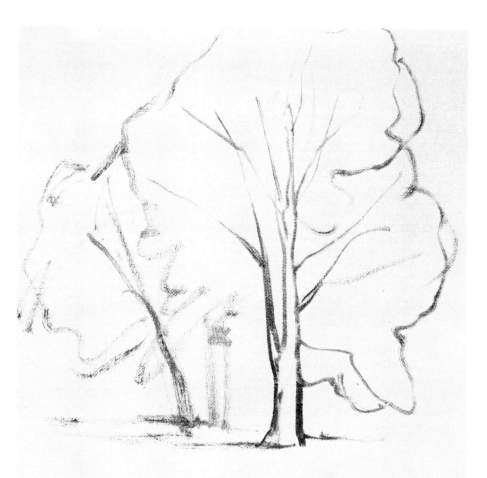

Step 2. To block in the darks of the foliage, a large filbert picks up a fluid mixture of tube color and painting medium. The bristle brush scrubs in the tones with broad strokes that retain the marks of the stiff hoghairs and suggest the texture of the foliage. Notice the small, rough strokes which really begin to look like leaves at the top of the tree.

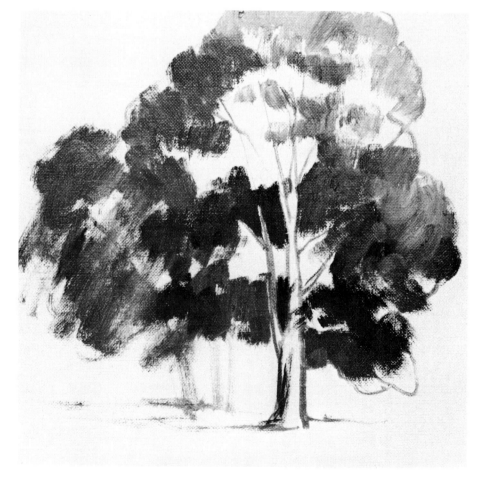

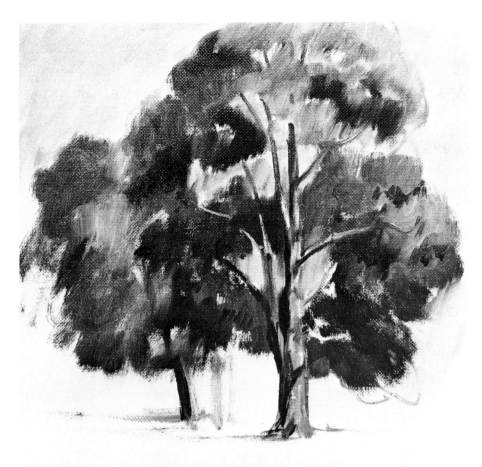

Step 3. The filbert completes the large shapes of the foliage with broad strokes of fluid color containing a lot of painting medium. Then the tip of a round, softhair brush adds precise, linear strokes for the sunlit and shadow sides of the trunk and branches. The shadow strokes are precisely drawn with fluid color containing enough medium to make the paint flow smoothly.

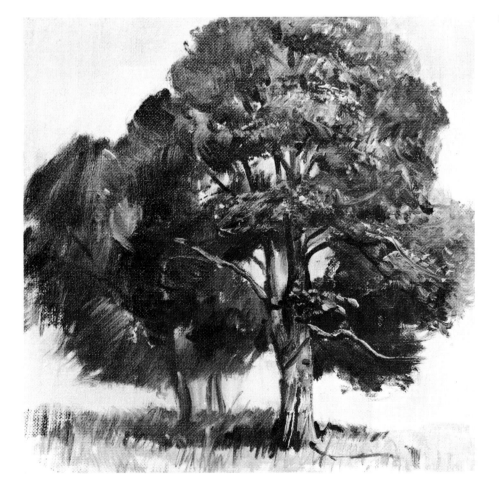

Step 4. A flat, softhair brush picks up fluid color to complete the distant tree with soft, smooth strokes that blend the lights and darks and soften the edges of the leafy masses. Then the tip of a round, softhair brush picks up a slightly thicker mixture of tube color and painting medium to dash in the sunlit leaves with small, quick strokes. The same brush paints the sunlit sides of the trunks and branches with long, slender strokes of this creamy mixture. Then, picking up more fluid color, a round brush scribbles the shadowy grass at the bases of the trees.

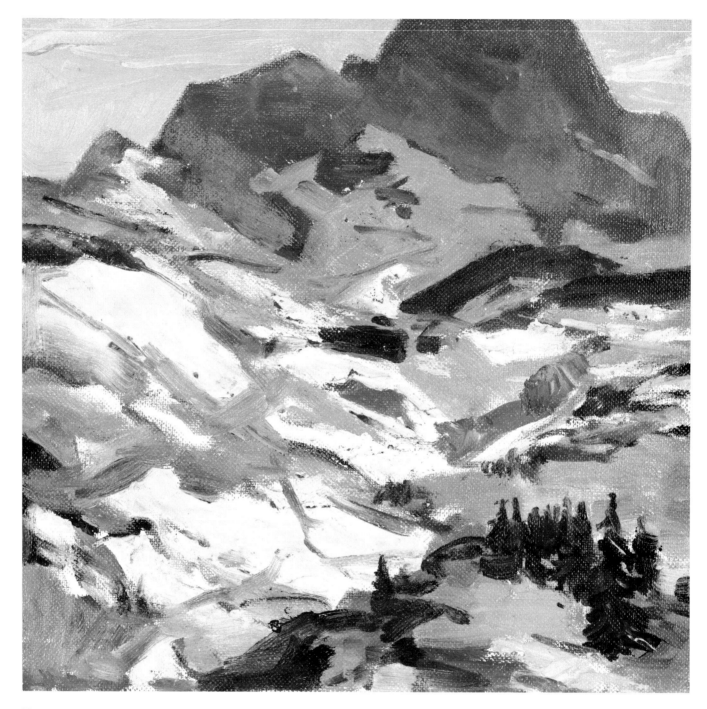

Mountains. Thick oil paint, used straight from the tube or diluted with just the smallest touch of medium to make the paint more brushable, has its own special look on the canvas. The paint not only looks thicker, but the color tends to look richer and brighter. For this reason, landscape painters often save their strokes of thickest color for patches of bright color or brilliant sunlight. In this mountainous landscape, the sunlit slopes are painted with thicker color than the slopes in shadow. Not only the pale color, but the sheer thickness of the paint makes the slope step forward into the sunlight. However, remember that this whole effect depends upon the *contrast* between the thick, bright color on the sunlit slopes and the thinner, more subdued color on the shadowy slopes. This *impasto* technique, as it's called, wouldn't be nearly so effective if the entire picture were covered with thick, bright color. So use the impasto technique selectively—for emphasis.

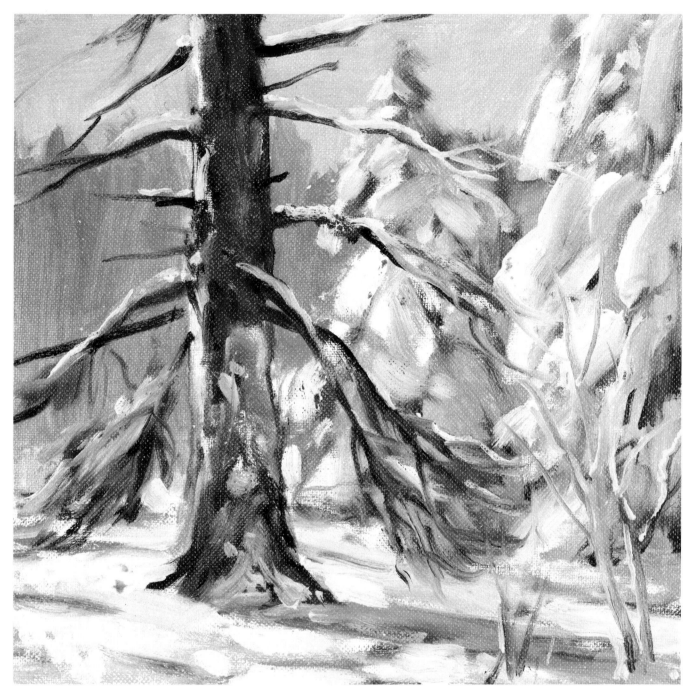

Snow-covered Trees. One of the great advantages of oil paint is that you can alter the thickness of your tube color by adding linseed oil, turpentine, or painting medium. Thus, on the same canvas, you can have thin color in one area and thick color in another. Thin color is easier to push around with the brush, so it's usually best to start with thin color and then work your way up to thicker color in the final stages of the painting. It's also a good "rule" to keep your darks fairly thin and save your thick color for the lights. It's most effective to reserve your thicker colors for the foreground. That's how this painting of snow-covered trees is done. The thinnest color is in the sky and in the distant mass of shadowy trees. The dark treetrunk is just a little thicker, but it's still painted with fairly fluid color. The shadowy tones on the snow-covered trees are painted with thicker color than the dark treetrunk—but the thickest color is saved for the patches of bright sunlight on the snow-covered branches and on the gound. The execution of this painting is shown in a step-by-step demonstration sequence which you'll see in a moment. You'll see that the thinnest colors are applied first and the thickest colors appear in the final stage.

Step 1. This picture will be completed with thick color—for which painters use the Italian word *impasto*—but the shapes are first drawn with precise strokes of fluid color. The tip of a round softhair brush defines the mountains and the trees with tube color thinned with turpentine to the consistency of watercolor.

Step 2. Now the dark shapes of the distant mountains at the horizon are painted with a creamy mixture of tube color and painting medium. The shadowy patch of snow is painted with slightly thicker color—tube color and a little less painting medium. At this stage, all the work is done with bristle brushes.

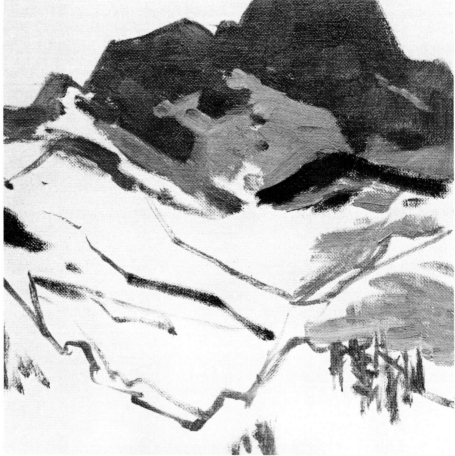

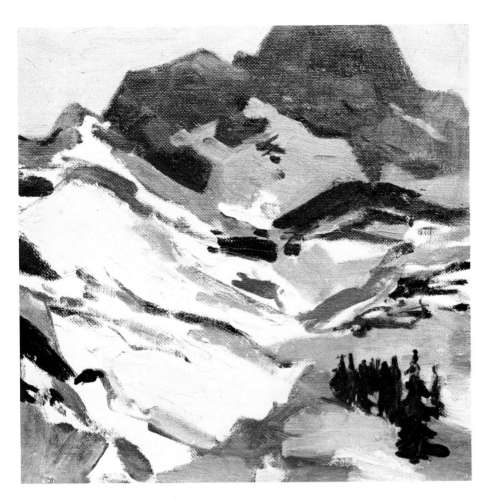

Step 3. The shadowy patches of snow in the foreground are painted with a bristle brush that carries color diluted to the consistency of thick cream. The *really* thick color is saved for the sunlit patches of snow, which are pure tube color, undiluted with painting medium and applied in solid, heavy strokes. A round softhair brush adds small, dark touches such as the trees.

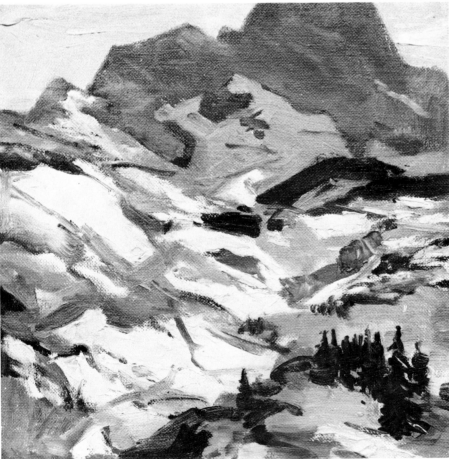

Step 4. To add some strokes of shadow to the sunlit snow, a bristle brush digs back into the thick, wet color that was applied in Step 3. Then the foreground is completed with strokes made by a round soft-hair brush. The strategy of this painting is worth remembering. The most distant shapes are painted with smooth, fairly thin color. The thick color is saved for the sunlit foreground.

Step 1. Most oil painters make it a standard practice to begin with thin color—diluted with lots of turpentine or painting medium—and gradually introduce thicker color as the painting progresses. This snowy landscape, like all the demonstration paintings you've seen so far, begins with a brush drawing in very thin color diluted with turpentine. The preliminary shapes are drawn with the tip of a round softhair brush.

Step 2. Still working with fluid paint—tube color diluted with painting medium and a little turpentine—a bristle brush adds the shadow tones on the snow-covered trees, plus the dark shape of the trees in the distance. A pale tone is also brushed across the sky, while a strip of shadow is brushed across the foreground.

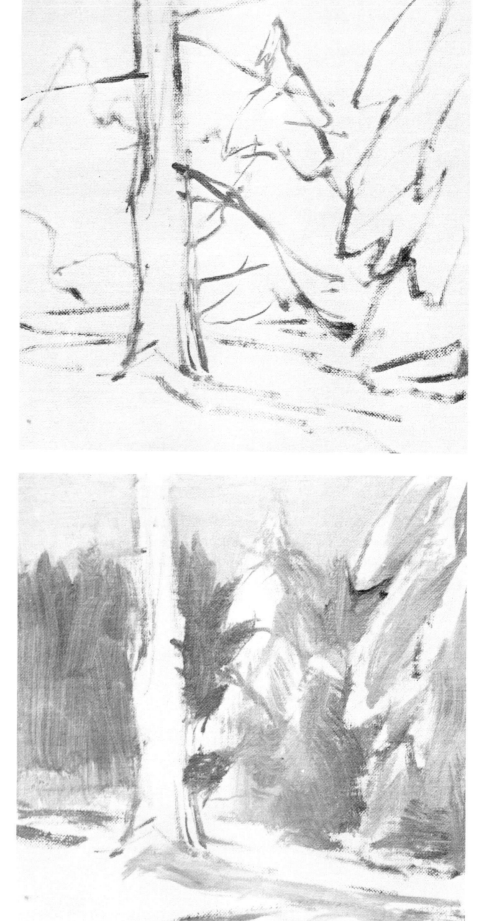

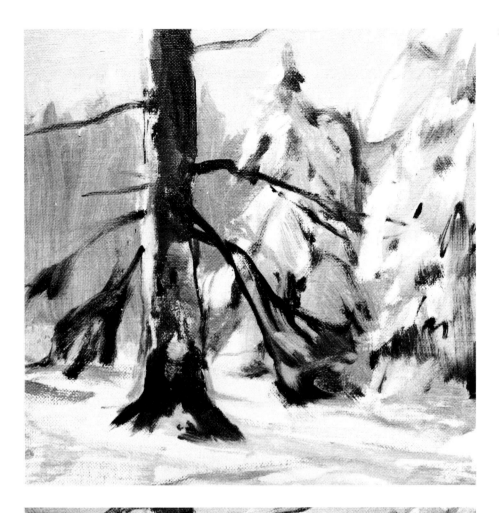

Step 3. Working with slightly thicker color diluted with medium to the consistency of thick cream, a bristle brush paints the sunlit patches on the snow-covered trees and the foreground. Then a round softhair brush begins to add the darks with strokes of fluid color a little thicker than the color used in Step 2, but not as thick as the sunlit snow.

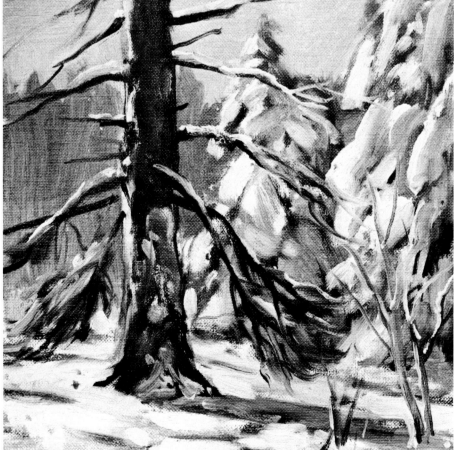

Step 4. Following the same strategy that was used for painting the mountains, the thickest strokes are saved for the very end. Now the paint is really piled on with a bristle brush to solidify the shapes of the snow on the trees and on the ground. And a round softhair brush adds creamy strokes to suggest snow on the branches of the dark tree.

Procedure. Decide which two or three tube colors will come closest to producing the right mixture. (You'll probably need some white as well.) Start out by mixing small quantities of just two colors. Then add a small quantity of the third color—if you need it. Keep adding color in modest amounts until you have the precise hue that you want. If you're absolutely sure that you need a fourth color to make some very subtle modification that you can't get with just three, you can add a touch of a fourth hue. But two or three colors should do for most mixtures.

A Typical Mixture. Let's see how this would work with a fairly common mixture. You need a rich, coppery tone for a clump of autumn trees. It seems logical to start with cadmium red and cadmium yellow, which you know will produce orange. You blend roughly equal quantities of red and yellow, which produce a brilliant orange—too brilliant for the more subdued tone of the trees. Now it's time for a third, more muted color. You reach for burnt umber and add this brown tone gradually to the orange until the mixture becomes more subdued. But now you've added too much burnt umber; the mixture is too brown and needs a slightly more golden tone. Just another speck of cadmium yellow and the mixture is just right. For the paler, more distant trees, you can use the same mixture, but add some white to make them paler—and perhaps a bit more brown to subdue the color.

Mixing Greens. In most parts of the world, the landscape is filled with growing things—trees, shrubs, grasses—and these are most often green. But there are so many different greens that you must learn to explore every possible mixture your palette can yield. Just blues and yellows will give you a surprising number of possibilities. The most brilliant greens will be mixtures of phthalocyanine blue and cadmium yellow. You'll produce more subdued greens with mixtures of ultramarine blue and cadmium yellow, ultramarine blue and yellow ochre, or phthalocyanine blue and yellow ochre. Cobalt blue is clear and bright as it comes from the tube, producing a clear, delicate green when mixed with cadmium yellow, but a very subdued green when blended with yellow ochre. Ivory black and cadmium yellow will give you another rich green, while black and yellow ochre yield a subtle, brownish green. Naturally, these hues will change radically as you vary the proportions of blue and yellow or black and yellow. And the range of these mixtures can be greatly extended by adding a touch of brown or red—burnt umber, burnt sienna, cadmium red, or alizarin crimson—to produce those brownish greens that are so common in landscapes. Of course, your palette also contains a ready-made green called viridian. Don't just use it straight from the tube. Learn to modify it with blue to produce blue-greens, with yellow to produce yellow-greens, and with browns and reds to produce brownish-greens.

Mixing Browns. When you paint outdoor subjects, you'll discover that browns are just as common as greens—and just as diverse. You do have two ready-made browns on your palette—burnt umber and burnt sienna—which can be modified in all sorts of ways. Touches of blue will give you grayish browns. And you can add any other color on the palette to give you reddish, greenish, blackish, and yellowish browns. But don't stop here. You can create an even greater range of browns by mixing them from scratch. Any blue-red-yellow combination will produce a great variety of browns, which change radically as you alter the proportions of the three components. More blue will give you a darker, grayer brown. More red will push the mixture toward copper. More yellow will give you a golden brown. You should also experiment with blends of red and green: viridian with cadmium red or alizarin crimson. As you can see, brown is far from dull. It's not really a color, but an extraordinarily diversified *family* of colors.

Observing Colors. When you set up your easel before a subject and start to mix your colors, look at the subject carefully and paint what you *see*—not what you *think* you see. Too many beginners simply decide that a tree is a bright green mass of leaves with a brown trunk. So they go right to work mixing those colors, without really *looking*. In reality, there are lots of different greens: the delicate, yellow-greens of spring, which often contain a hint of pink; the deep rich greens of summer; the smoky, bluish greens of evergreens; the grayish greens of trees on an overcast day. Treetrunks are rarely brown. More often, they're a brownish gray and some treetrunks turn out to be yellow, blue, brown-violet, or even dusty red. After the rain, a wet treetrunk can look black. At sunset, the bark sometimes turns bright orange. If you have trouble isolating a color—which is often hard to see because it's surrounded by so many other colors—carry a piece of white cardboard that's about half the size of this page. In the center of the cardboard, punch a hole that's roughly the size of a small coin. When you hold the card at arm's length in front of the subject, you can see the color through the hole. The rest of the card will block off the other colors.

Deciduous Trees. To paint trees in bright sunlight, try mixing phthalocyanine blue of viridian with cadmium yellow to get brilliant greens, or ultramarine blue with cadmium yellow for greens which are slightly more subdued but still sunny. Here, the sunstruck foliage and grass are ultramarine blue, cadmium yellow, and a little white; the shadow areas are ultramarine blue and yellow ochre.

Evergreens. Pines, spruces, and other evergreens tend to be deeper shades of green than deciduous trees. To darken a mixture of phthalocyanine blue or ultramarine blue and cadmium yellow, add burnt umber, burnt sienna, or ivory black. Phthalocyanine blue and yellow ochre will give you particularly deep green, which grows smoky and mysterious when you add some white—perfect for distant evergreens or evergreens in mist.

Autumn Trees. The hot colors of autumn call for brilliant colors such as cadmium yellow or cadmium red, but it's best to subdue them slightly with more muted colors such as yellow ochre, burnt umber, and burnt sienna. The yellow tree is cadmium yellow, burnt sienna, and white. The orange tone in the background is cadmium yellow, cadmium red, yellow ochre, and white.

Trees on Overcast Day. On a gray day, even the bright colors of autumn are subdued. The warm tones of the foreground tree and the grass are mixtures of viridian, yellow ochre, burnt sienna, and white. The distant trees, melting away into the atmosphere, are mixtures of ultramarine blue, burnt sienna, yellow ochre, and white.

Sunny Sky. The sky is usually darkest at the zenith, growing paler at the horizon. Don't just mix blue and white. Try adding a touch of yellow ochre or alizarin crimson for warmth, or perhaps viridian to make the blue cooler and brighter. This sky is mainly cobalt blue and white, with a slight hint of yellow ochre and alizarin crimson. The clouds are also this mixture, but with less blue.

Overcast Day. An overcast sky is full of subtle color. Try mixing one of your blues (ultramarine, phthalocyanine, or cobalt) with one of your browns (burnt umber or burnt sienna) and plenty of white to produce a great variety of beautiful warm and cool grays. Add a touch of yellow ochre for a more golden tone. This cloudy sky is painted with mixtures of cobalt blue, burnt sienna, yellow ochre, and white.

Meadows and Hills. This landscape contains a surprising variety of green mixtures: various combinations of ultramarine blue or viridian, cadmium yellow or yellow ochre, burnt sienna, and white for the lighter areas; various blends of phthalocyanine blue, cadmium yellow or yellow ochre, and burnt umber for the darks. For contrast, it's a good idea to exaggerate the blueness of the distant hills.

Sand in Light and Shadow. Look closely at a sandy beach and you'll see that it isn't nearly as yellow or gold as most beginners paint it. The sunlit areas of these dunes are mostly yellow ochre and white, heightened with delicate touches of cadmium yellow and burnt sienna. The shadows tend to reflect the cool tone of the sky—mixtures of cobalt blue, yellow ochre, alizarin crimson, and white.

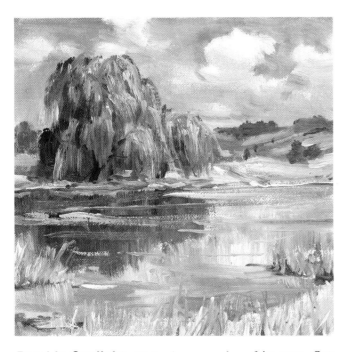

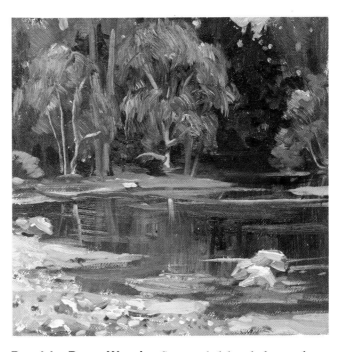

Pond in Sunlight. Water has no color of its own. Outdoors, the water acts like a mirror, reflecting the color of the surrounding sky and landscape. That's why most of this pond is painted with the same colors as the sky: cobalt blue, yellow ochre, alizarin crimson, and white. For the same reason, the water below the big willow is painted with the same mixtures used to render the tree.

Pond in Deep Woods. Surrounded by dark woods, a pond reflects very little sky color. Instead, the water picks up the colors of the surrounding trees. At the very top, a few patches of sky break through the trees, and these sky colors are reflected in a few streaks and ripples that break the water.

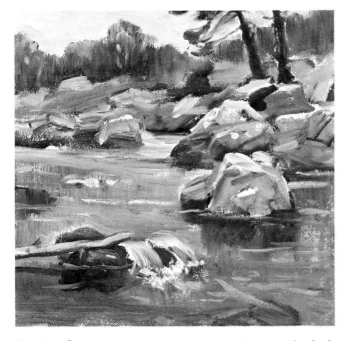

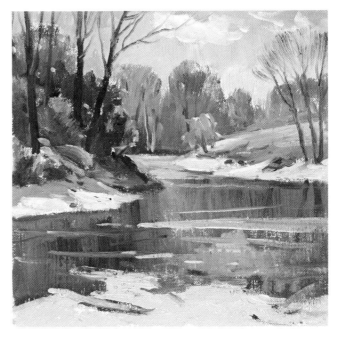

Rocky Stream. A turbulent stream is a particularly complicated combination of colors. Much of this stream reflects the tones of the surrounding rocks. You can see some cooler strokes that reflect the cooler tone of the sky—although the blue zenith of the sky is too far up to include in the picture. In the immediate foreground, the shallow water reveals the darker tone of the bed of the stream.

Smooth Stream. Calm water is an almost perfect reflecting surface. Look carefully at this placid stream, and you'll see reflections of the trunks and foliage along the shore, plus a clearly defined patch of sky color in the lower right area. The lesson is clear: don't try to mix some imaginary "water color," but paint water as a reflecting surface that mirrors its surroundings.

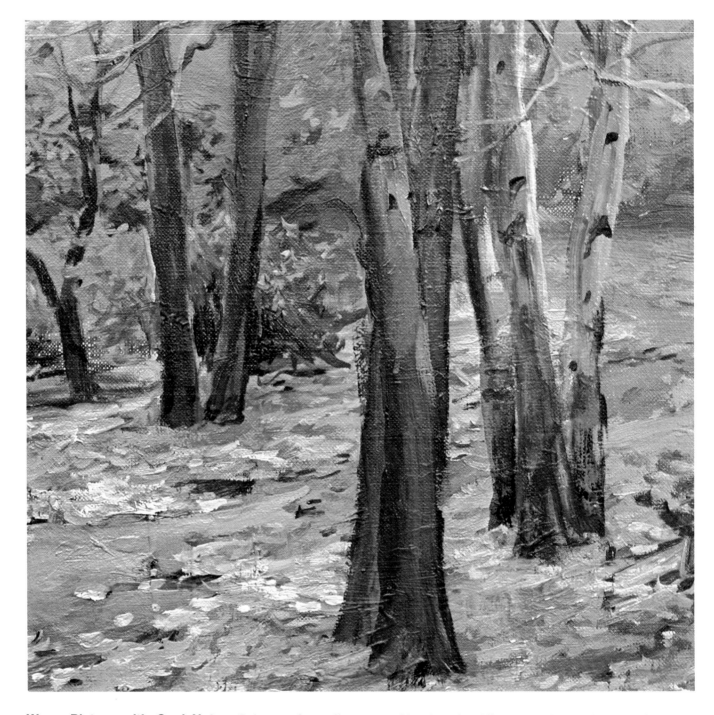

Warm Picture with Cool Notes. Painters often talk about "warm and cool colors." Reds, oranges, yellows, and browns are in the warm family. Blues and greens are generally regarded as cool colors. Some colors can go either way: a blue-green is considered cool, while a yellow-green is warm; a purple that tends toward blue would be considered cool, while a red-purple is warm. Grays are particularly interesting because it's possible to mix so many different warm and cool tones: a bluish or greenish gray would be considered cool, while a gray that tends toward brown or gold would certainly be warm. When you paint a landscape, think about the *balance* of warm and cool colors. This is a predominantly warm landscape—mostly yellows, yellow-greens, browns, and brownish grays. But the overall warmth is relieved here and there by touches of cooler gray on the treetrunks and the path. And notice those small strokes of cool color on the bush at the center.

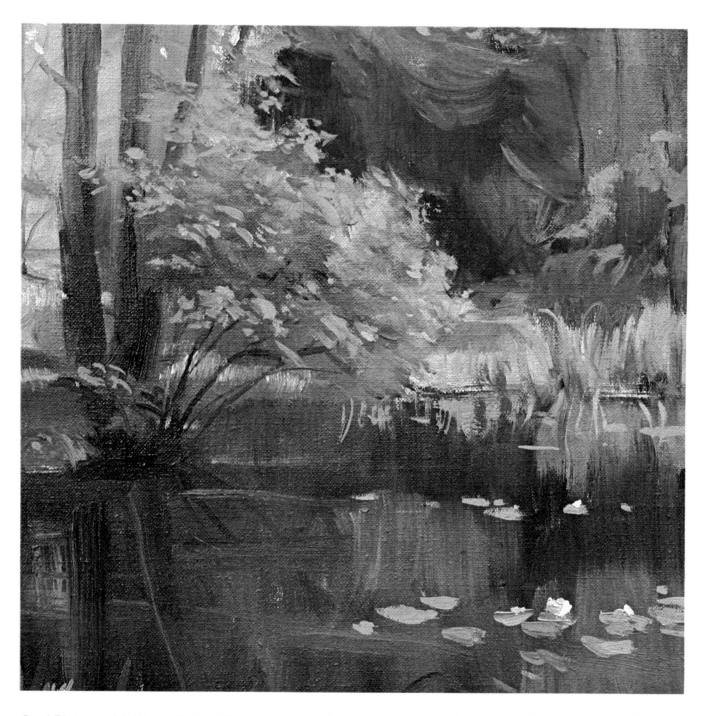

Cool Picture with Warm Notes. This is a close-up of a section of a woodland landscape that's painted almost entirely in cool colors. At first glance, the painting seems to consist entirely of greens. But look closely and you'll see many warm notes that lend variety and vitality to the green color scheme—which would be terribly monotonous without these subtle notes of contrast. There are many subtle touches of yellow and yellow-green among the foliage; these tones are brushed into the deep green of the water. The lily pads floating on the pond aren't a uniform green, but contain touches of yellow. At the left, the treetrunks are also a distinctly warm tone. It isn't always easy to find warm notes in a cool landscape or cool notes in a warm landscape—so *exaggerate* the contrasting colors that you do find. Or *invent* them if necessary.

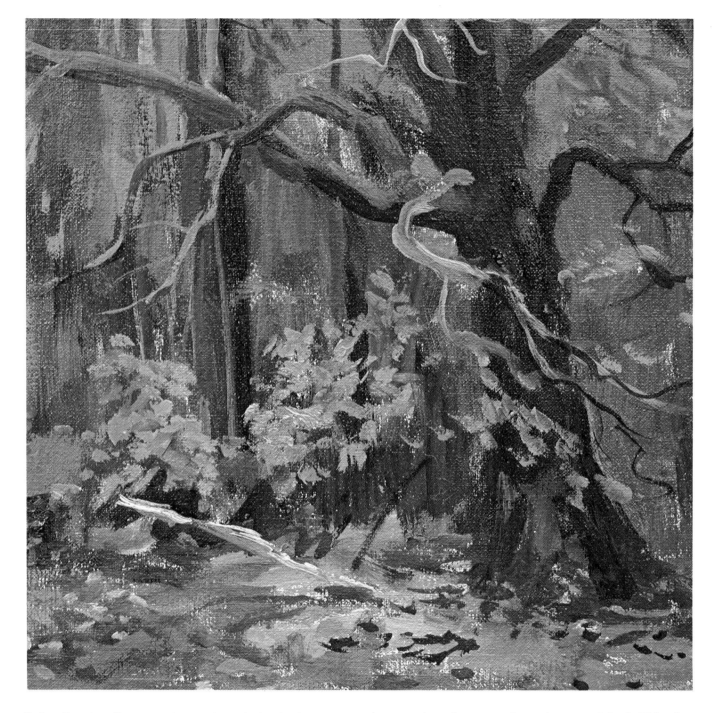

Color Creates Space. When you're painting landscapes, it's important to create a convincing sense of space—a feeling that some parts of the picture are close to the viewer, while other parts are further away. Color can help. In this close-up of a section of a wooded landscape, the darkest and the brightest colors are in the foreground. The deepest tones appear in the big tree, while the brightest colors appear in the clusters of leaves. The forest beyond seems further away because the colors are paler and more subdued. This phenomenon is called *aerial perspective*. According to the "rules" of aerial perspective, near objects tend to be darker or brighter than more distant objects—which tend to be paler and more muted in color. Professional landscape painters often exaggerate these color differences to make their pictures look more spacious.

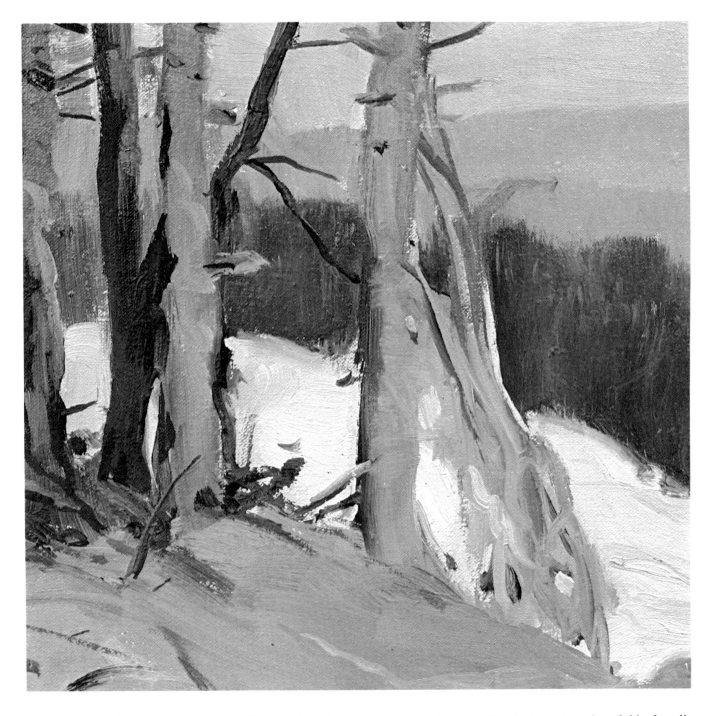

Value Creates Space. Painters often talk about the *value* of a color—which means its relative lightness or darkness. To create a convincing sense of space in a landscape, it's important to plan your values carefully. In this close-up of a portion of a winter landscape, the values clearly define the foreground, middleground, and distance. The trees and the slope in the foreground are one distinct tone, with some strong darks to make the trees move forward toward the viewer. Just beyond the shadowy trees is a field of sunlit snow with a stand of evergreens at the edge of the field. The snow is lighter and the evergreens are darker than the foreground; together they constitute the middleground of the picture. Beyond the evergreens are the pale forms of the hills, which are the most distant section of the landscape. The painting creates a sense of deep space because the landscape is clearly divided into distinct values.

Step 1. The preliminary brush drawing defines the trees as two big, simple shapes. A round softhair brush swiftly glides around the edges of the foliage with a mixture of burnt umber, viridian, and lots of turpentine to make the color flow as smoothly as watercolor. The shapes of the foliage aren't defined *too* precisely. These strokes will soon be covered by thicker color—and that will be the time to render the masses of foliage more exactly.

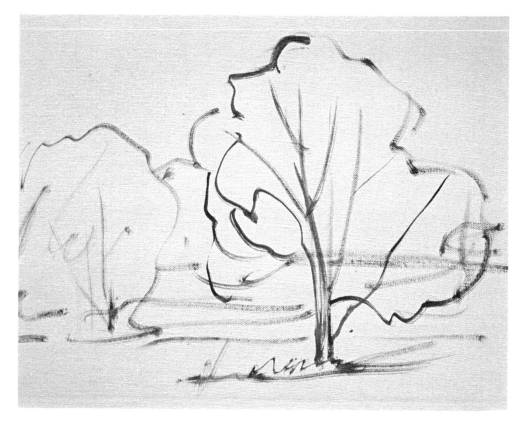

Step 2. A small bristle brush is used to paint the dark strokes of the trunk and branches with a mixture of viridian, burnt sienna, and white. The strokes are still very loose and casual—the forms will be more precisely painted in the final stages. Then a bristle brush begins to paint the foliage with a mixture of viridian, yellow ochre, and the slightest hint of cadmium red to add a touch of warmth. The strokes already begin to reflect the character of the subject: long, rhythmic strokes for the trunk and branches; short, ragged strokes of thicker color (diluted with less medium) to suggest the texture of the leaves.

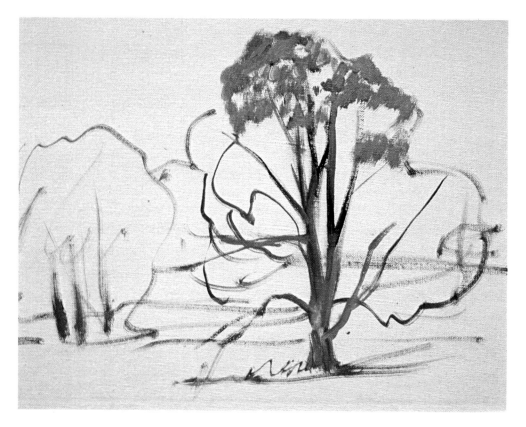

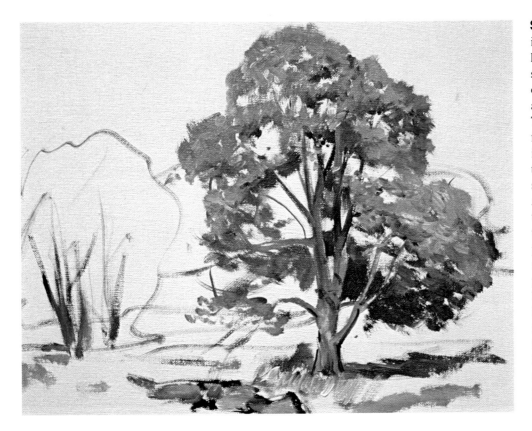

Step 3. A bristle brush works its way down to cover the foliage area with short, ragged strokes of viridian, yellow ochre, a hint of cadmium red, and white in the sunlit areas. Then the shadows among the foliage are painted with viridian and burnt sienna, a mixture which also appears in the shadow at the base of the tree. A softhair brush defines the trunk more precisely, using the same mixture as first appeared in Step 2, then adds some shadow strokes with phthalocyanine blue and burnt sienna. A bristle brush begins to suggest the rocks at the bottom of the picture with this same phthalocyanine blue/burnt sienna mixture, adding white for the sunlit planes of the rocks.

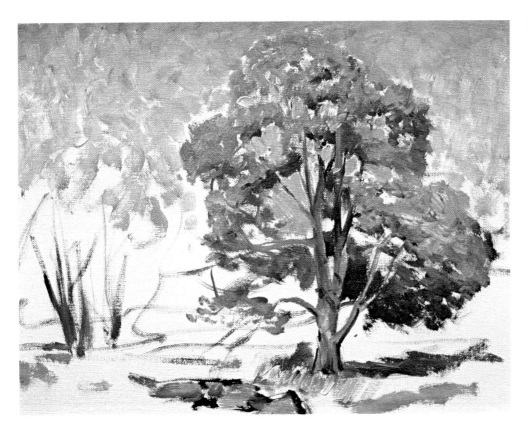

Step 4. The sky is painted around the trees with short strokes that overlap one another. The first strokes are cobalt blue and white. These are overlaid with strokes of alizarin crimson and white, and strokes of yellow ochre and white. The action of the brush blends these three tones—but there's no attempt to fuse the strokes into one smooth, continuous tone. Notice how the strokes at the top of the sky are darkest and bluest, growing warmer and paler toward the horizon. Also observe how patches of sky break through the foliage of the big tree.

Step 5. The sky strokes have obscured the brush lines that defined the smaller tree at the left, so now this tree is rebuilt with strokes of the same foliage mixture as was used on the big tree. A bristle brush goes over the sky with short strokes, partially blending the colors that were applied in Step 4, but still allowing each stroke to show. Then the sky mixture—with more blue—is used to paint a darker tone along the horizon. This tone will eventually become the distant hills. The grassy meadow is begun with scrubby, casual strokes of viridian, cadmium yellow, burnt sienna, and white.

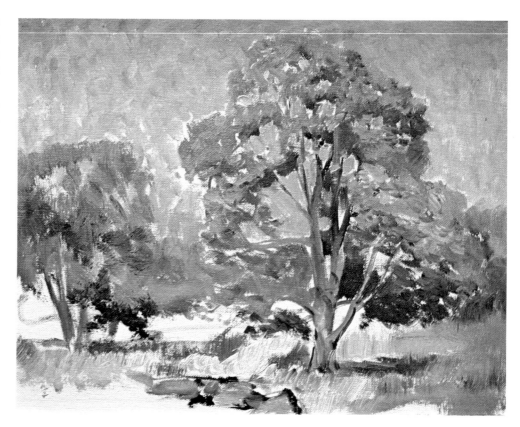

Step 6. The sky is completed with short, diagonal strokes that eliminate the patches of bare canvas. Then the foliage of the big tree is enriched with thick strokes of viridian, cadmium yellow, white, and the slightest touch of burnt sienna—emphasizing the brilliant sunlight. This same mixture brightens the meadow. Between the two trees, broad strokes of sky mixture sharpen the top of the distant hill. All this work has been done with bristle brushes. Now a round, soft-hair brush paints the lights and shadows on the trunks and branches with the original mixtures used in Step 2 and 3, adding more white for the strokes of sunlight. This same brush begins to add dark touches to suggest leaves.

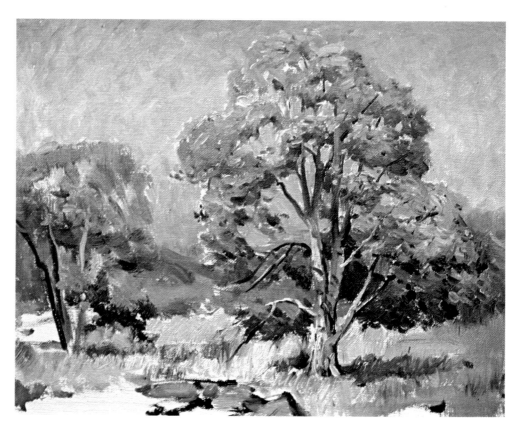

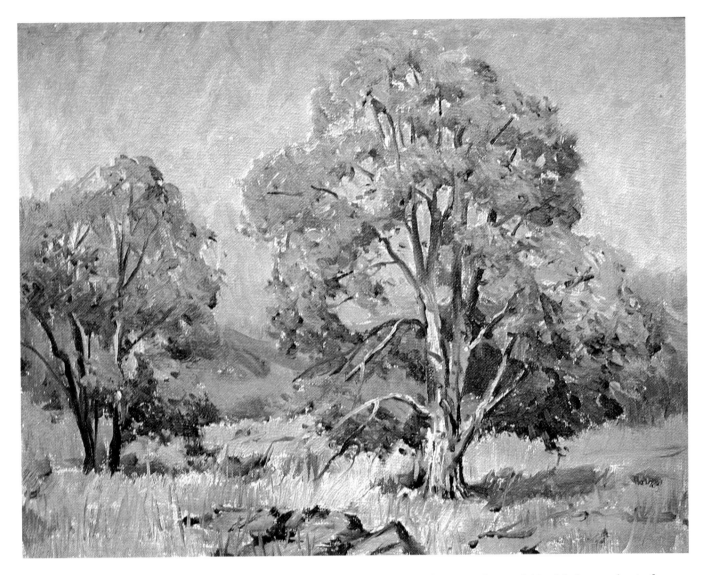

Step 7. It's always important to paint with broad, free strokes until the very end of the picture—when the last few details are added with smaller, more precise strokes. In this final stage, a bristle brush completes the foliage of the smaller tree with broad strokes of viridian and yellow ochre warmed with a speck of burnt sienna and lightened with white. This same tone covers the rest of the meadow. Then the tip of a round, softhair brush goes to work on those last details that give the painting a sense of completeness. The dark trunks of the smaller tree are flowing, rhythmic strokes of phthalocyanine blue and burnt sienna diluted with painting medium to fluid consistency that's just right for linear brushwork. The same brush adds more dark strokes to the trunk and branches of the bigger tree. Then the brush is rinsed out in turpentine, quickly dried on a sheet of newspaper, and dipped into a mixture of burnt umber, yellow, and white to strengthen the lighted patches on the bark. The point of the brush adds a few more dark touches among the trees to suggest individual leaves—but not too many. The round brush sharpens the shapes of the rocks with the shadow mixture that was used on the trunks. Then the tip of the brush scribbles vertical and diagonal strokes over the meadow to suggest grasses and weeds—pale strokes of white faintly tinted with cadmium yellow, plus darker strokes of viridian, burnt sienna, and yellow ochre. The finished painting contains just enough of these details to seem "real," but not enough detail to become distracting. The painting is still dominated by bold, free, broad brushwork.

Step 1. An evergreen forest can be full of distracting detail, so it's essential to keep your eye on the big, simple shapes. Here, the preliminary brush drawing does nothing more than define the trunks of the most important trees in the foreground, the pointed shapes of the forest against the sky, the small tree at the left, the lines of the shore, and a single round tree on the distant shoreline. A round, softhair brush draws these lines with burnt umber, ultramarine blue, and turpentine.

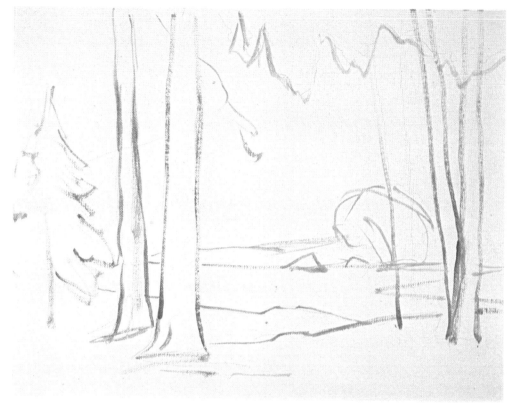

Step 2. Once the composition seems right, the same brush reinforces the original lines with darker strokes of burnt umber and ultramarine blue, but with less turpentine than was used in Step 1. Then the shapes of the big trunks are thickened with this mixture, since they'll become very important design elements—forming the "frame" through which you see the distant landscape.

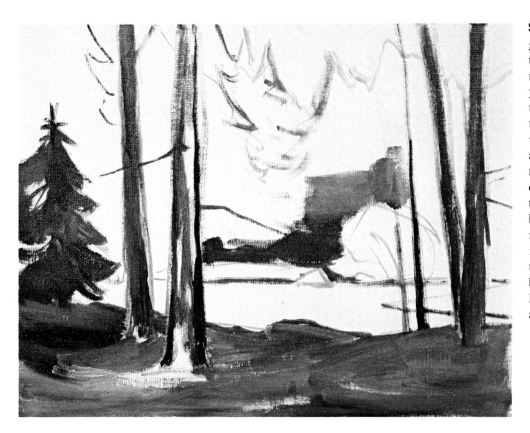

Step 3. To place the foreground close to the viewer, this area is covered with a rich, dark tone of cadmium yellow, burnt sienna, and ultramarine blue. Strokes of this mixture are carried upward over the small evergreen at the left—with more ultramarine blue added for the darks. Then the tone of the trees on the distant shore is begun with a soft, smoky mixture of yellow ochre, ivory black, and white. All the work is done with bristle brushes, and the color is diluted with painting medium to a smooth, fluid consistency.

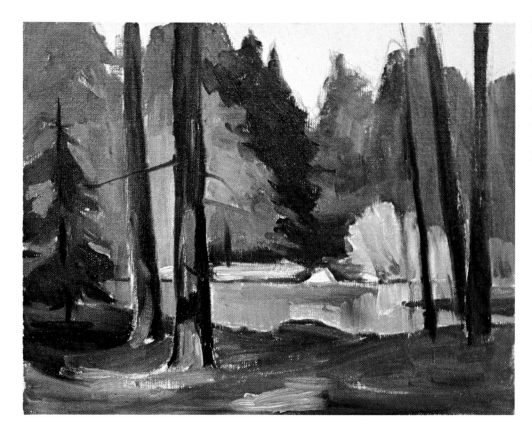

Step 4. The distant forest is covered with broad strokes of creamy color diluted with enough painting medium to make the color flow smoothly. The brightest trees are cadmium yellow and a touch of ivory black; this mixture is carried downward into the water, and a few strokes are added to the foreground to suggest a patch of sunlight. The dark tree at the center is phthalocyanine blue and yellow ochre. The more muted trees are phthalocyanine blue, burnt umber, yellow ochre, and white. Strokes of the foreground mixture are carried upward into the treetrunks on the left; some cadmium yellow is added to suggest sunlight on the bark.

Step 5. The sky is covered with liquid strokes of cobalt blue, alizarin crimson, yellow ochre, and white—defining the edges of the distant trees more sharply. Some of this sky color is brushed into the wet undertone of the distant trees to the right, which grow softer and cooler. The dark trunks in the foreground are more sharply defined by a round brush carrying a dark mixture of phthalocyanine blue and burnt sienna. The brush adds more darks to the small evergreen at the left and begins to add shadow lines to the ground. But something is wrong: the colors of the distant trees are too strong. They seem to be pushing their way into the foreground and need to be pushed back by a radical change in the color scheme.

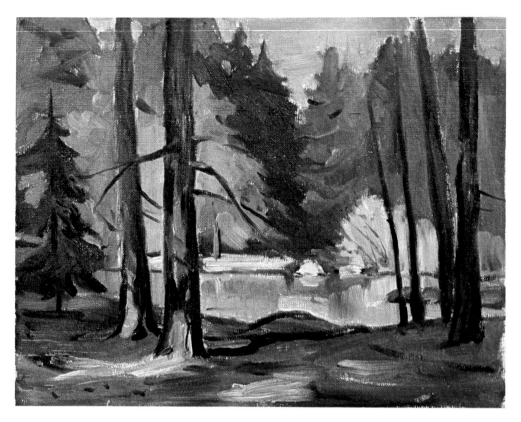

Step 6. The distant trees are scraped lightly with the palette knife. Then soft, warm tones of burnt sienna, ultramarine blue, yellow ochre, and white are brushed over and into the wet tone to create a new, more unified color that stays further back in the picture. Behind the two big trunks at the left, some of the original yellow tone still shines through. The new color is carried down into the water, and some darker strokes of this mixture are added to the foreground. The bark and branches of the foreground trees are painted with dark strokes of phythalocyanine blue and burnt sienna. On the far shore, only one bright yellow tree remains.

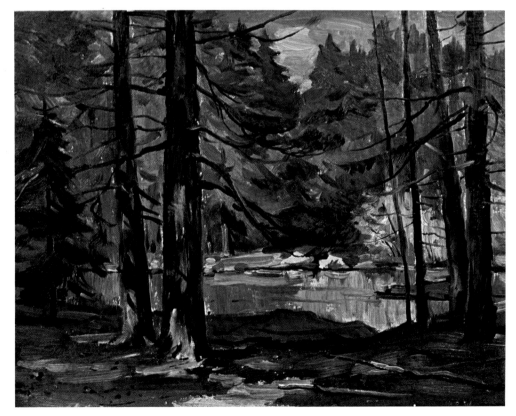

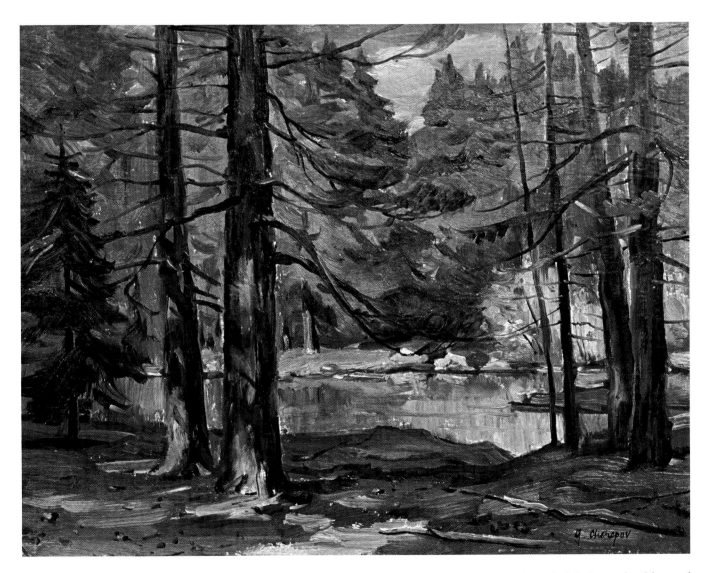

Step 7. The trees on the far shore have been unified by adding fresh color, but now they must be pushed further into the distance. Cool, delicate tones of cobalt blue, burnt sienna, yellow ochre, and white are blended into the wet color to make the distant trees look even more remote and subdued. Behind the treetrunks at the left, the yellow foliage is heightened with a bit more cadmium yellow, burnt umber and white; this mixture is repeated on the shoreline and carried down to the still water, which reflects the foliage above. In the foreground, thick strokes of this mixture, with an occasional dash of cadmium red, suggest patches of bright sunlight breaking through the trees. The tops of the nearby treetrunks are softened with strokes of the same cool mixture that appears on the distant trees in the upper right; this makes the tops of the trunks seem more shadowy and more remote. The dark edges of the foreground trees are sharpened with slender strokes of phthalocyanine blue and burnt sienna applied with the tip of a round softhair brush, which also adds more branches and twigs at this final stage. The patches of sunlight on the trunks are heightened with a few strokes of the cadmium yellow, burnt umber, and white mixture that appears on the ground. A small bristle brush adds a pale, warm cloud to the sky—mostly white, with a touch of cobalt blue and alizarin crimson—and then picks up the blue sky mixture to poke some "sky holes" through the foliage. The round softhair brush adds a few dark and light flecks to the ground, suggesting the usual debris of a forest—perhaps some fallen pine cones. The finished painting is an excellent example of the adaptability of oil paint, which remains wet and pliable longer than any other medium—permitting you to make major color changes by blending fresh color into the wet surface.

DEMONSTRATION 3. MEADOW

Step 1. As usual, the preliminary brush drawing is executed with a round softhair brush carrying a very fluid mixture of tube color diluted with lots of turpentine. Because the colors of this landscape will be generally cool, the brush drawing is done in ultramarine blue. The drawing is very simple: just the horizon line, the banks of the stream, the shapes of the foliage, and a few strokes for the trunks of the trees. The sky is brushed in with broad, rough strokes of cobalt blue, alizarin crimson, yellow ochre, and white—with more blue at the top and more yellow below. This sky tone is reflected in the stream.

Step 2. The trees at the horizon are so far away that they contain practically no detail, so they're painted as a broad mass of flat color. They're painted with the same mixture as the sky, but with more blue and less white. The colors aren't mixed too thoroughly; here and there you can see some yellow or pink shining through the blue. This makes the tone of the trees more lively and interesting.

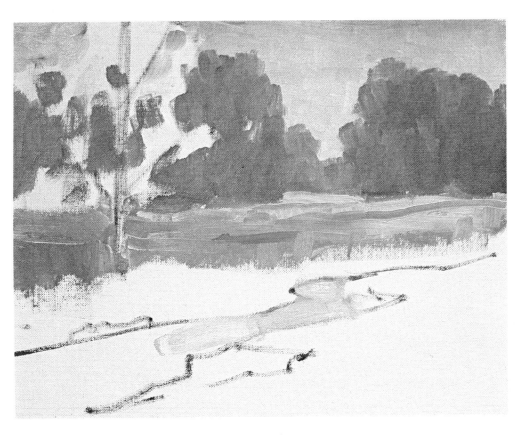

Step 3. The sky and the most distant portion of the landscape are covered with color. Now it's time to begin work on the middleground. The meadow beyond the stream is begun with various mixtures of cobalt blue, yellow ochre, cadmium yellow, and white. The bright patch to the left of center contains more cadmium yellow. Even at this early stage, the brushstrokes express the form. The tall trees in the distance are painted with vertical strokes, while the flat meadow is painted mainly with horizontal strokes.

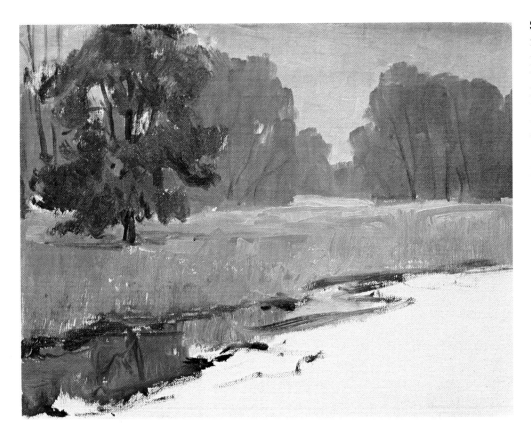

Step 4. The meadow at the far edge of the stream is painted with a brighter mixture of viridian, cadmium yellow, burnt sienna, and white. Now the strokes become vertical to suggest the tall grasses and weeds. The foliage of the dark tree is painted with rough strokes of viridian, burnt sienna, and yellow ochre—repeated in the reflection of the tree in the stream. The trunk and branches are painted with a dark mixture of viridian and burnt sienna. The cooler, softer color of the distant trees is also added to the center of the stream. Some trunks are added to the distant trees with a paler version of the same color used to paint the trunk and branches of the tree in the middleground.

Step 5. Work begins on the foreground. Here's where the color will be brightest and thickest, making the meadow on the *near* side of the stream seem very close to the viewer. Thus, the foreground is executed with a painting knife carrying a thick mixture of viridian, cadmium yellow, burnt sienna, and just a little white. No painting medium is added, so the paint is really thick and pasty. The colors aren't mixed too thoroughly, allowing patches of yellow and brown to show through the green.

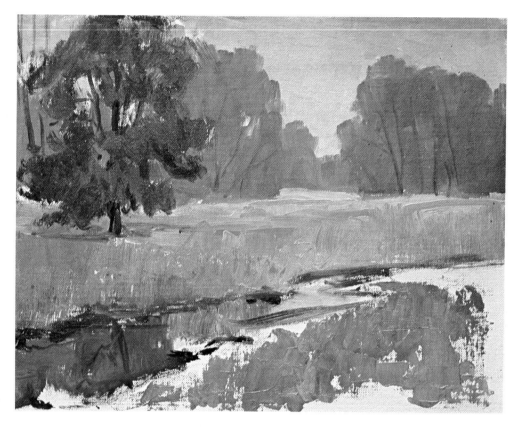

Step 6. When the foreground is completely covered with thick color, a softhair brush comes in to convert that heavy mass of paint to grass, weeds, and wildflowers. The job can be done with the tip of a round softhair brush or an old bristle brush with worn, ragged hairs. Picking up various mixtures of the same colors used to paint the meadow in Step 5, the brush paints vertical and diagonal strokes, some dark and some light, to suggest the detail of the meadow. A few quick dabs of cadmium yellow or a mixture of cadmium yellow and cadmium red look like wildflowers.

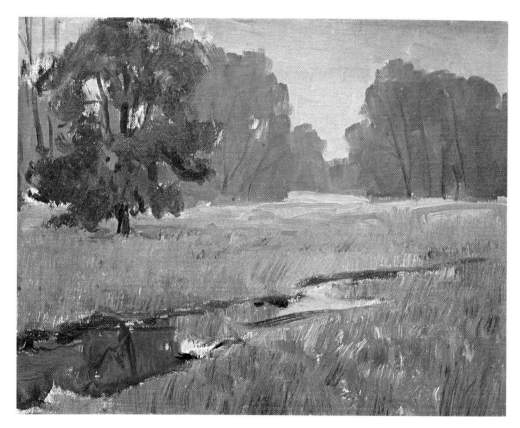

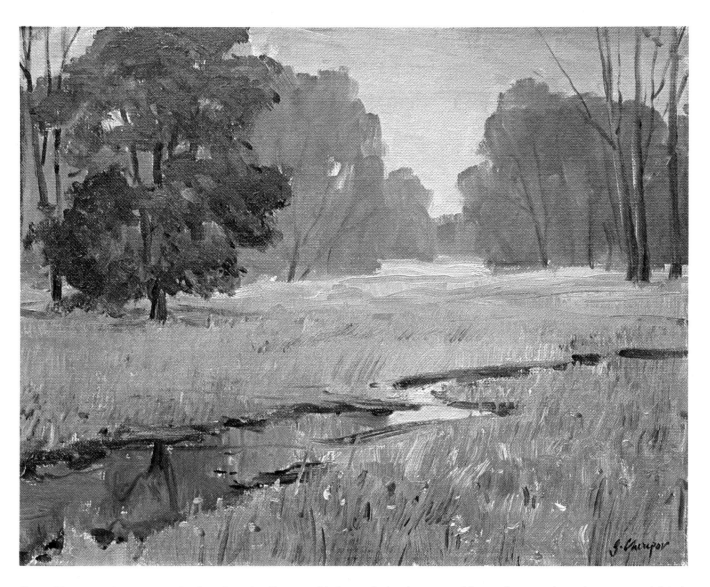

Step 7. In the final stage, the last few details are added with the tip of a round, softhair brush. More weeds and blades of grass are added to the foreground. The dark strokes are burnt sienna and viridian. The lighter strokes are yellow ochre and white. The brush continues to add tiny dots of color to suggest more flowers: bright mixtures of cadmium yellow and white or cadmium yellow and cadmium red; more subdued mixtures of cadmium yellow, burnt umber, and white. Notice that the strokes on the far side of the stream are a much more subtle color—the same mixture used to paint the distant trees in Step 2. The round softhair brush picks up a dark mixture of ultramarine blue and burnt sienna to add some dark touches to the big tree at the left, deepening the shadows within the foliage and suggesting some leaves with a few tiny dots of this shadowy mixture. The bare treetrunks at the extreme left are strengthened with this mixture. A little white is added to this mixture to make a few shadow lines beneath these trees. The composition needs something to balance the big, dark tree at the left, so now the tip of the round brush uses the same

dark mixture to add some bare trunks at the extreme right. A few strokes of pure white are added to these trunks to suggest sunlight. Finally, this treetrunk mixture darkens the shadowy banks of the stream and strengthens the reflection of the treetrunk in the lower left area. It's worthwhile to remember the sequence of painting operations in this landscape. Look back over these seven steps, and you'll see that the job is done from top to bottom and from distance to foreground. The sky and the most distant trees are painted first in pale, cool, thin color diluted with lots of painting medium. The middleground—the dark tree and the meadow beyond the stream—is painted next with colors that are darker, brighter, thicker, and more roughly brushed. The immediate foreground comes last. Here the colors are brightest, thickest, and roughest. Details of grass, weeds, and wildflowers are saved for the foreground. The middleground contains only a slight suggestion of detail—you really can't see the leaves on the tree—and the distant trees contain no detail at all.

DEMONSTRATION 4. HILLS

Step 1. In the summer, hills are often covered with tree foliage. You can't paint every tree on the hill, so it's best to begin a hilly landscape with a few simple brush lines that indicate the overall shapes of the landscape. A round, soft-hair brush traces the lines of the horizon, the hills just below the horizon, the bigger hills in the foreground, the lower edge of the biggest hill where the meadow begins, and a few trees on a slope in the lower right area. The preliminary brush drawing is made with ultramarine blue, a little burnt umber, and turpentine to make the color flow smoothly.

Step 2. Here the painting strategy is totally different from that in the preceding demonstration. The shape of one big hill will dominate the picture. This shape must be the most richly colored area in the painting—and all other parts of the painting must be more subdued. So the biggest, brightest hill is painted first with the rough, vertical strokes of a big bristle brush. The sunlit area is painted with various mixtures of viridian, cadmium yellow, yellow ochre, burnt sienna, and white—never more than four of these colors to a stroke. The darks are ultramarine blue, viridian, and alizarin crimson. The rough, vertical strokes already begin to suggest the texture of the trees on the hillside.

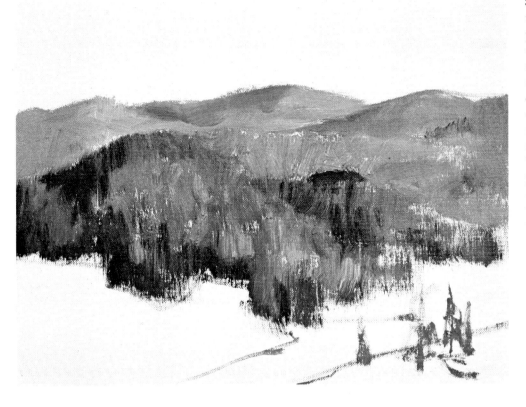

Step 3. The smaller hill to the right of the big hill is painted with vertical strokes of the same colors, but the shadow side (containing more alizarin crimson) isn't quite as dark. There's a much stronger contrast between sunlight and shadow on the big hill that still dominates the painting. Then the distant hills are painted with smoother strokes of slightly more fluid color: ultramarine blue, burnt umber, yellow ochre, and white, with more blue in the shadows. This paler, bluer tone makes the distant hills more remote and provides a subdued background to dramatize the brighter hills in the foreground.

Step 4. The lower sky, just above the horizon, is painted with soft strokes of smooth, fairly fluid color containing a lot of painting medium. This passage is a mixture of cobalt blue, yellow ochre, alizarin crimson, and a lot of white. Observe the smooth brushwork of the distant hills and the lower sky, where the strokes are softly blended together by moving the brush back and forth to obliterate most of the individual strokes. In contrast, each stroke retains its identity on the bright hills in the foreground, making the color more vibrant and the texture more dramatic.

Step 5. More cobalt blue and alizarin crimson are added to the sky mixture to complete the upper sky with a darker, cooler tone. A lot of white is added to this mixture to suggest a single cloud whose lower edge is softly blended into the warm tone beneath. A filbert, the softest of the bristle brushes, smoothes the tones of the distant hills and adds some shadows to the hills at the right with ultramarine blue and burnt sienna. (If you've been painting outdoors, you've probably noticed that clouds cast shadows on the landscape.) Some white is blended into the tops of the distant hills to suggest sunlight. Now a bristle brush begins to work on the meadow in the immediate foreground with paler mixtures of the same colors used on the brightest hill: viridian,

cadmium yellow, yellow ochre, burnt sienna, and more white. You can see that some strokes contain more green, more yellow, or more brown. Compare the brushwork in the meadow with the strokes in the hill. The meadow is painted with smooth, horizontal strokes of creamy color that contains as much painting medium as the distant hills. In contrast, the big hill is painted with rough, vertical strokes of thick color. The brushwork reflects the form and texture of the subject. The slope in the lower right area—a small, dark triangle—is painted with the same colors as the meadow, but darker. In the process of painting the meadow, the small trees in the lower right have disappeared, but they'll return in the final stage.

Step 6. So far, everything has been broadly painted. There's been no attempt to suggest the form of a single tree on these densely wooded hills. Now the round softhair brush returns to add the final touches. Just a little more white and yellow ochre are added to the original mixtures that have been used to paint the sunlit hillside. Here and there the small brush adds little dabs of this sunny color to suggest the forms of individual trees. Notice, however, that the original rough brushwork *isn't* completely covered; the round brush adds just enough of these little touches to create the impression of individual trees—and then it stops. The round brush picks up a fluid mixture of ultramarine blue and burnt umber to add the last few dark notes. In the lower right section, the evergreens and their shadows are added with quick touches. A few dark dabs and lines are added to the meadow to suggest individual trees and their shadows, plus some breaks in the meadow. Notice that the lower slopes of the big hill also cast some shadows on the meadow. A few dark touches are added to suggest some darker trees on the wooded hills. Once again, analyze the strategy of the completed painting. The "star" is the big hill with a "supporting actor" to the right. Here's where you see the brightest colors, the thickest paint, the roughest brushwork, and the strongest suggestion of detail. The sky and distant hills are paler, cooler, smoother, and more thinly painted. The meadow in the foreground is smoother and more thinly painted. Nothing competes with the bright, richly textured hills that form the center of interest.

Step 1. The colors of this mountainous landscape are generally cool, so the preliminary brush drawing is made with a mixture of phthalocyanine blue and burnt sienna thinned with turpentine to a liquid consistency. The composition is worth studying. The artist places some shattered trees in the immediate foreground—close to the viewer—to make the mountains seem loftier and more remote. You feel that you're standing in the foreground, looking far into the distance. The top edge of the picture actually cuts off the top of the biggest mountain, making it seem *so* lofty that it won't even fit into the painting.

Step 2. The darkest, most dramatic, and most important shape in the painting is the big mountain, of course. Everything else in the picture will have to be related to that dominant form. So the big mountain is painted first. A large bristle brush blocks in the dark shape with broad strokes of phthalocyanine blue and burnt sienna, with just a slight touch of white and a whisper of yellow ochre. The paint is diluted with medium to a creamy consistency. On the lower slopes, a bit more white is added to suggest a hint of sunlight. Now that the strongest dark note in the painting is established, it's easier to make all the other parts of the painting lighter.

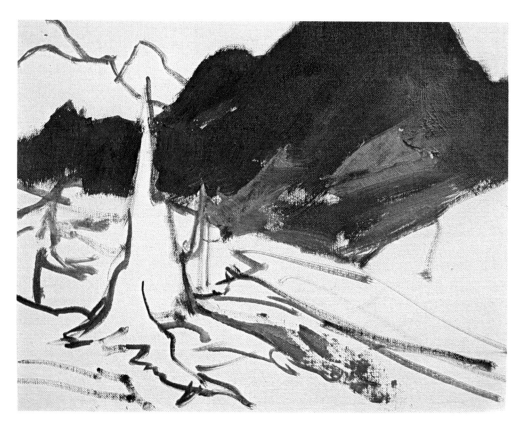

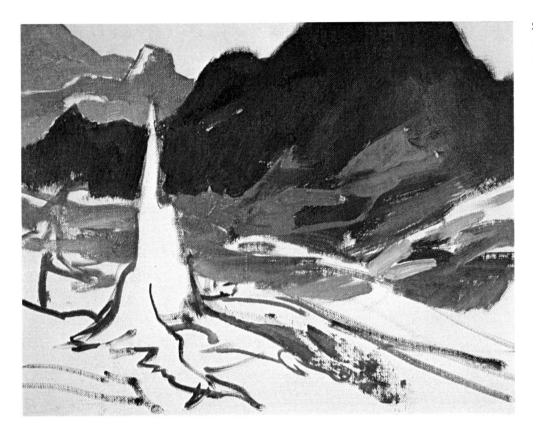

Step 3. The paler slopes at the base of the dark mountain are further developed with he original mixture, but with more white. Now these strokes are sharper and more distinct. The mountains in the upper left are painted with thinner mixtures of the same color combination: phthalocyanine blue, burnt sienna, and a little yellow ochre, plus enough white to lighten these tones. Notice that the warmer mountain contains more burnt sienna, while the cooler shape contains more phthalocyanine blue. The grassy middle-ground—just beyond the shattered tree stump—is begun with rough strokes of viridian, burnt sienna, yellow ochre, and white. The paler, warmer strokes obviously contain more burnt sienna.

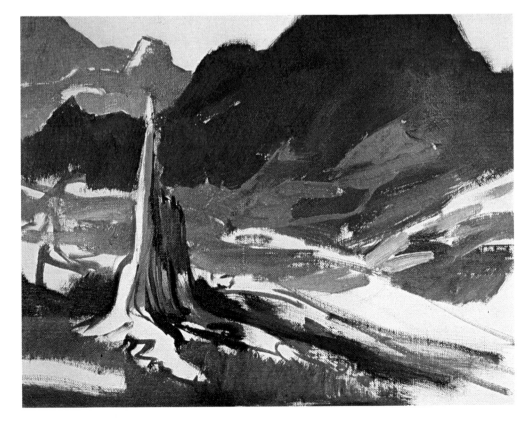

Step 4. The shadow side of the tree stump and the shadowy underside of the fallen treetrunk are painted with fluid strokes of the same mixture that's used to paint the mountains in the distance. Broad tones are laid down by the bristle brush, and then some vertical lines are added with the tip of a round softhair brush to suggest the weathered texture of the stump. The rich, dark green of the grass in the immediate foreground is scrubbed in— mainly with vertical strokes of viridian, cadmium red, and yellow ochre. At this stage, the foreground colors are thin and fluid. Notice that the mountain in the upper left has been made cooler by the addition of more blue.

Step 5. To warm the grass in the lower left area, a bristle brush scrubs in some cadmium red and cadmium yellow. The up-and-down brushstrokes suggest the texture of the grass. Just to the left of the stump, some mountain color is blended into the middleground to suggest a shadowy ravine. More white and burnt sienna are added to the mountain mixture, which is brushed across the sunlit top of the fallen trunk. This same tone appears in the fallen twigs scattered across the grass. In the lower left area, a broken branch is painted in exactly the same way as the fallen trunk. The form and texture of the jagged stump are developed with this same mountain mixture, with more white.

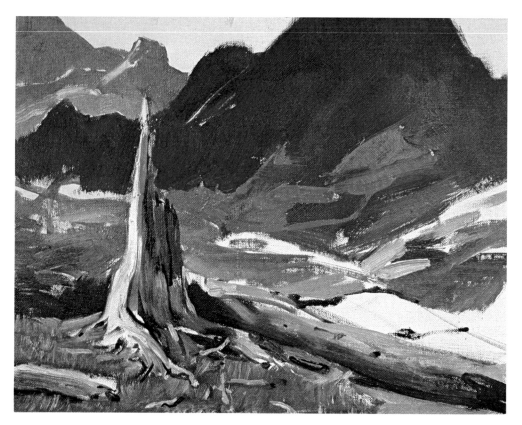

Step 6. To suggest snow at the base of the dark mountain, a bristle brush applies thick strokes of white tinted with the slightest touch of ultramarine blue and burnt umber. A bristle brush completes the sunlit grass with viridian, yellow ochre, a little cadmium red, and white. The top of the fallen trunk—and the log in the lower left area—are enriched with thick strokes of the snow mixture. Then a round, softhair brush picks up a darker version of the mountain mixture to add some evergreens to the middleground, another dark tree at the left, and some dark strokes to the foreground. To suggest sunlight on the new tree dend grassy texture in the foreground, the brush adds strokes of the snow mixture.

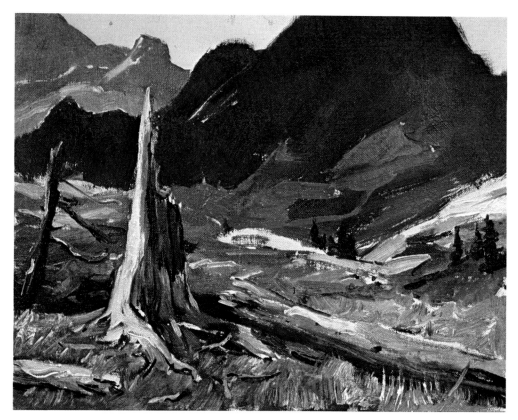

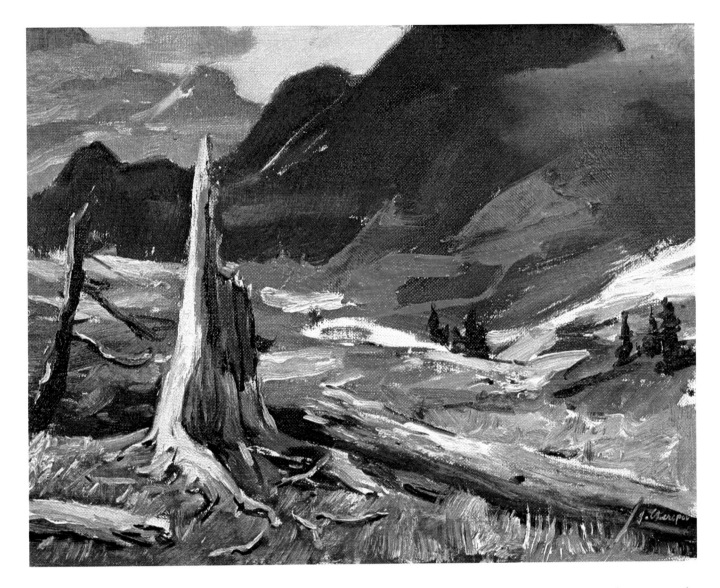

Step 7. Here's where the soft, smooth, flowing stroke of a *flat* softhair brush lends its special magic. Until now, the patches of the sky have been still bare canvas. Now the flat softhair brush covers them with a smooth, fairly fluid mixture of yellow ochre, burnt sienna, and white, cooled with the slightest hint of phthalocyanine blue. Then, with more blue added to this mixture and the paint diluted with plenty of medium, the softhair brush adds a cloud to the sky in the upper left—and carries this cloud over the mountains. The cloud tone blends softly with the underlying mountain color. The softhair brush creates a more dramatic effect at the extreme right. The cloud tone is carried over the edge of the mountain and blended softly into the dark undertone with a back-and-forth motion of the brush; now the mountain seems to disappear into a mysterious mist. A bit of this color is also blended into the dark mountain just behind the shattered stump. Now the distant mountains really seem remote and dramatic. Moving into the middleground, a bristle brush adds some thick strokes of snow mixture—mostly white, with just a touch of ultramarine blue and burnt umber—to the right of the stump. As usual, the final touches of texture and detail are added by the tip of a round softhair brush. Here and there the brush adds a stroke of white—tinted with a little snow mixture—to strengthen the sunlit areas of the broken trees and branches in the foreground. Then the brush picks up a really dark mixture of phthalocyanine blue and burnt sienna to strike in the last few shadow lines beneath the trunks and branches, plus a few more textural details within the shadow side of the broken stump. In the finished painting, notice the effects of aerial perspective. The only sharp details and the strongest contrasts of light and shadow appear in the foreground. The middleground is painted with much simpler, broader strokes. And the distant mountains are painted with broad, flat strokes that emphasize the simplicity of the shapes and contain virtually no detail.

Step 1. This demonstration is painted on a panel rather than on canvas. The panel is a sheet of hardboard covered with acrylic gesso. You can buy gesso panels in some art supply stores, but it's just as easy to make them yourself. Buy a tin or a jar of this thick, white liquid; add enough water to produce a milky consistency; then brush one or more coats onto the hardboard with a nylon housepainter's brush. You can see that this panel is covered with one very thin coat that shows the streaky marks of the brush. The preliminary line drawing is made with cobalt blue, burnt umber, and lots of turpentine.

Step 2. A sunny sky isn't just a smooth, uniform blue like a coat of paint on a wall, but contains lots of subtle color variations. Here's a method for capturing the subtleties of a blue, sunny sky. A bristle brush covers the sky with short, distinct strokes of cobalt blue and white. At the very top, the strokes are darker and closer together. Lower down, the strokes contain more white, and there are bigger spaces between them.

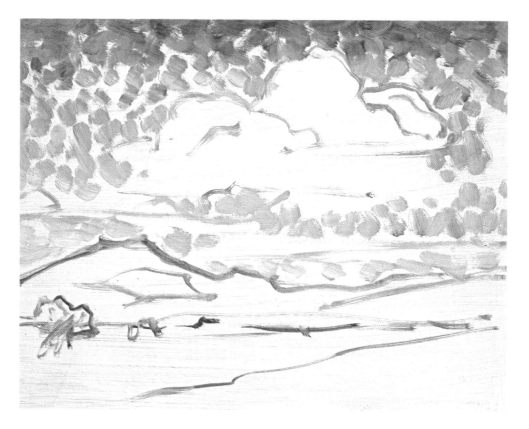

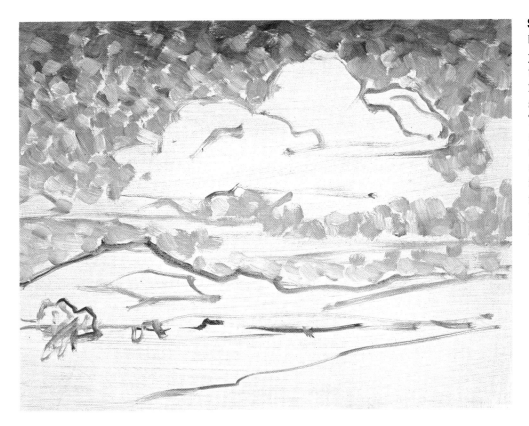

Step 3. Now another bristle brush picks up a mixture of yellow ochre and white. Like the blue tone applied in Step 2, this mixture is added to the sky in short, distinct strokes. These strokes of yellow sometimes overlap blue strokes and sometimes fill the spaces between them. Only a few yellow strokes are added toward the very top; the yellow strokes become denser further down.

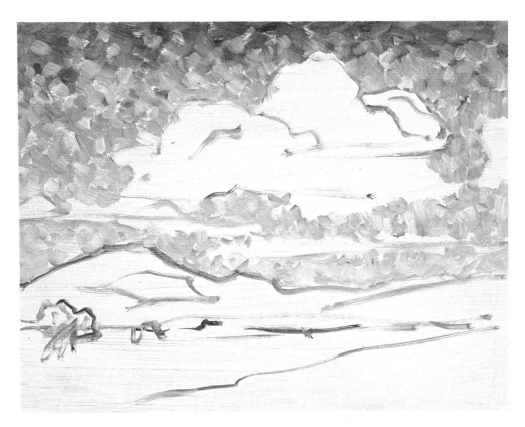

Step 4. Alizarin crimson and white are blended on the palette to a pinkish mixture. Like the yellow strokes in Step 3, a few strokes of this pink are scattered across the top of the sky. More pink strokes appear on either side of the big cloud. But the greatest number of pink strokes appear toward the horizon. Now half-close your eyes and look carefully at Step 4. You can see how these three colors are beginning to blend to create a sky that's darkest and bluest at the top, gradually growing paler and warmer toward the horizon. So far, no attempt is made to blend these strokes together. That comes next.

Step 5. With short, slightly diagonal strokes, a clean brush works its way across the sky from left to right and from top to bottom, gently fusing the blue, yellow, and pink strokes. It's possible, of course, to sweep the brush across the sky with long strokes that would blend all the colors smoothly together. But that would destroy all the subtle color variations. The short, diagonal blending strokes preserve all those subtle suggestions of blue, yellow, and pink which make this sky tone so luminous and vibrant. Now the shadowy undersides of the clouds are painted with a mixture of the same three colors (plus white) as in the sky. Notice that some shadow strokes contain more blue, pink, or yellow.

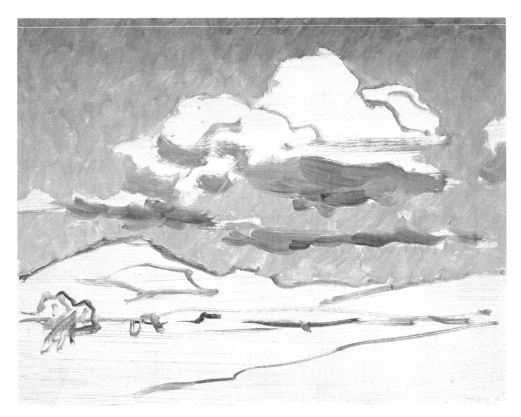

Step 6. The sunlit areas of the clouds are completed with curving strokes of white tinted with slight touches of the shadow mixture. The lights and shadows are blended softly together, but not too smoothly; you can still see the brushstrokes. The pale, distant mountains are painted with exactly the same mixture that's used for the sky—with a little more alizarin crimson in the light tones and more cobalt blue in the shadow. And the darker, nearer mountains are painted with a darker version of this mixture— more cobalt blue in the darks and more yellow ochre in the patch of sunlight at left of center. A few trees are begun with short strokes of cobalt blue and cadmium yellow.

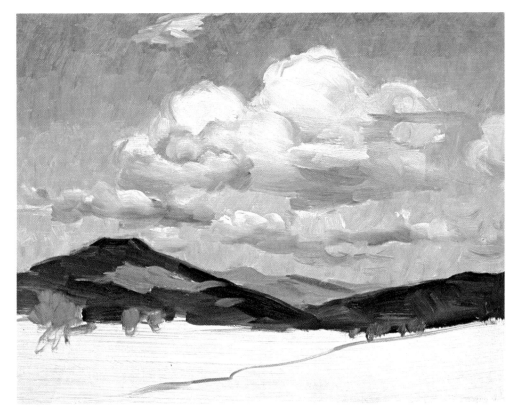

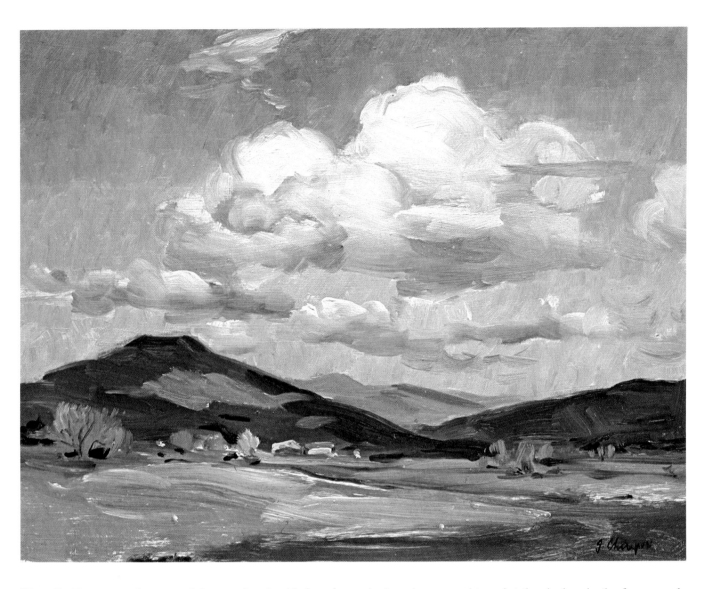

Step 7. The sunny foreground is completed with broad, rapid strokes of viridian, cadmium yellow, burnt sienna, and white. The patch of shadow that travels across the foreground to the right is mainly viridian and burnt sienna. The brilliant sunlight at the center of the foreground is almost pure white, tinted with the grassy mixture. Notice that the foreground strokes aren't smoothly blended: some contain more viridian; others contain more cadmium yellow or burnt sienna. The last few touches are the trees and houses at the lower edges of the mountains. A small bristle brush adds more dabs of cobalt blue, cadmium yellow, and a little burnt sienna to suggest additional trees as well as some white tinted with a little yellow ochre to suggest the sunlit walls of houses and the sunlit tops of the trees. The job is completed with the tip of a round, softhair brush that picks up a mixture of ultramarine blue and burnt sienna to add some shadow lines under the trees, a few dark strokes to the mountains, and a dark line along the road just beneath the houses. The same brush adds a few strokes to suggest a trunk and branches within the tree at the extreme left—this

is the mixture used to paint the shadow in the foreground. This brush adds some final warm touches: a line of burnt sienna for the road, some more lines of burnt sienna at the bases of the mountains, and a single stroke of burnt sienna for the top of one house. The brushwork deserves close study. The blue sky consists almost entirely of short, slightly diagonal strokes. In contrast, the clouds are painted with horizontal and arc-like strokes that match the curves of the forms. Most of the strokes in the landscape are long horizontals and diagonals that follow the contours of the terrain. Since this is primarily a sky picture, the clouds are painted with the greatest sense of detail, while the landscape is painted with an absolute minimum of strokes. On the smooth gesso panel, it's *possible* to use a flat softhair brush to blend all the strokes together and create uniform tones that eliminate the marks of the brush—but this would produce a lifeless picture! Instead, each stroke is allowed to show clearly. The smooth panel actually emphasizes the vitality of the brushwork.

Step 1. A sunset usually displays a particularly dramatic pattern of dark and light shapes. The dark landscape and dark clouds are silhouetted against the pale tones of the sky. These dark and light shapes, in turn, are reflected in the water. It's important to define these shapes carefully in the preliminary brush drawing, which outlines the silhouettes of the mountains, the clouds, and the shoreline. The combination of cobalt blue, alizarin crimson, and yellow ochre is particularly effective for sky pictures, as you've already seen. So this mixture is diluted with turpentine for the initial brush drawing.

Step 2. The darkest, most sharply defined shape is painted first. The mountains at the horizon are brushed in with a rich, dark mixture that's mostly cobalt blue, plus a little alizarin crimson, yellow ochre, and white. Just below the shoreline, the reflection of these mountains is added to the water. With this dark note clearly defined, it's easier to determine just how light to make the sky and water. It's also easier to paint the dark clouds, which must be slightly lighter than the dark landscape.

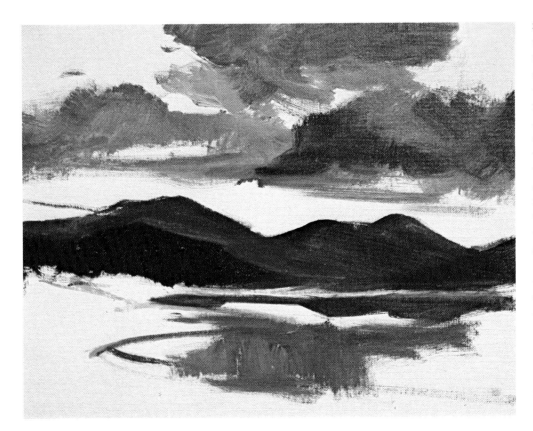

Step 3. Still working with this same color combination—cobalt blue, alizarin crimson, yellow ochre, and white—a bristle brush scrubs in the shapes of the clouds. As you can see, this color combination is amazingly versatile. The cool, dark tones contain all of these colors, but the mixture is dominated by cobalt blue. The warm tone at the center contains less cobalt blue and is dominated by alizarin crimson and yellow ochre. Strokes of these mixtures are carried down into the water, which always reflects the sky. And this same mixture, containing more cobalt blue and less white, defines the murky shape of a hill just below the mountain at the left.

Step 4. Leaving bare canvas for the pale patches of sky and water, a bristle brush continues to define the shapes of the shoreline. The dark mixture of the hill—mainly cobalt blue, with just a little yellow ochre and alizarin crimson—is carried downward at the left to create a spur of land that juts out into the water. The edge of the shoreline in the immediate foreground is completed with this mixture. A round, soft-hair brush adds a few small strokes of this dark tone to suggest the tips of evergreens rising above the dark hill at the extreme left. Then more yellow ochre is added to complete the warmer tone of the grassy beach. The brush handle scratches weeds into the beach at the lower left.

Step 5. Work begins on the bright patch of sky just above the horizon. A bristle brush paints thick, horizontal strokes of white, cadmium yellow, and just a little cadmium red beneath the clouds. Just above the peaks, a little more cadmium red is added. More strokes of this mixture fill the breaks within the lower edges of the clouds. And this same mixture, with just a little more cadmium red, is repeated in the water, which now reflects the forms of the peaks, sky and clouds.

Step 6. Work continues simultaneously on the sky and water, since the same colors must appear in both. The upper sky—above and between the clouds—begins with smooth strokes of cobalt blue and white at the very top. Then, as the brush works downward toward the clouds, yellow ochre and more white are added to this mixture. This process is reversed in the water: cobalt blue and white appear at the lower edge, with more white and yellow ochre added as the brush moves upward. Bright touches of sunlight are added to the lower edge of the topmost cloud with thick strokes of cadmium yellow, cadmium red, and white. And streaks of this mixture are added to the center of the bright sky.

Step 7. At the end of Step 6, the canvas is completely covered with color. The main shapes and colors are established. But now it's time to refine these shapes and colors in the final stage. A large bristle brush moves up and down over the central band of clouds, sharpening their shapes with vertical strokes of the original mixture, sometimes lighter and sometimes darker, to create a distinct sense of light and shadow. A few horizontal strokes of this tone are added to suggest streaky clouds within the sunlit strip above the peaks. And the topmost cloud is darkened with this tone. Just as the dark clouds are redefined, so are the sunlit areas of the sky. A small bristle brush adds thick strokes of cadmium yellow, cadmium red, and white at the break between the peaks, where the sun is brightest. Then a round softhair brush adds curving strokes of this mixture to brighten the lower edges of the two top clouds. Notice how a few wisps of this mixture are added at the upper left to suggest wind-blown strips of cloud. Having defined the dark clouds more clearly, the bristle brush also solidifies the dark reflections of these clouds in the water. Moving horizontally, the bristle brush blends the tones of the water at the left and in the foreground to soften the shapes so that they won't distract attention from the more dramatic shapes in the sky. The tip of a small bristle brush adds a few scrubs of the cloud mixture beneath the evergreens at the extreme left to suggest the last few rays of the light falling on the grassy shore. No more details are added. The picture consists almost entirely of broad, simple shapes. It's particularly interesting to note that this sunset consists mainly of cool, subdued colors that frame a few areas of brighter color. Sunrises and sunsets are rarely as brilliant as most beginners paint them. At this time of day, most of the landscape is already in shadow, and most of the clouds are dark silhouettes. So the key to painting a successful sunrise or sunset is to surround your bright colors with these somber tones.

Step 1. A moving stream is filled with subtle, complex detail, which is really impossible to draw at this stage. The preliminary brush drawing can do nothing more than define the edges of the shoreline with its rocky shapes; a few rocks in the water; the trunks of the trees along the shore; and their reflections in the water, along with a big, curving ripple in the lower left area. The final picture will be filled with warm sunlight contrasting with the cool tones of the rocks and water; thus the brush drawing is done with a warm mixture of burnt umber, ultramarine blue, and turpentine.

Step 2. The sunlit tones in the distant woods will reappear in the water, so these bright colors are painted first with rough, liquid strokes. The texture of the foliage and the flickering sunlight between the leaves are painted with strokes of cadmium yellow, viridian, and white. Over this goes the more shadowy tone of the woods at the right: ultramarine blue, viridian, and burnt sienna, with a touch of white. At the center of the woods, the quick, casual strokes already begin to look like clusters of leaves.

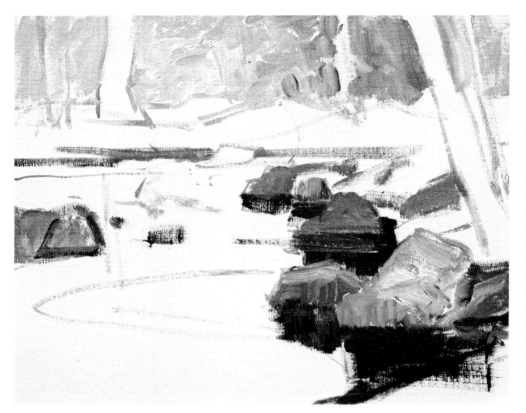

Step 3. The dark, shadowy reflections beneath the rocks are painted with rough strokes of a bristle brush that carries mixtures of burnt umber, viridian, and yellow ochre. The rocks are painted with various combinations of these three colors, plus white. You can see that the warmer rocks contain more burnt umber, while the cooler ones contain more viridian, producing a cool gray. To suggest the blocky character of the rocks and their reflections, they're painted with straight horizontal, vertical, and diagonal strokes that retain the marks of the bristles. Notice that a bit of the yellow-green foliage color is reflected in the face of the biggest rock in the lower right area.

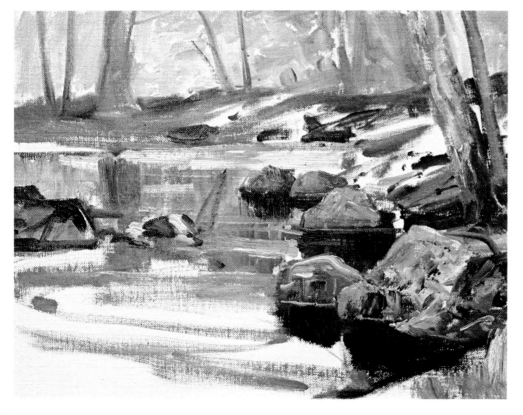

Step 4. The treetrunks are painted with burnt umber, ultramarine blue, and white. This mixture is thickly painted over the rock and the trees at the right. The biggest rock and the thickest trunk are executed with the knife, which leaves a particularly ragged texture. The shore is painted with strokes of this mixture, sometimes containing more burnt umber and sometimes containing more blue. Then a cooler version of this mixture, with more blue and white, is carried down into the water, where vertical and diagonal strokes indicate the reflections of the trees. Over this wet color, horizontal strokes of the bright foliage mixture suggest sunlit reflections.

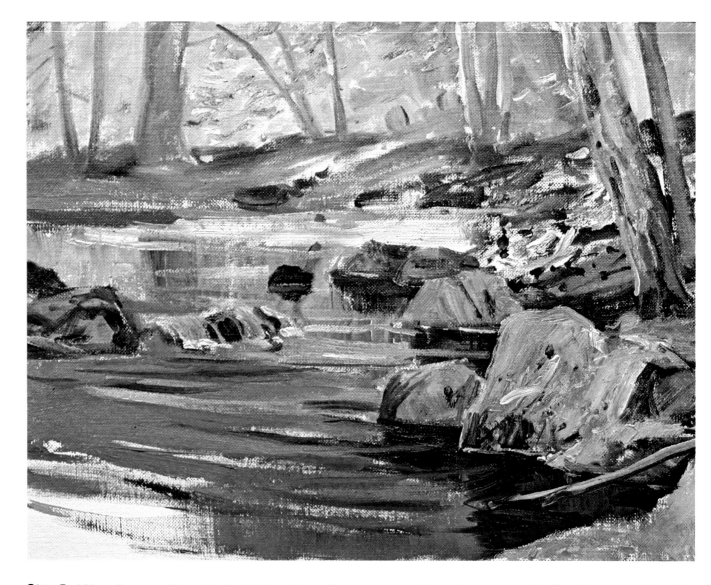

Step 5. Although you can't see the sky in the picture, the bright blue reflection of a sunny sky appears in the water. This is rendered with curving, horizontal strokes of ultramarine blue, viridian, and white, warmed with an occasional touch of burnt umber. As you can see in the foreground, these strokes curve to match the rippling movement of the stream. Horizontal strokes of this color are carried back toward the shore, alternating with strokes of the sunny foliage mixture. The dark reflections beneath the rocks are strengthened with ultramarine blue and burnt umber; shadowy streaks of this tone, lightened with a little white, are carried into the bright water. The sunlit faces of the rocks at the right are textured with thick strokes of ultramarine blue, burnt umber, and white, warmed with a touch of yellow ochre. Scattered strokes of the foliage mixture ap-

pear on the rocks to suggest the dappled pattern of sunlight falling through the leaves. The rocks in the stream at the left are darkened with ultramarine blue, burnt umber, and a hint of white. Then a small bristle brush picks up a thick mixture of white warmed with a touch of yellow ochre and carries impasto strokes across the distant stream to suggest the glare of sunlight. A bit of ultramarine blue is added to this mixture, and the same small bristle brush draws curving strokes over the rocks in the middle of the stream to suggest the water spilling over their dark forms. A round softhair brush begins to add more precise touches: some leafy strokes of viridian and cadmium yellow within the sunny forest; and some dark touches of ultramarine blue and burnt umber to suggest pebbles and other shoreline debris above the rocks at the right.

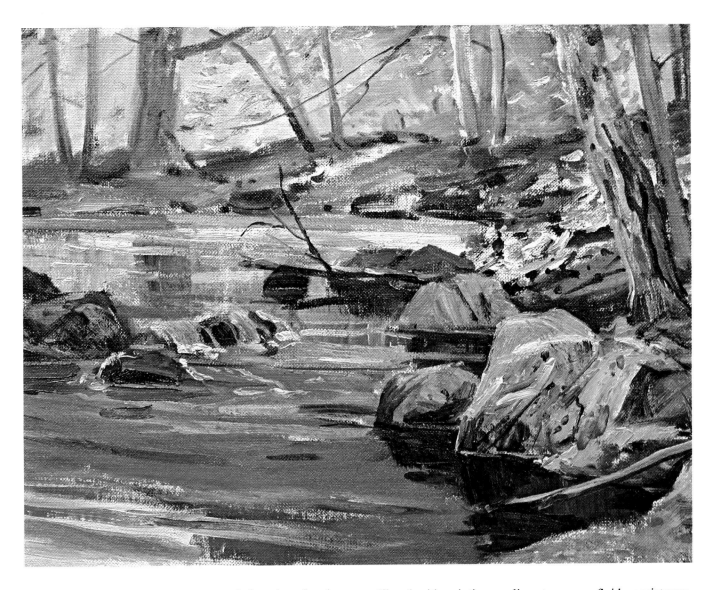

Step 6. A bristle brush adds one more dark rock to the cluster of rocks in the water at the left: a mixture of ultramarine blue, burnt umber, yellow ochre, and white, with more burnt umber in the shadow. Then this brush adds more sunny streaks of cadmium yellow, viridian, and white to the center of the stream; this bright color is softened as it blends with the underlying cool tone. In the foreground, this brush obliterates some of the dark, distracting ripples that you see in Step 5, covering them with the blue mixture—ultramarine blue, viridian, and white, with a touch of burnt umber. Adding thick, pure white to this mixture, the bristle brush makes a flash of light on the water in the lower left. The tip of a round, softhair brush picks up this same cool white to add lines and ripples of foam around and beneath the dark rocks in the water at the left. The same brush adds some streaks of sunlight to the big rock in the lower right with white and a little yellow ochre. Now the round brush picks up a dark mixture of burnt umber and ultramarine blue

diluted with painting medium to a very fluid consistency. The tip of the brush adds a slender, fallen tree to the center of the stream, tracing its branches with delicate, curving lines, and making a horizontal stroke for the reflection of the tree in the water. The tip of the brush adds dark cracks to the big rock in the lower right and to the the thick treetrunk above. Some dark branches are added among the distant woods and two more dark trunks are added in the upper right corner. The tip of the brush adds dark flecks to the distant shore, suggesting pebbles, fallen leaves, and similar details. As always, the brushstrokes and the texture of the paint reinforce the character of the subject. The water is painted mainly with long, smooth strokes of creamy color that emphasize the movement of the stream. The rocks are painted with straight, short, ragged strokes of thick color to emphasize their texture. The distant foliage is painted with quick, random strokes that go in all directions, suggesting the leaves and the flickering light.

Step 1. A "gray" winter day is actually filled with subtle, cool color. So this snow scene begins with a brush drawing in ultramarine blue, burnt sienna, yellow ochre, white, and enough turpentine to make the paint the consistency of watercolor. The drawing does nothing more than define the major shapes: the mass of the trees against the sky; the lines of the bare trunks and a couple of evergreens at the right; the edges of the pond; and the shapes of two rocks in the immediate foreground. There's no point in making these lines too precise, since they'll disappear under the brushwork that follows.

Step 2. Since the ground is completely covered with snow and the pond has turned to ice, the entire lower half of the picture is actually *water*. This means that the ground and the pond will be strongly influenced by the color of the sky. For this reason, the sky is the key to the picture and must be painted first. So the sky is covered with rough strokes of ultramarine blue, burnt sienna, yellow ochre, and white, diluted with medium to a creamy consistency so that the paint spreads smoothly.

Step 3. The misty woods are essentially the same color as the sky, but darker. So the same big bristle brush paints these woods as a rough mass of color. These woods are again ultramarine blue, burnt sienna, yellow ochre, and white—but containing more blue and less white. The darker, more greenish strokes contain more ultramarine blue and yellow ochre, suggesting that some of the trees are a bit closer to the viewer. The rough brushstrokes retain their identity, suggesting the vague forms of individual trees seen through the mist. Notice the gaps of bare canvas left for the evergreens, which will be painted later.

Step 4. The colors of the trees and sky are carried down into the frozen pond. First the pond is covered with a dark mixture of ultramarine blue, burnt sienna, yellow ochre, and white—approximately the same tone as the woods. This undertone is executed with vertical strokes. Then a paler mixture, matching the sky, is carried across the lake with horizontal strokes that suggest the glint of light on the ice. The darker pond color is drawn across the snow to suggest tree shadows. Then a round, softhair brush goes back into the wet color of the distant woods to draw trunks and branches with the original tree mixture, now darkened with more ultramarine blue and yellow ochre.

Step 5. The two evergreens are painted with short, choppy strokes of viridian, burnt umber, and yellow ochre, with some white added for the snow on the branches. Then a touch of sky color is added to some thick white, straight from the tube, and brushed over the sunlit patches of the snow on the far shore and in the immediate foreground. The thick texture of the paint accentuates the luminosity of the snow. A round softhair brush adds the dark rocks and a few touches of darkness on the distant shore with ultramarine blue and burnt umber. The rock is capped with a single stroke of the snow mixture.

Step 6. With the same dark mixture of burnt umber and ultramarine blue, plus a touch of yellow ochre, a small bristle brush paints the big tree-trunk with rough strokes. A round, softhair brush adds branches and twigs, then darkens some trunks and branches on the far shore with the same mixture—and adds more rocks. The round brush drags thick, irregular strokes of the snow mixture over the dark trunk and branches of the big tree and the dark tree across the pond. Then a small bristle brush darkens the shadows in the lower right area and adds more shadows to the pond behind the tree, using a darker version of the sky mixture. This same color appears in the vertical strokes that suggest tree reflections.

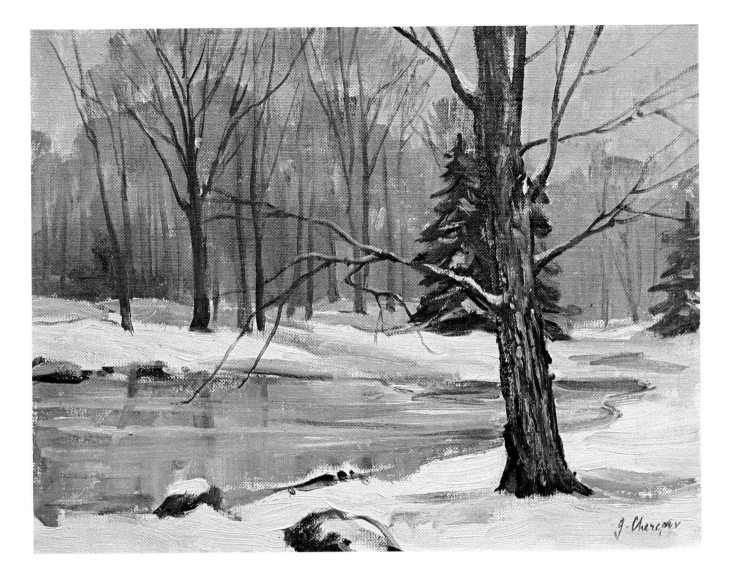

Step 7. The tip of a round, softhair brush completes the distant trees with a dark mixture of ultramarine blue, burnt umber, yellow ochre, and a little white—adding more trunks and branches with rhythmic, delicately curving strokes. A darker version of this same mixture—containing practically no white—is used to add more branches and twigs to the big tree that dominates the foreground. Then the same brush moves carefully along the tops of these dark strokes, adding lines of the snow mixture to suggest a layer of snow resting delicately on the branches. The snow mixture is tinted with a touch of ultramarine blue and burnt umber to produce the light tone of the strokes that travel down the dark trunk, completing the craggy texture of the bark. The round brush adds a few more dark strokes to define the big evergreen more sharply; this is the same mixture of ultramarine blue and burnt umber, with a little viridian. More strokes of snow are added to the branches of the evergreens. Finally, the tip of the round brush draws a few more horizontal lines of the snow mixture across the frozen lake to reinforce the feeling of light shining on the smooth ice. Remember the color mixtures in this subdued, but rich landscape. These muted tones are full of color because they contain *not one drop of black*. This lovely variety of blue-grays is created entirely with rich colors such as ultramarine blue, burnt sienna, and yellow ochre. Even the blackish tones contain a suggestion of color because they're created with rich hues such as ultramarine blue, burnt umber, and yellow ochre. At the same time, note that the snow is never pure white: snow is water and therefore reflects the tone of the sky.

Step 1. A round softhair brush draws the major shapes of the composition with ultramarine blue, burnt umber, yellow ochre, and white, diluted with turpentine. The shapes of the trees are reflected in the pond, so they're repeated in the water, upsidedown. The brush defines the trees rather casually, but carefully traces the outline of the pond—particularly the zigzag contour of the far shore. This zigzag line is important because it leads the eye back into the picture.

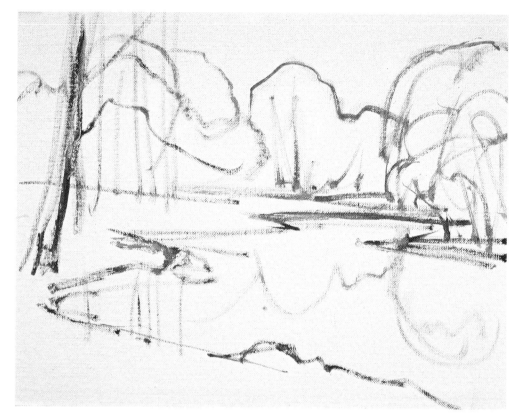

Step 2. This is one of those slightly overcast days when the sunlight shines through and lends a soft, golden glow to the sky and the water. Because the water reflects the color of the sky, these two areas are painted first. A big bristle brush covers the sky with broad strokes of yellow ochre, ultramarine blue, burnt umber, and lots of white. You can see that the sky is slightly darker at the right, where it contains just a bit more ultramarine blue and burnt umber. The water is painted with these same colors—becoming distinctly darker at lower right. Notice that the water is first painted with vertical strokes, followed by a few horizontal strokes to suggest glints of light in the foreground.

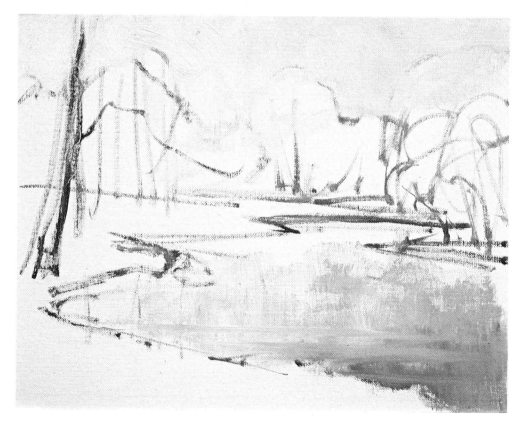

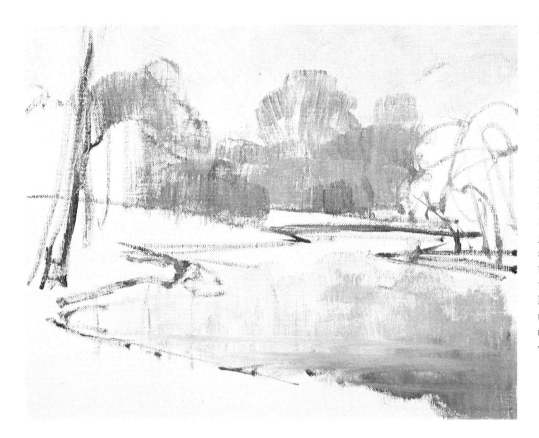

Step 3. The distant trees at the center of the picture are painted with broad, rough strokes that suggest masses of foliage. A bristle brush applies ultramarine blue, alizarin crimson, burnt umber, and white. These colors aren't mixed too smoothly on the palette, so you can see touches of blue, crimson, or umber within the individual strokes. Notice how some gaps are left between the strokes for the sky to shine through the foliage. The warmer mass of trees to the left is begun with strokes of ultramarine blue, burnt umber, yellow ochre, and white.

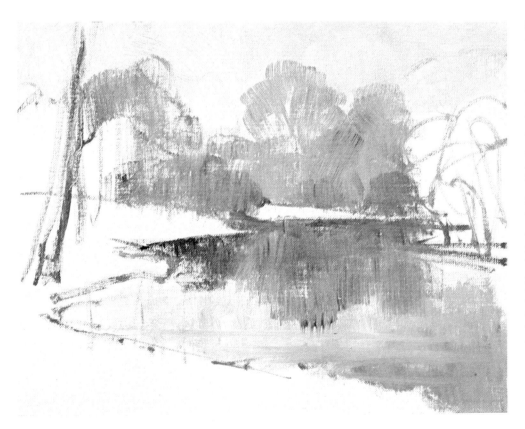

Step 4. The colors of the trees are now carried down into the water with vertical strokes. First the central tree color is darkened and cooled with a bit more ultramarine blue then stroked downward to merge softly with the wet color that already covers the pond. The strokes remain blurred and streaky—very much like reflections. Then the warmer tone of the foliage at left is darkened with a bit more burnt umber and blended into the water with rough, vertical strokes. Notice that a small tree is added to the shore at right with the same colors used for the warm foliage at left.

Step 5. The green willow at the right is first painted as a rough mass of color—a loose mixture of ultramarine blue, cadmium yellow, burnt umber, and white. This is done with a bristle brush, which carries the colors downward into the water. Then the tip of a round soft-hair brush picks up some white, faintly tinted with the green foliage mixture, to strike in some slender strokes of sunlight on the foliage. Finally, the round brush adds dark strokes of ultramarine blue and burnt umber, suggesting a trunk and shadows among the foliage. Notice how most of the brushstrokes curve downward, following the movement of the foliage of the willow.

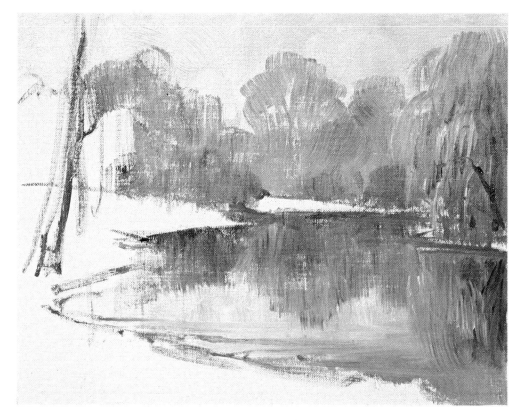

Step 6. At the left, the dark foliage is extended upward and out to the edge of the picture. The ragged brushstrokes do a particularly good job of suggesting the texture of the foliage. The brush doesn't carry too much paint and is dragged lightly over the canvas, allowing the texture of the weave to break up the strokes. The strokes combine several different color mixtures: the cool colors of the most distant trees; the green of the willow; and the warmer tone that first appears in Step 3. The dark reflection in the water is painted with vertical strokes of ultramarine blue, burnt umber, yellow ochre, and white. A round softhair brush picks up this dark mixture to add a few slender tree-trunks among the foliage.

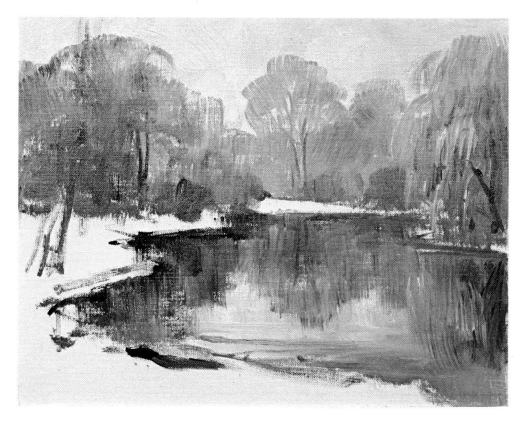

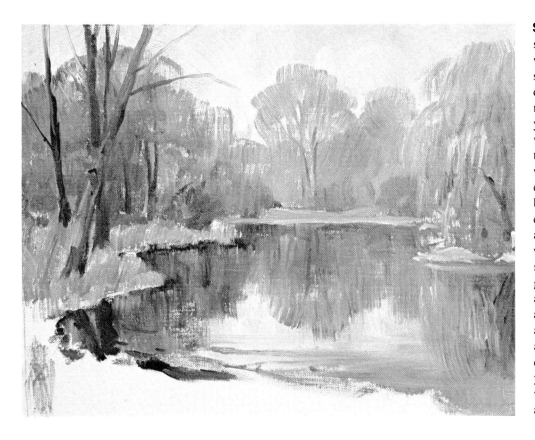

Step 7. Work begins on the shore at the left. The soft, warm tone of the dry grass is scrubbed in with vertical and diagonal strokes of ultramarine blue, burnt umber, yellow ochre, and plenty of white. A round brush paints the treetrunks and branches with this same mixture, darkened with more ultramarine blue, and burnt umber. The dark reflections of these trees are carried down into the water with thick, irregular strokes. The soft tone of the grassy mixture is carried across the distant shoreline and beneath the willow. Here and there along the shoreline a warm touch is added with a quick stroke of cadmium yellow, cadmium red, and white to suggest some bright autumn foliage.

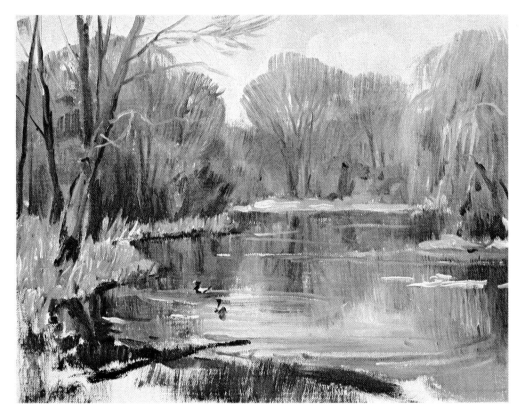

Step 8. A small bristle brush and a round softhair brush alternate, adding shadows, more trunks, and more branches to the distant foliage. These dark reflections are pulled downward into the water with vertical strokes. A bristle brush begins to scrub in the dark tone of the immediate foreground with viridian and burnt sienna. The tip of a round brush picks up some white, tinted with the original sky mixture, to add pale strokes that suggest sunlit weeds on the shore, sunlit branches on the trees, and streaks of light and ripples on the water. Quick dark and light strokes indicate two ducks swimming on the surface of the pond. In the lower left area, a single dark stroke becomes a fallen log.

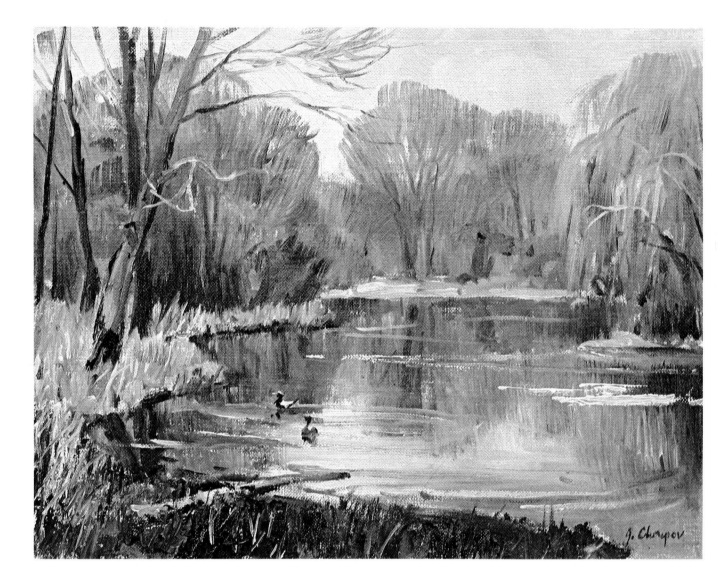

Step 9. The weedy foreground is painted first with rough strokes of yellow ochre, burnt sienna, ultramarine blue, and a touch of white. The paint is thick and rough, applied with a stiff bristle brush. Then the point of a softhair brush goes back into this thick color to pick out individual, sunlit weeds with scribbly strokes of white tinted with yellow ochre. A single stroke of this mixture renders the sunlit top of the fallen log at lower left. Now a small bristle brush and a round softhair brush wander over the surface of the painting, adding touches of darkness and stronger color to heighten the contrasts in the finished painting. Look carefully and you can see where dark notes are added to the foliage and branches with ultramarine blue and burnt sienna. Warm tones are added to the foliage and to the reflections in the water with various mixtures of burnt sienna, yellow ochre, and occasional touches of cadmium yellow or cadmium red, darkened here and there with ultramarine blue. These subtle changes are particularly evident in the willow at the right, where the shadows are darkened, more dark branches are added, and a hint of warmth is blended into the reflection. Among the foliage of the willow, the round brush adds a few strokes of ultramarine blue softened with a hint of burnt umber and white. The completed painting has stronger darks, sharper contrasts, and greater warmth. The sequence of painting operations is worth remembering. First, the sky is painted—with its reflection in the lake. This is followed by the painting of the foliage—and its reflection in the lake. At this point, the canvas is almost entirely covered with soft color. In the final stages, the painting is completed with stronger darks, warm notes, and the usual touches of texture and detail.

There Are No Perfect Subjects. One of the most famous American landscape painters had a unique system for selecting a subject. He walked for a short time—no more than ten or fifteen minutes—until he found a comfortable rock or tree stump to sit on, plus some trees that would shade his head and his canvas from the sun. (Yes, it's best to keep your painting in the shade; it's easier to see the colors.) Then he turned around three times, sat down, and started to paint whatever he was facing. This method certainly isn't recommended for everyone. But the *lesson* is important. The artist knew that, no matter how far he walked, he'd never find the "perfect" landscape subject, so he might as well settle for an "imperfect" subject, which he could transform into a picture by grouping those scattered trees, leaving out the smaller clouds, and adding some rocks that were *behind* him.

Looking for Potential. Instead of spending hours wandering about trying to discover a ready-made picture, force yourself to stop at the first reasonably promising subject. Like the professional, look for a *potential* picture. Don't worry if the trees are too scattered, the clouds are too small, and the rocks too far away. You're not a photographer, but a *painter*. You can bring all these scattered elements together to create a satisfying picture.

Finding Pictorial Ideas. There are many ways to spot a potential picture. The most obvious way is to look for some big shape that appeals to you, such as a clump of trees, the reflections in a lake, a rock formation, or a mountain peak. You organize the other parts of the landscape around this center of interest, deciding how much foreground, background, and sky to include, then bringing in various "supporting actors" such as smaller trees, rocks, and more distant mountains. Still another approach is to look for some interesting color contrast, such as the hot colors of autumn trees against a background of blue-green evergreens, or the bright colors of a clump of wildflowers against the somber background of a gray rock formation. You might also be intrigued by a contrast of light and shadow, such as a flash of sunlight illuminating the edges of treetrunks in dark woods. Or you might discover an idea for a picture in a contrast of shapes, such as the long, low lines of the plains contrasting with the round, billowing forms of the clouds above.

Orchestrating the Picture. Having found your subject, you still have to decide how to organize the various elements that make a picture. You can't just stick that clump of trees or that rock formation in the middle of the painting, include a little sky and a little background, and then go to work. Just as a famous star needs a supporting cast, the focal point of your picture needs some secondary elements. If the dominant shape in your picture is a big tree, place it a bit off center and balance it against some smaller trees—which will make the big tree look that much bigger. A mountain peak will look more imposing with a meadow and some low hills in the foreground, plus some paler, more distant peaks beyond. If those smaller trees, that meadow and hills, or those distant peaks aren't exactly where you want them, you can *move* them to the right spot in the picture. If they're too big or too small, don't hesitate to change their scale.

Using a Viewfinder. Many landscape painters use a very simple tool to help them decide what to paint. Take a piece of cardboard just a bit smaller than the page you're now reading. In the center of the cardboard, cut a window that's about 5″ x 7″ (125 mm x 175 mm). Hold this viewfinder at a convenient distance from your eye—not too close—and you'll quickly isolate all sorts of pictures within the landscape, far more pictures than you could paint in a day. You can also make a viewfinder simply with the fingers of both hands.

Make It Simple. Knowing what to leave out (or take out) is just as important as deciding what to put into a painting. Nature offers you an infinite amount of detail, and it's tempting to try to load it all into the picture. But you can't include everything. It makes the job of painting much harder and bewilders the viewer. So don't try to paint every treetrunk, branch, twig, and leaf in the forest. Pick out a few trunks and a few branches; try to paint the leaves as large masses of color. Don't try to paint every cloud in the sky, like a vast flock of sheep, but focus on a few large shapes, even if it means merging several small clouds into a big one—and just leaving out a lot of others. Don't try to paint every rock on the beach; pick out a few large rocks for your center of interest, then include some smaller ones to make the big ones look bigger.

Don't divide your landscape into two equal halves by placing the focal point of the picture in the dead center. Here, the trunk of the big tree runs right down the middle to create a dull, symmetrical composition. To make things worse, the base of the tree sits right on the lower edge of the picture, while the top of the tree pushes right out past the upper edge. So the composition looks terribly crowded.

Do place the focal point of your picture off center. Now the trunk of the big tree divides the picture into unequal parts. The composition is also improved because the big tree at the right is balanced by a smaller tree at the left. And there's more room above and below to give the composition a more spacious feeling.

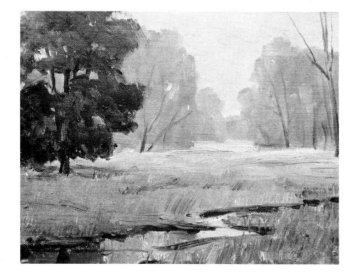

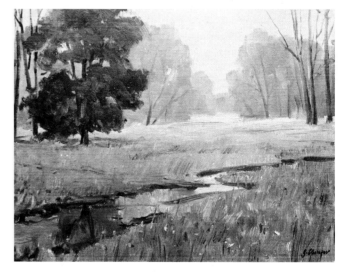

Don't run the horizon straight across the center of the picture. Here, the distant edge of the meadow becomes a line that divides the composition into two equal halves, above and below. This is just as dull as a big treetrunk that splits the composition into two vertical halves.

Do place the horizon above or below the center of the picture. Now the distant edge of the field is slightly above center. This not only divides the canvas into more interesting shapes, but allows more space for the meadow and for the stream that carries the eye back into the picture.

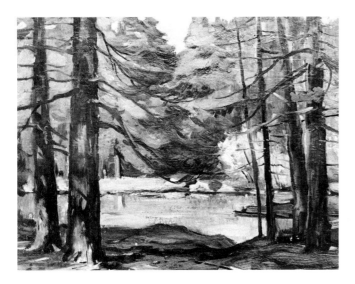

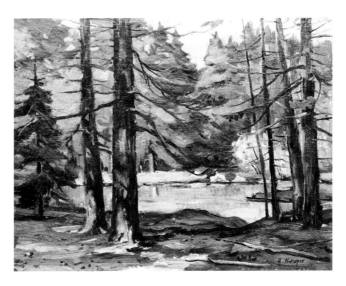

Don't construct a kind of symmetrical "frame" that turns the center of the picture into a box. Here, you can see that the dark trees have been placed neatly around the sunlit rectangle of the lake and the distant foliage. The rectangle is right in the dead center of the picture. This is another one of those dull compositions.

Do place your "frame" off-center. Now the trees have been moved to the right, which means that the sunlit box between the trees is also further to the right. And the sunlit focal point of the picture is now balanced by a dark tree at the left. This is obviously a more interesting composition.

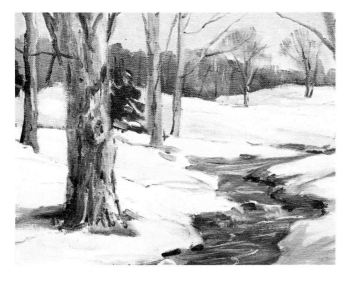

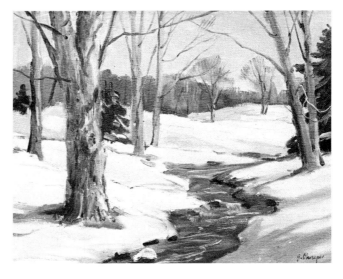

Don't lead the eye out of the picture. The dark stream enters the composition at the bottom and winds around to the right, carrying the eye out past the right edge. You can make this same mistake with a road, a fence, or any compositional element that leads the eye across the landscape.

Do lead the eye into the picture and block any exit. Now the stream has been moved further to the left. It still winds around to the right, but the eye is stopped from leaving the picture—those trees at the right side form a barrier. So the eye travels up the stream and then bounces back into the center of the composition.

Trees in Side Light. When you paint any outdoor subject, it's important to determine where the light is coming from. The direction of the light will determine how much light and how much shadow appear on any subject—such as these trees. In this landscape, the light is coming from the left. Thus, the left sides of the foliage and the trunks are in sunlight, while the rest is in shadow. And shadows are cast on the ground to the right. This kind of lighting creates a strong contrast between light and shadow, giving the trees a dark, dramatic form.

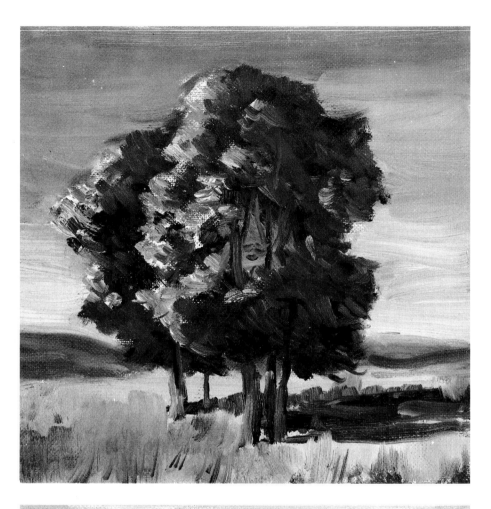

Trees in 3/4 Light. Now the light is coming from the left, slightly *above* and slightly in *front* of the trees. More of the foliage is in light and less is in shadow. The cast shadows on the ground are also shorter because the sun is higher in the sky. These are the same trees you see in the preceding illustration, but the distribution of light and shadow is totally changed.

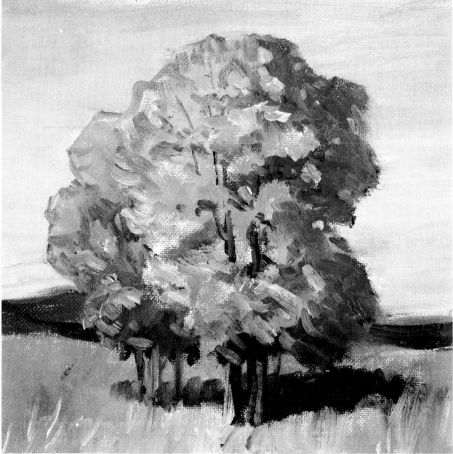

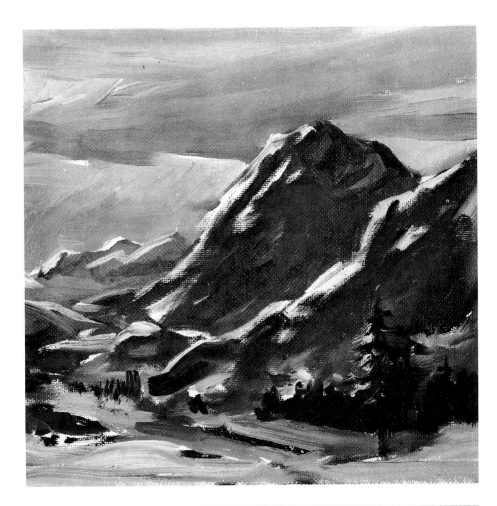

Mountains in Back Light. The sun is low in the sky and behind the mountains. Just a bit of light creeps around the edges of the peaks, but they're almost entirely in darkness. This lighting effect is most common at sunrise and at sunset, when the big shapes of the landscape become dark silhouettes. Landscape painters often choose this type of lighting to create a dramatic mood.

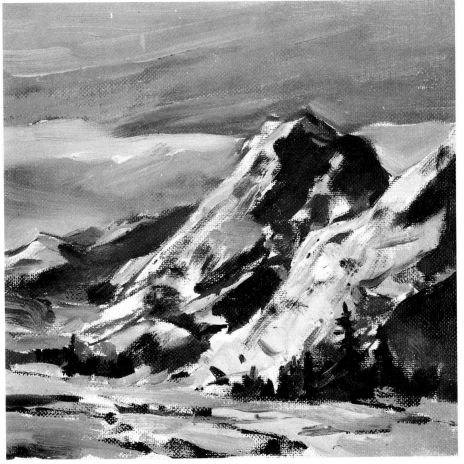

Mountains in 3/4 Light. Now the light comes from slightly above the peaks and from the left. This enlarges the sunlit planes and reduces the shadow planes. The landscape is sunnier, but less dramatic. Try painting the same subject—whether it's trees, peaks, rocks, or whatever—at different times of the day to see how the light alters their forms.

Stream in Perspective. The zigzag shape of this stream, cutting across the meadow, looks random and unpredictable. But the stream clearly moves back into the distance—the shapes obey the "laws" of linear perspective.

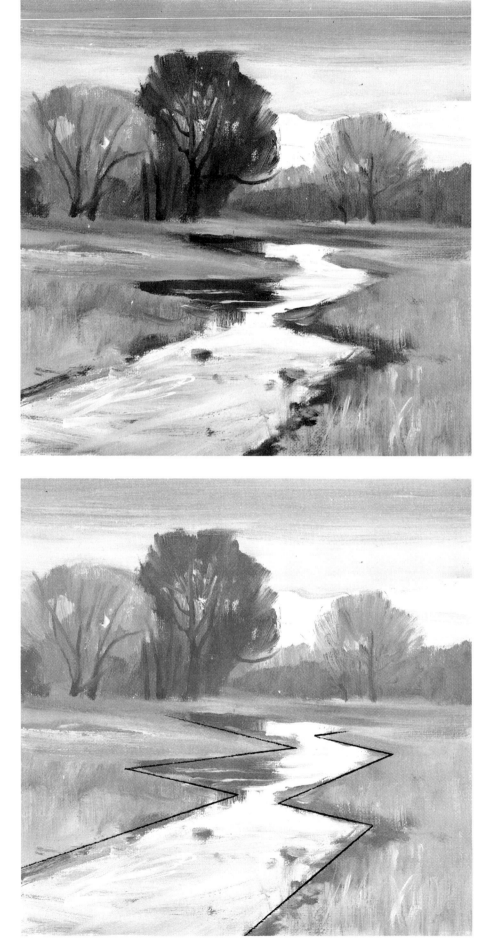

Diagram of Stream. According to the "laws" of linear perspective, parallel lines seem to converge as they approach the horizon. The diagram simplifies the stream into a series of oblong boxes. Notice how the sides of the boxes gradually converge as the oblong shapes approach the distant horizon. This is an effect you commonly see in railroad tracks, walls, and other geometric objects. But it's just as true when you're painting irregular forms such as a stream or a winding road.

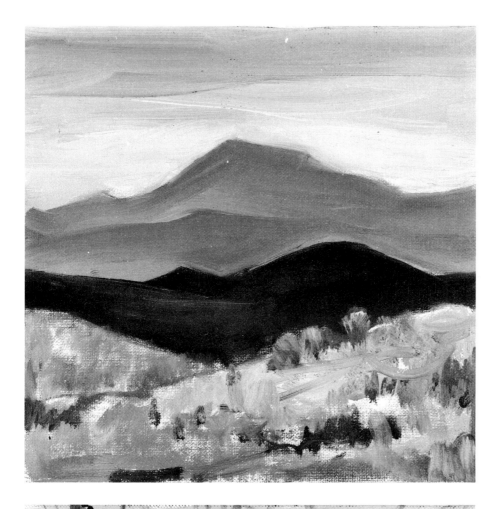

Mountain Range. Aerial perspective is actually much more common—and much more useful—in landscape painting than linear perspective. According to the "laws" of aerial perspective, near objects are brightest, exhibiting the most detail and the sharpest light and dark contrast; distant objects grow paler and less detailed, exhibiting less contrast between light and shadow. These phenomena are obvious in this mountain landscape, where the sunlit fields and the nearby slope are more distinct than the paler forms of the slopes in the distance.

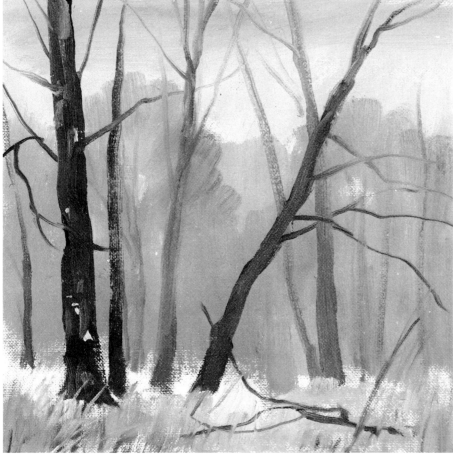

Woods, Near and Far. The effects of aerial perspective are just as obvious in this woodland landscape. In the immediate foreground, you can see the details of grasses, weeds, trunks, branches, and twigs. The more distant trunks grow paler and less distinct. And the mass of trees in the remote distance becomes a pale blur.

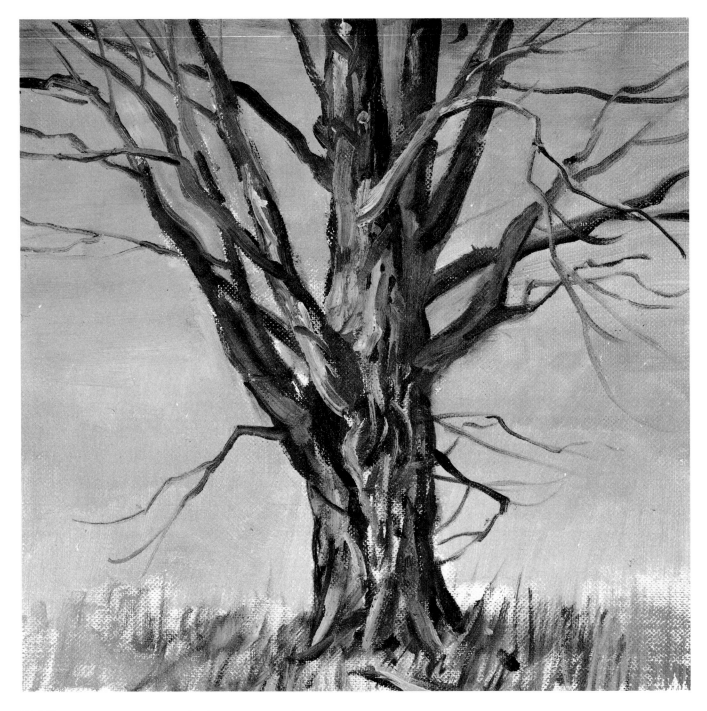

Old Tree. As you study any landscape, try to plan your brushstrokes to reflect the unique character of the subject. This rugged old tree is rendered with wavy, ragged strokes that emphasize the craggy texture of the bark. The lighter strokes are particularly thick, creating the feeling that the paint would be rough if you touched your fingertips to the surface of the canvas. The roughness of the paint actually reflects the roughness of the old tree.

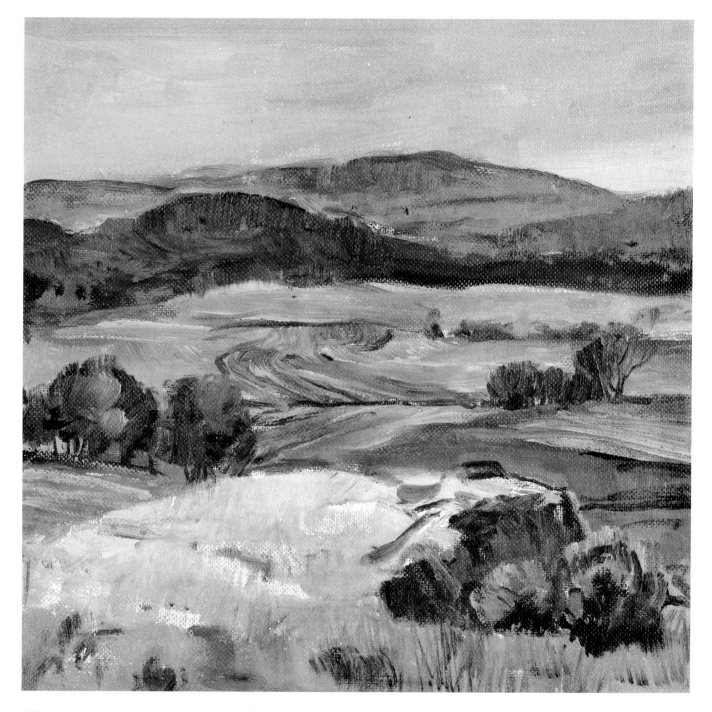

Hilly Landscape. Brushstrokes, properly planned, can also enhance the feeling of three-dimensional form in the landscape. Here, the *direction* of the brushwork actually seems to model the forms. The faces of the distant hills are painted with vertical strokes. The rolling meadow in the middleground is painted with curving strokes. The flat areas of the meadow are painted with horizontal strokes. On the trees, the clusters of foliage are painted with short, curving strokes that seem to "grow" like the foliage itself. In the immediate foreground, the scrubby grass and weeds are rendered with up-and-down scribbling strokes. Thus, the form of each stroke reinforces the form of the subject.

Step 1. The rugged old tree begins with a brush drawing that already reflects the character of the subject. The strokes are made with quick, choppy movements of the hand. The brush doesn't carry too much color, so the texture of the canvas breaks up the strokes and makes the brush mark seem more ragged.

Step 2. The tip of a small filbert reinforces the darks of the trunk and adds shadows with rough, ragged strokes. The brush doesn't move too carefully over the surface of the canvas, but makes erratic, jerky, scrubby movements. Thus, the strokes have a ragged, irregular quality that matches the weathered form and texture of the tree.

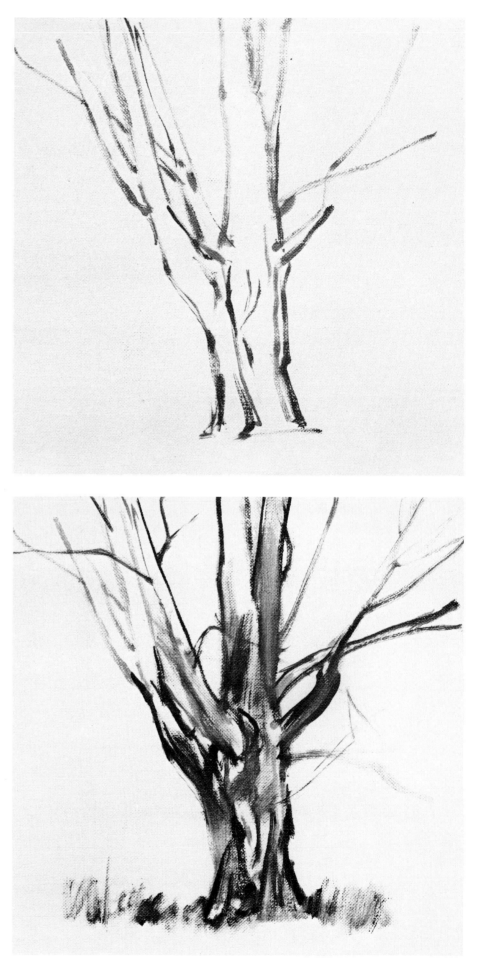

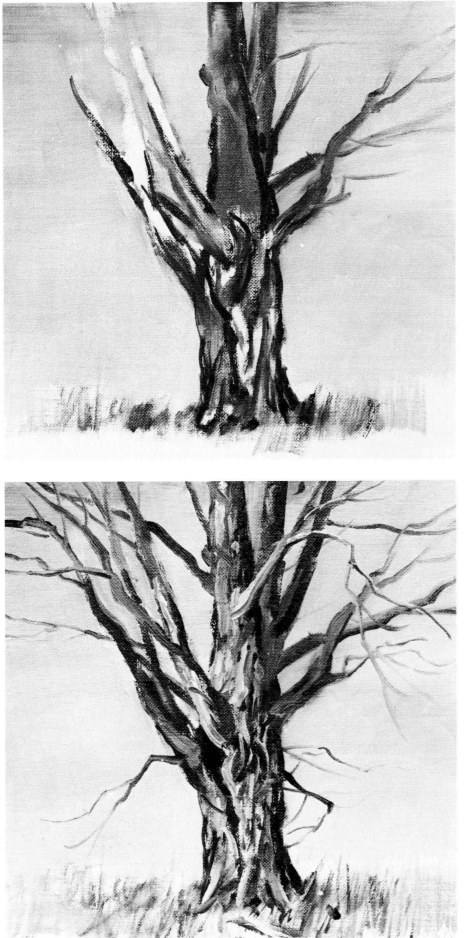

Step 3. A flat softhair brush spreads a smooth, even sky tone around and behind the tree. The smoothness of this tone emphasizes the roughness of the tree by contrast. Then a bristle brush begins to scrub in the dark tones of the trunk, blurring and softening some of the original brushwork applied in Steps 1 and 2. So now the tip of a round softhair brush returns to reinforce some of the dark lines. The brush is pressed down hard, spreading the hairs so that the strokes have a more ragged quality. The round brush also re-establishes some of the dark branches at the right—which were obliterated by the tone of the sky.

Step 4. The dark trunk, branches, and twigs are completed with quick, choppy strokes of a small filbert and a round softhair brush. Then the filbert and the softhair alternate, applying thick lines of pale color over the darks to emphasize the sunlight falling on the weathered, irregular texture of the bark. These light strokes contain no painting medium. The color is thick, just as it comes from the tube. The strokes actually stand up slightly from the surface of the canvas. The texture of the paint appears to match the texture of the subject.

Step 1. The preliminary brush drawing is made with very fluid color diluted with enough turpentine to make the strokes flow smoothly and rhythmically. The round softhair brush carefully traces all the curving forms of this hilly landscape.

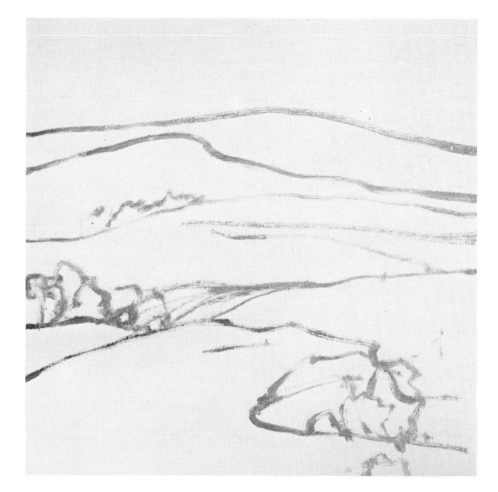

Step 2. The bristle brush now begins to model the forms in the foreground. Vertical strokes move down the shadowy side of the cliff in the lower right. At the left, a triangle of flat land is painted with horizontal strokes. Above this, the dark trees are modeled with short, rounded strokes that begin to match the round masses of the foliage.

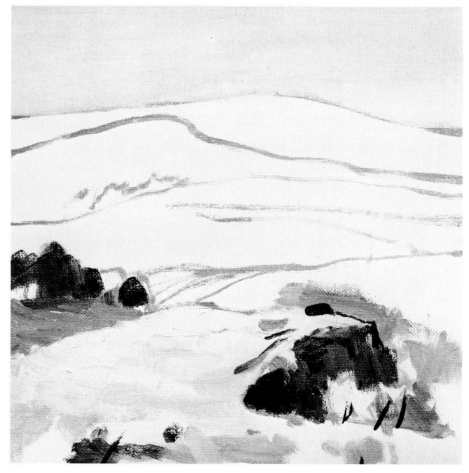

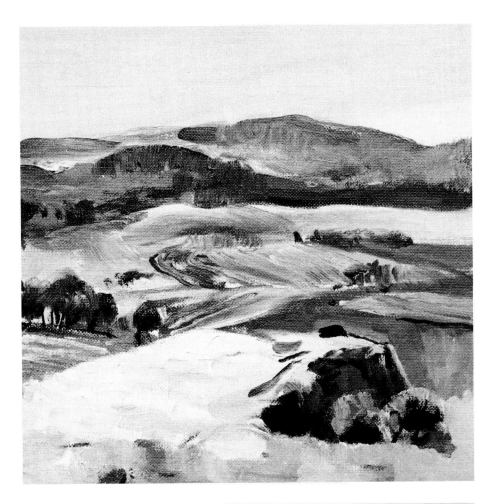

Step 3. The placid sky is covered with smooth, horizontal strokes that become almost invisible. The rounded forms of the distant hills are first painted with curving horizontal strokes. These are followed with short, vertical strokes that suggest the vertical, shadowy faces of the cliffs. The brush moves in rhythmic curves to match the rounded forms of the meadow. The flat portions of the meadow are rendered with straight, horizontal strokes.

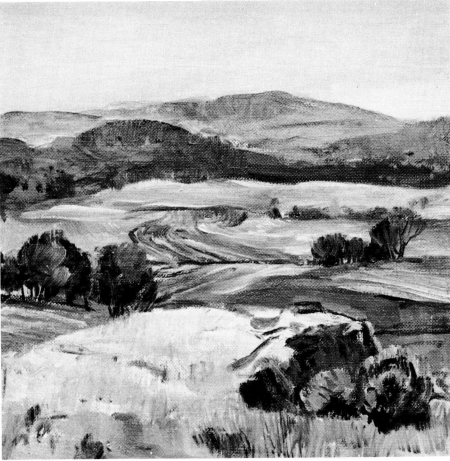

Step 4. To reflect the growing forms of the trees, the dark strokes seem to spring upward from the ground. The pointed brush draws long rhythmic, curving lines across the meadow and short, rhythmic lines for the treetrunks. The foreground is completed with scrubby strokes in which the brush is moved up and down to suggest the texture of the grass and weeds on the nearby hilltop.

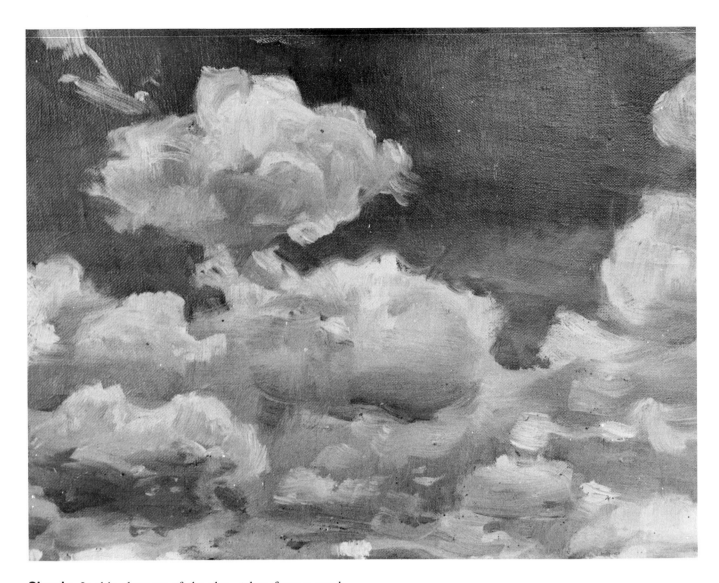

Clouds. In this close-up of the sky—taken from a much larger landscape painting—you can see clearly how the brushstrokes express the texture, the form, and even the movement of the subject. Clouds are never motionless, but are always pushed along by the wind, which gradually tears them apart and reshapes them. The shadowy undersides of these clouds are painted with soft, arc-like, curving strokes that not only express the rounded forms of the clouds, but also make them appear to be moving across the sky. The sunlit tops of the clouds, torn by the wind, are painted with short, curving, slightly nervous strokes that blur the edges of the cloud shapes. The brushwork in the lower right area is particularly interesting. Notice how the small cloud shapes are painted with short irregular strokes that seem to be dragged across the sky by the wind. The entire sky seems to be in motion. You can feel the wind blowing through it.

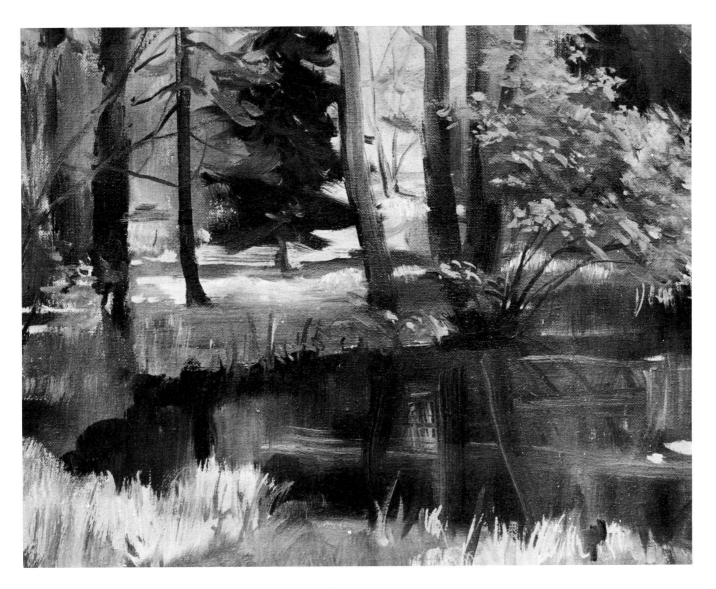

Woods and Pond. The diverse forms and textures of the woods—filled with treetrunks, foliage, grass, weeds, and water—require varied brushwork. The trunks are smooth, long, slightly curving, vertical strokes. To render the dark shape of the evergreen with its jagged masses of foliage, the brush presses down and pulls outward to the side. The flowering tree in the upper right area is painted with quick touches of the very tip of a round brush—the brush is pressed lightly against the canvas and then quickly pulled away. The dark pond is an interesting combination of vertical, horizontal, and diagonal strokes. First, the blurry tones of the reflections are painted with vertical movements of the brush. Then the reflections of the trunks and branches are painted with darker verticals and diagonals. Finally, the streaks of light on the surface of the pond are painted with slender, horizontal strokes. The weedy underbrush surrounding the pond is painted with scrubby, up-and-down strokes. None of this brushwork happens by accident. You've got to get into the habit of planning the stroke before you touch the brush to the canvas.

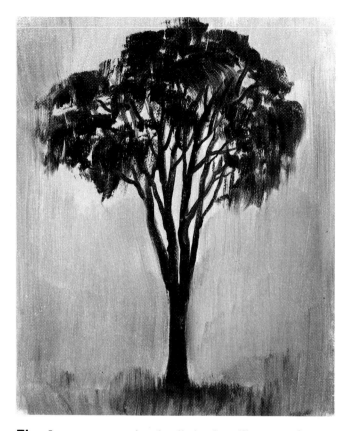

Elm. Learn to recognize the distinctive silhouette of every tree. The elm's trunk and branches are essentially vertical, gradually fanning out. The foliage forms a curving umbrella.

Apple. The branches of the apple tree are more jagged and unpredictable, reaching out in all directions. The foliage is sparse and scrubby, revealing the branches.

Oak. The branches of the oak grow upward and outward from the thick, sturdy trunk. The dense rounded mass of foliage conceals many of the branches.

Spruce. The spruce is like a series of arrowheads, pointing upward. The outer edges form a zigzag pattern. The dense foliage hides the trunk and branches.

PART THREE

SEASCAPES IN OIL

Seascapes in Oil. Perhaps because life first emerged from the sea, human beings in general—and artists in particular—are fascinated by the seashore. Every year, as soon as the weather is warm enough, painters set up their easels and their paintboxes on the beaches, rocks, and headlands of coastlines all over the globe. Many of them love to paint the classic drama of waves crashing against rocks and flinging sunlit foam into the sky—and this book will show you how to paint this romantic and challenging subject. But the word "seascape" means a lot more. You'll also learn how to paint so many different coastal subjects—from the graceful shapes of sand dunes to the jagged forms of cliffs looming over the water—that you'll soon discover that the landscapes of the coastline are as diverse and fascinating as any landscapes you'll find inland. Once you begin to paint seascapes (or coastal landscapes) you'll discover why so many great artists have devoted their entire lives to depicting the infinite variety and romance of sea and shore.

Why Oil? The rich, thick consistency of oil paint seems particularly "right" for painting coastal landscapes. You can actually vary the character of the paint to suit the subject. Used straight from the tube, oil color is a thick paste that lends itself beautifully to the rough brushwork and ragged textures of rocks and headlands. Diluted with linseed oil and turpentine, oil paint becomes smooth and creamy; now it's ideal for painting waves with rhythmic strokes or painting sandy beaches with long, smooth, even strokes. The slow drying time of oil paint is also a great convenience. Working outdoors under the pressure of time and changing weather conditions, you can capture the basic forms and colors of your subject with rapid, spontaneous strokes. You may want to stop there. Or you may want to take the painting home and do some more work on it, refining certain colors or adding details at your leisure. Since oil paint stays wet for several days, you have the time to start a painting outdoors and finish it indoors. Of course, you can also regard the outdoor painting as a "color study" from which you can paint an entirely new and more ambitious picture at home.

Basic Techniques. The two fundamental tools of the oil painter are the bristle brush and the softhair brush. The noted painter George Cherepov begins by showing you how these two different kinds of tools behave, individually and in combination. First you'll see how surf and rocks are painted with the rough strokes of the bristle brush, capturing the dramatic textures of the subject. Then you'll see how bristles and softhairs are combined to paint waves, which require more delicate and controlled brushwork. You'll see how brushstrokes are used to model the rounded forms of clouds and the graceful shapes of dunes. In oil painting, the traditional "working sequence" starts with thin color and gradually works toward thicker color; you'll see how this is done in a study of rocks.

Color Sketches. The color section begins with some sketches that teach us important lessons about the colors you'll find along the coastline. Light and weather can make radical changes in the colors of any subject, as you'll see in color sketches of waves, surf, rocks, sand, and skies on a sunny day and then on an overcast day. You'll see some close-ups of sections of George Cherepov's paintings, in which you'll observe how he handles thick and thin color, as well as warm and cool color, in studies of rocks, water and sky.

Painting Demonstrations. Then there are ten step-by-step painting demonstrations in which Cherepov shows how to handle the most popular coastal subjects. The first three demonstrations deal primarily with water, showing how to paint the subtle colors and rolling action of waves; the violent movement of surf; and the calm, reflective surfaces of tidepools. You'll watch Cherepov paint a salt marsh, where the sea invades the land and creates "islands" of marsh grass. Three demonstrations concentrate on weather, light and atmosphere: the brooding colors of a storm at sea; the luminous tones of a sunrise along the shore; and the delicate, mysterious tone of fog. Finally, Cherepov demonstrates how to paint the solid shapes of the coastal landscape: craggy rock formations; a majestic headland rising from the beach; and the sunlit tones of sand dunes.

Special Problems. In this last section, you'll read about how to select seascape subjects. You'll find suggestions about how (and how not) to compose a successful seascape. You'll see how light can dramatically alter such subjects as rocks and clouds. You'll learn how a knowledge of perspective can help you create a sense of space in a coastal landscape. You'll see some more close-ups of finished paintings in which various types of expressive brushwork capture the special character of water and rocks. And finally, you'll learn how to recognize different kinds of wave and cloud forms.

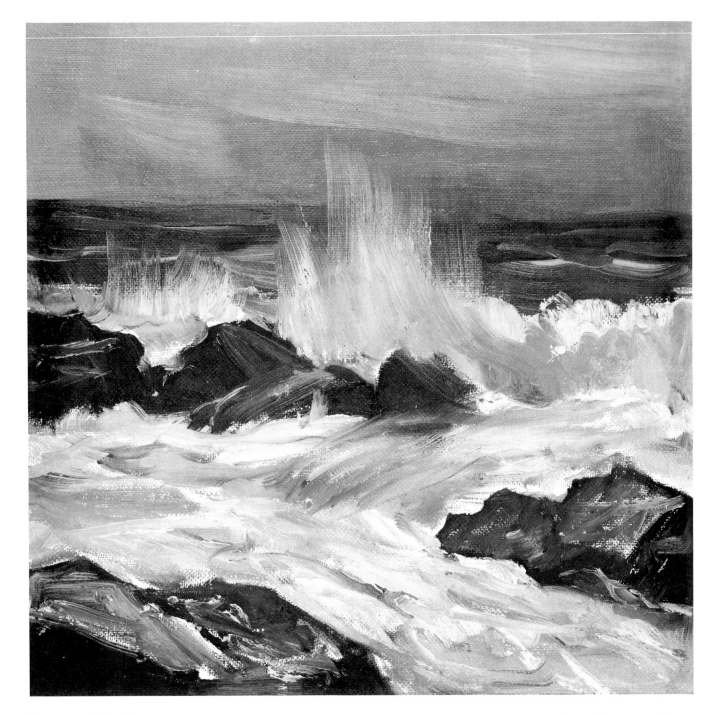

Rocks and Surf. Bristle brushes do most of the work in oil painting, and they're particularly effective for painting richly textured subjects like rocks and surf. The stiff hoghairs of the bristle brush make a firm, decisive stroke that retains the imprint of the bristles. Working with thick tube color—diluted with very little painting medium or none at all—the bristle brush makes a ragged stroke that's ideal for rendering the rough textures of these rocks. When the color is diluted with just enough medium to produce a creamy consistency, the brush makes a softer stroke that captures the movement of the foam. And when you add enough painting medium to produce a fluid consistency, the bristle brush will make soft, smooth strokes like those in the distant sky. The sky—like the rocks and surf—retains the imprint of the bristles, suggesting the horizontal movement of streaky clouds.

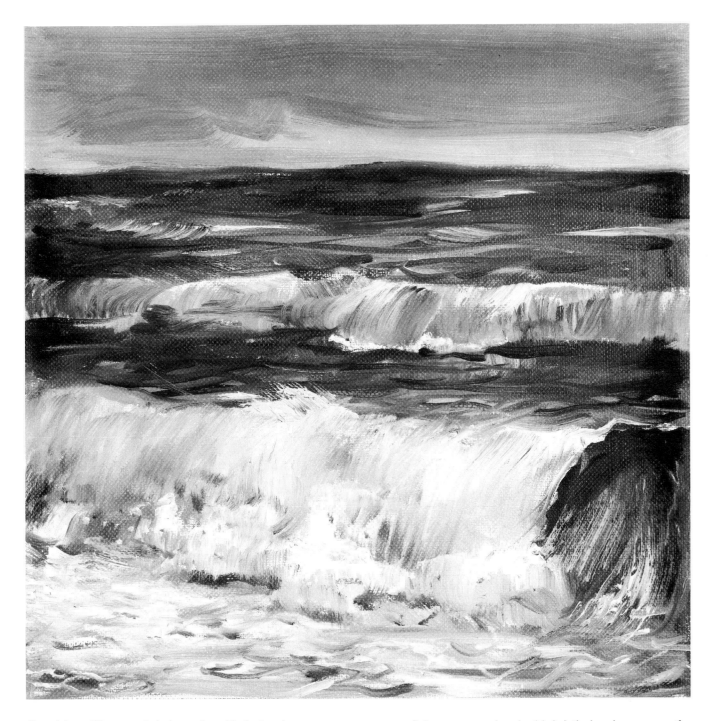

Crashing Waves. Bristle and softhair brushes are an effective combination when you're painting a subject that needs bold brushwork in some areas and smoother, more precise brushwork in other parts of the picture. In this study of crashing waves, a bristle brush captures the rough texture of the foam as the forward edge of the wave curves over and explodes. Between the crashing waves, the broad, dark tones of the sea are painted with bristle brushes, as are the broad strokes of the sky. But then the tip of a round softhair brush paints the slender, arc-like ripples that appear in the foamy water in the immediate foreground. The same brush paints the slender, horizontal strokes that define the details of the dark water between the waves and beneath the horizon.

Step 1. The tip of a round softhair brush draws the main shapes with tube color diluted with turpentine to the consistency of watercolor. (Even when the entire picture will be executed with bristle brushes, the round, softhair brush is the best tool for making the preliminary drawing.) The brush defines the horizon with a single line and then carefully defines the silhouettes of the three rocky shapes. The leaping foam also has a distinct shape—it's not just a blur—and this shape is defined as precisely as the rocks.

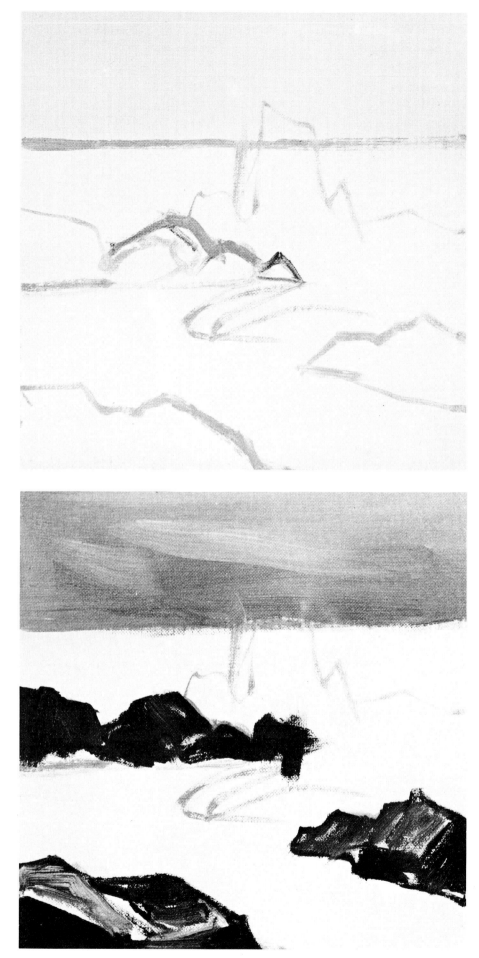

Step 2. A big bristle brush covers the sky with long, smooth strokes of tube color diluted with medium to a fluid consistency. Paler strokes suggest the horizontal movement of the clouds. Then a bristle brush picks up much thicker color—diluted with just a touch of painting medium—to cover the dark rocks with heavy strokes. The squarish strokes of the bristle brush redesign the rocks very slightly; they become more jagged and blocky. The weave of the canvas joins forces with the thick paint to capture the rough texture of the rocks.

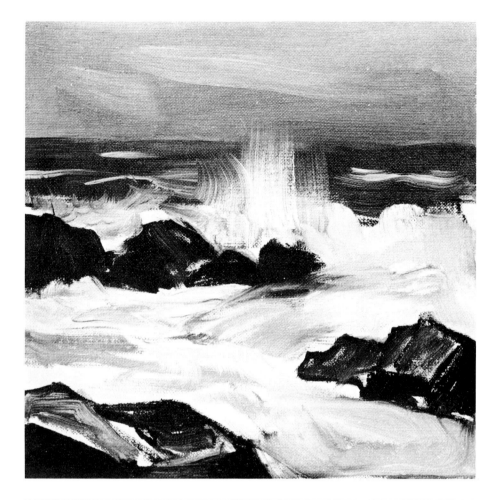

Step 3. A bristle brush covers the distant sea with dark, fluid strokes—the same consistency as the sky. Then a bristle brush picks up thicker color—diluted with painting medium to a creamy consistency—to paint the foamy surf. The movement of the brush follows the movement of the foam. The brush is pulled swiftly upward to render the flying foam behind the rocks. Then the foam flowing between the rocks is painted with big, curving strokes that follow the movement of the water. On the distant sea, a few horizontal strokes suggest foam on the tops of the waves.

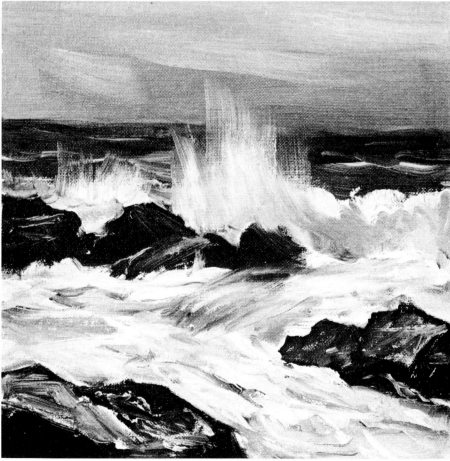

Step 4. A bristle brush pulls the flying foam further upward across the distant sea and sky. Working with thick color, a smaller bristle brush adds detail to the flowing foam in the foreground, strengthening both the lights and the shadows. Pale, thick strokes complete the tops of the rocks, which now look rough, wet, and shiny. The entire picture retains the lively textures of bristle brushstrokes.

Step 1. The preliminary drawing is executed with the tip of a round softhair brush. The strokes of the softhair brush have a spontaneous, rhythmic character that capture the gentle curves of the waves at the horizon, as well as the more erratic curves of the crashing waves in the foreground. Be sure to add enough turpentine to make the paint very fluid so that the softhair brush glides swiftly and effortlessly over the canvas.

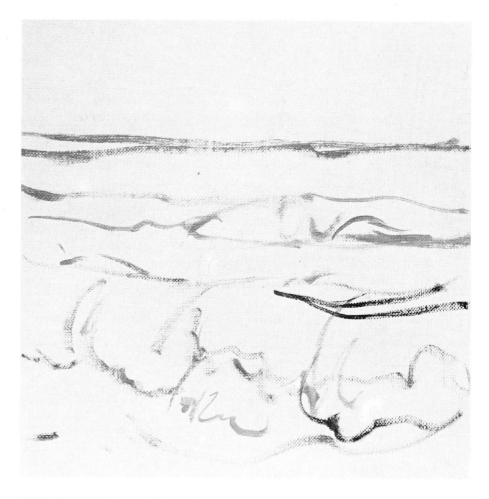

Step 2. The first broad tones are applied with a long, springy bristle brush—such as a filbert—which captures the lively movement of the distant waves beneath the horizon, then adds the darks that appear beneath the foam on the wave in the middleground. Quick movements of this bristle brush begin to add the shadowy patches on the wave in the foreground.

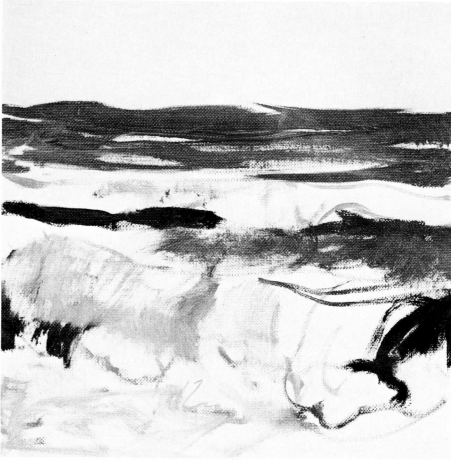

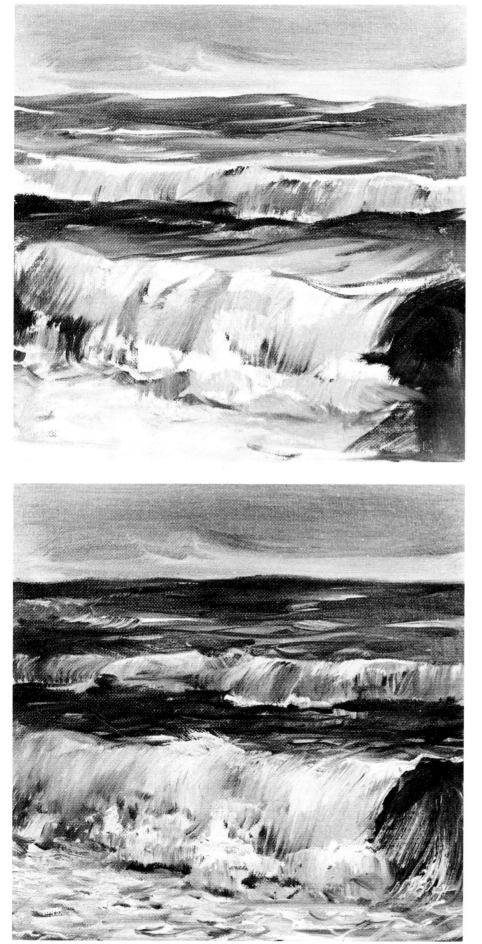

Step 3. A big bristle brush carries smooth strokes across the sky. Then the short, stiff bristles of a bright suggest the tones and textures of the rolling surf. Notice how the marks of the bristle brush capture the curving movement of the waves. The bright also darkens the shadowy inside of the wave at the lower right. Now the tip of a round softhair brush begins to add streaky, horizontal strokes to define the shining, foamy tops of the waves beneath the horizon, plus the dark ripples beneath the waves in the middleground.

Step 4. The stiff bristles of the bright complete the rolling surf with short, curving strokes of thick color. The tip of the round softhair brush completes the dark, distant sea and the dark strip of sea between the waves, with slender strokes that suggest ripples and low waves. In the immediate foreground, the round brush renders the foam-covered water with short, arc-like strokes that capture the movement of the ripples.

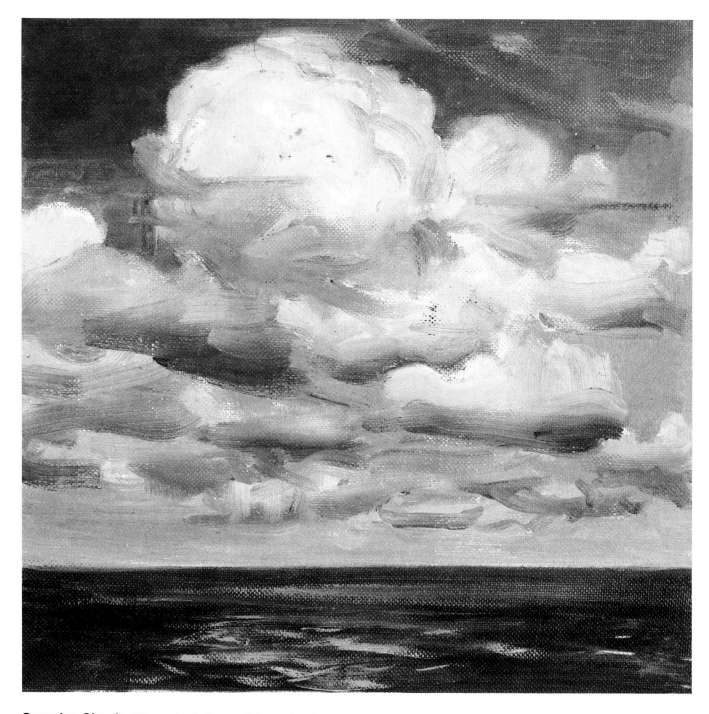

Cumulus Clouds. The majestic forms of these clouds are built by various strokes of a bristle brush. The rounded, sunlit tops of the clouds are curving strokes of thick color diluted with painting medium to a creamy consistency. The shadowy undersides of the clouds are mostly horizontal strokes of darker, slightly more fluid color containing more painting medium. This is a good rule of thumb to keep in mind: your brightest lights can be thick and opaque, while it's wise to keep your shadows thinner, more fluid, and a bit more transparent by adding more painting medium. Notice how the shadowy undersides of the clouds are blended into the sunlit areas with rough, casual strokes. The blending isn't overdone—not carried far enough to make the paint look too smooth and thereby obliterate the brushwork. It's the brushwork, after all, that gives movement to the clouds.

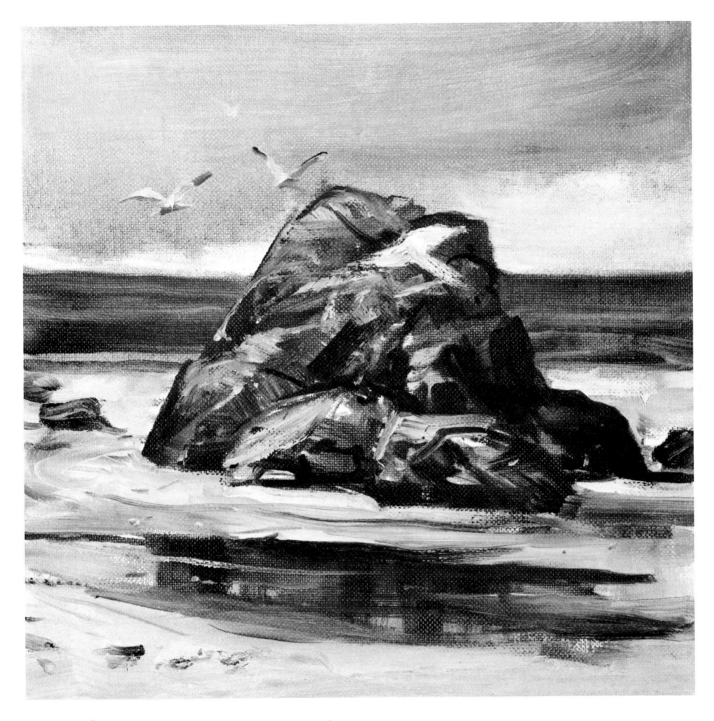

Rocks on Shore. The heavy, solid shapes of this rock formation are actually built by very simple brushwork. Look closely and you can see that there are just three tones: a middletone that actually covers most of the rock formation; a few dark strokes that suggest the shadows on the right sides of the forms; and a few pale strokes that suggest the lighter tops of the shapes. The square strokes of the bristle brush lend a ''blocky'' character to the rocks. The streaky marks of the bristles suggest the rough texture—and the roughness is accentuated by the weave of the canvas. Always remember to look for the darks, lights, and middletones. Once you've identified these three *values*, as they're called, it's surprisingly easy to build any three-dimensional form with quick, decisive strokes.

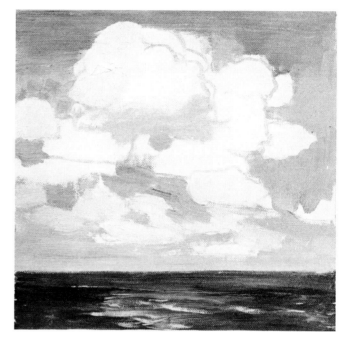

Step 1. Clouds may *seem* no more substantial than a puff of smoke, but to the artist, they're as solid and three-dimensional as any rock. The preliminary brush drawing defines their shapes with great care. Notice that these clouds are rounded and dome-like at the top, but tend to be flat at the bottom.

Step 2. A bristle brush surrounds the clouds with the tones of the sky. Here and there, these tones appear *between* the clouds. The first soft shadow tone is brushed along the bottom of the biggest cloud. The strip of sea is first covered with dark strokes, and then a round, softhair brush adds slender strokes to suggest light shining on the water.

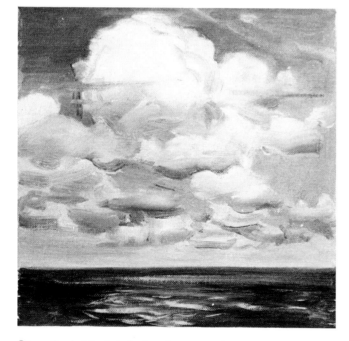

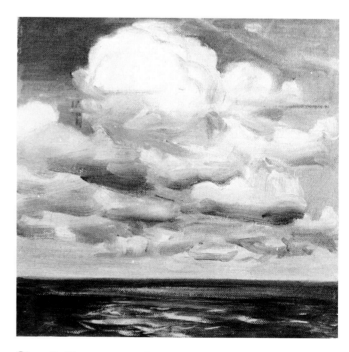

Step 3. A big bristle brush covers the sunlit tops of the clouds with thick, creamy color applied in curving strokes. The shadowy undersides of the clouds are painted with horizontal strokes of darker, more fluid color, which is blended softly into the paler tones above. The upper sky is darkened at the left, while a few wispy clouds are added at the upper right.

Step 4. Now some really strong shadows are added to the undersides of just a few clouds. A large bristle brush also simplifies the cloud formation by merging several smaller clouds into a few big shapes at the extreme left, and then enlarges the cloud at the lower right. The cloud formation now has a distinct pattern of lights, darks, and middletones.

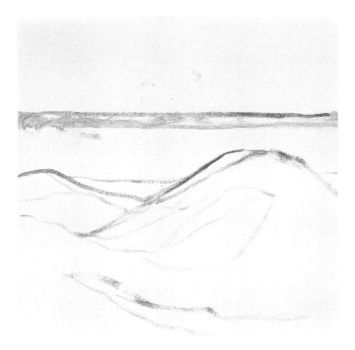

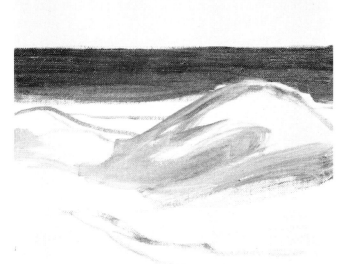

Step 1. After placing the horizon line, a round softhair brush traces the curves of the dunes. Then, within the shape of the bigger dune, the brush draws the shapes of the shadows. Another shadow shape is indicated on the sand in the immediate foreground.

Step 2. A large bristle brush covers the distant sea with a dark tone that silhouettes the top of the bigger dune. Then a bristle brush moves down the sides of the dunes to indicate the shadows. Notice how the brushstrokes actually follow the sloping sides of the soft, round shapes.

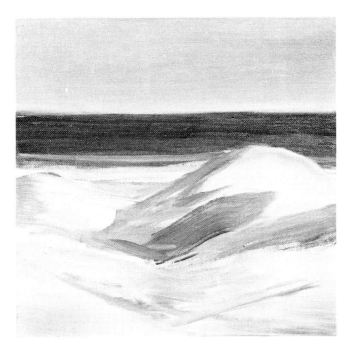

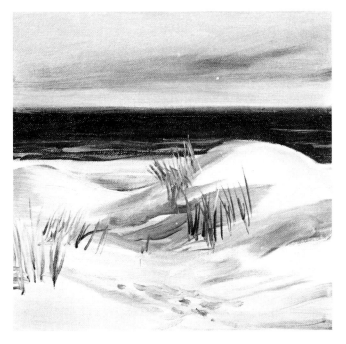

Step 3. The sunlit areas of the sand are now covered with smooth, creamy color, which is carried up to the edge of the beach. Delicate shadows are brushed across the foreground. Now each dune has a clearly defined light and shadow side. A pale tone is brushed across the sky.

Step 4. Softhair brushes add touches of darkness to deepen the shadows, and then add beach grass among the dunes and a few pebbles in the foreground. The sea is darkened to emphasize the shape of the sunlit top of the big dune. A few lines of surf are added to the dark sea. The sky is completed with horizontal strokes that suggest cloud layers.

Step 1. As a general rule, most oil painters start with thin color, gradually working with thicker color as the painting progresses, and saving their thickest strokes for the final stages. This study of a rock formation begins with a brush drawing in which the color is diluted with so much turpentine that the paint handles like watercolor. After the outlines of the rocks, sea, and tidepool are completed with a round softhair brush, a bristle brush covers the sky and sea with washes of liquid color—a little tube color and lots of turpentine. The tip of the round brush suggests shadows on the rocks with parallel strokes.

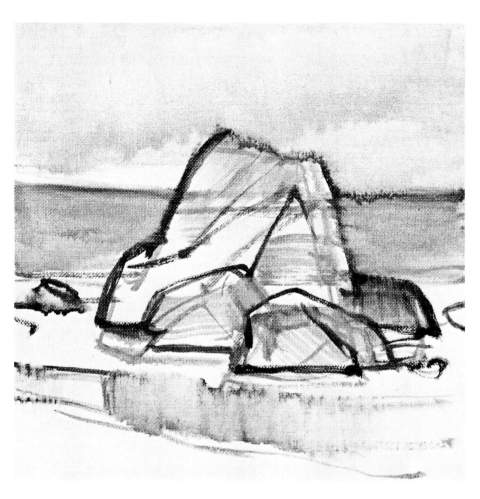

Step 2. Still working with liquid, transparent color—tube color and lots of turpentine—the round softhair brush covers the rock formation with parallel strokes to indicate the pattern of lights, darks, and middletones. The lights are bare canvas, untouched by the brush. Some of these liquid tones are carried down into the tidepool to suggest reflections.

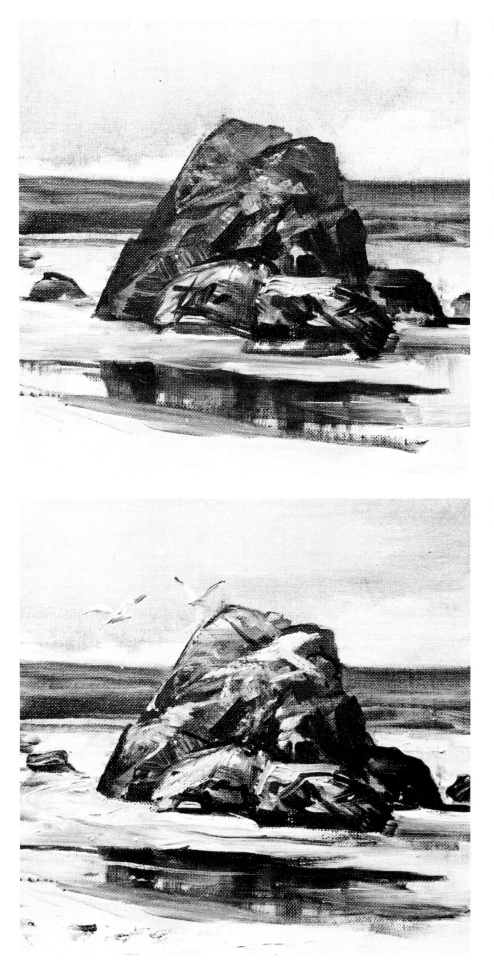

Step 3. The middletones and the shadows are now strengthened with slightly thicker strokes of tube color diluted with painting medium to a smooth consistency something like thin cream. The underlying drawing in "turpentine washes" begins to disappear under strokes of more solid color. The sea and the tide-pool are also strengthened with strokes of creamy color. The sandy beach is covered with horizontal strokes of tube color diluted with painting medium.

Step 4. Now the sunlit top planes of the rocks are completed with thick, richly textured strokes of tube color containing only a touch of painting medium. The sunlit sand is painted with thick strokes too. The gradual buildup from thin to thick gives you maximum control over the painting, since thin color is easier to handle than thick color. The last strokes of thick color have maximum impact because they're saved for the very end—and applied in just a few places.

Painting Water. When you paint water—waves, tidepools, surf, or foam trickling down the side of a rock—it's important to remember two things. First, pure water has no color of its own, but acts as a reflecting surface, taking its color from its surroundings. Second, water is transparent, which means that you can often see through it to whatever is beneath. Thus, you should never make up your mind that water is some "standard" blue or green. It can be practically *any* color. Because water is a reflecting surface, it usually picks up a lot of its color from the sky. A bright blue sky generally means bright blue water, while a gray sky usually means gray water. At sunrise or sunset, the water can be red, pink, orange, or violet—if these colors appear in the sky. A tidepool surrounded by black, brown, green, or gray rocks, will reflect their colors. If the pool is shallow enough, the color may also be influenced by the yellow sand or the green seaweed at the bottom.

Painting Skies. Sky colors aren't much more predictable than the colors of water. Even on the brightest day, the sky is rarely one uniform color. It's usually a gradation from dark to light and from warm to cool. The deepest, brightest blue is apt to be at the top, and the tone often grows paler and warmer toward the horizon, where there's sometimes a gold or pinkish tone. We all know that the sky can turn red, violet, orange, or pink at sunrise or sunset. But an early morning or late afternoon sky can also be bluish green or mauve. The colors of clouds can be just as diverse and unpredictable. On a bright day, the sunlit area of the cloud isn't just white, straight from the tube, but often has a hint of golden sunshine at midday, pink or orange at sunrise or sunset, gray or blue-gray on an overcast day. The shadow area of the cloud is never just a "standard" gray, but bluish gray, or even a golden tone. In the early morning or late afternoon, clouds often turn blue or purple.

Surf and Sand. Remind yourself that surf is simply water in another form—which means that surf is a reflecting surface, just like waves or tidepools. Like a cloud, surf has light and shadow planes. The bright area of the surf is likely to reflect the gold or pink glow of the sunlight, though it might also be a pearly gray on an overcast day. The shadow area *might* be gray—but it can also be gold, green, blue or even violet. Just as surf is more colorful than you might think, sand is usually more subdued. Beginners often paint sand a brilliant yellow, when it's more likely to be a pale tan or a golden gray.

Mixing Blues. There are so many different blues in coastal subjects that you may wonder how you can create all these hues with just two or three blues on your palette. Blue is a *primary* color, which means that you can't create a new blue by mixing two other hues. All you can do is *modify* the blues that come from the tube. By adding minute touches of other colors, you can produce a surprisingly broad range of blues that should satisfy all your needs. Of course, the blues generally look dark and lifeless as you squeeze them from the tube, so you must add white to bring out their full brilliance. Then you should experiment by adding touches of other colors. Just a hint of viridian can make any of your blues look cooler and brighter—but don't add too much unless you want to make the blue turn green. A hint of yellow ochre will soften a blue without turning it green—but beware of adding the more powerful cadmium yellow. A trace of burnt umber or burnt sienna will darken both blues, while you can produce subtle, grayish blues by adding a bit *more* of either brown, plus more white. A speck of alizarin crimson will give you purplish blues. And a touch of black will turn any blue cold and steely.

Mixing Grays. Professional artists never talk about *gray*—they talk about *grays*. For gray isn't some drab non-color, a mere mixture of black and white, but a vast family of subdued colors that might contain any hue on your palette. It's hard to imagine painting seascapes—or any outdoor subject—without knowing how to mix the extraordinary variety of grays that appear in nature. You should certainly learn to mix the wonderful range of warm and cool grays you can produce by combining any blue and brown, plus white. When the blue dominates, you get a cool gray; when the brown dominates, you get a warm gray. Starting with any one of these basic blue-brown combinations, you can then modify that mixture by adding a touch of any other color on your palette. Yellow ochre will give you a golden gray, but be careful with the more unpredictable cadmium yellow—just add a speck at a time or you may suddenly find that your gray turns green. Viridian will give you a greenish gray, of course, while the reds will give you brownish or even purplish grays. Black and white will give you the *least* interesting gray mixture, but a touch of any other color can produce a magical transformation.

Waves on Sunny Day. A sunny day means a bright blue sky. Since the color of the water normally reflects the color of the sky, a blue sky means blue water—or blue-green. Notice that these waves aren't a uniform, monotonous blue, but contain hints of other colors. The warm, pale sky tone, just above the horizon, reappears in the pale strokes that suggest the sunlight shining on the waves.

Waves on Overcast Day. When the colors of the sky are more subdued, the waves also darken. However, an overcast day doesn't necessarily mean a uniformly gray sky. This sky is actually full of color—blue-grays and brown-grays—and darker versions of these same colors appear in the sea.

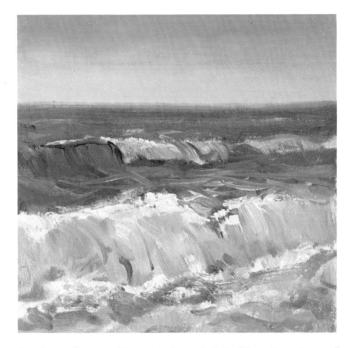

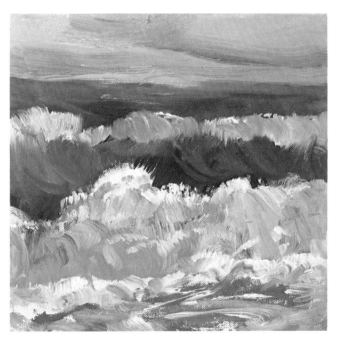

Surf on Sunny Day. Under a bright blue sky, the surf tends to have a warm, sunny tone. The sunlit tops of these crashing waves aren't pure white, but pick up the warm tone of the sun. The shadowy face of the crashing wave contains warm grays and hints of tan or gold.

Surf on Overcast Day. Even when the sun is blocked by an overcast sky, the crashing surf has a lighted top and a shadowy face. The top isn't pure white, but contains a hint of gray. The shadowy face of the crashing wave is predominantly gray, but contains suggestions of blue, plus some warm tones that reflect the distant sun and the colors of the beach.

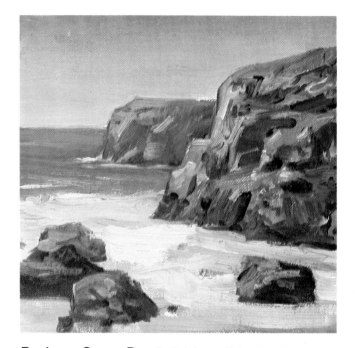

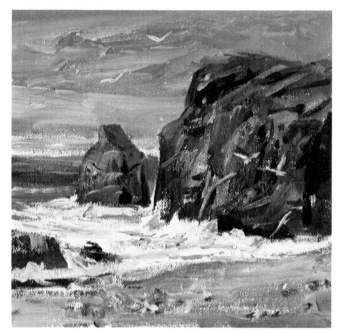

Rocks on Sunny Day. In bright sunlight, there's a strong contrast between the lighted top planes of the rocks and the dark, shadowy sides. The lighted tops are warmed by the sun, while the sides often contain a hint of cool color, reflecting the tone of the sky. This is equally true of the rocks on the beach and the massive headlands—which are just bigger rocks.

Rocks on Overcast Day. When the sky turns gray and there's less direct sunshine, you may find very little contrast between the colors of the top and side planes of rocks and headlands. The rock formations turn dark overall, and the shadows are only a bit darker. Here and there, the tops pick up a hint of the paler tone of the sky.

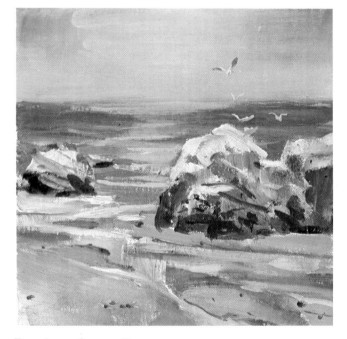

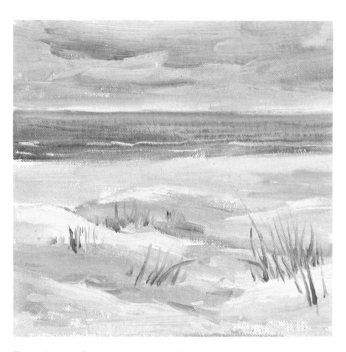

Beach on Sunny Day. When the sun shines brightly on the beach, the sand is a pale tan, with an occasional hint of gold. You can exaggerate the golden tone in a few places—as you see here—but don't overdo it. Sunlit sand is basically tan, with cool shadows that reflect the tone of the sky.

Beach on Overcast Day. When the sun is screened by clouds, the color of the sand turns distinctly cooler. It tends to be a grayish tan or a bluish gray. The shadows still reflect the color of the sky. You sometimes find a hint of warm color in the shadows, which you can exaggerate just a bit.

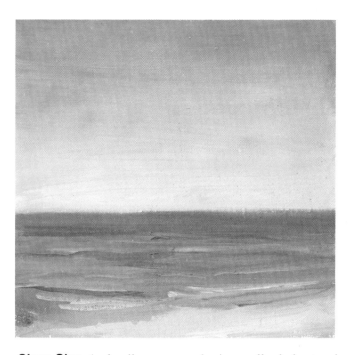

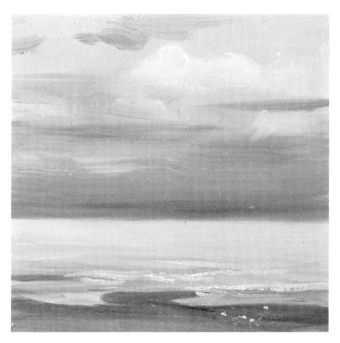

Clear Sky. A cloudless, sunny sky is usually darkest and bluest at the zenith, growing paler and warmer toward the horizon. The same thing happens to the reflective surface of the sea, which looks darkest and bluest at the horizon, gradually growing paler and warmer toward the shore.

Overcast Sky. A "gray" sky can be much more dramatic than you might expect. Here, the dark clouds are concentrated at the horizon, allowing some gentle rays of sunlight to break through at the top. This subdued sunlight is reflected by the surface of the sea, which contrasts beautifully with the cloud layer above. Notice that the sunlight isn't a bright yellow, but a very muted gold-gray.

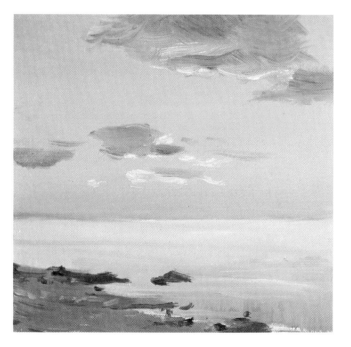

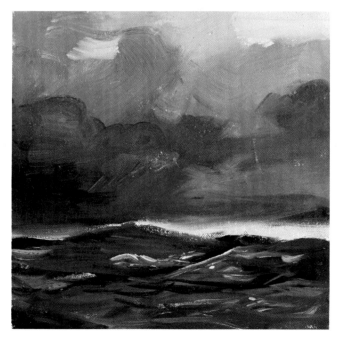

Sunset. The colors of the sunset aren't nearly as fiery as most beginners paint them. The brightest, warmest colors are usually at the horizon, while the upper sky is more subdued. The clouds are darker and even more subdued than the sky, picking up hints of bright sunlight along their lower edges. As usual, the sea mirrors the sky—brightest at the horizon and more subdued in the foreground.

Stormy Sky. The dark, ominous tones of a stormy sky contain more color than you might expect. These clouds contain blues, blue-grays, brown-grays, and subdued golden tones where the sunlight breaks through the clouds. The reflecting surfaces of the waves carry brighter versions of the same colors.

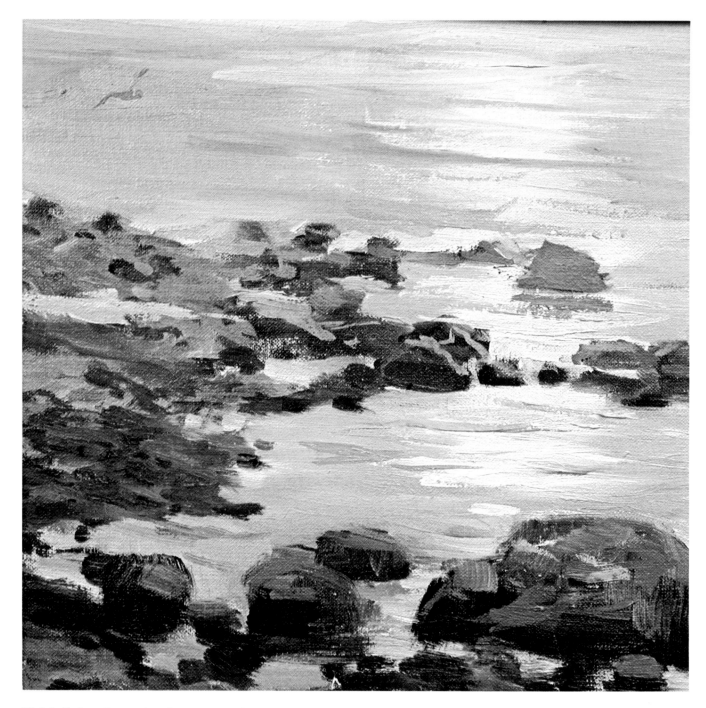

Thick Color. Remember that you can plan the *consistency* of your paint to match the character of the subject. For thick strokes, you can work with pure tube color or just add the slightest touch of painting medium to make the color "brush out" more easily. For more fluid strokes, you can add more painting medium, while a bit of turpentine will make the color even more fluid. In this close-up from a much larger painting of a rocky shoreline, the dark tones of the water, as well as the rocks and seaweed in the middle distance, are painted with smooth, creamy color diluted with a fair amount of painting medium. The foreground rocks are painted with strokes of thicker color, containing less medium, to emphasize the rocky texture. And the brilliant sunlight, shining on the sea, is painted with horizontal strokes of thick, pasty color. Some of these sunny strokes are thick enough to stand up from the surface of the canvas. The brilliance of the sunlight is emphasized by the thickness of the paint.

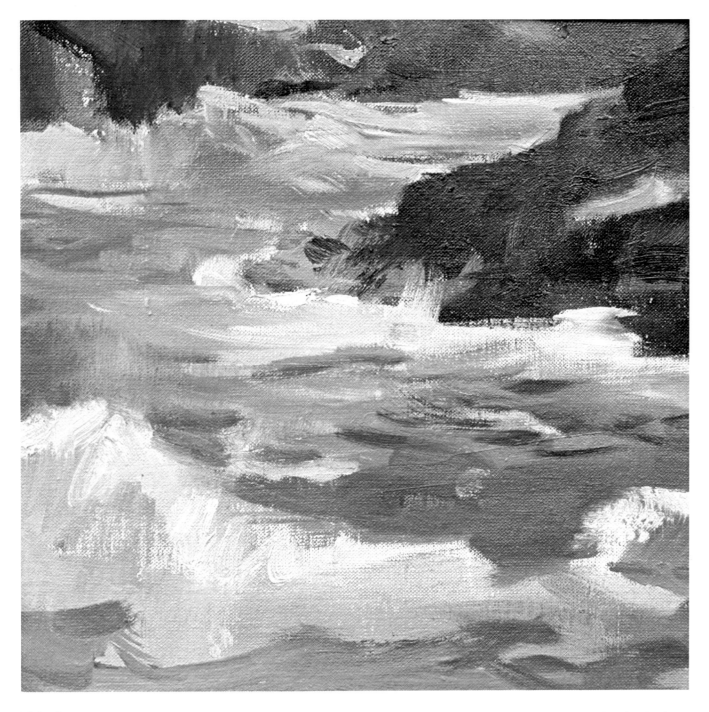

Thin Color. The sea in this close-up is painted with fluid color that contains a good deal of painting medium. Here, the goal is to capture the lively splash and flow of the water. The brush moves quickly over the canvas, following the movement of the waves. It's important for the color to contain plenty of medium so the brush can move rapidly and spontaneously, making long, sweeping strokes for the flowing water; short, choppy strokes for the ripples; and quick, upward scrubs for the splashing foam. In the foreground, you can see that the paint is actually thin enough to reveal the weave of the canvas. In the lower left, strokes of thicker color emphasize the sunlit top of the foam.

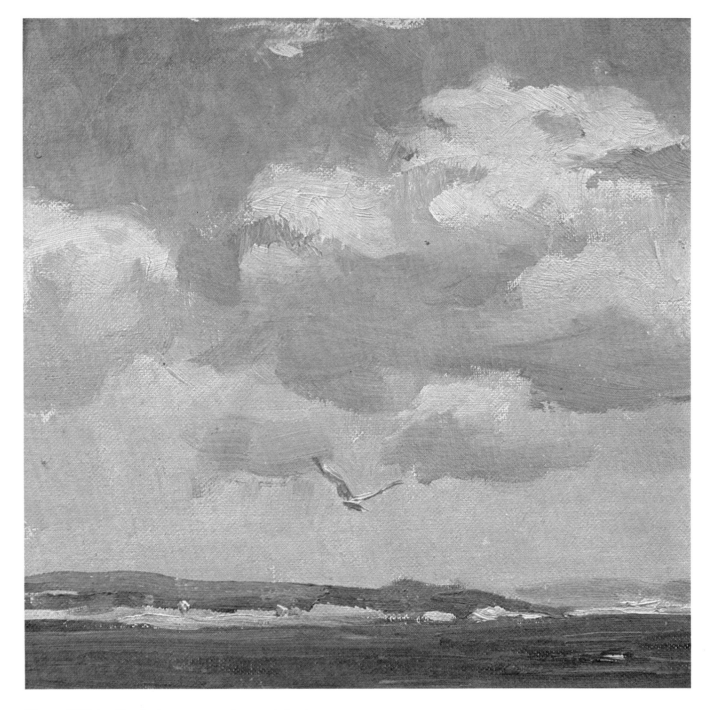

Warm Within Cool. Seascapes and coastal landscapes contain so much sea and sky that the picture is often dominated by cool colors—blues, greens, blue-greens, blue-grays, and green-grays. When your color scheme is basically cool, it's important to look for some notes of warm color that will contrast with the cool, and give the viewer a pleasant change of pace. These warm colors don't have to be hot reds, oranges, and yellows; they might also be subdued browns, brownish-grays, tans, pinks, or violets. Notice how these delicate, warm tones are softly brushed into the cool colors of the sky. If you can't actually *find* the warm tones you need, there's nothing wrong with inventing them—just keep them quiet. Remember that this strategy is just as important when you're painting a predominantly warm picture, such as a sandy beach: try to introduce a few cool colors for relief.

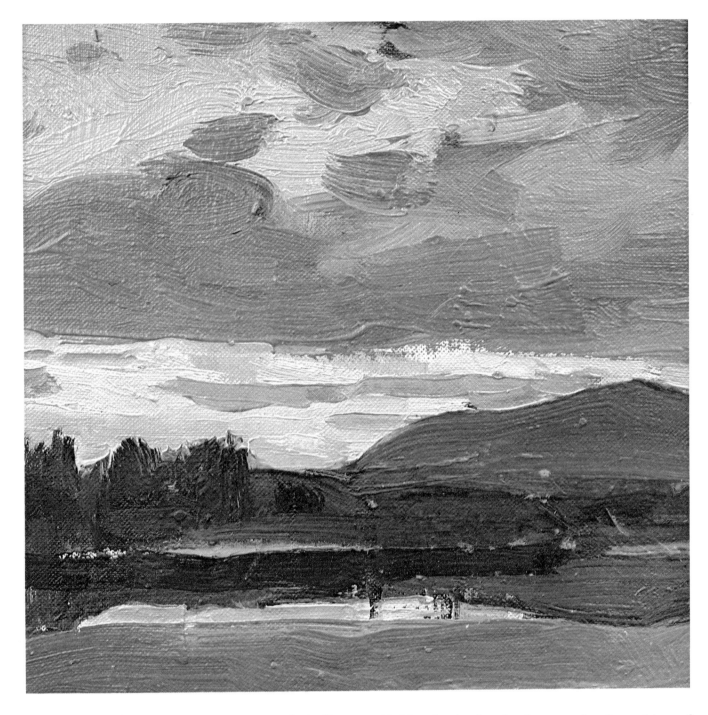

Warm Against Cool. You've seen that one method of introducing warm color is to blend a few warm notes into the cool tones with subtle strokes. Another method is to design your picture so that the composition contains alternating areas of cool and warm color. In this close-up taken from a much larger picture, there's a patch of warm color at the very top of the sky, followed by the cool tone of the clouds, which contrasts beautifully with the warm strip of sunlit sky just above the horizon. The rest of the picture is literally divided into bands of cool and warm color: the cool tone of the hills; the warm tone at the foot of the hills; the cool tone of the grassy shore and the clump of trees; and the various strips of warm and cool color that are reflected in the water. Before you start to paint, it's a good idea to decide which way your picture will go: predominantly cool, with some notes of warm color; or predominantly warm, with some notes of cool color. This is a cool picture with warm notes.

DEMONSTRATION 1. WAVES

Step 1. A round softhair brush draws the major shapes of the composition with cobalt blue diluted with turpentine to a liquid consistency. Although the soft forms of the clouds are constantly changing, it's important to focus your attention on the sky, make a firm decision about where you want the clouds to be, and record the shapes of the cloud mass and the patches of open sky with the minimum number of quick, decisive strokes. In the same way, watch the repetitive action of the waves and then freeze each wave in your mind, drawing its curving edge and the shape of the foam with a few firm strokes.

Step 2. A big bristle brush paints the distant water with long, horizontal strokes of cobalt blue, yellow ochre, viridian, and white, diluted with painting medium to a creamy consistency. Notice that some strokes are darker and cooler, containing more cobalt blue, while other strokes are paler and warmer, containing more yellow ochre. (At the center of the distant sea, some patches of canvas are left bare to suggest the reflection of the sunlight on the water.) A single stroke of this same mixture, darkened with more cobalt blue, suggests the shadow in the curl of one wave.

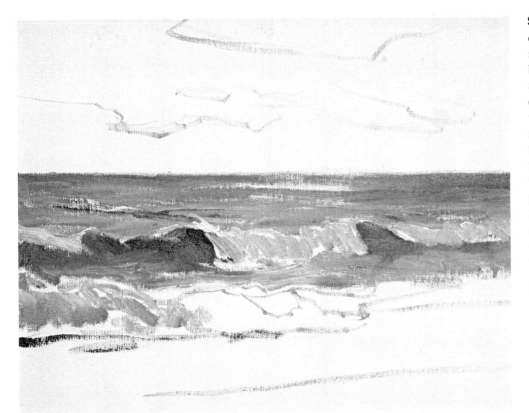

Step 3. The face of the wave curves over and is therefore in shadow— painted with cobalt blue, viridian, yellow ochre, and white. The strokes are darker at the upper edge, where the mixture contains more cobalt blue, and paler at the base of the wave, where the mixture contains more white. The shadowy foam is painted with broad, diagonal strokes of cobalt blue, yellow ochre, burnt umber, and lots of white. Work begins on the foreground wave with this same mixture with more cobalt blue and less white. At the right, a warm patch of water catches the sunlight; this is painted with the foam mixture, with more yellow ochre.

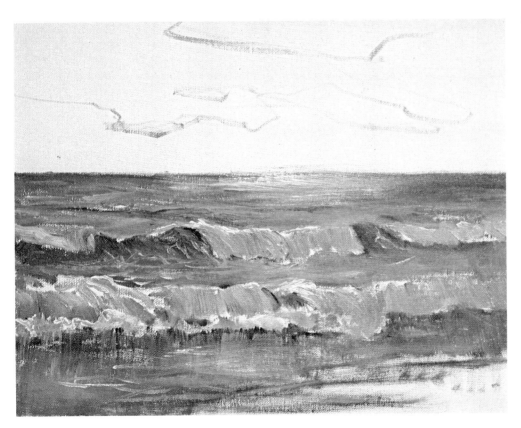

Step 4. Still working with a mixture of cobalt blue, yellow ochre, burnt umber, and white, a bristle brush completes the shadow tones on the surf. Notice how the brushstrokes curve downward to suggest the foam crashing toward the water. The strip of water between the waves, and the water that washes up on the beach, are covered with horizontal strokes of the same mixture used to paint the distant sea: cobalt blue, viridian, yellow ochre, and white. Beneath the edge of the foreground wave, the water is darkened with vertical strokes of this same mixture, containing more cobalt blue. A round softhair brush picks up pure white, tinted with a little yellow ochre, to trace the sunlit tops of the foamy shapes.

Step 5. A big bristle brush covers the lower sky with a mixture of cobalt blue, burnt umber, yellow ochre, and white—with some additional strokes of white where the sun's rays will appear at the center. The brush carries this mixture to the top of the canvas to suggest more patches of sky. More white is blended into this mixture, and a bristle brush carries horizontal strokes across the distant ocean to suggest the sun shining on the sea. The wet beach in the foreground is darkened with more strokes of the original mixture that appears in Step 4. Strokes of this mixture darken the waves in the foreground and are carried across the distant sea to suggest waves.

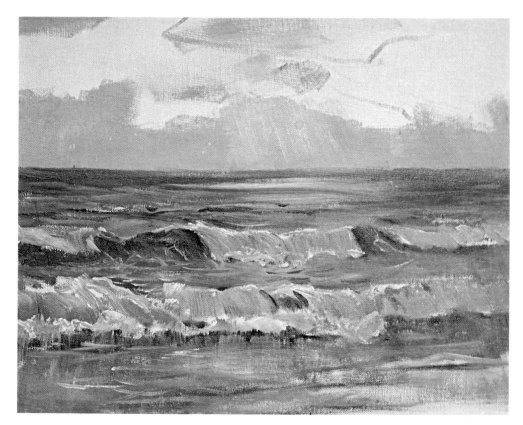

Step 6. The bold shapes of the clouds are painted with broad strokes of a big bristle brush that carries a darker mixture of cobalt blue, yellow ochre, burnt umber, and white. Then a smaller bristle brush traces the sunlit edges of the clouds with thick strokes of white tinted with yellow ochre. This same brush reinforces the rays of the sun that first appear in Step 5. The cloud mixture is brushed across the shiny beach in the foreground, covering the last patches of bare canvas. A round softhair brush adds two gulls above the horizon with a darker version of the cloud mixture and, with the dark tone of the water, begins to adds small, dark strokes to suggest ripples between the waves.

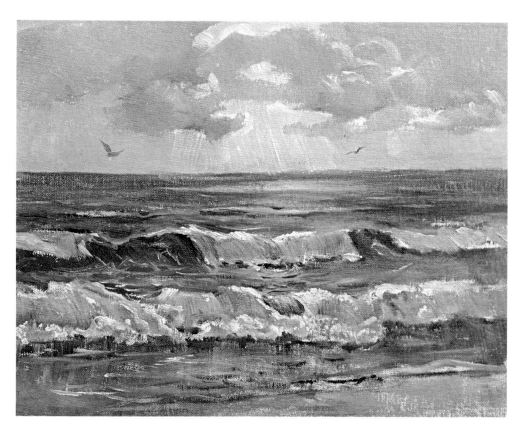

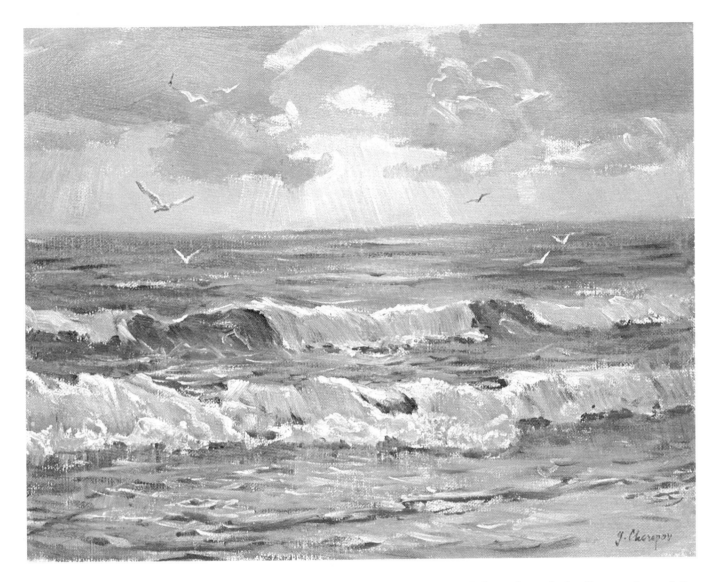

Step 7. A bristle brush blends more yellow ochre and white into the foreground to suggest the warm glow of the sun on the water—and perhaps the influence of the warm color of the underlying sand. The distant ocean is also warmed with some horizontal strokes of this mixture; now the water clearly reflects the warm tone of the sky. A big bristle brush darkens the cloud at the upper left to heighten the contrast between the shadowy cloud and the sunny sky beneath. The tip of a round softhair brush travels swiftly across the foreground and over the space between the waves, making small, arc-like strokes of white and yellow ochre to suggest the sun gleaming on the ripples. This same brush adds darker ripples with a mixture of cobalt blue and burnt umber. Here and there, beneath the foamy edges of the breaking waves, this brush adds a few dark strokes to create shadows and heighten the contrast between the pale foam and the darker water. The small brush adds touches of sunlight (white and yellow ochre) to the biggest gull at the left, then adds more gulls with this same mixture. The finished painting is a fascinating example of the interplay of sky and water. The waves do contain blue and green, of course, but these cool tones constantly interweave with the subtle, warm tones of the sun breaking through the overcast sky. The surf is essentially the same color as the clouds, both in the light and in the shadows. After all, surf, like clear water, is a reflecting surface.

Step 1. The big, rugged shapes of this dramatic seascape don't require a precise preliminary brush drawing, so the first lines on the canvas are executed with a small bristle brush rather than the usual softhair brush. Phthalocyanine blue is warmed with burnt umber and the mixture is then diluted with lots of turpentine. The small bristle brush indicates the horizon and the waves at the left with a few casual strokes. The shape of the surf is carefully defined. Then, working with darker color, the brush draws the silhouettes of the rocks and fills one tiny rock with solid color. This small rock is important because it balances the bigger shapes.

Step 2. Working with the original mixture of phthalocyanine blue and burnt umber, softened with white and diluted with turpentine *and* painting medium, a big bristle brush scrubs in the shadow tone of the surf. The up-and-down movement of the brush begins to suggest the upward splash of the foam.

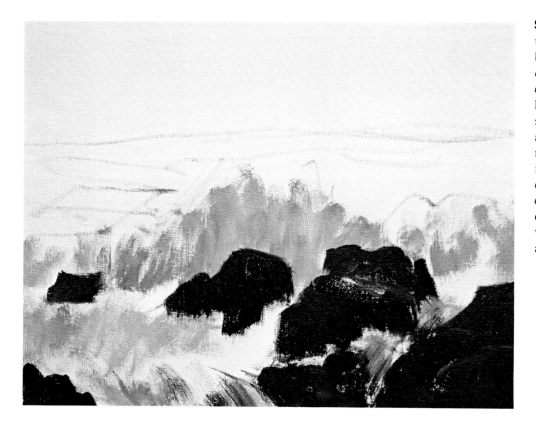

Step 3. The dark shapes of the rocks are covered with broad strokes of phthalocyanine blue and burnt sienna. The square end of a large bristle brush makes squarish strokes that accentuate the blocky forms of the rocks. At this stage, it's most important to establish the contrast of three tones: the dark rocks, the shadow plane of the foam, and the bare canvas that represents the lighted areas of the foam.

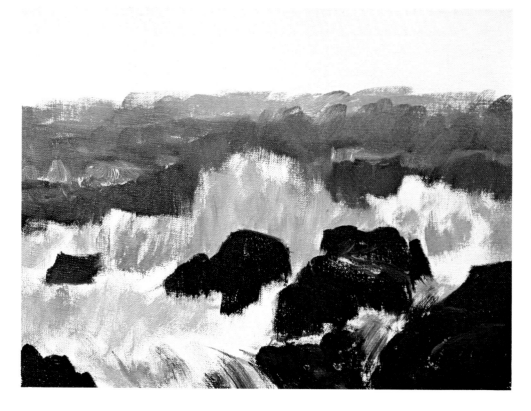

Step 4. The distant waves are painted with short, scrubby strokes of phthalocyanine blue, burnt sienna, and white. Notice that some strokes contain more white, while others contain more phthalocyanine blue or burnt sienna. The strokes are darkest directly behind the foam and lightest at the horizon. Now the sunlit edge of the surf is clearly silhouetted against the dark, distant waves. These lighted areas are still bare canvas.

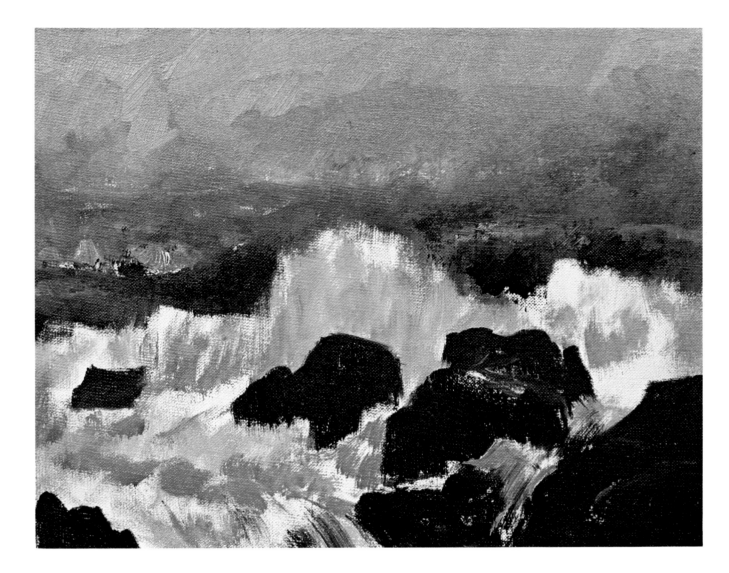

Step 5. The sky is covered with irregular strokes of phthalocyanine blue, burnt sienna, and white, diluted with painting medium to a more fluid consistency than the waves beneath. The sky mixture contains more burnt sienna and white than the mixture used to paint the waves. A big bristle brush carries the sky tone downward over the sea, blending the two tones together. The distant waves are now paler and more remote; the horizon seems to melt away into the sky. Directly behind the surf, a bristle brush adds some dark touches of the rock mixture to heighten the contrast between the pale tone of the surf and the dark waves. In the left foreground, a bristle brush adds shadows to the surf with the sky mixture. A few strokes of the sky mixture are carried over the rocks to make them look wet. It's interesting to see how *little* detail the painting contains even at this late stage. The emphasis is on big shapes and broad tones. When these are right, the picture is close to completion.

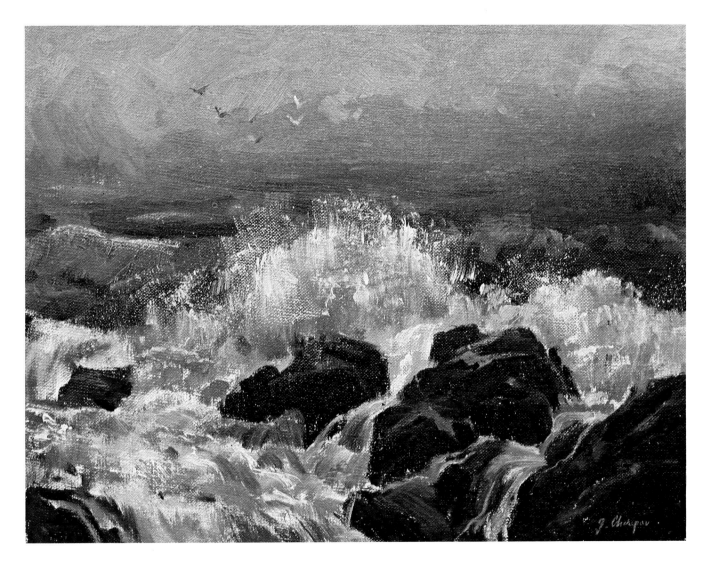

Step 6. Now smaller bristle brushes go back to work on the rocks in order to divide those dark shapes into top and side planes. Warm strokes of phthalocyanine blue, burnt sienna, yellow ochre, and white—obviously dominated by the burnt sienna—are carried across the tops of the rocks. A darker version of this mixture, containing less white and more phthalocyanine blue, is carried down the sides of the rocks. Now the rocks look warmer and more three-dimensional. The tip of a small bristle brush makes the rocks look wet by adding some slender strokes of the sky mixture—phthalocyanine blue, burnt sienna, and lots of white. Thick white, straight from the tube, is tinted with this mixture and just a little painting medium is added to produce a dense, creamy consistency. Then a bristle brush travels over the foam, adding thick touches of this cool white to cover the bare canvas that represented the sunlit foam in Step 5. The brush is then pulled upward with short, quick strokes that suggest the flying foam behind the rocks. In the left foreground, the strokes curve downward from left to right, following the action of the foam flowing over the rocks. The shadow tones within the surf are darkened with fluid strokes of the sky mixture; these tones are most apparent directly behind the rocks and in the middle of the foreground, where the foam pours over the rocks. A large bristle brush darkens the lower sky and blends the meeting place of sea and sky into one continuous, dark tone. Behind the exploding surf, a small bristle brush adds a few pale strokes to suggest the foamy tops of more distant waves. The tip of a round brush adds some gulls. Except for these gulls, the entire picture is painted with stiff bristle brushes whose rough strokes match the texture and the action of the subject.

Step 1. One of the most beautiful seaside subjects is the pattern of tidepools and sandbars created by receding water. These shapes form a fascinating and intricate design which you must draw carefully—in contrast with the more casual drawing in Demonstration 2. A round softhair brush traces the shapes of the clouds, the horizon line, the band of light just below the horizon, the sandbar, the tidepools, the edge of the beach, and the shoreline rocks. The brush works with the basic palette that will be used throughout the painting: cobalt blue, alizarin crimson, yellow ochre, and white, thinned with lots of turpentine.

Step 2. A large bristle brush covers the patches of sunlit sky appearing between the clouds and the reflecting surface of the water. The strokes are all various mixtures of cobalt blue, alizarin crimson, yellow ochre, and white. The lightest, brightest areas obviously contain more yellow ochre and white, while the darker tones contain more cobalt blue and alizarin crimson. Because the shapes in the original drawing are so important, these big strokes are painted carefully to avoid obliterating the lines.

Step 3. Following the original brush drawing as carefully as possible, a bristle brush blocks in the dark clouds. This is still the basic combination of cobalt blue, alizarin crimson, yellow ochre, and white, but the clouds obviously contain less white than the sunlit sky—the clouds are dominated by cobalt blue and alizarin crimson. Adding more alizarin crimson and yellow ochre to this mixture, a small bristle brush begins to paint the outlying sandbars.

Step 4. The small bristle brush continues to cover the sandbars with this mixture, which contains more alizarin crimson and yellow ochre than the clouds. The colors of the strokes vary, the cooler strokes containing more cobalt blue and the warmer strokes containing more yellow ochre. The beach in the immediate foreground is covered with thick, short strokes of this mixture. More cobalt blue and alizarin crimson are added to paint the shadow sides of the rocks, while the lighted tops of the rocks are the same mixture as the sandbars. Notice how the closest tidepool has been darkened to reflect the cloud tone.

Step 5. A bristle brush brightens the center of the sky with more yellow ochre and white, then blends alizarin crimson, yellow ochre, and white into the lower edge of the sky and the surrounding clouds. Thick, horizontal strokes of white and yellow ochre are carried down over the water to create the bright reflection of the sun. Strokes of the cloud mixture are blended into the water as it approaches the shore. The edges of the sandbars are also modified with strokes of this mixture. A round softhair brush adds dark touches to suggest more pebbles, then brightens the tops of the pebbles with the sky tone. A single dark stroke suggests a strip of distant shore.

Step 6. The clouds are warmed and darkened with strokes of the original mixture modified with more alizarin crimson and yellow ochre. Then the edges of the clouds are brightened with thick strokes of yellow ochre and white. Now there's a much stronger contrast between the dark clouds and the glowing sky. On either side of the reflection of the sun on the water, the sea is darkened very slightly by blending in some soft strokes of the cloud mixture. This brightens the reflection. The sandbars are also darkened and warmed with a version of the original mixture that contains more yellow ochre and less white. Now there's a much stronger contrast between the sandbars and the tide pools.

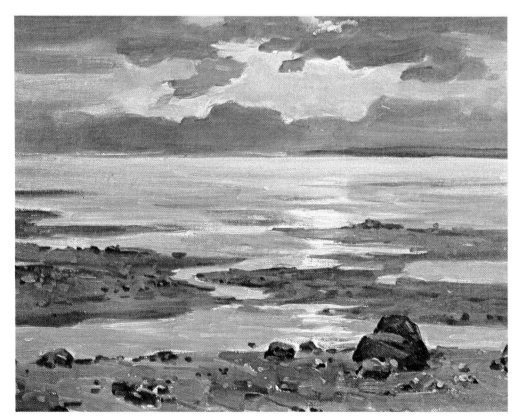

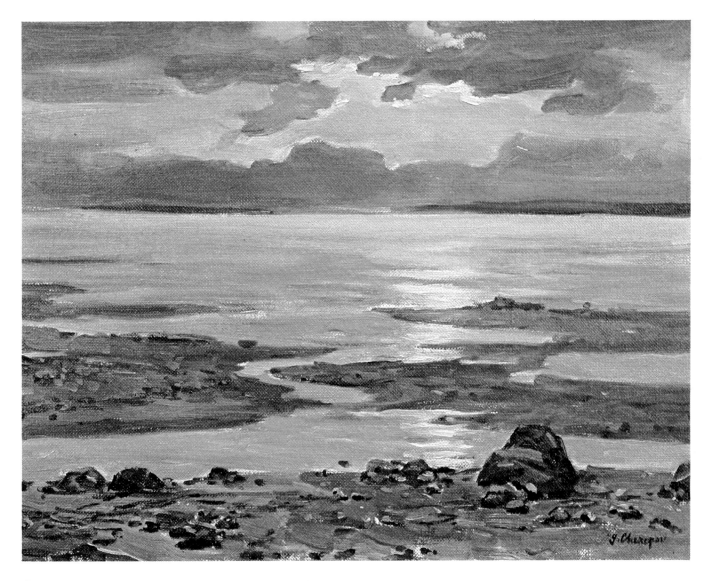

Step 7. To focus the viewer's attention on the brightest patch of sky and the reflection on the water beneath, the sea and the sandbars are darkened still more. On either side of the sun's reflection in the ocean, a bristle brush softly blends horizontal strokes of the cloud mixture into the water. The reflection and the sunlit clouds above are brightened with thick strokes of yellow ochre and white. Strokes of the darkest cloud mixture are carried over the sandbars and the beach. Notice how the water is palest at the horizon and gradually grows darker until it reaches the edge of the beach. In the same way, the distant sandbars are palest and the beach in the immediate foreground is darkest. Now the interlocking shapes of the dark sandbars and the paler water form a beautiful, jagged pattern. This contrast is echoed by the sky in which the dark clouds seem to float like islands in a sea of sunlight. The tip of a round, softhair brush adds the last few rocks and pebbles with the mixture that first appeared in Step 4. Here and there, the foreground is brightened with a few casual strokes of burnt sienna and cadmium yellow to suggest the warm tones of seaweed scattered on the beach.

Step 1. When the sea invades the land, and "islands" of marsh grass spring up out of the salt water, this is called a salt marsh. The round, soft-hair brush draws just a few preliminary lines in burnt umber and yellow ochre diluted with plenty of turpentine, plus the horizon line, the shapes of a few clouds, a strip of land at the horizon, and a few scribbly strokes to suggest the marsh grass in the foreground and the middleground. Then the golden tones of the early evening sky are begun with a few broad strokes of yellow ochre and white, placed above the horizon with a bristle brush. The dark strip of coastline is painted with a mixture of cobalt blue, yellow ochre, burnt umber, and white.

Step 2. The slightly darker patches of sky at the top of the canvas are painted with a big bristle brush that carries the same mixture of yellow ochre and white that appears in Step 1, but here darkened very slightly with cobalt blue and burnt umber. Then the dark shape of the cloud is carried over the sky tone with cobalt blue, yellow ochre, a touch of alizarin crimson, and white. So far, the paint is thinned with lots of painting medium to a consistency something like thin cream. At the upper right, notice how the dark patch of sky is blended softly into the paler, brighter sky tone below.

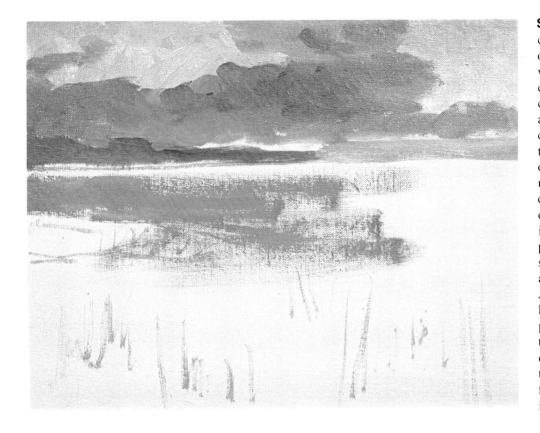

Step 3. For the darker clouds, cobalt blue, yellow ochre, alizarin crimson, and white are blended on the palette—but now the mixture contains more yellow ochre and alizarin crimson than the cloud in Step 2. A large bristle brush carries this mixture over the center of the sky and up to the top to create a darker, warmer cloud. A wisp of this cloud mixture is placed in the upper left corner. A paler stroke of this mixture suggests a cloud layer just above the horizon at the right. Just above this warm cloud layer, a cooler cloud is painted with the same mixture that appears in Step 2. The dark shoreline is reshaped as the clouds are painted. A reflection of the cloud mixture is placed in the water.

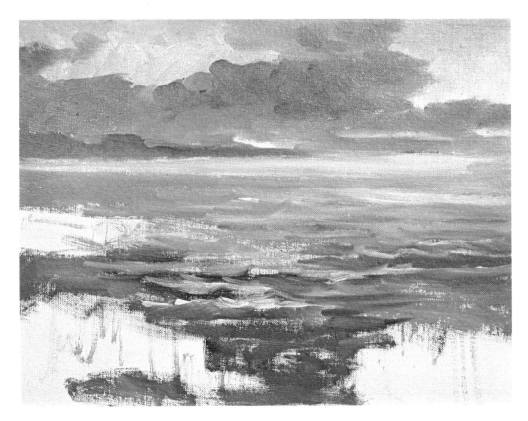

Step 4. A bristle brush carries the sky colors down into the water. At the horizon, the water begins with horizontal strokes of the warm, pale sky mixture. Working toward the foreground, the brush adds horizontal strokes of cloud tone, then interrupts these with ripples that reflect the color of the pale sky. Notice how the water grows darker as it approaches the foreground—containing more cobalt blue in some strokes, more alizarin crimson and yellow ochre in other strokes. Closer to the foreground, the ripples grow brighter; they're painted with almost pure white, tinted with sky tone. At this stage, the colors of the sky are repeated throughout the water.

Step 5. Work continues on the water in the foreground, which is covered with more of the dark cloud color. More cobalt blue is added to this mixture for the dark ripples, while the sunstruck ripples are painted with pure white, sometimes tinted with the warm sky color and sometimes tinted with the cool cloud mixture. These ripples are painted with the tip of a round softhair brush. This same brush is rinsed and begins to paint the marsh grass with rapid, slender strokes. The blades of grass are painted with various mixtures of viridian, burnt sienna, yellow ochre, and white; the dark strokes contain more viridian, while the warmer strokes contain more burnt sienna.

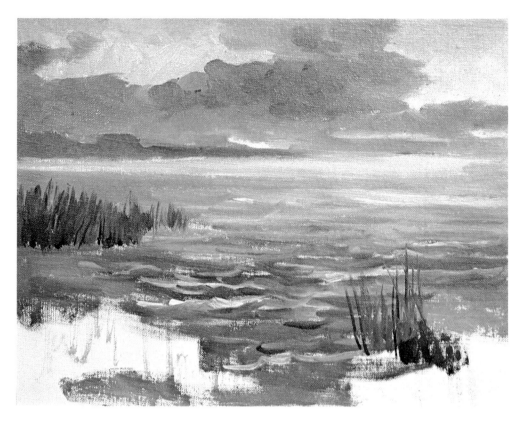

Step 6. In the lower right and left corners, the canvas is covered with strokes of marsh grass. The round softhair brush continues to work with viridian, burnt umber, yellow ochre, and white. Then, for the darker strokes, ultramarine blue is substituted for viridian. To suggest a few blades of grass caught in sunlight, the brush works with *almost* pure white, tinted with a little yellow ochre and viridian. A bristle brush carries the dark tones of the foreground water among the marsh grass. Then the round brush returns to add more sunlit ripples with strokes of thick white tinted with yellow ochre.

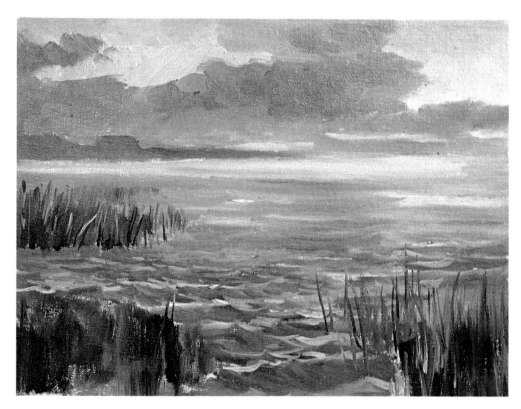

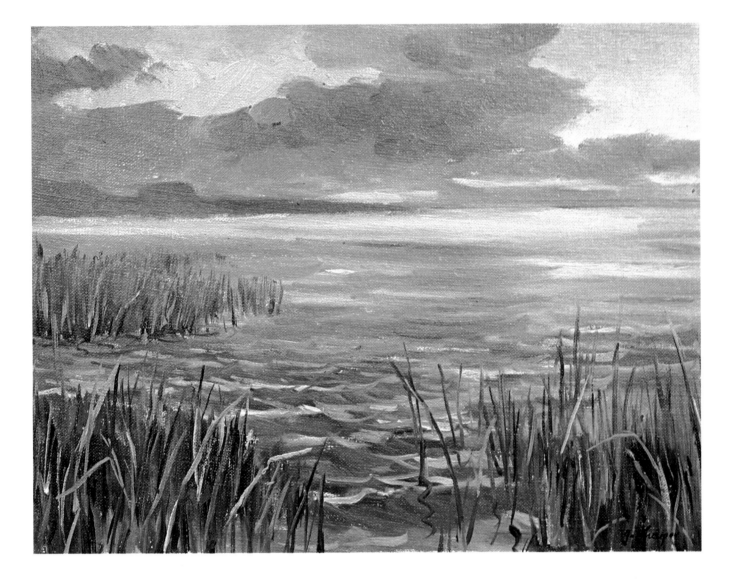

Step 7. Adding more burnt sienna to the marsh grass mixture, the round brush adds strokes of warmer color to the patch of grass in the middleground. Moving on to the grass in the immediate foreground, the brush adds more blades with this warm mixture. Then the brush switches to a darker mixture of ultramarine blue, burnt sienna, and yellow ochre to strike in the darkest blades of grass in the immediate foreground. Over these dark strokes, the tip of the brush draws sunstruck blades of grass with yellow ochre and white. As these last strokes blend slightly with the wet undertone, the white and yellow ochre mixture turns a bit darker and cooler. Like Demonstration 3, the final painting of the salt marsh shows how just three colors can produce a surprisingly rich range of sky and water tones. The bright patches of sky, the dark clouds, the sunlit water, and the darker areas of the water are all painted with cobalt blue, yellow ochre, and alizarin crimson, plus white.

Step 1. In a storm, the clouds and waves move so swiftly that it's often difficult to record their forms in the preliminary brush drawing. The important thing is to focus your attention on just a few forms, isolate them from all the turmoil, and draw them with a few simple strokes. The tip of a small bristle brush draws the shape of one big wave against the horizon, some smaller waves in the foreground, and just two big clouds. The brush drawing is made with phthalocyanine blue and burnt sienna, diluted with turpentine.

Step 2. Since the sky normally establishes the color of the sea, a large bristle brush begins work on the sky first. At the horizon, the dark tone is painted with diagonal strokes of phthalocyanine blue, burnt sienna, a touch of yellow ochre, and white. More white is added to this mixture for the paler patch of sky just above this dark area. Above this pale tone, the darker tone again contains more phthalocyanine blue and burnt sienna, with less white. The rapid, diagonal brushwork emphasizes the movement of the windblown clouds.

Step 3. The lower sky is covered with a rich blue tone that consists mainly of phthalocyanine blue, burnt sienna, and white, with just a touch of yellow ochre. More white, burnt sienna, and yellow ochre are added to this mixture for the pale tone in the upper sky. A bristle brush uses this mixture to shape the pale cloud that hangs just above the horizon. Then the dark edges of the waves are painted with flowing strokes of phthalocyanine blue and burnt sienna, lightened with just a touch of white to "bring out" the color.

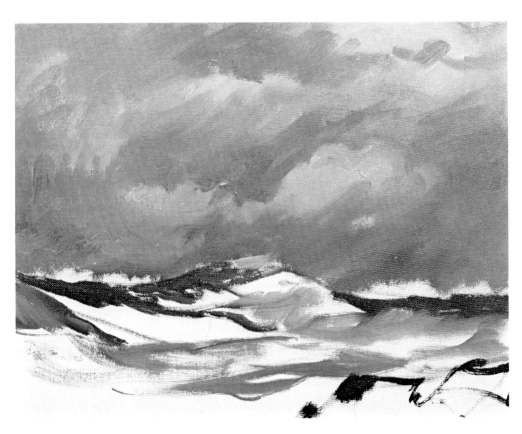

Step 4. The upper sky is darkened with diagonal strokes of the rich tone that appears above the horizon. Now the sky consists of alternating patches of dark and light. At either side of the big wave, the lower edge of the sky remains bare canvas to suggest light breaking through at the horizon. Dark strokes of phthalocyanine blue, burnt sienna, and a little white complete the silhouette of the sea against the sky. More white is added to this mixture for the strokes that sweep across the waves in the foreground and the foam at the crest of the big wave. The rocks in the lower right are also phthalocyanine blue and burnt sienna—but the mixture contains more burnt sienna.

Step 5. The dark shape of the big wave, silhouetted against the sky, is painted with slashing, horizontal and diagonal strokes of phthalocyanine blue and burnt sienna, heightened with just a touch of white. Varying amounts of white are added to this basic mixture to paint the foreground waves with back-and-forth, curving strokes that match the wave action. The sky is darkened with this mixture, and a dark cloud replaces the pale cloud that first appeared in Step 3. The rocks are painted with knife strokes of phthalocyanine blue and enough burnt sienna to create a warm tone. The tip of a round brush begins to paint the lines of foam with thick white, tinted with the water mixture.

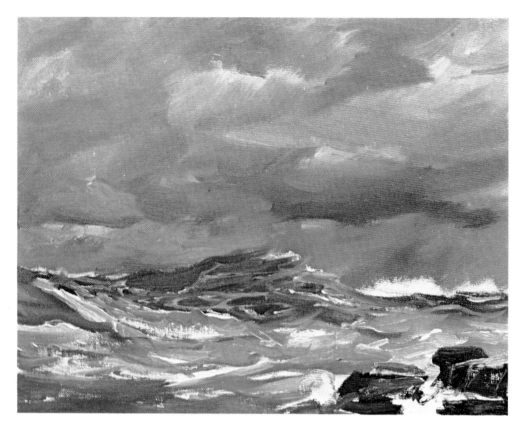

Step 6. The round, softhair brush continues to add trickles of foam to the big, dark wave. The darker trickles are phthalocyanine blue, a little burnt sienna, and white. The paler trickles are *almost* pure white tinted with a faint touch of yellow ochre. A bristle brush picks up a thick load of this mixture to draw some streaks of sunny sky at the horizon, just below the dark clouds and on either side of the big wave. Thick strokes of foam are carried across the foreground with the tip of a small bristle brush plus an occasional touch of the knife blade. A bristle brush carries this mixture into the lower right corner to suggest surf breaking over the rocks and splashing between the dark forms.

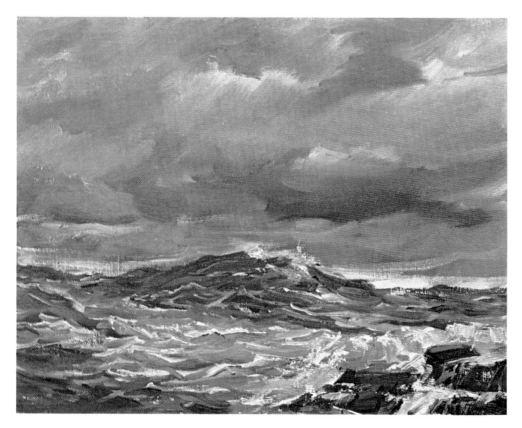

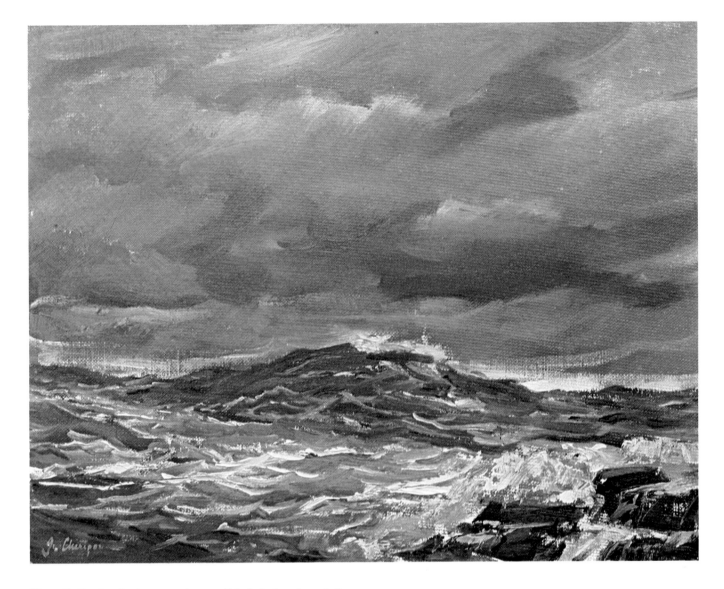

Step 7. In the final stage, the small bristle brush and the knife continue to build up the foam in the foreground to contrast with the dark shape of the wave at the horizon. To emphasize the darkness of the wave, the crest of the wave is crowned with thick strokes of foam. In the upper sky, more pale strokes are added to extend the pale edges of the clouds—and to suggest some windblown wisps of cloud at the very top of the canvas. At first glance, the finished picture is almost entirely blue and white. However, in this final stage, a small bristle brush enlivens the sea and sky with some touches of other colors—which you may have begun to notice in Step 6. Look closely at the waves and you'll see warm touches of burnt sienna, plus an occasional hint of green where yellow ochre has been blended into the wet blue of the waves. As your eye moves across the sky, you'll see where the brush has blended burnt sienna and even an occasional hint of alizarin crimson into the underlying cool tone. Although these last few color notes are almost invisible, they add richness and variety.

DEMONSTRATION 6. SUNRISE

Step 1. For painting sunrises and sunsets—and skies in general—George Cherepov favors a technique adapted from the impressionists. A simple, preliminary brush drawing defines the horizon and the shapes of the shore with cobalt blue diluted with turpentine. Then the sky is covered with a dense mosaic of brushstrokes of cobalt blue and white, applied with a bristle brush. The strokes are darkest at the top of the sky, where they overlap to produce a fairly solid tone. As the brush works its way downward toward the horizon, the strokes contain more white and are more widely spaced, leaving gaps between them for the other colors which will come next.

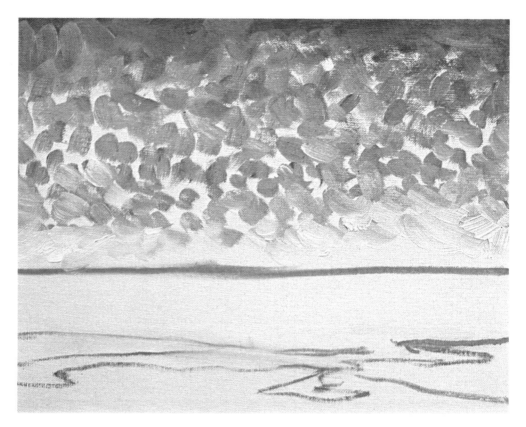

Step 2. The golden tones of the sky come next. Yellow ochre and white are blended on the palette and then carried across the sky in a series of separate touches. Some of these strokes fall between the blue strokes applied in Step 1. Other strokes of yellow ochre and white simply overlap the underlying blue tone. The yellow strokes start just below the top of the canvas, leaving the deepest blue of the sky untouched. As the yellow strokes move down toward the horizon, they contain more white.

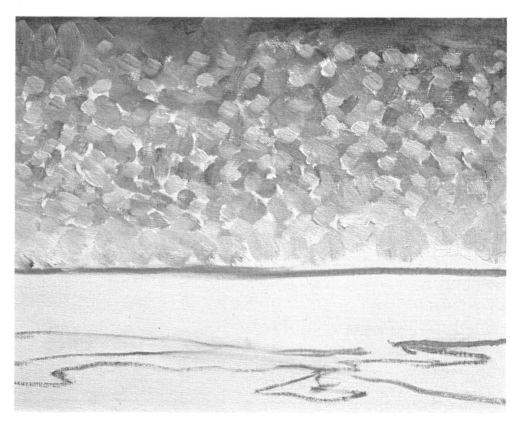

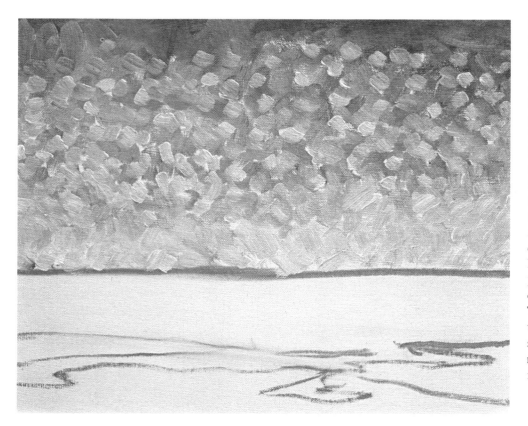

Step 3. Alizarin crimson is blended with white on the palette to produce a delicate pink. Starting slightly further down than the yellow strokes in Step 2, the brush applies separate strokes of this pink. These strokes begin to overlap the blue and yellow strokes and mix with the wet undertone. The bristle brush continues to add yellow strokes in the lower sky, carrying these touches of color down to the horizon. At the horizon, a hint of cadmium yellow is added to the mixture of yellow ochre and white. The pink strokes are concentrated across the center of the sky, while the top is predominantly blue and the lower sky is predominantly yellow.

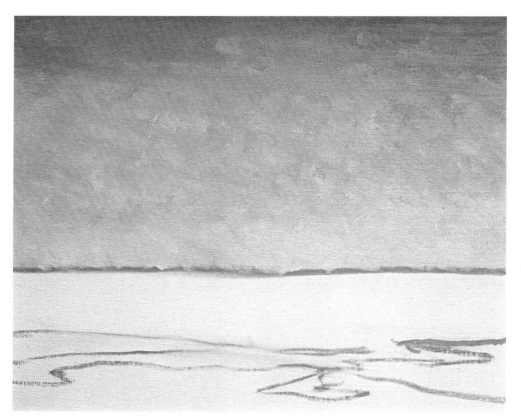

Step 4. A large bristle brush blends the blue, pink, and yellow touches together with short strokes. The big brush doesn't move across the sky with continuous, horizontal or vertical strokes; this would produce a monotonous, mechanically smooth tone. The short strokes of the big brush preserve the lively brushwork of Steps 1, 2, and 3 so that the sky retains a suggestion of the original strokes. Thus, the sky seems to vibrate with light. The golden glow of the sunrise is strongest just above the horizon.

Step 5. The dark tones of the sea are painted with darker, richer strokes of the same colors used for the sky: cobalt blue, alizarin crimson, yellow ochre, and white. More white is added to this mixture for the shadowy face of the surf. More alizarin crimson and white are added to this mixture for the dark clouds. The palest clouds are strokes of yellow ochre and white, made more brilliant with a touch of cadmium yellow. The sandy tones of the beach are painted with horizontal strokes of yellow ochre and white, darkened with a touch of cobalt blue and alizarin crimson.

Step 6. Still working with various mixtures of cobalt blue, alizarin crimson, yellow ochre, and white, a bristle brush covers the sandy beach in the foreground. You can see where the strokes sometimes contain more cobalt blue or yellow ochre. The bright pools that wander across the sand are painted with thick strokes of yellow ochre and white, darkened with a slight touch of the sandy tone. The dark lines of the distant waves and the darks of the crashing wave are painted with ultramarine blue brightened with a touch of viridian. More white is added to this mixture for the scrubby up-and-down strokes that darken the surf. The tip of a round brush uses the cloud mixtures to paint gulls.

Step 7. The oncoming wave is enriched with strokes of ultramarine blue, viridian, yellow ochre, and white. Notice how two sections of the crashing surf—at the right end of the wave—have been overpainted with this mixture. (Compare Step 6.) Now the eye goes directly to the patch of surf just left of center. This same mixture of ultramarine blue, viridian, yellow ochre, and white is blended into the sand in the foreground, which now has a richer, more varied color. The shapes of the sand are darker and more clearly defined, contrasting more strongly with the pale trickles of water that move across the beach. This contrast makes the wet parts of the beach shine more brightly. The tip of a round brush traces shadow lines around the surf of the crashing wave with ultramarine blue and viridian. Tiny touches of this same dark mixture suggest pebbles scattered across the beach. Small touches of pure white tinted with yellow ochre brighten the sunlit top of the wave, strengthen the reflection of the sunlight on the distant sea, and add glistening tops to a few pebbles in the foreground. Like most good pictures of sunrises and sunsets, this coastal scene avoids garish colors. The colors are clear, but delicate. The brightest tone appears just above the horizon and is surrounded by more subdued colors.

Step 1. Although fog tends to make the shapes along the shoreline pale and remote, it's important to begin with a brush drawing that defines these shapes clearly. The brush drawing is executed in ultramarine blue, softened with a touch of burnt umber, and diluted with turpentine. Although the distant rocky islands will be obscured by the fog, their silhouettes are important to the pictorial design, so the brush draws the rocky shapes carefully. Notice that the beach and rocks in the foreground are drawn with thicker, darker strokes to indicate that they're closer to the viewer.

Step 2. In the preceding demonstration, you've seen a very effective technique for painting the effects of light and atmosphere. Now the fog is painted in the same way, but with different color combinations. First, the sky and sea are covered with separate strokes of yellow ochre and white, spaced apart so that bare canvas shows between them. On a foggy day, the sky and water tend to be one continuous color—with little or no break at the horizon. They're painted in one continuous operation.

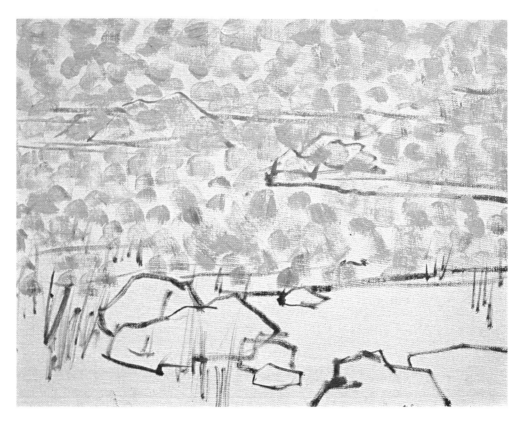

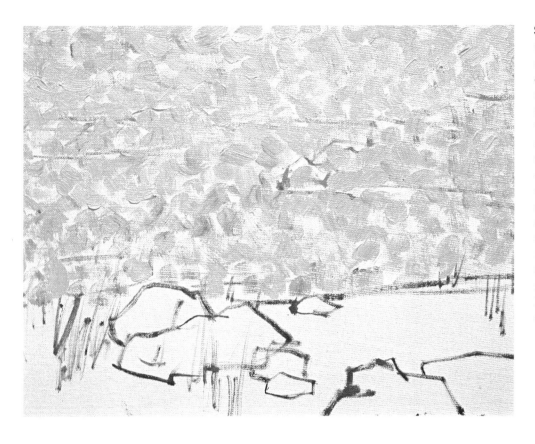

Step 3. Alizarin crimson, ultramarine blue, yellow ochre, and lots of white are blended on the palette to produce the next tone. This tone is applied in separate strokes that sometimes fill the gaps between the strokes applied in Step 2 and sometimes overlap the wet color. Where the strokes overlap, they tend to blend softly, although the brush doesn't actually scrub the two colors together. The underlying brush lines of the horizon and distant islands are beginning to disappear, but enough lines remain to define the overall shapes.

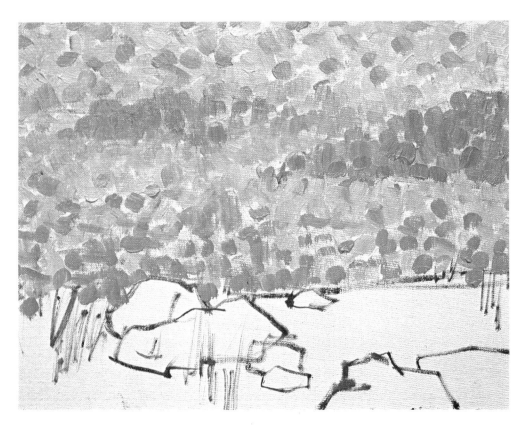

Step 4. Ultramarine blue, a hint of yellow ochre, and white are blended on the palette and individual strokes of this new mixture are carried over the sky and sea to complete the "mosaic." Notice how the strokes are scattered across the sky, densely concentrated over the shapes of the distant islands, then scattered across the water near the shore—while the water around the islands is practically untouched. The islands contain some darker strokes in which a touch of alizarin crimson has been blended into the ultramarine blue, yellow ochre, and white. Now the brush lines of the rocky islands have disappeared beneath the thick strokes of paint, but their silhouettes have been filled in.

Step 5. Working with short, diagonal and vertical strokes, a big bristle brush begins to blend the sky, the rocky islands, and the water around them. The quick, irregular touches of the brush preserve the lively texture that suggests the flickering light creeping through the fog. As the brush blends the darker tones of the islands, it redefines the shapes that were originally drawn in Step 1. The shadow side of the island at the right is painted with thick, ragged strokes of ultramarine blue, burnt sienna, yellow ochre, and white, as are the shadow sides of the rocks on the beach; the lighted top is simply painted with the color that's accumulated on the big bristle brush that blends the sky and water.

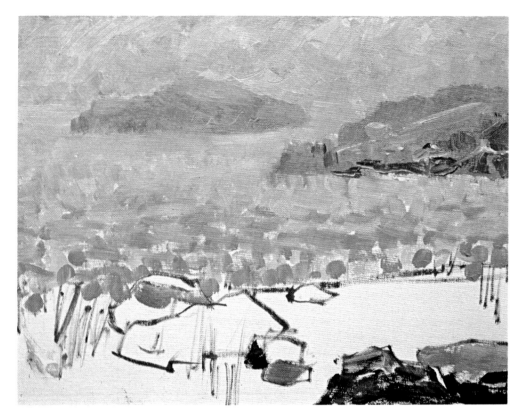

Step 6. Now the big brush blends the water at the edge of the beach, adding some horizontal strokes of ultramarine blue, yellow ochre, and white to suggest gentle waves. A stroke of yellow ochre and white indicates a line of foam. The big brush then goes back to redefine the shape of the more distant island. The rocky island that's closer to shore is built up with small, thick strokes of various mixtures of ultramarine blue, burnt sienna, yellow ochre, and white. A bristle brush begins to build the forms of the rocks at the center of the beach; the shadow sides are ultramarine blue, burnt sienna, and just a little white. The sand is the same mixture—but with more yellow ochre and white.

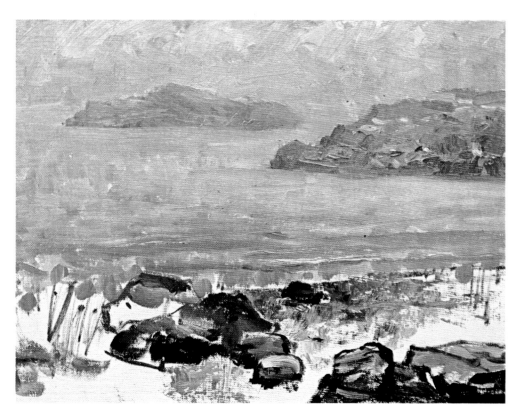

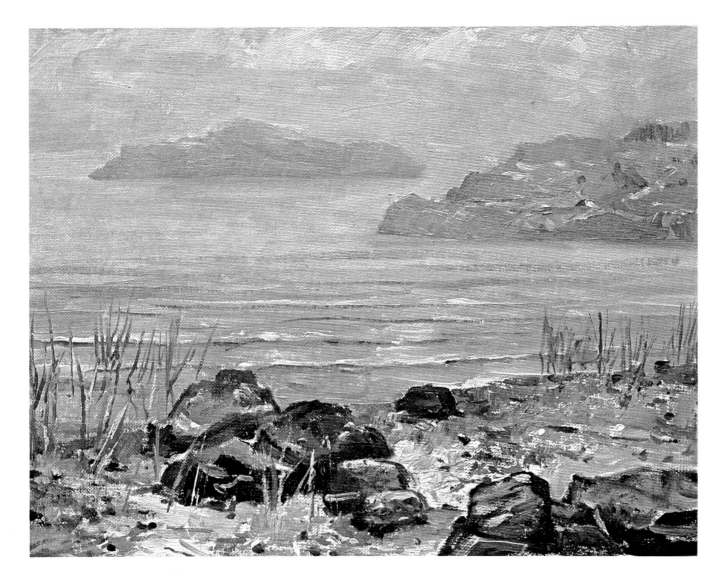

Step 7. The bright continues to cover the beach with short, ragged strokes of thick color. The sunlit patches of sand are mainly yellow ochre and white, with just a hint of ultramarine blue and burnt sienna added to the mixture. The cooler, shadowy areas of the beach contain more ultramarine blue and less white. The warm patches of sand contain more burnt sienna. The cool tops of the rocks are painted with the same mixture that's used to paint the cool shadows on the sand. Notice how an occasional touch of burnt sienna, yellow ochre, and white brightens the generally cool tone of the rocks. A few rocks have touches of bright light on the edges that face the sky; these are thick strokes of white tinted with yellow ochre and a speck of ultramarine blue. A round, softhair brush returns to the water, indicating the dark lines of incoming waves with ultramarine blue, yellow ochre, alizarin crimson, and white. The same brush adds lines of foam with yellow ochre and white.

The tip of this brush adds coarse stalks of beach grass with a mixture of viridian, yellow ochre, and white, occasionally warmed with a touch of burnt sienna. The sunstruck blades of grass are yellow ochre and white, heightened with a touch of cadmium yellow. The round brush completes the beach with small touches of ultramarine blue, burnt sienna, and white to suggest scattered pebbles among the rocks. In the finished painting, all the original brush lines have disappeared, but most of the shapes have been followed carefully, except for the most distant island, which has been redesigned to make its shape lower and less prominent. The sky and water are brushed together so that the horizon line virtually disappears, except at the extreme left. This coastal landscape is an example of *aerial perspective*: the brightest colors and the strongest contrasts are in the foreground, while objects gradually grow paler and cooler as they recede into the distance.

Step 1. Rocks are hard and they should *look* hard. Thus, the preliminary brush drawing renders these rock formations with straight, hard lines. The foreground rocks are simply drawn as silhouettes enclosing jagged shape of a tidepool. The big rock formation—the focal point of the picture—is drawn in greater detail. The round, softhair brush defines its silhouette with ultramarine blue and burnt sienna diluted with turpentine, then goes on to define the shapes of the shadows within the rock.

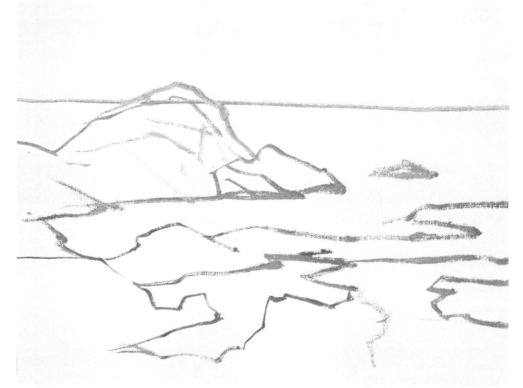

Step 2. The dark, warm tones of the rocks in the center are painted with straight, diagonal and horizontal strokes of burnt umber, yellow ochre, ultramarine blue, and white—with more ultramarine blue in the shadows. The paler, cooler tone of the rocks in the immediate foreground is a mixture of ultramarine blue, burnt umber, and white, applied with a big bristle brush that pulls the strokes downward to emphasize the blocky character of the shapes. The thick color contains almost no painting medium so that the heavily loaded brush drags the paint over the textured surface of the canvas; the weave of the canvas comes through to enhance the roughness of the rocks.

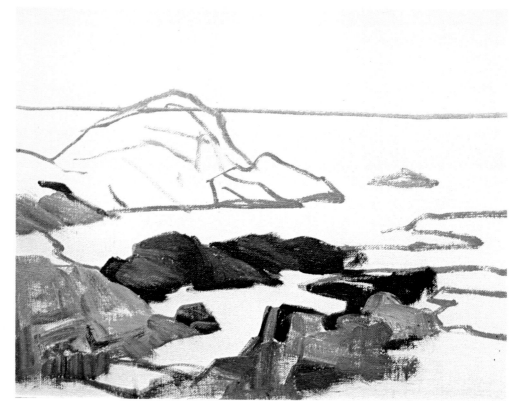

Step 3. The big rock that dominates the picture is painted with thick, straight strokes of ultramarine blue, burnt umber, and white, with more blue in the shadows. Work continues on the foreground rocks with this same mixture; the sides of the rocks are painted with vertical and diagonal strokes, while the tops are often painted with horizontal strokes. A small bristle brush picks up a dark mixture of ultramarine blue and burnt sienna to strike in the dark lines of the shadows and the cracks. A bristle brush goes back over dark, seaweed-covered rocks with burnt sienna, viridian, yellow ochre, and white, and then carries this mixture along the shoreline.

Step 4. A large bristle brush begins to cover the sea with horizontal strokes of ultramarine blue, burnt umber, and white. With a darker version of this same mixture (containing less white) a small bristle brush places more shadow strokes on the big rock formation. The dark slope of the big rock formation and the dark reflection in the water are both painted with ultramarine blue and white, softened with a touch of burnt umber. The tidepool in the foreground is painted with the same mixture that's used for the distant water, but a hint of yellow ochre and more white are added.

Step 5. The sea is now covered with long, horizontal strokes of ultramarine blue, burnt umber, and lots of white—with more white near the horizon, where the sun shines on the water. The sky is painted by the method you've already seen, starting with separate strokes of ultramarine blue and white. A touch of viridian is added to the original mixture of ultramarine blue, burnt umber, and white to suggest the grassy slopes of the big rock formation. Small touches of viridian, burnt sienna, yellow ochre, and white accentuate the weedy texture of the seaweed-covered rocks and shore.

Step 6. Work continues on the sky with strokes of alizarin crimson and white, and yellow ochre and white, which the brush has already begun to blend. Notice how additional white has been brushed into the section of the overcast sky where the sun begins to break through. A strip of distant shore is placed at the horizon with ultramarine blue, alizarin crimson, yellow ochre, and lots of white to make this coastline seem far away.

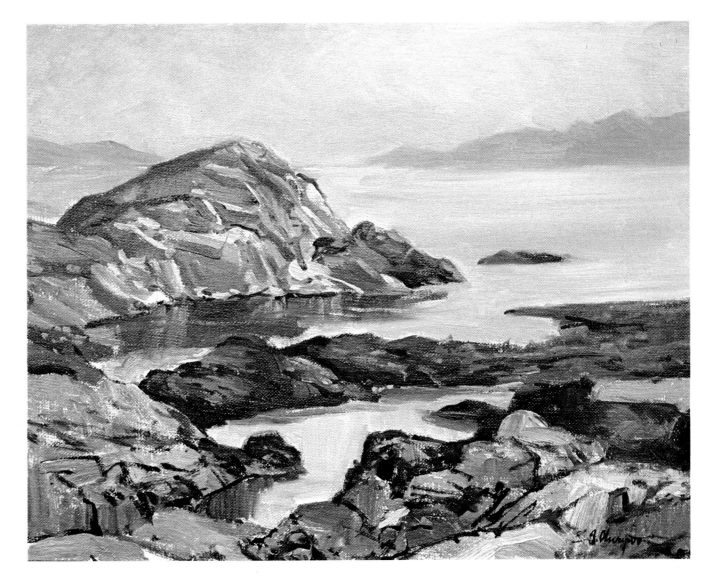

Step 7. In this final stage, the sky is completely blended, but you can still see traces of the original brushwork. In the process of blending the sky, the brush softens the edge of the distant shoreline at the right, then adds another piece of shoreline along the horizon at the left. The tip of a small bristle brush accentuates the lighted planes of the biggest rock formation with straight strokes of thick color—ultramarine blue, burnt umber, yellow ochre, and lots of white. The tip of a round brush carries horizontal lines of this mixture across the dark reflection in the water to suggest a few ripples. The tone of the seaweed is enriched with short, thick strokes of viridian, burnt sienna, yellow ochre, and white. A round, softhair brush wanders over the rocks in the foreground, placing scattered touches of warm color among the cool tones: the small strokes on the rock at the extreme left are yellow ochre, cadmium yellow, burnt sienna, and white, while the warm touches in the central rocks are burnt sienna with a little ultramarine blue and white. Then the tip of the round brush picks up a rich, dark mixture of ultramarine blue and burnt sienna to add more cracks to the foreground rocks and redefine their dark edges.

Step 1. A round softhair brush executes the preliminary drawing in two colors. Because the headland will contain a variety of cool tones, it's painted with ultramarine blue and a touch of burnt umber diluted with turpentine. This same color is used to place the horizon and to draw the distant headland on the left. The patterns of the sandy beach are drawn with a warmer version of the same mixture, but with less ultramarine blue and more burnt umber. The tidepools on the sand form a particularly interesting pattern, and these are traced carefully, even though they'll be redesigned later on. At this point, the composition looks best with a bare sky, but this will change too.

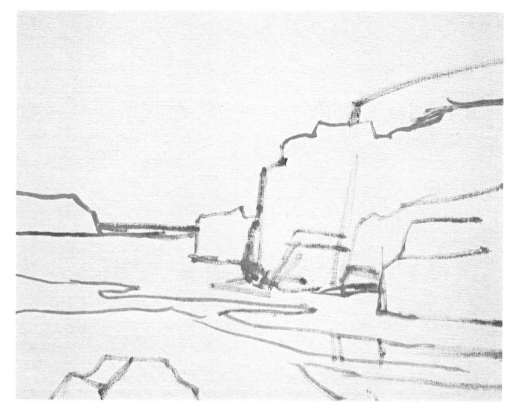

Step 2. The shadow planes of the big headland are the darkest notes in the picture, so they're painted first with broad, thick strokes of ultramarine blue, burnt sienna, yellow ochre, and white. The darkest shadows contain more burnt sienna and less white. Notice how the vertical strokes follow the planes of the rocks. Just beyond the big headland, at the center of the picture, a more distant cliff is painted in a cooler tone: ultramarine blue, alizarin crimson, yellow ochre, and white. The color is smoother and more fluid than the big headland, which is painted with rougher, thicker strokes to bring it closer to the viewer.

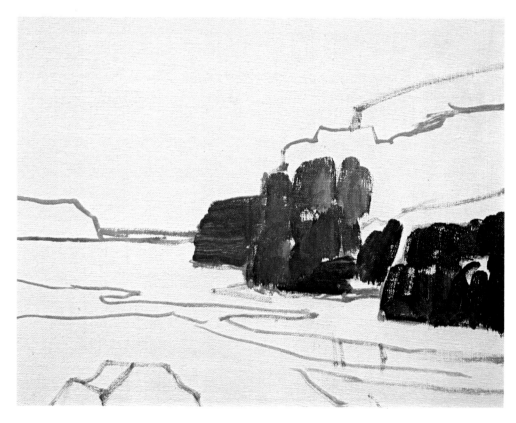

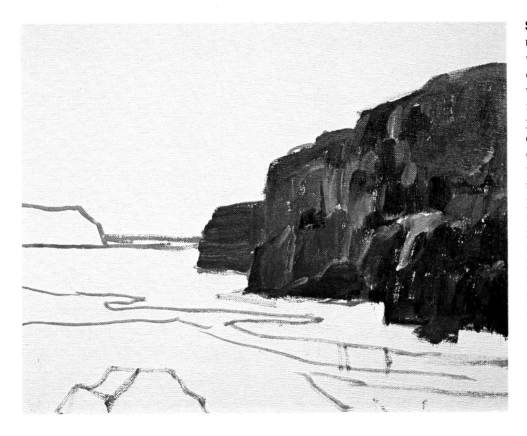

Step 3. The entire shape of the big headland is covered with vertical strokes of thick color. These strokes are all various mixtures of ultramarine blue, burnt sienna, yellow ochre, and white. You can see where some strokes contain more burnt sienna, while others contain more ultramarine blue or more yellow ochre. Notice that the very top of the cliff—which receives the direct light of the sky—contains more blue. Patches of grass are indicated by substituting viridian for ultramarine blue in several strokes.

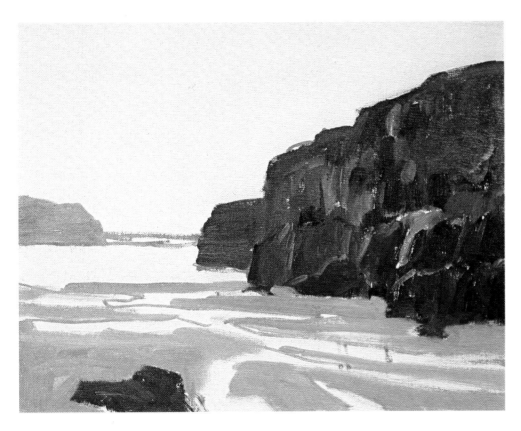

Step 4. The distant headland at the left is painted with a pale mixture of ultramarine blue, alizarin crimson, yellow ochre, and white. The soft tone of the sand is painted with long, smooth strokes of creamy color: a subtle mixture of yellow ochre, burnt umber, ultramarine blue, and white. Compare Step 4 with Step 3 to see how the pattern of the tidepools has been redesigned to create a path that leads the eye into the picture from the bottom edge of the canvas. The dark rock at the lower left is painted with the same mixtures used for the big headland.

Step 5. The sky needs a big, bold shape to balance the massive shape of the headland. So a large bristle brush paints an irregular cloud formation with dark and light strokes of the same mixture that was used to paint the small headland on the left. The clouds are ultramarine blue, alizarin crimson, yellow ochre, and white, with less white in the dark clouds at the top of the canvas. Notice that most of the cloud shape is paler than the distant headland at the left, so the clouds are obviously more remote than the cliff.

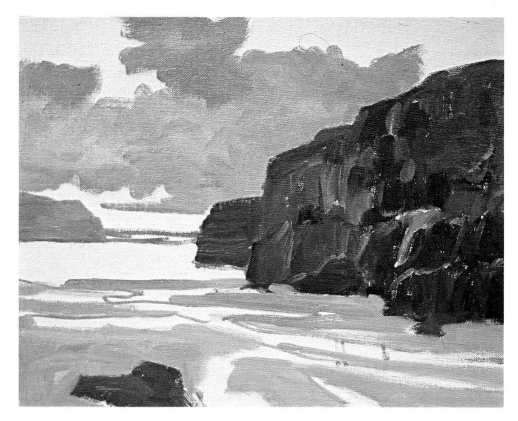

Step 6. The overcast sky is painted with yellow ochre and white, subdued with just a hint of the darker cloud mixture. As the brush paints the surrounding sky, the edges of the clouds are blurred and softened. The sky mixture is carried down into the bright tidepools. More blue is blended into the cloud mixture to paint the dark sea at the horizon; then a few strokes of this mixture are brushed over the big headland at the right and the small headland at the center to suggest the skylight falling on the rocks. Darkened, this mixture becomes the reflection in the tidepools. Lightened, this mixture is brushed into the tidepools in the foreground and carried over the water's edge.

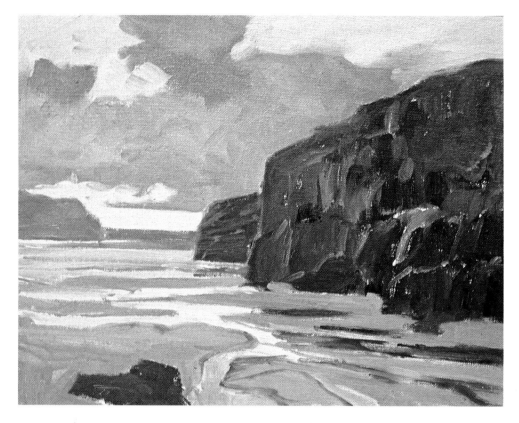

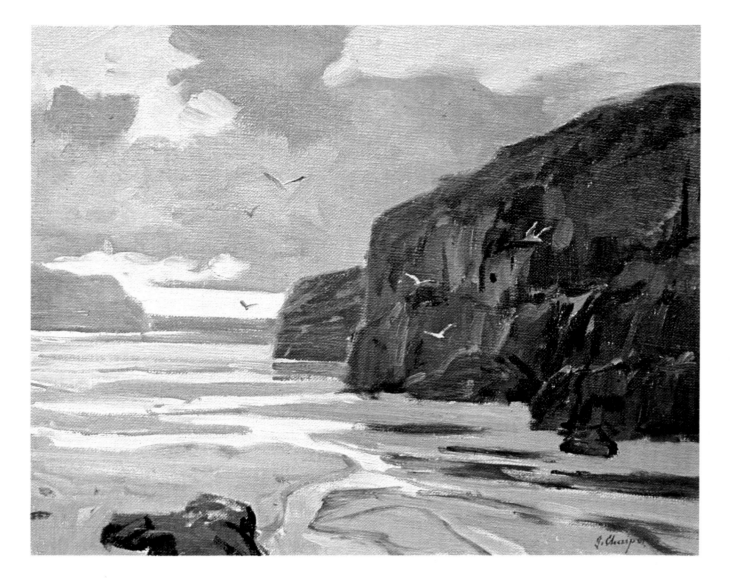

Step 7. At the end of Step 6, the tip of a round softhair brush began to sharpen the shadowy edges of the tidepools with slender strokes of the cloud mixture. This sharpening up operation continues as the round brush adds dark lines of shadow to the big headland and the rocks in the lower left. These dark strokes are burnt umber and ivory black diluted with enough painting medium to make the brush move smoothly over the canvas. Several more grassy patches are added to the top of the cliff with ultramarine blue, viridian, yellow ochre, and white. Small strokes of bright light are swiftly brushed over the top of the rock at the lower left with pure white tinted with a speck of the cloud mixture. The tip of the round brush uses this mixture to paint the pale shapes of the gulls silhouetted against the dark cliff. More blue is added to the cloud mixture to paint the dark gulls silhouetted against the sky.

Step 1. The lines of sand dunes are soft and sinuous, but certainly not shapeless. Their curves must be drawn with great precision so that the design of the picture is clearly determined from the very beginning. The tip of a round softhair brush executes these lovely curves with a mixture of cobalt blue, alizarin crimson, yellow ochre, and white—which will become the basic palette for the painting.

Step 2. The shape of the distant water is painted with long, smooth, horizontal strokes of cobalt blue, softened with touches of alizarin crimson and yellow ochre, plus some white to brighten the blue. At the edge of the beach, more yellow ochre is blended into the water. The sunlit area of the sand is covered with thin, casual strokes of yellow ochre and white, made more subdued by adding a speck of yellow ochre and alizarin crimson. Now the strongest contrast in the painting has been established—the contrast between the dark note of the sea and the light note of the sunlit sand. All the other tones in the painting will fall somewhere between these two.

Step 3. By now, you're familiar with this method of painting the sky. Once again, the sky is first covered with separate strokes of cobalt blue and white. The strokes are darkest and closest together at the top of the sky, gradually growing lighter and sparser as the brush approaches the horizon. The shadowy underside of the cloud is painted with the same mixture that was used to paint the sea, but with slightly more yellow ochre for greater warmth.

Step 4. Yellow ochre and white are blended on the palette and then this mixture is carried across the sky in a series of separate strokes. These strokes sometimes fall between the touches of cobalt blue and sometimes overlap the blue. The brush makes no attempt to blend the two hues just yet, but as the yellow-laden brush moves over the wet blue undertone, the two colors tend to merge.

Step 5. When the small strokes of alizarin crimson and white have been added, a big bristle brush blends all these colors together with short strokes. You can see that the warmer, paler tones are concentrated in the lower sky. The lighted areas of the clouds are painted with white tinted with touches of yellow ochre, alizarin crimson, and cobalt blue. A darker version of this mixture is brushed across the shadowy undersides of the clouds. The pale wisps of cloud at the upper right and left are quick strokes of the same mixture that's used to paint the lighted tops of the bigger clouds. The tip of a round brush pulls this mixture across the sea with horizontal strokes that suggest sunshine on the waves.

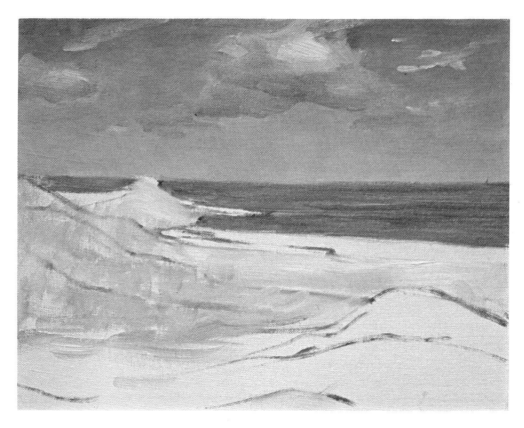

Step 6. A cloud often casts its shadow on the landscape beneath. Such a *cloud shadow*, as it's called, can act as a handsome "frame" for the sunlit area of the landscape. Here, a cloud shadow is painted over the beach in the foreground with the same mixture that's used to paint the shadowy undersides of the clouds: cobalt blue, alizarin crimson, yellow ochre, and white. The long, curving brushstrokes of creamy color follow the curves of the dunes. A small bristle brush places shadows on the more distant dunes with this same mixture. Notice how the sunlit beach is brightened by the contrasting shadow tone.

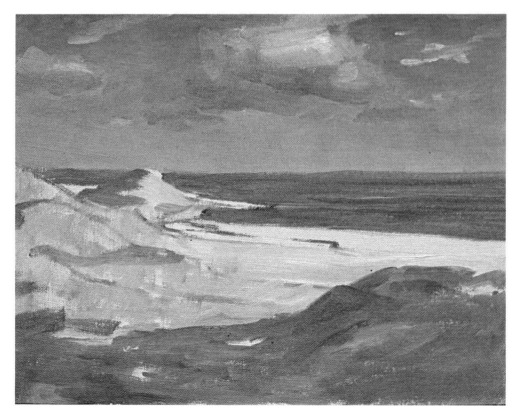

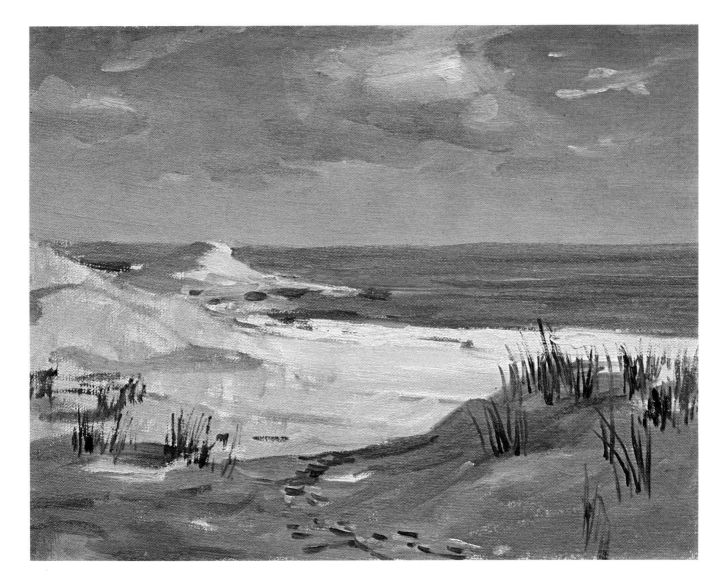

Step 7. To strengthen the contrast between the sunlit sand and the dark tone of the sea, a bristle brush sharpens the edge of the beach with thick strokes of yellow ochre and white, softened with just a speck of cobalt blue and alizarin crimson. The sea mixture is darkened with more cobalt blue for the touches of shadow where the distant dunes meet the edge of the sea. Small strokes of this same mixture curve upward from the lower edge of the canvas to suggest a trail of pebbles, seaweed, or other shoreline debris. Then ultramarine blue, cadmium yellow, and burnt umber are blended on the palette with plenty of medium to produce a fluid mixture for the beach grass. The tip of a round softhair brush places clumps of this grass in the foreground with rapid, spontaneous strokes; the tip of the brush is pressed down and then pulled swiftly upward, following the curve of each blade.

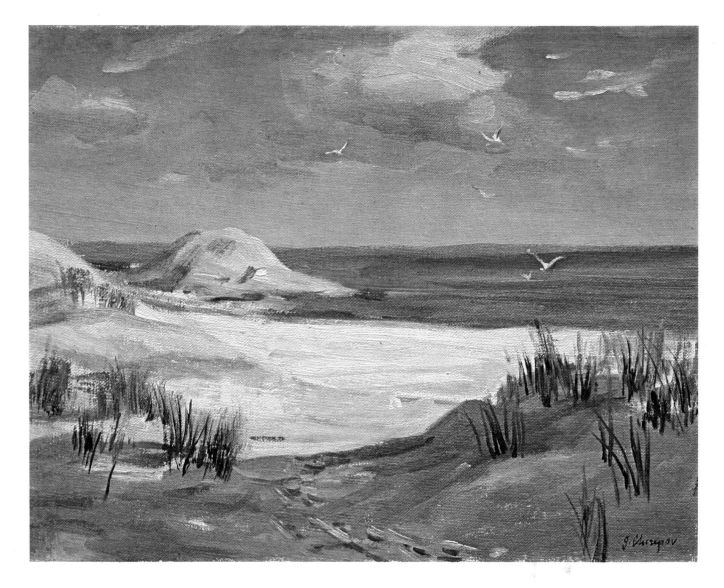

Step 8. A big bristle brush brightens the tone of the sunlit sand with long, sweeping strokes of yellow ochre and white, with an occasional touch of burnt sienna which you can see in the warm streaks and the warm patches at the left. The shape of the distant dune is enlarged and rounded with thick strokes of this mixture. The shadow side of the big dune is warmed with yellow ochre, burnt sienna, and white; then the dark shadows are restated with the original mixture of cobalt blue, alizarin crimson, yellow ochre, and white. The beach grass is also brightened with strokes of viridian, burnt sienna, and white to emphasize those patches of grass that are silhouetted against the sunlight. Touches of the warm, sandy mixture are carried over the foreground where they mingle with the dark strokes placed there in Step 7. A single horizontal stroke creates a cloud shadow on the water with cobalt blue, yellow ochre, and white. The tip of a round brush paints the sunlit shapes of the gulls with yellow ochre and white. It's worthwhile to study the colors of the finished painting to see how the light of the sky influences every aspect of the subject. The sea reflects the tone of the sky, of course. But the colors of the beach are influenced just as strongly. The crystalline sand in the center reflects the warm sunlight, while the shadowy sand in the foreground reflects the cooler tone of the sky.

Panoramas and Close-ups. When you're standing on a beach or at the top of a headland, you see an incredible panorama that's just too much to include in one painting. You've got to zero in on just one small part of the panorama and paint *that*. You can *suggest* the vastness of the sea by painting one big cliff, a couple of smaller ones; a curve of beach, two long waves, and a few clouds. If you try to include much more, you'll actually *lose* that sense of space and majesty—which you'll achieve if you concentrate on just a few big shapes. It's usually best to focus on some memorable close-up. Don't paint the entire length of the wave, but concentrate on that section of the wave that's crashing into the big rock formation. Don't try to paint all the clouds in the sky, but just those few clouds with the bright light of the sun behind them—and just two or three shining tidepools that reflect the sun's rays.

Finding the Right Spot. Before you set up your painting gear, walk around for a few minutes to find the vantage point or the angle from which the subject looks most appealing. Try to find the spot where you can see the curve of the beach moving gracefully toward that big rock formation—so you can design the picture to lead the eye along the edge of the beach to the center of interest. If you walk around to the shadow side of the cliff, that big, craggy shape may look darker and more impressive than it does from the sunlit side. The beautiful reflections in a tidepool may be easier to see if you climb up on a rock.

Looking for Ideas. How do you spot a really good pictorial idea? It's not enough to fall in love with one handsome motif—like a cliff, a dune, or a tidepool—and just paint that. A successful seascape is a *combination* of elements that work well together. One thing to look for is conflict or contrast; another is repetition or harmony. The most common conflict—and it's always wonderful—is the graceful form of a wave battling the jagged form of a rock. But look for other contrasts, such as the calm tidepool with the turbulent storm clouds overhead; or the overcast day with the flashes of sunlight breaking through the gray clouds and shining on the wet beach. But repetition or harmony may be equally fascinating: the long, low lines of the waves rolling into shore, echoed by long, lazy clouds just above the horizon; or the exploding shapes of the surf repeated in the billowing forms of the clouds.

Orchestrating the Picture. As you can see, the whole secret of a successful seascape is to find the right *interplay* of pictorial elements. Of course, you won't find the exact combination ready-made. Nature tends to give you scattered raw material which it's your job to organize. You may want to emphasize the contrast between the calm sea and the distant storm clouds—but those clouds may be too far off, too small, and not dark enough. You're perfectly free to make those clouds bigger and darker. You can also exaggerate the tranquility of the sea by making the waves longer and lower. If you want to make that cliff look taller, you can move some low, flat rocks up the beach to the foot of the cliff, where their horizontal lines will contrast nicely with the vertical lines of the cliff.

Keep Looking. Make a point of looking at the same coastal landscape under different light conditions. At one moment, a subject may seem hopelessly dull. But an hour later, the light comes from a slightly different direction and that subject is transformed. At noon, those shoreline rocks may not impress you at all because the sun is high in the sky, producing a bright, even light, with very few bold shadows. But in the late afternoon, with the sun low in the sky, creating strong shadows and interesting silhouettes, those "dull" rocks may take on unexpected drama: now their shapes may suddenly become dark and powerful. Conversely, the brilliant, transparent blues and greens of the waves may look brightest at midday and lose their fascination in late afternoon, when the light is more subdued. As you walk *around* the subject, you may discover that there are lots of different ways to paint it. When you stand at one spot, you may see the tidepools framed by the shapes of the rocks. As you stand at another spot, you may see beautiful, dark reflections of the rocks in the sunlit pool.

A Note of Caution. Be sure to take along suntan lotion on sunny days, not only to protect yourself from the direct sunlight, but also from the brilliant light that shines off the water. An experienced seascape painter also travels with a hat that has a broad rim and a cord that goes under his chin to keep the hat from being blown off by the wind. Keep an eye on the tide; it can be a rude shock to set up your painting gear on a rock formation and then look down to see yourself surrounded by water!

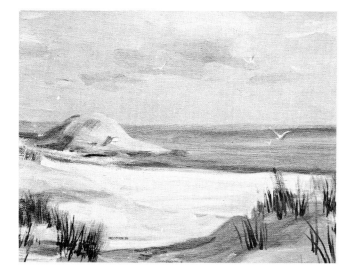

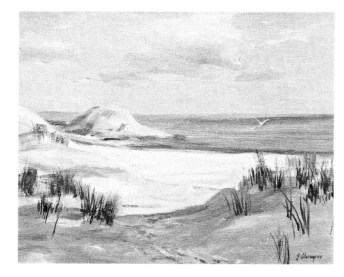

Don't Place your horizon line at the midpoint of the picture, dividing the composition into two equal halves.

Do place the horizon line a bit above or below the midpoint of the picture. Here, the horizon line is raised slightly *above* the midpoint. Now there's room for more foreground—particularly the dramatic foreground shadow that frames the sunlit beach.

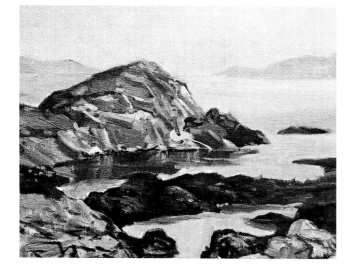

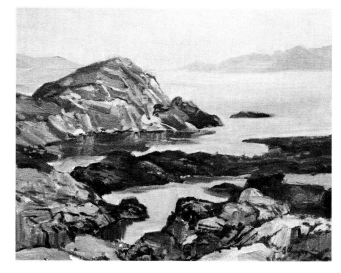

Don't place the focal point of the picture too close to the center. In this coastal landscape, the eye enters the picture through the gap between the rocks at the lower edge, then travels straight upward to the big rock formation like an arrow heading for a bullseye.

Do place the focal point of your picture slightly off center and give the eye a more interesting route to get there. Here, the big rock formation has been raised and pushed to the left. The pattern of shapes in the foreground becomes more interesting, challenging the eye to "climb" over more rocks and water to reach the focal point of the painting.

Don't drop the horizon line so far down that the sea seems to be squashed at the bottom of the painting—with mostly sky above. It's true that the coastline often seems to be dominated by sky, but it's important to include *enough* sea or shore.

Do try to arrive at a proper balance of sea and sky. Here, the waves and shore occupy the lower third of the canvas, while the sky occupies the upper two thirds. Dividing the picture into thirds is an almost foolproof method. This painting might work equally well if the sky occupied the top third of the canvas, while the sea and shore occupied the lower two thirds.

Don't become so fascinated with one big shape that it fills the canvas and allows practically no room for anything else. The dark, dramatic shape of this headland is so big that it crowds everything else out of the picture.

Do allow room for the interplay of large and small shapes. Now the big headland is balanced by the smaller shapes of a rock formation in the foreground and a smaller, more distant headland at the left. There's also more beach, which means that there's room for an interesting pattern of tidepools that lead the eye into the picture by a lively zigzag route.

Rocks in 3/4 Light. Before you begin to paint any coastal subject, observe the direction of the light and see how that light molds the forms. This is ¾ light, which means that the light is coming over one of your shoulders as you stand at the easel, facing your subject. The light strikes the rocks at an angle, illuminating the front and one side of each rock, but plunging the other side into shadow. In this particular case, the light is coming over your left shoulder.

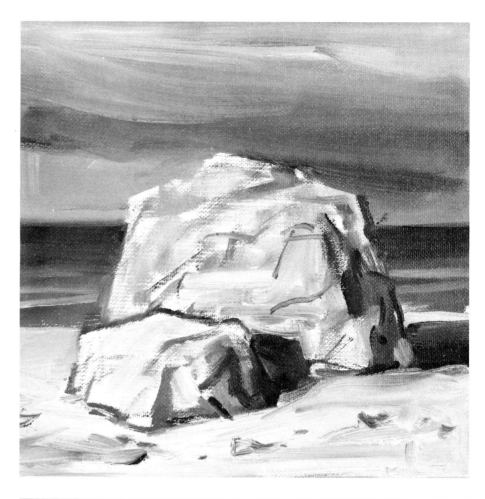

Rocks in Side Light. Here's the same rock formation at a different time of day, when the light hits the rocks from one side. Actually the sun is just a bit behind the rocks, illuminating the top and left side of each rock, but plunging the front and right side into darkness. Because the sun is to the left and slightly behind the rocks, the shadows slant diagonally to the lower right. The rocks are completely transformed by a change in the location of the sun.

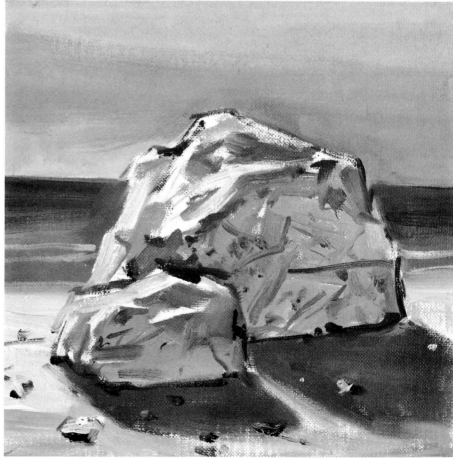

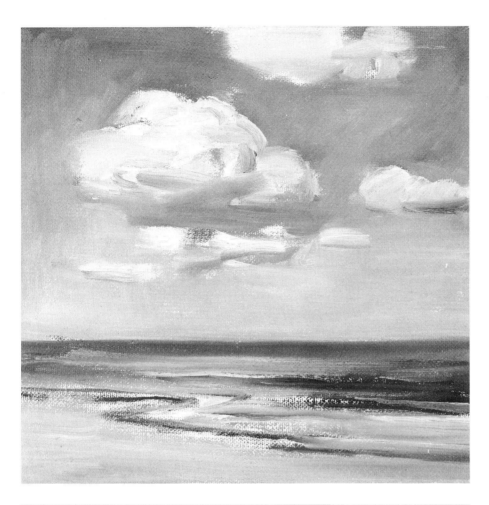

Clouds in 3/4 Light. Clouds, like rocks, have distinct planes of light and shadow. These clouds, like the rocks at the top of the preceding page, are in ¾ light. Once again, the light comes from the left, which means that the tops and left sides of the clouds are in sunlight, while the bottoms and the right sides are in shadow.

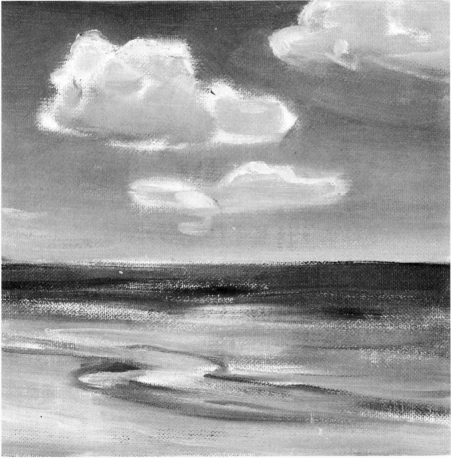

Clouds in Back Light. When the sun goes behind the clouds, their faces are in shadow, while only a bit of light creeps around the edges. This effect is common in early morning and late afternoon, when the sun is low in the sky. Not only clouds, but waves, rocks, dunes, and headlands look particularly dramatic in back light.

Waves in Perspective. Too often, we think of perspective in connection with geometric forms such as walls and highways, but we forget that natural forms also obey the "laws" of perspective. When you paint the parallel forms of waves rolling into shore, you'll paint them more convincingly if you think of the diagram below.

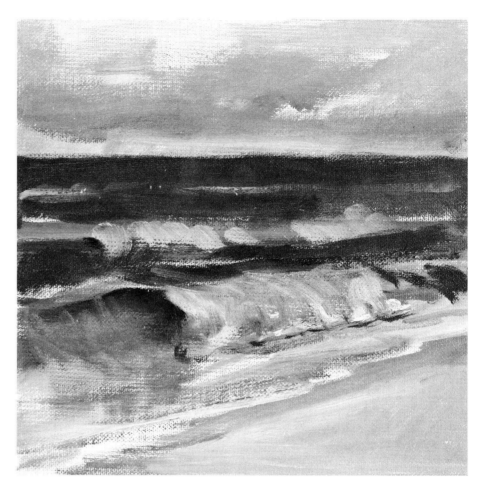

Diagram of Waves. One of the basic laws of *linear* perspective is that parallel lines tend to converge toward some unseen point in the distance. Most of us have seen this phenomenon when we look down a railroad track—but it also happens with waves. Here, the lines of the waves all seem to be converging toward some "vanishing point" somewhere off to the right. The lines are not geometrically perfect—things are always slightly askew in nature—but the waves follow these lines closely enough to create a convincing sense of space.

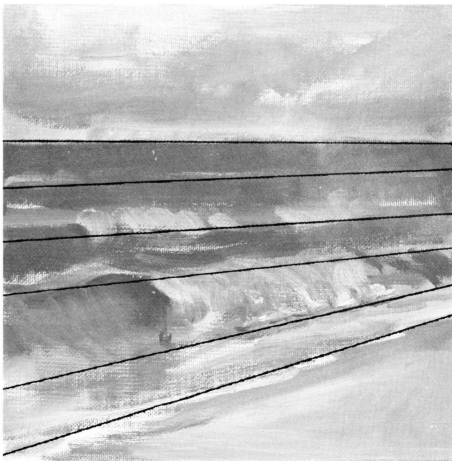

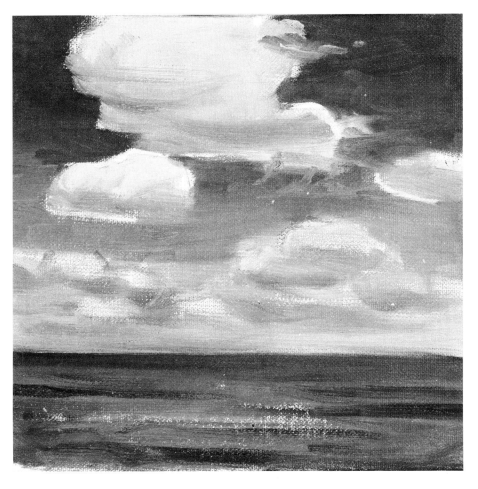

Clouds in Perspective. Another obvious "law" of perspective is that things tend to get smaller as they recede into the distance. We all know that this is true of earthbound objects like rocks and trees, but it's also true of clouds. The nearest clouds are bigger and appear highest in the picture. As the clouds grow more distant, they become smaller and they drop toward the horizon. The most distant clouds are smallest and closest to the horizon.

Aerial Perspective. When you're painting outdoor subjects, *aerial* perspective is even more important than *linear* perspective. According to the "laws" of aerial perspective, objects are darkest and most detailed in the immediate foreground, growing paler and less detailed as they recede into the distance. Here, the rocks in the foreground are not only darker and more detailed than the rest of the picture, but exhibit the strongest contrast between light and shadow. The distant island is paler and shows much less detail. The next island, just below the horizon is even paler and less distinct. Looking back at the demonstrations in color, you'll also see that distant objects become cooler—which means bluer or grayer.

Waves Approaching Shore. When they paint the forms and movements of the sea, professional seascape painters strive to match the brushstrokes to the subject. Here's a close-up of a section of a seascape in which a variety of strokes represent the changing character of the waves. In the upper half of the picture, the choppy movement of the waves is captured by long, arc-like strokes. Bands of light and dark strokes alternate to suggest the shadowy faces of the waves and the sunlit patches of sea between them. Just below the midpoint of the picture, the brushwork changes to short, scrubby, vertical strokes that suggest the movement of the wave as it crashes downward and explodes into foam. In the immediate foreground, a smooth pool of water washes up the beach; now the paint is smoothly applied, barely showing the texture of the bristles. The tip of the brush traces the shining edge of the pool with curving strokes of thick color.

Calm Water. Here's another close-up of a section of a painting in which the brush captures the calm surface of the water with soft strokes. Beyond the rocks, the distant water is rendered with horizontal strokes of soft, creamy color in alternating bands of light and dark. As the water passes between the rocks at the left, the brushwork changes to shorter strokes that tilt slightly to suggest a few low waves. Beneath the big rock formation, the brush returns to soft, smooth, horizontal strokes that are blended into one another so that the individual stroke almost disappears to create an even, motionless surface. In the immediate foreground, some gentle ripples are suggested by shorter strokes that curve slightly, overlap one another, and alternate from light to dark. Essentially, the water is painted with long, horizontal strokes, occasionally interrupted by shorter, more active brushwork to suggest an occasional break in the smooth texture of the water. Note how the smooth, horizontal strokes of the water accentuate the rough texture of the rocks, which are painted with diagonal strokes of thick color.

Sunlit Ripples. This close-up comes from a painting of a calm sea on a bright, sunny day, when the sunlight shines on the gently rippling water. The distant sea is painted with long, slender, horizontal strokes made by the tip of a long, resilient bristle brush—most likely a filbert. The paler strokes suggest the light shining on the water. Closer to the shore, the bristle brush paints the broad tones of the water with shorter horizontal strokes that suggest individual waves. Then the tip of a round softhair brush moves over the water, making short strokes of pale color that suggest brilliant sunlight gleaming on the ripples. In the immediate foreground, the slender strokes of the round brush curve slightly and overlap to suggest the gentle movement of the waves moving into shore. In contrast with the delicate brushwork of the water, the rocks are painted with rough, diagonal strokes of thick color. The strategy is always to orchestrate the brushstrokes—playing one type of brushwork against another.

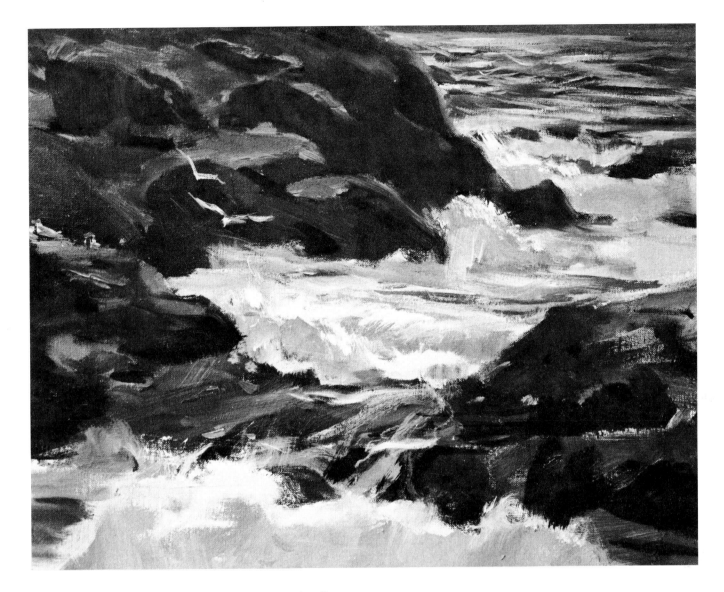

Crashing Surf. In the upper righthand corner, the distant sea is painted with slender, choppy, strokes made by the tip of a round brush to suggest the action of the waves before they strike the rocks. Then, as the waves crash against the rocks, the brushwork changes dramatically. The crashing foam is painted with vertical and diagonal strokes of thick color, applied with a stiff bristle brush that captures the erratic movement of the surf as it splashes between the rocks. The brushwork is scrubby and erratic, like the action of the surf itself. In contrast with the rough brushwork and thick color of the surf, the surrounding rocks are painted with smoother, creamier color, applied in horizontal and vertical strokes. The smoother, more solid tones of the rocks contrast nicely with the scrubby, irregular brushwork of the surf.

Swells. It's helpful to memorize the different types of waves so that you can identify them when you start to paint. In the open sea, before the waves approach the shore, they're called swells. The sea is a rhythmic series of ridges and valleys with sunlight shining on the ripples.

Whitecaps. In a high wind or a storm, the wind whips the tops off the swells. The foamy edges of the swells are called whitecaps. The action of the water tends to be more violent: the waves curve upward, and their faces become darker and more shadowy. It's important to distinguish between whitecaps and real surf—which is caused by the wave exploding into foam as it approaches shore.

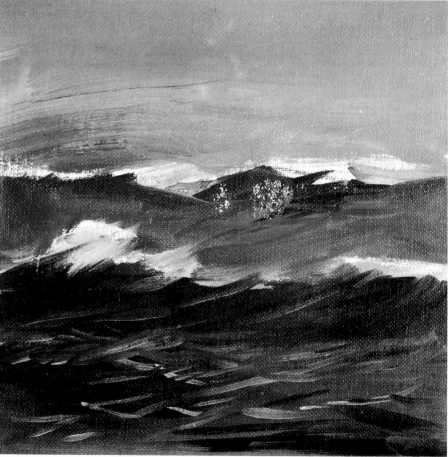

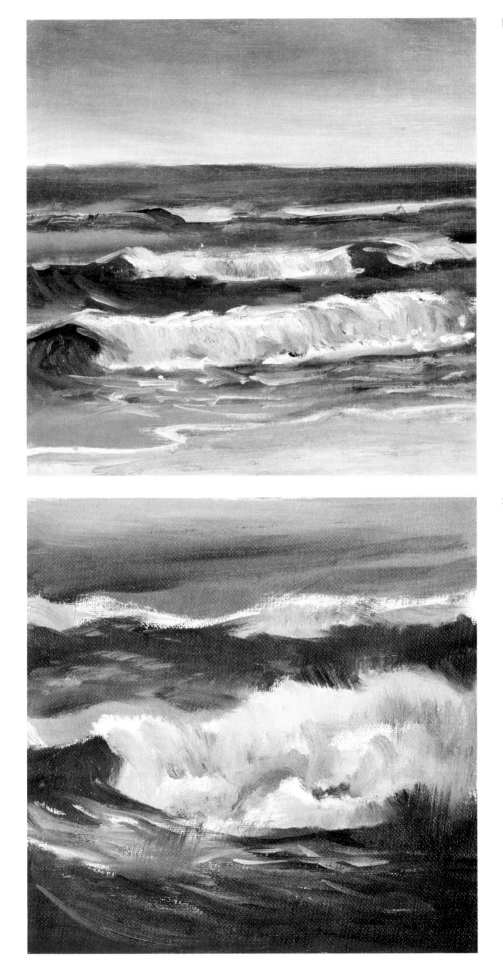

Breakers. As the ocean waves approach the shore, they surge upward and then curve forward. The leading edge of the wave curves over and explodes into foam. After the wave breaks, the water continues to move, forming a shallow pool that spills forward across the beach.

Surf. Here's a close-up of two waves exploding into surf. The leading edge of the more distant wave is just beginning to break as the wave curves forward. The foreground wave has already curved over and struck the water; the surf literally seems to explode, moving upward in a thick burst of foam. Notice how the foam in the foreground is painted with short, vertical strokes of thick color. It's also important to remember that foam has a distinct pattern of light and shadow, just like a cloud. This foam divides into several distinct shapes, with sunlit tops and shadowy faces. The surf on the distant wave is also sunlit at the top.

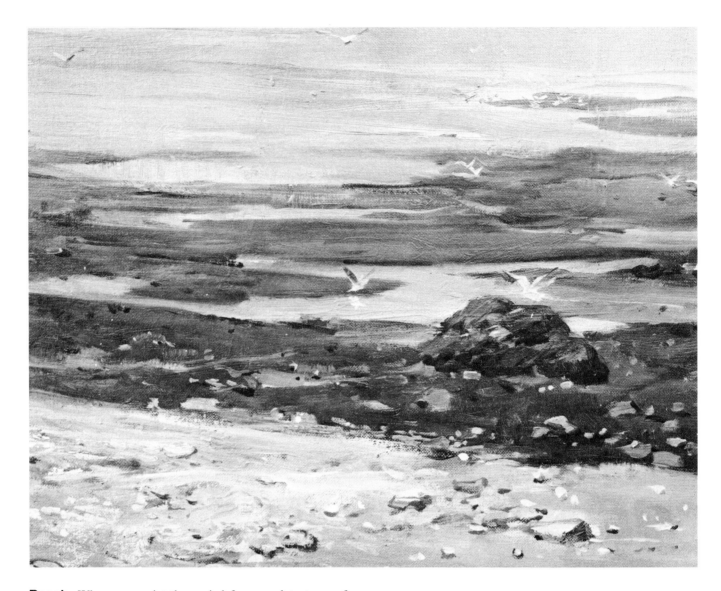

Beach. When you paint the varied forms and textures of the shore, it's important to plan your brushwork as carefully as you plan the strokes of the water. In this close-up of a section from a painting of tidepools, the sand and water become alternating bands of light and dark. The big horizontal shapes are all painted with horizontal strokes of creamy color. The distant water is painted with smooth, fairly thin color. But as the brush approaches the beach in the foreground, the color becomes thicker and the strokes become rougher. A small bristle brush and a round softhair brush paint dots and dashes of thick color across the foreground to suggest pebbles and other shoreline debris. The one big rock displays a totally different kind of brushwork: short, diagonal strokes of thick paint that express the blocky shape and contrast very effectively with the smoother texture of the sand and water.

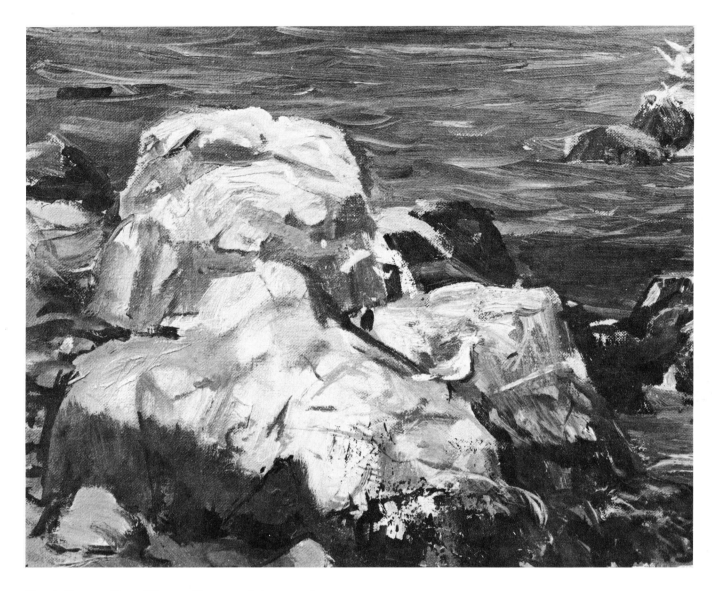

Rock Formation. The sunlit tops of these rocks are painted with horizontal and diagonal strokes of thick color undiluted with painting medium. In contrast, the shadowy sides of the rocks are painted with vertical strokes of thinner, darker color. The tip of a round softhair brush draws the cracks and other details in the rocks. This same brush suggests the ripples in the distant water with short, slender, curving strokes. As you can see, the experienced painter not only plans his brushwork, but also plans the consistency of the color.

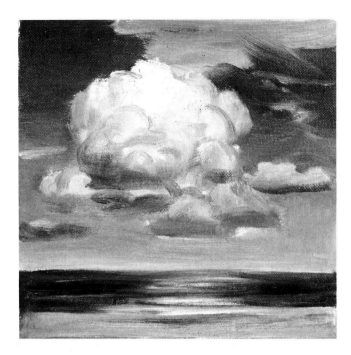

Cumulus Clouds. Each cloud has its own unique character, so it's important to learn to recognize the different types of clouds. These huge, rounded forms are called cumulus clouds. They tend to occur in clusters and move across the sky like magnificent islands. They usually have round, sunlit tops and flatter, shadowy undersides.

Layered Clouds. Another common cloud formation is a series of horizontal layers. The clouds tend to form parallel bands, some light, some dark. The wind sometimes breaks up the layers and pulls them diagonally across the sky, as you can see at the very top.

Storm Clouds. The high winds of a storm at sea can tear the clouds into ragged shapes. But even these unpredictable forms have a distinct pattern of light and shadow. The dark cloud at the top of the picture and the lighter cloud just above the horizon are surprisingly similar: each has a lighted top and a shadowy underside.

Mackerel Sky. When the wind breaks the clouds into a regular pattern of tiny puffs—like scales on a fish—this is called a mackerel sky. These puffs tend to form horizontal or diagonal clusters with strips of sky between them. Each mackerel sky has its own unique design. Never invent clouds: paint them from nature and store them in your memory bank.